THE UNFEATHERED BIRD

THE UNFEATHERED BIRD

Katrina van Grouw

PRINCETON UNIVERSITY PRESS

PRINCETON AND OXFORD

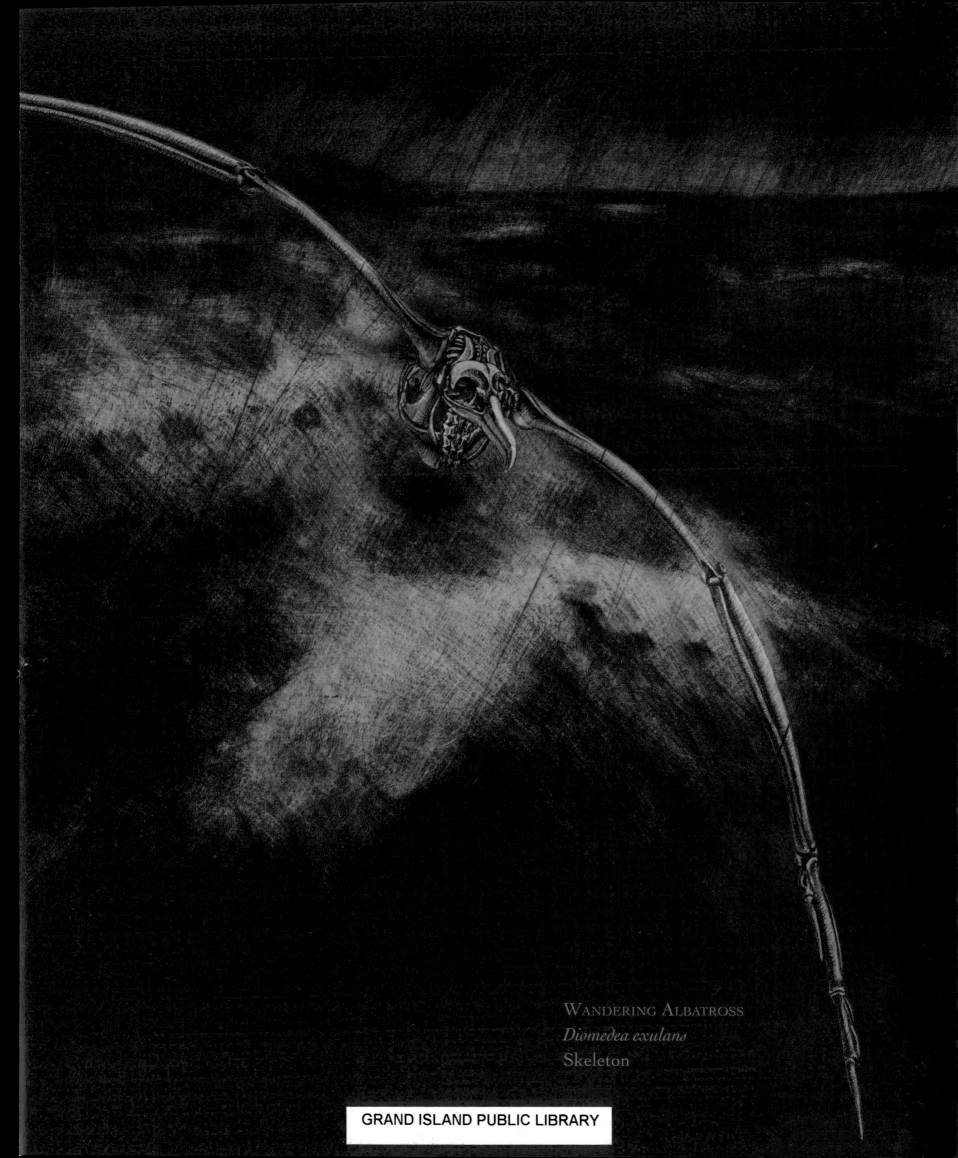

WANDERING ALBATROSS
Diomedea exulans
Skeleton

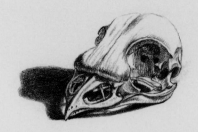

Published by Princeton University Press, 41 William Street, Princeton, New Jersey 08540
In the United Kingdom: Princeton University Press, 6 Oxford Street,
Woodstock, Oxfordshire OX20 1TW

nathist.princeton.edu

Library of Congress Cataloging-in-Publication Data

Van Grouw, Katrina, 1965–
The unfeathered bird / Katrina van Grouw.
p. cm.
Includes index.
ISBN 978-0-691-15134-2 (hbk. : acid-free paper) 1. Birds—Anatomy.
2. Birds—Behavior. 3. Birds—Adaptation. 4. Birds—Pictorial works.
5. Ornithology—Fieldwork. I. Title.
QL697. V26 2013
598—dc23 2012010955

British Library Cataloging-in-Publication Data is available

This book has been composed in Cochin with Dominican for display

Printed on acid-free paper. ∞

Printed in Singapore

3 5 7 9 10 8 6 4 2

GREEN BROADBILL
Calyptomena viridis
Skull.

02 14

To Amy

~ Contents ~

viii Acknowledgments

x A Note about Names

xii Introduction

Part One: Generic

 2 The Trunk
 8 The Head and Neck
 14 The Hind Limbs
 19 The Wings and Tail

Part Two: Specific

 30 I Accipitres
 32 Vultures
 35 Birds of Prey
 44 Owls

 52 II Picae
 54 Parrots
 58 Turacos and Others
 62 Kingfishers
 65 Hornbills and Allies
 70 Toucans and Barbets
 74 Woodpeckers
 80 Hummingbirds

 84 III Anseres
 86 Waterfowl / Domestic Waterfowl
 104 Penguins
 114 Loons
 119 Grebes
 124 Albatrosses, Petrels, and
 Storm Petrels

132 Tropicbirds and Frigatebirds
136 Pelicans
139 Gannets
144 Cormorants and Darters
150 Gulls, Terns, Skimmers, and Skuas
154 Auks

162 IV Grallae
164 Flamingos
167 Herons
173 Shoebill
174 Storks, Ibises, and Spoonbills
181 Cranes
185 Rails
190 Kagu
192 Waders

202 V Gallinae
205 Gamebirds / Domestic Fowl
220 Screamers
223 Hoatzin
226 Ostrich, Kiwis, and Other Ratites
237 Tinamous
239 Bustards
242 Sandgrouse
244 Dodo and Solitaire

248 VI Passeres
250 Pigeons / Domestic Pigeons
258 Nightjars
263 Swifts
266 Passerines

284 Index

~ Acknowledgments ~

This book was begun twenty-five years ago. Broken down, that roughly constitutes: five years of innocent research, little expecting what it would lead to; one moment of inspiration; fifteen years hoping to convince someone else that it was a good idea; and several more years of *very* hard labor.

Publishers are like buses—no sign of one for ages, and then two come along in quick succession. So it was in this case. Thus my opening acknowledgment goes to Ian Langford, of Langford Press, for being the first publisher to believe in *The Unfeathered Bird*, although this relationship was ultimately not to be. And of course my heartfelt thanks to Robert Kirk, of Princeton University Press, for being the second. The day of our serendipitous meeting was a blessed day for me indeed. It would be impractical here for me to thank everyone at Princeton who has helped and supported me, but the copy editor Jennifer Backer, designer Lorraine Betz Doneker, and production editor, Mark Bellis, deserve special mention.

At this stage I must assure readers that no birds were harmed during the making of this book. I relied exclusively on the goodwill of birds dying naturally in places where they could be found and on the goodwill of a great many people who picked them up for me. Also on people who tolerated my unsavory activities.

Kenneth James Ferguson, my first long-term partner, put up with bad smells and a flat full of seabirds, and I fear he never recovered from the incident with the swan on the sitting room floor. Dave Butterfield made it his mission in life to retrieve every bird that died in the Scottish Highlands—and hid them all in the family freezer labeled as pies belonging to the neighbors. Brian Etheridge, of the RSPB Highland Region, donated the ones that Dave Butterfield missed. Mark Dugdale demonstrated his ardor for me by wading up to his waist in a fetid African swamp to bring me a decomposing pelican. And David Norman and Ian Wallis did no end of paperwork to enable me to legally import it to the UK. Other birds found dead were passed on to me by David Bolton, Keith Grant, Peter Potts, Jill Ford, and Sue Rowe. From the lovely Lucy Garrett I received a long-dead tropicbird as a souvenir from some far-flung Indian Ocean island. And Adrian Skerrett tried valiantly to find me a dead frigatebird on the Seychelles.

Norman McCanch, the late, great, Don Sharp, Barry Williams, James Dickinson, and especially Bas Perdijk—all professional taxidermists—kindly passed many specimens on to me from their own frozen stock. Bas has helped in countless other ways, providing tools and materials and, in collaboration with Johan Bink, loaning me a whole crate of bird skulls. I also borrowed skulls from Richard Smith, John Gale, and George Beccaloni. Barry's son, Luke Williams, volunteered the use of his beetle colonies to clean the smallest bird specimens. And of course there's the New Zealand taxidermist Noel Hyde, who happened to have a fresh kiwi just when I needed one.

Then there are the aviculturalists, pigeon fanciers, poultry farmers, and other keepers of domestic and exotic birds: Hans Bulte, Craig Stanbury, Taco Westerhuis, Colin Ronald, Kees Verkolf, Theo Jeukens, Hans Ringnalda, and Campbell Murn of the Hawk Conservancy Trust. Al Dawes and David Waters of the Great Bustard Group exchanged a dripping bag of putrefied bustard soup for a beautifully cleaned and reassembled skeleton for their educational displays, meanwhile treating me and my husband like visiting royalty. And I cannot forget Scott Dyason, the Ostrich farmer who didn't bat an eyelid at my request for spare body parts. I'd be in trouble if I failed to mention my mum, who has kept many of these birds in her freezer all these years, even farming them out to neighbors when her own freezer broke down. Mum also takes care of my dog, Feather, for me during my innumerable museum visits.

I also received plenty of help of a more conventional kind. Martin Spink and Jonathan Eames, the owners of two of the drawings, very kindly removed them from their frames so that they could be scanned. David Miller—sub-aqua wildlife artist—gave me more photos of auks underwater than I knew what to do with. And every time my pile of drawings outgrew their storage box, David's wife, Lisa, sent more by first class post. Thanks also to Sophie Wilcox, the librarian at the Edward Grey Institute, Oxford, and Alison Harding at Tring. And a whole host of colleagues and friends who have cheered me on to the finish line.

All my drawings are from actual specimens. Photographs were sometimes used as additional reference but never in place of the real thing. Wherever possible I drew from skeletons prepared at home for the purpose of the book. That way I could be sure of knowing if any bones were missing and of getting the posture of the bird correct. But inevitably it was often necessary for me to use museum specimens. Special thanks are therefore due to Malgosia Nowak-Kemp and Matt Lowe for allowing me to make repeated visits to the scientific collections of the university museums of Oxford and Cambridge, respectively, and for making me feel so welcome; Georges Lenglet in Brussels and Christine Lefèvre in Paris; and Jo Cooper and my husband, Hein, at the Natural History Museum's ornithology collections at Tring, and in his former incarnation as collections manager in charge of birds and mammals in Leiden.

Thanks, too, to David Willard at the Field Museum, Chicago, for sending several specimen loans to the UK. Your help is very much appreciated. And Tom Trombone, Paul Sweet, Peter Capainolo, and Matt Shanley for providing photographs of specimens from the American Museum of Natural History in New York. Last but not least, thanks go to Kaitlin Evans of the Bishop Museum, Hawaii—I'm sorry I allowed your honeycreepers to be ousted by vangas at the final cut.

Spouses and partners are the pillar of rock behind every book. It is they who take over the household duties, provide encouragement, mop up the tears, are endlessly called upon to discuss the work and offer opinion, suffer torrents of stress-fueled abuse, and put their own life on hold as though it were less important. My own husband, Hein van Grouw, has been all of that and more. So much more.

If this is heralded as a great book rather than a good one, it is because of Hein. He has made the difference. Hein took over all the specimen preparation to leave me time to write and draw. He boiled and cleaned the bones. It was he who sifted through the bustard soup. He, who put together nearly fifty skeletons in beautiful, lively, and accurate postures. He, who plucked and skinned and set birds up on Audubonesque wires for me to draw. Hein suggested the inclusion of domestic birds and called upon many of his own contacts and colleagues to provide examples of the rare breeds whose skeletal anatomy is virtually unknown.

Again and again we shared in the excitement of discovering for ourselves some little-known anatomical feature. With Hein by my side, my task became an adventure, and I pushed my standards higher and higher.

If any book can be described as a labor of love, this is it—my twenty-five-year love for my idea, our mutual love of birds, and my husband's love for me.

~ A Note about Names ~

Here and there throughout *The Unfeathered Bird* I've referred to bird groups (called taxa) by their scientific names. Although I've attempted to qualify these wherever possible, I thought it useful to include a few words about the different groups and how to recognize them. Not all the divisions are used in the book, but I have listed them here anyway.

KINGDOM—Animalia: all animals.

PHYLUM—Vertebrata: animals with backbones (mammals, birds, reptiles, etc.).

CLASS—Aves: all the birds.

ORDER—ending in –iformes: e.g., the Anseriformes (waterfowl and screamers).

FAMILY—ending in –idae: e.g., the Anatidae (waterfowl = geese, swans, and ducks).

SUBFAMILY—ending in –inae. Only large and diverse families are divided into subfamilies and tribes: e.g., Anatinae (the ducks).

TRIBE—ending in –ini; e.g., Anatini (the dabbling ducks).

GENUS—always begins with a capital letter. Called the generic name. Plural—genera: e.g., *Anas* (a group of very similar dabbling ducks).

SPECIES—always begins with a lowercase letter. Called the specific name. Always preceded by the genus or the genus shortened to its first letter (when this will not cause ambiguity). Think of genus and species in the same way as surname and Christian name: e.g., *Anas platyrhynchos or A. platyrhynchos* (the Mallard).

SUBSPECIES or RACE—a geographically distinct population of a single species. It is written as a third name and also begins with a lowercase letter: e.g., *A. p. platyrhynchos*. This population inhabits most of the Palearctic and Nearctic region. It was the race described by Linnaeus in 1758, and because it was the one first described and bears the same name as the species, it is known as the nominate race.

It was Linnaeus who first applied the system of giving organisms a generic and specific name (called binomial nomenclature = two names). Until then animals and plants were known only by colloquial names that varied from region to region, so it was impossible to know if you were talking about the same thing. It was a stroke of genius. Latin was chosen as a language that could be universally understood (though most birds have Latinized versions of Greek names), and the system is still in use today, providing a rigid, uniform, unambiguous identity to all living things.

At least that's the Holy Grail that all taxonomists strive for.

In practice, things are slightly different. Scientific names are in a constant state of flux, ever-changing, according to the latest taxonomic theories and methods. And until we know unequivocally how each species or population is related, scientific nomenclature will continue to evolve. Sometimes the trend is to lump groups together, giving fewer species with more races, sometimes to split them apart into a greater number of species. So even *with* scientific names, it's important to know which school of thought is being followed.

Although I have maintained a rigidly noncommittal stance as far as taxonomy goes, the nomenclature used in *The Unfeathered Bird* is that used in the third edition of the *Howard and Moore Complete Checklist of the Birds of the World*, edited by Edward C. Dickinson (2003).

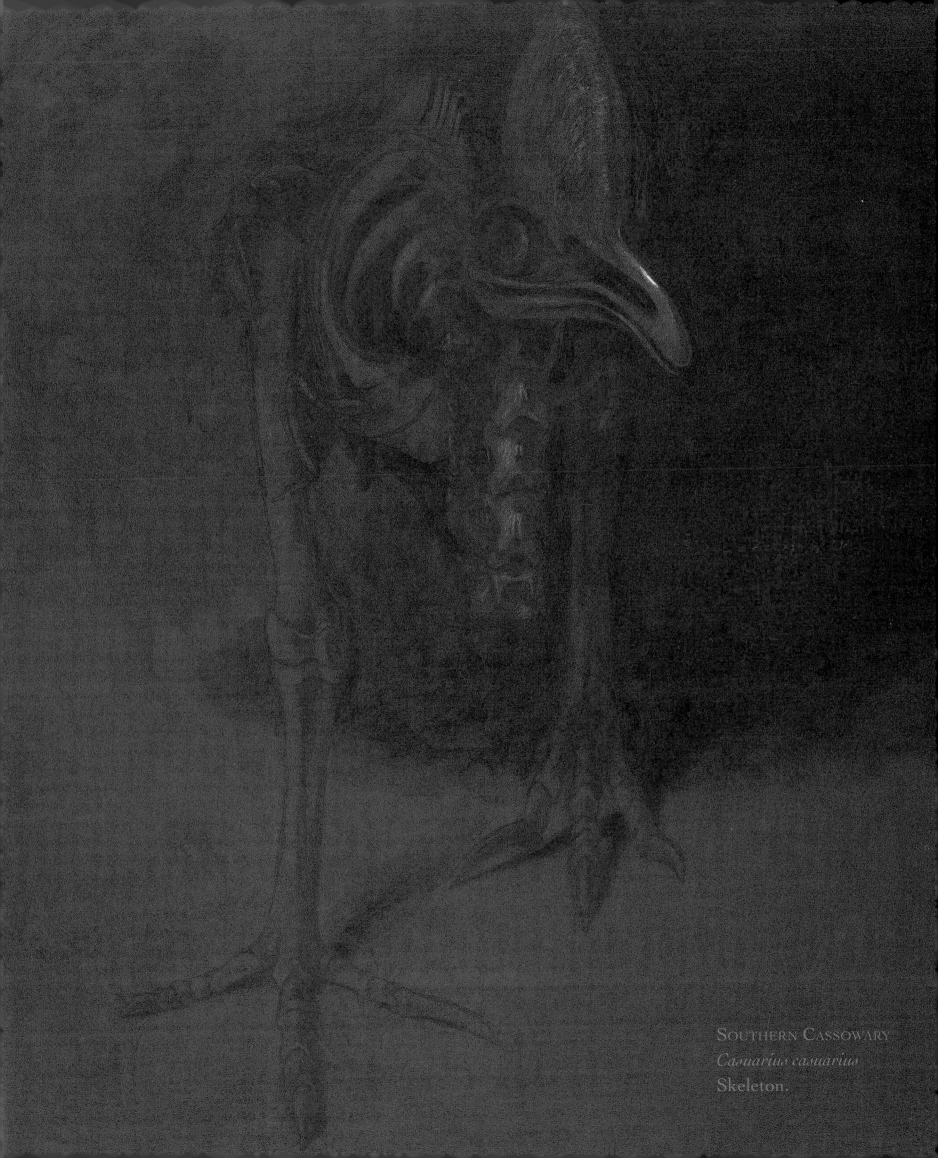

SOUTHERN CASSOWARY
Casuarius casuarius
Skeleton.

~ Introduction ~

This book is not an anatomy of birds.

That is to say, you won't find any difficult Latin words or scientific jargon. You won't learn much about the deep plantar tendons of the foot or the comparative morphology of the inner ear. Nothing beneath the skeleton is included—no organs or tissues; no guts or gizzards. There's no biochemistry and very little physiology.

In fact, this is really a book about the *outside* of birds. About how their appearance, posture, and behavior influence, and are influenced by, their internal structure.

Originally intended as a book for artists, it didn't take long to realize that it would have wider appeal. Nothing similar exists. Modern ornithological textbooks sometimes provide a cursory line drawing showing the parts of bird; some even show the skeleton or a view inside the body cavity. But these are diagrams as opposed to works of art—dry, academic, and not at all pleasing to the eye. The illustrations in historical works tend to be rather more aesthetically stimulating, if sometimes a little highbrow for the general bird-lover. But when complete skeletons are shown, their appeal is more often than not counteracted by placing them in the most unlikely postures, bearing little resemblance to their attitude in life. Hardly surprising, considering that the anatomists of the past had seldom seen these birds alive.

This book attempts to combine the visual beauty and attention to detail of the best historical illustrations with an up-to-date knowledge of field ornithology; for the first time showing the internal structure of many species engaged in natural behavior.

Most of the major bird groups of the world are included, especially where their anatomy is of particular interest, though, sadly, it was not possible to include them all. Domestic birds have a place here, too, and provide some of the most bizarre and unlikely revelations in the whole book.

Much anatomical writing—at least in ornithology—is an impenetrable forest of basipterygoid processes and occipital fontanelles, so little wonder that readers often give it a wide berth. I have attempted to take the mystery out of a subject until now shrouded in long words. I've done this by looking down the wrong end of the binoculars, so to speak—allowing the illustrations to speak for themselves when it comes to the fine details and concentrating my descriptions on the birds' most obvious adaptations to their particular environment.

Now nature has a tendency to reinvent itself. For example, webbed feet are useful for swimming, and a hooked beak is useful for tearing flesh, so features like these have arisen independently in groups that are not necessarily closely related. This is called convergent evolution—otherwise known as the taxonomist's worst nightmare. The features that do give genuine clues about evolutionary relationships, those that are not influenced by adaptations to a particular environment or way of life, tend to be the subtle things—the structure of the palate; the coiling of the intestines; or an extra tendon or muscle here and there. Once the primary weapon against the problems of classification, this brand of comparative anatomy is now just a tiny part of the taxonomist's armory; an armory that includes egg-white proteins, DNA hybridization, digestive enzymes, feather structure, and vocalizations—to name but a few.

So are we now close to establishing a universally accepted "natural" classification of birds?

Not really.

I wanted *The Unfeathered Bird* to remain firmly on the fence through the swampy territory of taxonomic debate. After all, it's concerned with outward appearances and adaptations, not with tracing evolutionary

pathways. And it's supposed to be enjoyable. But this of course led to a problem—which order do I use? At all costs I wanted to spare myself and my readers a slavish trudge through each taxon in turn. My answer—a somewhat unorthodox one—was to turn modern classification on its head and to base my order of chapters on a system that is concerned *only* with outward structural appearances; on the first truly scientific classification of the natural world—the *Systema Naturae* of Linnaeus.

Thus my rapacious birds, swimming birds, gallinaceous birds, and so on are grouped together according to convergent evolution under their respective chapter headings in part 2, and I've attempted to place groups that are superficially similar next to each other for ease of comparison. Thus storks are next to cranes and swifts next to swallows. The *actual* relationships are discussed within the text at some length.

Part 2, by the way, in true Linnaean fashion, is entitled "Specific"—looking at birds group by group—while the much shorter part 1 is "Generic"—dealing with the anatomical features common to all birds.

I've attempted to make *The Unfeathered Bird* a convergence of art and science; accessibility and erudition; old and new—without compromise and without apology. I hope it finds its niche.

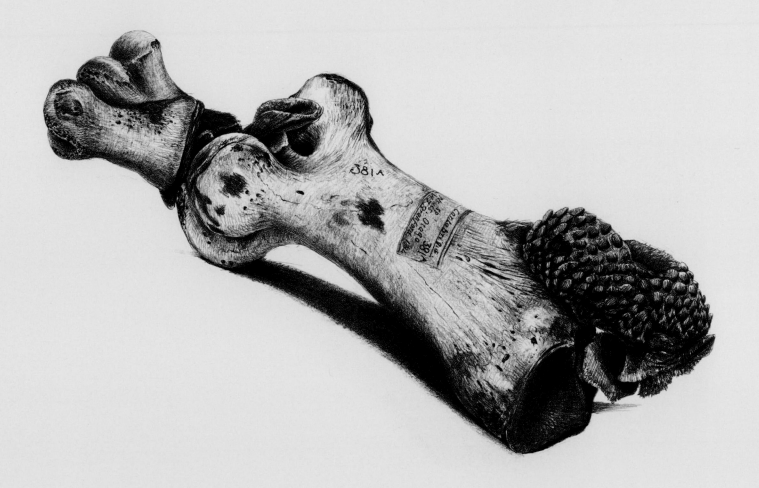

HEAVY-FOOTED MOA
Pachyornis elephantopus
Preserved partial foot, viewed from underside.

PART ONE:
generic

The Trunk

All birds evolved from flying ancestors. That applies equally to the Ostrich, penguins, the Dodo, and even the long-extinct giants—the moas and Elephant Bird.

Flight makes rather specific demands on the physical engineering of an animal. The skeleton needs to be of a lightweight structure, with large flattened surfaces for the attachment of muscles, and to have tremendous rigidity and the strength to support the entire weight of the animal while airborne. The components are highly specialized and once a satisfactory blueprint has been achieved there is very little room for modification. The paradox, then, is that although the birds represent the largest class of all the vertebrates—approaching ten thousand species—they are fundamentally rather uniform; though with some very surprising variations!

The adaptation for flight is the most important factor behind the structure of birds and can provide an explanation for virtually all of their anatomical characteristics—even those that seem to have nothing to do with flying. For example, with wings instead of front legs, birds need two strong hind limbs and a modified posture to balance on them. And with a body rigid enough to cope with the demands of flapping flight, it's vital to have a long and flexible neck to compensate for the loss of movement. But it's important to remember that birds didn't learn to fly first and develop these perfections afterward. Many of these qualities had long been present in the birds' Theropod ancestors—the upright dinosaurs that walked on two legs—and only through a constant process of adaptation and counteradaptation spanning millions of years did it become possible for the feathered dinosaurs to survive and take wing.

The trunk of a bird's body is rigidly immovable. It's more or less egg-shaped; larger and rounded at the front end and more pointed at the rear, with a central depression below the neck like the cleavage in a peach. Some are rather flattened vertically; others horizontally; some elongated, depending on the bird's lifestyle. There is a good deal of variation between the bones of various species and in their posture and carriage. But no matter what the bird is doing, the body always remains virtually the same shape.

The thorax—the front end of the trunk—is composed of the ribcage, breastbone, and pectoral girdle, which together support most of the machinery for flight. The breastbone, or sternum, is enormous—far larger than it is in other vertebrates—and is uniquely furnished with a plate-like keel along its midline, just like the keel of a ship, providing a broad surface for the attachment of the flight muscles. In general (in nondomesticated birds, that is), the stronger the flier, the broader the breastbone and the deeper the keel. And in birds whose capacity for flight is reduced, the keel is reduced also. One group of birds (the Ostrich, Emu, etc.) that lost the power of flight very early on in its evolutionary history lacks this keel altogether. *Their* breastbone (to continue the nautical theme) is more like the underside of a raft than the hull of a ship and so they have been given the name of "ratites," meaning "raft-like."

It may seem surprising that almost all of the flight muscles of birds are concentrated on and around the breastbone—on the underside of the bird's body and not on the wings themselves. For aerodynamic reasons, it's better to keep the wings as slender and as lightweight as possible, so birds have long tendons that may even span several joints, so they can keep the majority of their musculature concentrated toward the center of their frame. The muscles along the forearm are minimal and mainly control the more subtle movements of the wrist and hand.

The primary force in flight is the downward pull exerted by the large pectoral muscles that lie at the surface of the breast on either side of the keel, and these are attached to the lower surface of the wings. This is the main locomotory thrust that propels the bird forward. Beneath these, however, lies another, smaller set of muscles that pulls the wing up again. Their tendons pass through a gap between the bones at the base of the wing and are attached to the wing's *upper* surface.

Traveling through air doesn't demand much from this upward motion, and it's really little more than a recovery stroke to prepare the wing for the next downward thrust. Water presents a different problem, however, and birds that propel themselves underwater using their wings need power on the upstroke as well as the downstroke. In these groups the muscles responsible are rather better developed and may even be supplemented by others attached to the shoulder blades.

Three pairs of bones connect the wings with the body, and collectively these are known as the pectoral girdle. They are the shoulder blades or scapulars (which in birds are usually long and narrow), the wishbone or furculum, and a pair of stout struts called coracoids that are firmly attached to either side of the breastbone and brace the wings apart. The wishbone corresponds with our collarbone and is similarly composed of two sections that meet—or usually meet—in the middle. The wings are attached at the junction of these three pairs of bones by a joint that seems impossibly shallow but allows a good range of movement.

COMMON MOORHEN
Gallinula chloropus
Trunk with skin removed.

There's little skeleton to see on the underside of a freshly skinned bird, however. The breast muscles dominate everything. They engulf the entire breastbone and keel, overlap onto the ribs, and cover the coracoids completely, extending all the way to the edges of the wishbone where they round out majestically to their insertion points on the wings. This leaves, in the angle of the wishbone, the aforementioned cleavage—the furcular pit. The space provides a comfortable lodging for the lower curve of the neck, as well as the crop (though by no means all birds have one), and is why birds' necks appear so deceptively short in life, especially with the contours smoothed by a thick layer of feathers.

A bird may possess up to nine pairs of complete ribs. Each is composed of two sections that meet at an angle: one attached to the spine and the other to the breastbone. In the mammalian ribcage the section attached to the breastbone is formed of cartilage instead of bone. But birds need the extra strength to cope with the powerful contractions of those enormous flight muscles. Both sections are made of bone, and there are even additional bony projections called uncinate processes that overlap from each vertebral rib to the one behind

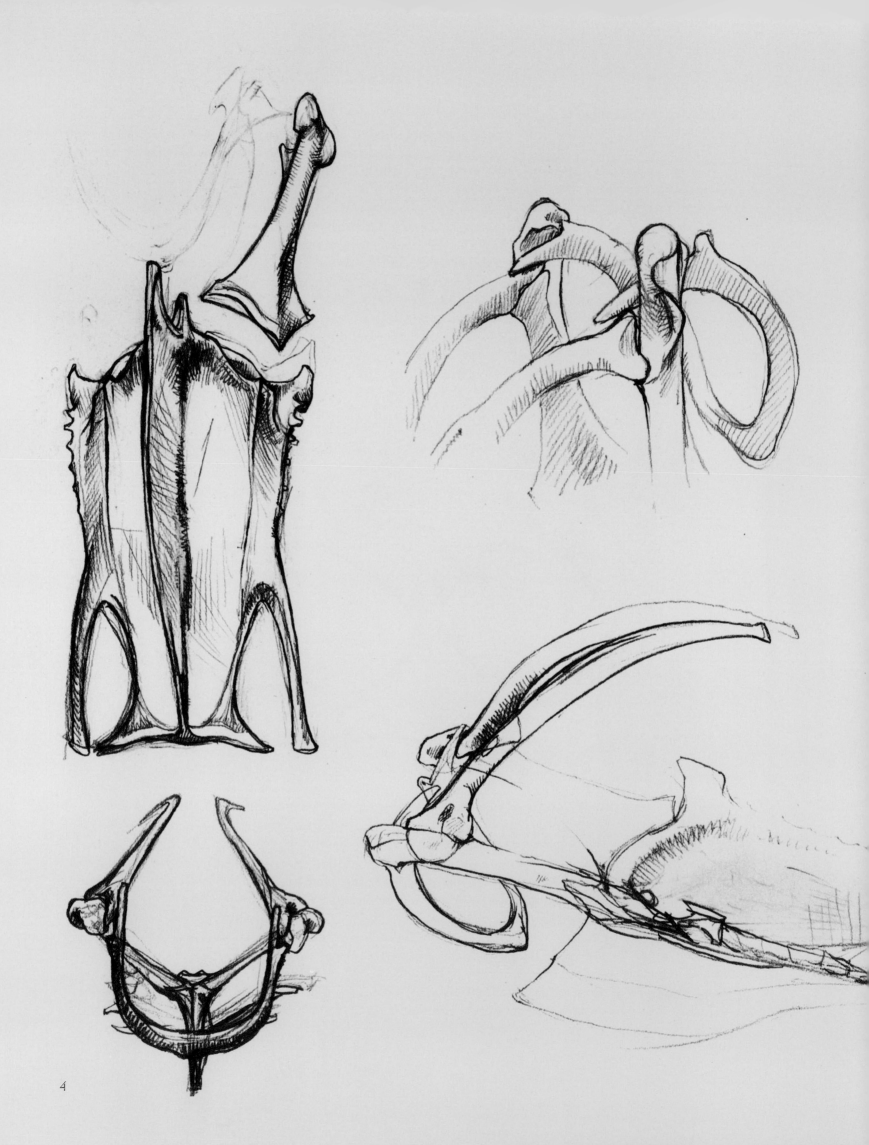

4

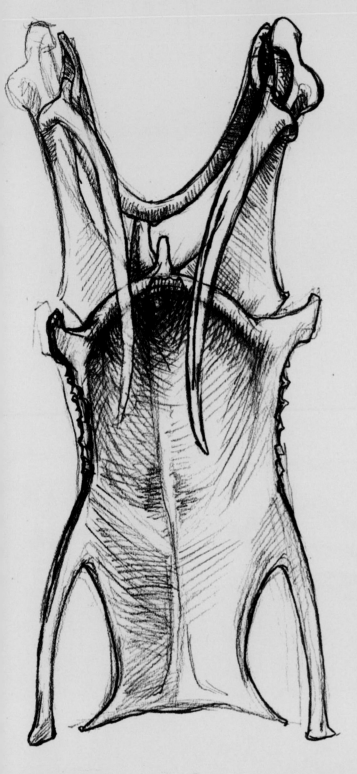

to bind the ribcage into a single inflexible unit. By no means are all the ribs formed in such a way. Several at the front or back may be incomplete and may articulate instead with the nearest adjoining rib; with the pelvis; or with the breastbone. Only a proportion of the ribs possess uncinate processes, and one bird family does not possess them at all.

Even the backbone of birds becomes rod-like and rigid soon after it has left the neck and entered the thorax. Indeed in some groups many of the thoracic vertebrae are fused together into a single bone. One or two free vertebrae come next—presumably to act as a shock absorber—before the serious fusion begins. All the vertebrae, from the middle of the back to the base of the tail, along with the pelvic girdle (itself a fusion of several pairs of bones), are welded together to form the synsacrum—here referred to simply as the pelvis.

Fusion of bones is extensive in the avian skeleton. It has the dual function of reducing the weight of the bird and helping provide that all-important rigidity. Like the breastbone, the pelvic region provides a large surface area for the attachment of muscles and has the strength needed to support the weight of the entire bird when walking. The sides of the pelvis widen out into laterally spreading wings, the hindmost of which curves downward to partially enclose and protect the abdomen. There is also a slender bony projection—one on each side—called the pubis, or pubic bone. The backward-sweeping orientation of these bones is unique among living vertebrates, only having been detected in fossils of the "bird-hipped" dinosaurs. It's one of the great ironies of natural history that birds descended not from these but from the "lizard-hipped" Theropod dinosaurs.

Birds excrete all their waste material from a single orifice called the vent or cloaca—a name derived from the Latin word meaning "sewer." The raised opening lies behind the arc of the pubic bones and just in front of the tail. Birds also copulate via this orifice, though some have an extendable phallus. It takes only a few moments for sperm to be transferred from the male to the female and the brief act has earned the rather grotesquely corny name of "cloacal kiss."

MALLARD
Anas platyrhynchos
Breastbone and pectoral girdle.

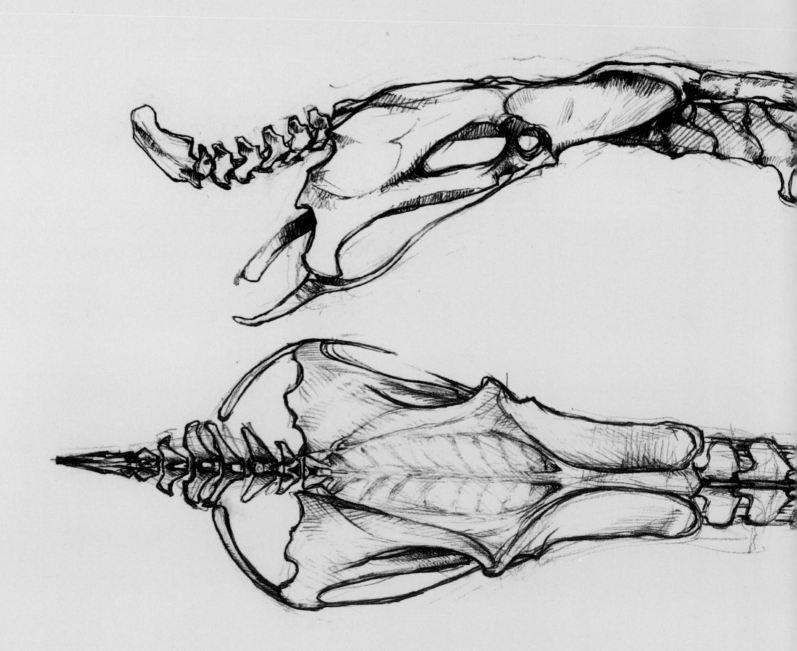

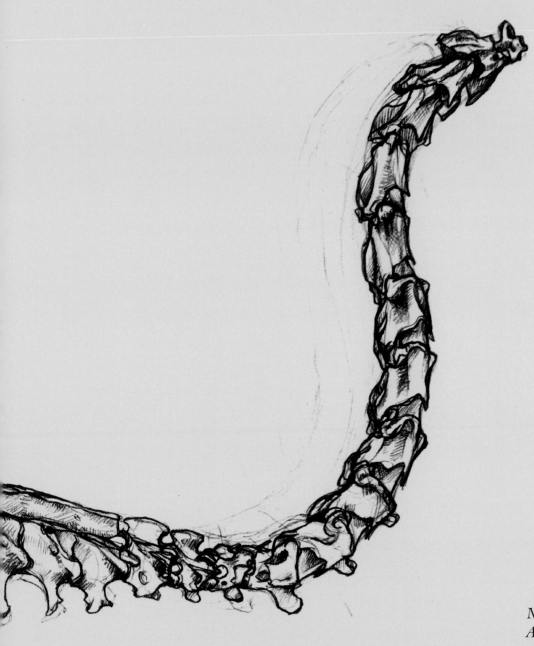

MALLARD
Anas platyrhynchos
Vertebral column and pelvis.

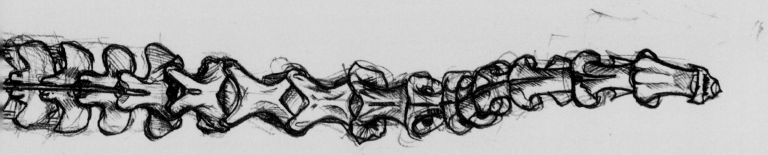

The Head and Neck

With a rigidly immovable body, a long, flexible neck is an absolute must. A neck must be long enough to allow the bird to preen all its feathers, not to mention reaching the preen gland above the tail. It has to be capable of swift movement to locate and follow prey (birds hunt by sight, but their eyeballs have little maneuverability). It has to be able to raise the head above tall vegetation to spot the approach of predators and to be withdrawn again to remain out of sight; to reach the ground in long-legged birds or to reach the bottom in surface-feeding swimming birds. It has to provide the power for a spear-like thrust and absorb the impact of hammering blows. Such a neck is a fundamental requirement for being a bird.

Of course, some birds have a longer neck than others, and more vertebrae don't necessarily mean a longer neck. Some birds with relatively few neck vertebrae have a very long neck indeed. But what sets birds apart from mammals is not the length of the neck alone but its flexibility. Imagine a giraffe that could coil up its neck like a flamingo! Whatever the species—whether bat, giraffe, whale, or human—mammals have only seven neck vertebrae, whereas birds have a variable number and always more than mammals.

The joints between the vertebrae are also different in birds, and their smooth sliding surfaces allow the greatest degree of movement between the bones. It is these that dictate the characteristic "S" shape of the neck, giving free forward movement at both ends and backward movement in the middle, as well as some rotational movement to the sides. This "S" shape is evident even when the neck is fully extended. Usually, of course, much of the neck's length is hidden by feathers, and the bottom of the "S" sits in the cavity formed by the wishbone, making the neck appear far shorter than it really is. The neck connects with the skull in a sweeping curve and enters it, with few exceptions, at the back, rather than from beneath, forming a continuation of the streamlined "S" shape with the same smooth forward movement. Although the size of the vertebrae tapers somewhat toward the head, the surrounding muscles smooth out the transition and give support to the skull.

The upper part of a bird's skull can roughly be divided into thirds: the braincase, the orbits, and the upper mandible of the bill. Birds inhabiting a particularly saline environment may have shallow depressions above their eye sockets, in which the salt excretion glands are situated. In many birds these glands respond to the amount of salt in the environment and may become larger or smaller within the bird's lifetime. The upper mandible is comprised of three strips of bone—one at the top and one on each side—that converge toward their tip. The nostrils lie within the angles formed by these strips. Birds also have internal nostrils that open into the nasal cavity situated within the palate between the bones of the upper mandible. The bones of both jaws are perforated with numerous tiny holes through which blood vessels and nerves pass, particularly in the highly sensitive bill tip.

The lower jaw runs the entire length of the skull, with the two sides joining at the bill tip to form a "V" shape. It articulates with the braincase—not directly, as it does in mammals, but by an independent bone, one on each side, called the quadrate. Now mammals, when they eat, bite, or even talk, move only their lower jaw. Birds, however, are capable of moving the upper part of their bill, too. They do this by means of a complicated pushing mechanism of all the little bones that connect, directly or indirectly, with the quadrates

within the skull, and the thin bone—the jugal bar—that runs alongside the lower jaw. This means that birds can either flip up their entire upper mandible, as parrots do, or grip a worm deep underground, using only the bill tip, like a woodcock. There are many variations in between, and which action a bird is capable of depends on the position of "elastic zones" within the upper mandible. These may take the form of a definite hinge or zone at the base of the bill or as an area of flexible bone tissue farther down its length. In the latter case, the pushing forces are transmitted via the nostrils, so birds with longer, slit-like nostrils can usually flex just a portion of their upper mandible whereas rounded or oval nostrils are usually an indication of a basal hinge in which nostrils play no part.

In the overwhelming majority of birds, a sense of smell is negligible. Kiwis and petrels are notable exceptions and, in their nocturnal activities, their olfactory sense has filled the niche usually occupied by their eyesight. Some New World vultures also have a well-developed sense of smell, being able to locate carrion screened from the sight of circling birds by the forest canopy.

As most of what birds see on the ground is, quite literally, a bird's-eye view from far overhead, excellent vision—and, in particular, long-distance vision—is essential. Birds therefore have eyeballs divided into two hemispheres: a small cornea—the clear "window" that lets light in—and a large retina onto which the image is projected. The eyeball is consequently considerably bigger than it seems when seen through the eyelids of the feathered bird. Although this is an excellent solution for sharp vision over long distances, the dual-hemisphere avian eye is less stable than the spherical eye of mammals and is only made viable by the retention of a reptilian characteristic: a ring of tiny plates of bone that forms a supporting ridge around the circumference of the cornea. This bony ring, and the irregular shape of the eyeballs fitting closely within their orbits, restricts the rotation of the eyes, which means that most birds need to rely on the flexibility of their neck in order to look around in all directions.

WOODPIGEON
Columba palumbus
Head with skin removed, skull,
tongue, and cross-section of eyeball.

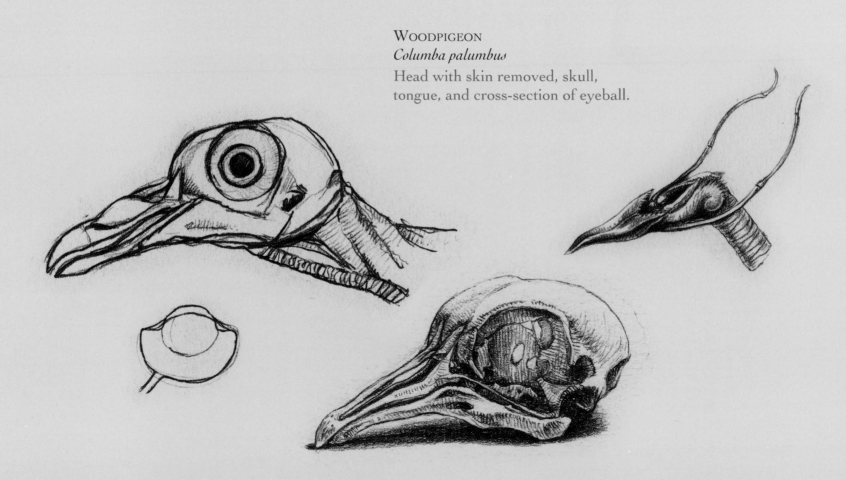

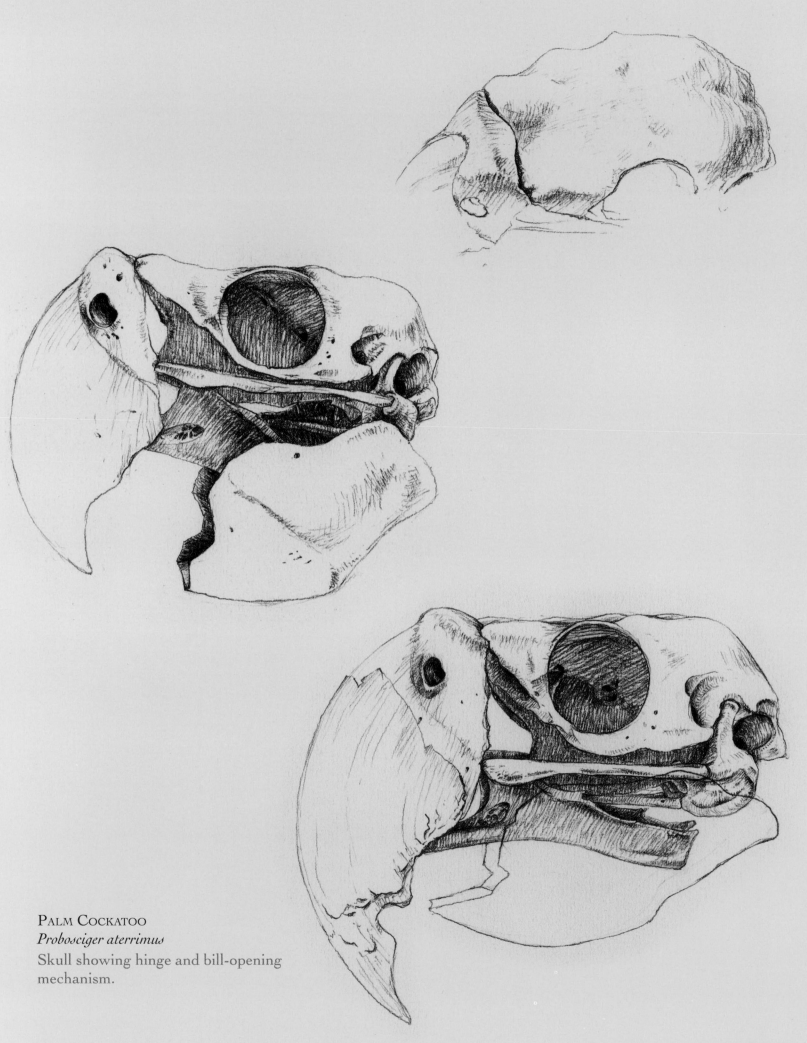

PALM COCKATOO
Probosciger aterrimus
Skull showing hinge and bill-opening
mechanism.

10

Birds have two true eyelids, one upper and one lower, fringed with eyelashes. These are not hairs but modified feathers. Unlike human eyelids, however, it is the lower lid that is drawn upward to meet the upper when sleeping. Owls and some nightjars are the exception, with eyelids capable of independent movement. A "third eyelid," the nictitating membrane, can be drawn across horizontally from the bill side to protect the eye from damage, and in some diving birds such as gannets and kingfishers, this membrane is transparent so as not to lose visual contact with prey while plunge-diving into the water.

Birds have ears, too, though they are seldom visible beneath the feathers. The "ears" of owls, pheasants, grebes, and so forth are simply decorative or camouflaging tufts of feathers and have nothing whatever to do with hearing. The true ears are situated just above the angle of the jaw and are usually visible as a small oval hole, lacking the external flap of skin and cartilage so characteristic of mammals.

Where a bird's skin meets the bill, it is thickened to form a horny or leathery sheath called the rhampotheca, completely covering the bone. As this is technically part of the skin, the rhampotheca has been removed for the majority of skeleton drawings in this book in order to more clearly show the underlying structure of the jaws, though in some cases particular bill characteristics are thereby rendered less obvious.

The tongue sits on the floor of the mouth, within the angle formed by the sides of the lower mandible. Bird tongues are highly diverse in structure and appearance though distinctly different from those of other animals. They—like those of many vertebrates—have bones. The tongue itself is supported by a short pedestal, which, in turn, is positioned at the apex of a pair of thin, whip-like structures called hyoid horns. These extend backward, encircling the base of the lower jaw and curl upward again to hug the rear of the braincase.

Beneath the tongue and within the angle formed by the lower jaw is an area of soft skin called the gular region, which may in some species be distended to form a pouch for food, prior to swallowing, or may be inflated in display. But birds have other inflatable regions in their neck, too. Some may blow up their esophagus like a balloon, or specialized branches of the esophagus, or they may inflate their air sacs—the lungs' supplementary air supply.

Once swallowed, food passes down the length of the esophagus and may be temporarily stored in a crop that sits in the cavity formed by the wishbone, beneath the curve of the neck. Not all birds have a crop, but when present it is essentially a little bag—just a widening of the esophagus—which stores food prior to digestion in the stomach, or gizzard. Particularly heavy meals can be seen as a distinct bulge, clearly visible through the feathers. Alongside the esophagus runs the windpipe or trachea, which transports gases to and from the lungs and the air sacs. The trachea is formed of many interlocking rings of cartilage or bone. It begins its downward path just behind the base of the tongue, symmetrically central within the angle of the jaws, but soon crosses over to the side of the neck; usually to the right side. From here it continues toward the thoracic cavity where it divides to enter the lungs. Birds do have a larynx in their throat, as we do, but their vocalizations are made at this dividing point of the trachea—called the syrinx—by a series of membranes and pads that vibrate when air is passed across them. Although the syrinx, and everything else within the body cavity, is outside the territory of this book, some birds give additional volume to their calls by having a windpipe that is essentially too long for them. And this may lie outside the body cavity, within the bone structure itself, or even just beneath the skin.

GREAT WHITE PELICAN
Pelecanus onocrotalus
Skull and bony eye ring.

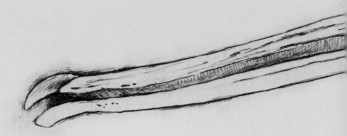

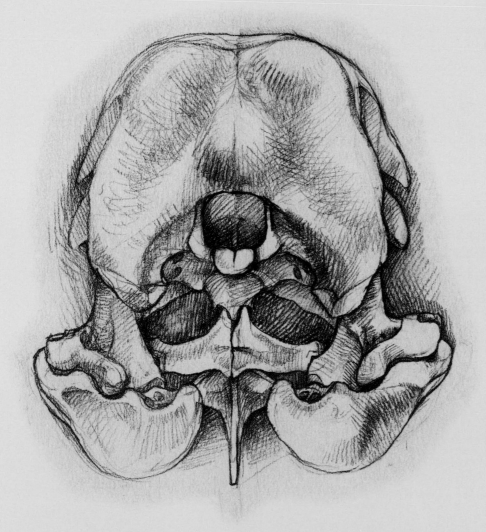

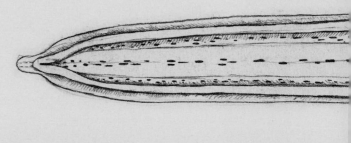

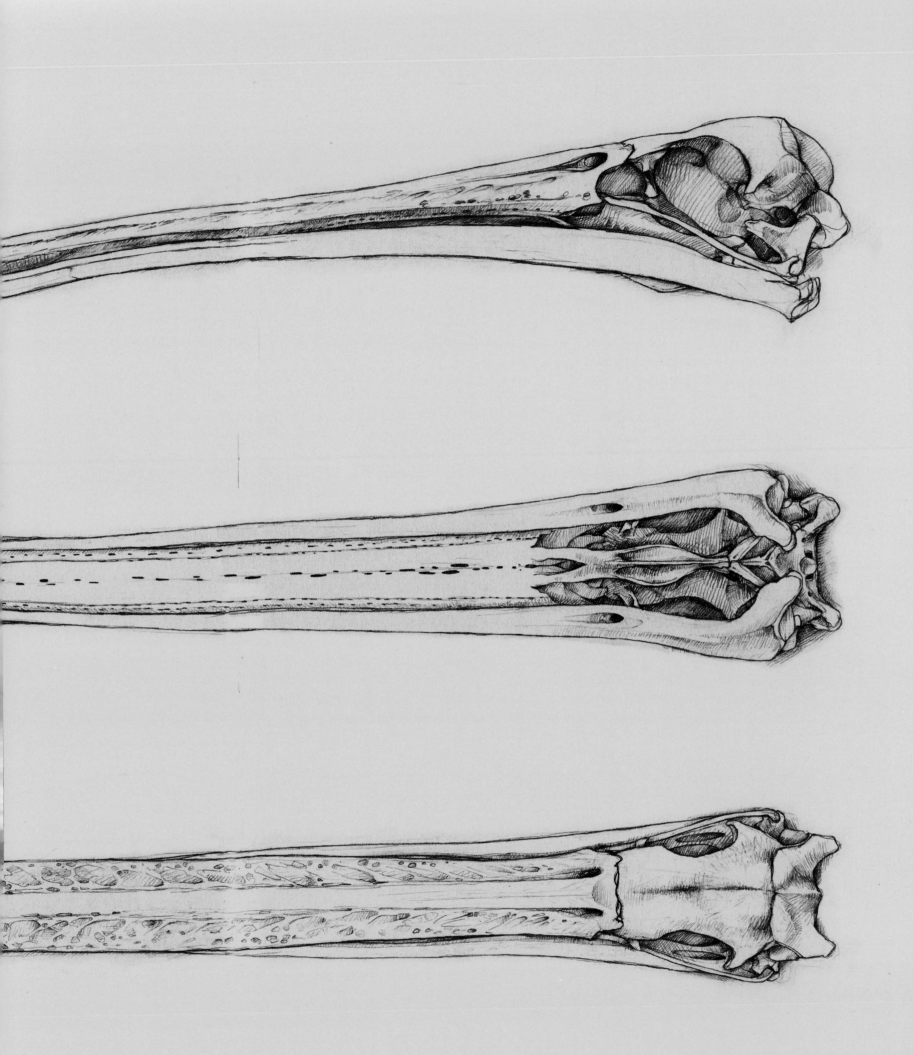

The Hind Limbs

With the front limb modified into wings, birds have only two legs to stand on; two points of contact with the ground, on which to balance. Their distant reptilian ancestors would have had legs that projected out to the sides of the body rather than underneath it, like a crocodile—clearly not a feasible option for sustained bipedal locomotion. But long before birds became birds, Theropod dinosaurs were walking the earth on two legs, which had changed their orientation to support the body from beneath.

In order to maintain balance, the posture of the body also needed to change. The knees needed to be rotated upward with the thighs lying almost horizontally, to bring the legs forward and thereby place the center of gravity above the feet.

Birds' legs are structurally just like those of any other terrestrial vertebrate—give or take the loss of a bone here or the fusion of bones there. They have all the same component parts and the joints articulate in the same directions. But because the thighs of a bird lie close to the ribcage, the top part of the leg is enclosed within the skin of the body and is barely discernible on the feathered bird. This leads to all sorts of confusion farther down the leg and even professionals who really ought to know better frequently refer to the "thighs" when they mean the lower leg, the "knees" when they mean the ankle, and so on. Consequently, many people believe that birds' legs bend in the opposite direction to our own. They don't!

The thigh bone, or femur, is relatively short, thick, and robust. It's surrounded by the majority of the muscles that control the legs and feet, and these muscles have points of attachment spanning virtually the entire back end of the bird. The thigh itself is therefore capable of little movement at its articulation with the pelvis, and its principal function is to maintain the position of the feet beneath the center of gravity. Most of the movement of the leg is from the knee joint. This is mostly a backward-and-forward swinging motion, though there are also lateral muscles that rotate the body to cover the supporting limb when the bird is standing on one leg or walking. A knee bone is present in most but not all groups and is usually rather well developed in water birds.

The lower leg is, like our own, composed of two bones—the tibia and the slender, tapering fibula that lies along its outer edge and ends in a sharp point. The latter is the one conveniently used as a toothpick when we eat roast turkey. In birds, however, the lower end of the tibia is fused with one of the tiny bones from the ancestral ankle, the tarsal bones, making its correct name the tibiotarsus. The remaining ankle bones are fused with the foot bone or metatarsus, and again its correct name is a similarly complicated fusion—the tarsometatarsus—though referred to in the remainder of this book simply as the tarsus or foot.

At the back of the tarsus is a raised platform-like process, its surface deeply furrowed with grooves and crests and perforated by canals. These act as channels for the tendons that close the foot. (Those that open the foot run along the front edge of the tarsus.) When the bird is crouched, the joint is flexed, producing the tension on the tendons required to lock the foot into position, a particularly useful configuration that has enabled birds to roost high in trees without the risk of falling. Ridges on the tendons of the toes also help by forming a ratchet mechanism triggered off by the weight of the bird and thus preventing accidental loosening of the grip.

Because of the position of the thigh, mentioned earlier, many people regard the tarsus as a portion of the leg and consider the toes alone as constituting the foot. This is incorrect. At its most basic level, the tarsus is the solid part of a bird's foot, before the toes, and directly comparable with our own foot bone. It's comprised of three parallel sections—one for each of the forward-facing toes—though in the majority of birds (penguins are the exception) this is only apparent at its farthest end.

The hind toe is something of a misnomer, though it is the term that is adhered to, for the sake of simplicity, throughout this book. Although indeed it usually faces backward, or nearly backward—to balance the bird when walking and to oppose the forward-facing toes when perching—it arises not from the back of the tarsus but from the inside edge. It may be at the same level as the other toes in more arboreal species or raised above the ground or even absent altogether in terrestrial birds. Its correct name is the hallux, but it is often referred to as Digit I, with the other toes numbered II to IV consecutively outward.

Not all birds have four toes, though all derived from a four-toed avian ancestor. Some cliff-nesting, wading, or fast-running species and even a few woodpeckers have lost a toe or are in the process of losing one. Ostriches have even lost two. In such cases the hind toe is usually the first to go; Ostriches have lost the hind and inner toes. But a minority of species—some kingfishers and even a single passerine—have retained the hind toe for perching and lost one of the forward-facing toes.

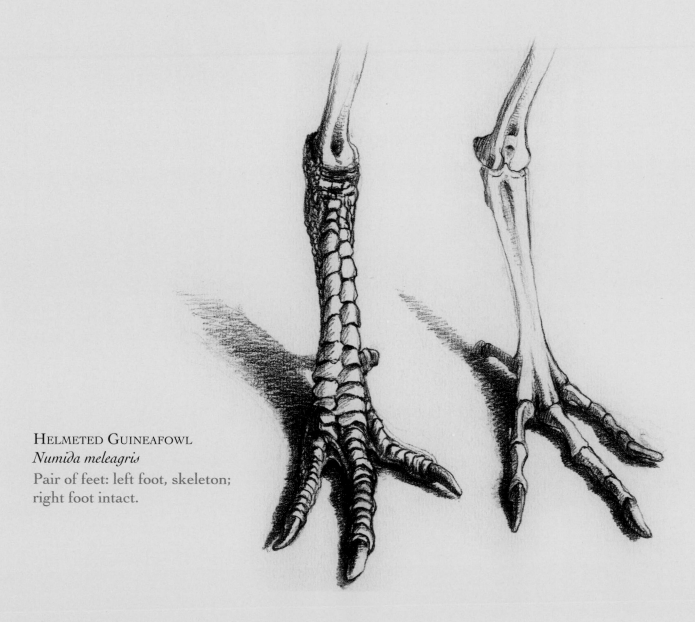

HELMETED GUINEAFOWL
Numida meleagris
Pair of feet: left foot, skeleton;
right foot intact.

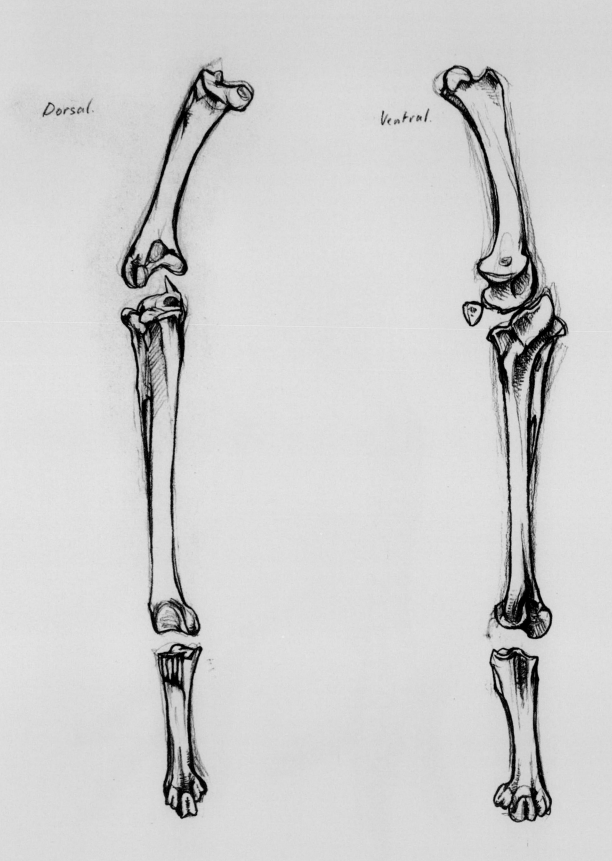

Dorsal.

Ventral.

16

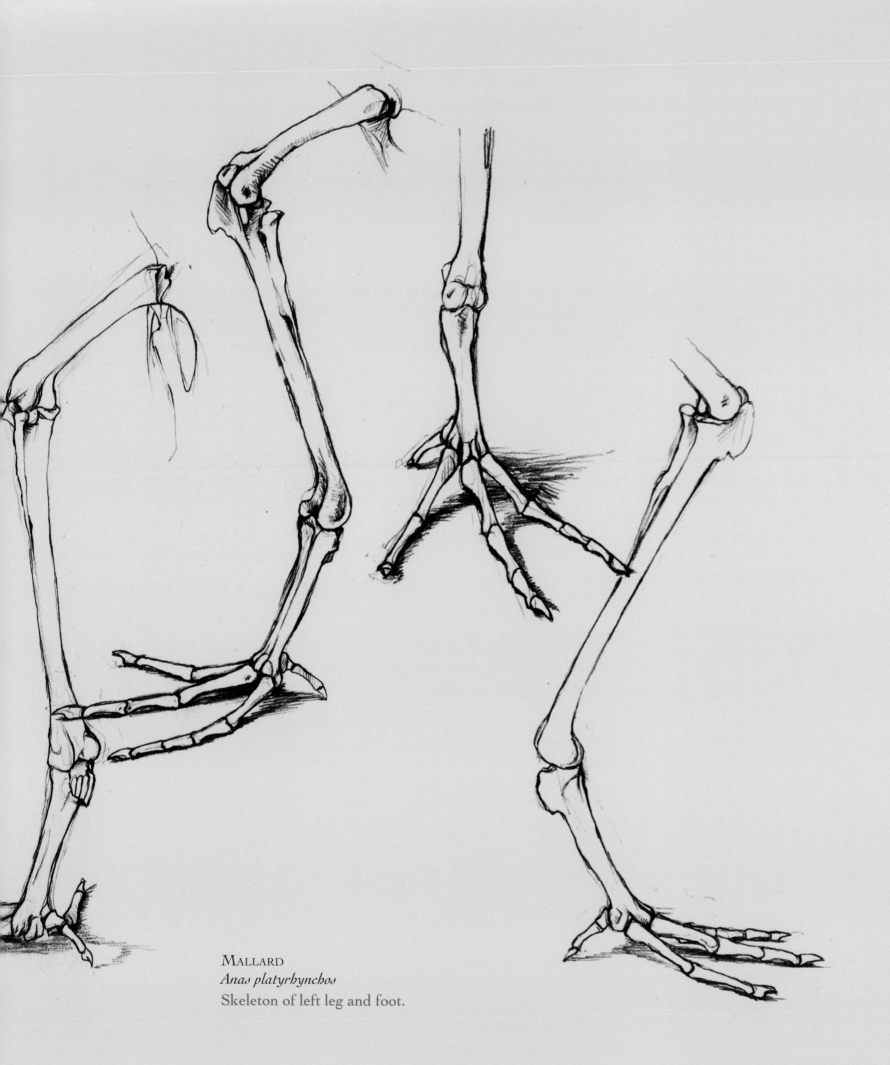

MALLARD
Anas platyrhynchos
Skeleton of left leg and foot.

A few varieties of domestic fowl have five toes, but this is not an ancestral characteristic. It's an abnormality caused by a genetic mutation and perpetuated only by selective breeding. Although the mutation could, theoretically, arise in any bird species at any time, the chances of sufficient five-toed individuals of the same species surviving, meeting, and interbreeding in the wild to produce a viable population is slim to say the least—but not impossible, over time, if conditions for natural selection were in its favor.

But to return to the normal, four-toed foot. The hind toe is composed of a single bone, although it's attached to the tarsus by a free tarsal bone at its base. The inner toe has two bones; the middle, three; and the outer toe has four. This means that the outer toes are progressively more flexible than the inner ones. The claws also each contain a bone, though these are like claws in miniature and very distinct from the bones of the toe.

Where it is unfeathered, the skin of the leg and foot is thickened into a horny or fleshy covering of scales that may fall within several different categories according to their shape and form—armor-like overlapping scales, polygonal plates, or raised granular pimples, or a mixture of these types. It's usually, but not always, possible to discern the joints of the toes beneath this horny covering.

Some gallinaceous birds have formidable-looking spurs on the hind edge of the tarsus and facing slightly inward. These are present mostly in males, though females may develop them, too, on occasion, and these spurs continue to grow during the life span of the bird. They are used in fights between rival males but may play an underlying role in sexual selection.

The underside of the foot is protected by a series of fibrous pads, separated from one another by furrows. The furrows open and close when the toes are bent, allowing them to move freely. There is a large central pad beneath the ball of the foot and a series of smaller pads of varying length that may or may not correspond to the bones and their joints. There's enormous variation. Terrestrial birds often have joint and bone pads of roughly the same size. Passerines tend to have their joint pads reduced to folds, and many waterbirds lack furrows altogether. The toes may be connected by webbing or partial webbing in aquatic groups, though many wholly terrestrial or arboreal birds—completely nonaquatic—have an area of interconnecting skin at the very base of their toes.

The claw sheaths, too, are highly variable and developed according to the bird's need for a strong grip, or to aid balance when running. A disparate group of families from a variety of orders—including herons, pelicans, several seabirds, pratincoles, barn owls, finfoots, the Crab Plover, and nightjars—have comb-like serrations along the inner edge of their central claw, thought to have a function in preening or cleaning the feathers. Indeed, in some groups the width of the serrations corresponds exactly with the width of the feather barbs, though sadly this theory falls short in others. The benefit of a feather-comb for messy, fish-eating birds takes little imagination, whereas it is rather less obvious in the case of pratincoles and barn owls, and the question remains as to why this feature is possessed by such isolated groups and not others that are closely related and share a similar lifestyle.

Generally speaking, birds' feet may be adapted for gripping, walking, or swimming, and these three broad and indistinct categories can be further subdivided into a wide variety of specific and often unique types illustrated and discussed throughout the remainder of this book.

The Wings and Tail

The wings of birds, just like the forelimbs of any other vertebrate, have three broad sections: the upper arm, forearm, and hand. They articulate in just the same way as our arms, except that the hand section has been rotated to lie almost parallel with the arm to form an "N" shape in the folded wing. The hand itself is elongated and the digits have been reduced to just three.

Wings need to be flattened, lightweight, and rigid, offering little resistance to the flow of oncoming air. The angle formed by the elbow is therefore filled by a flat expanse of feathered skin called the patagium, which is kept taut on the spread wing by a tendon running along its leading edge from the shoulder to the wrist, streamlining the contours and increasing the surface area for generating lift. On the trailing edge, the flight feathers complete the aerodynamic perfection in the same way.

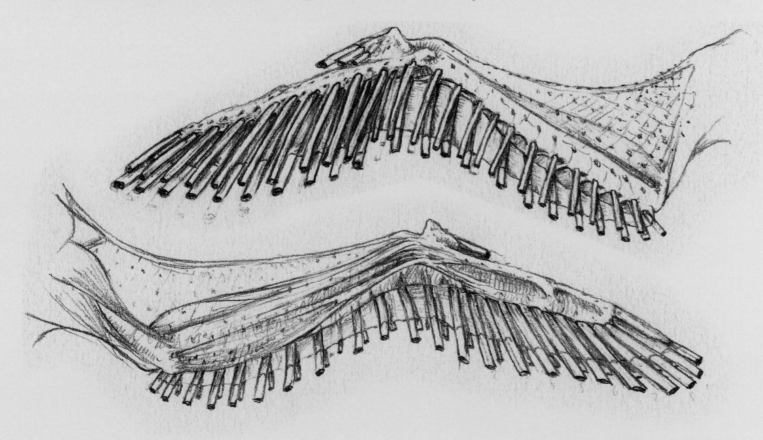

EUROPEAN NIGHTJAR
Caprimulgus europaeus
Left wing with feathers removed; upper side above, underside below.

AMY LEFT WING

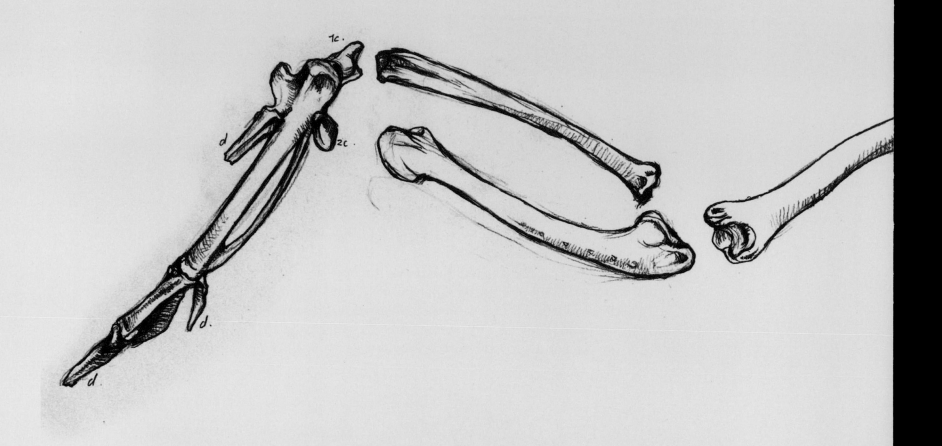

Ventral view

MALLARD
Anas platyrhynchos
Skeleton of left wing.

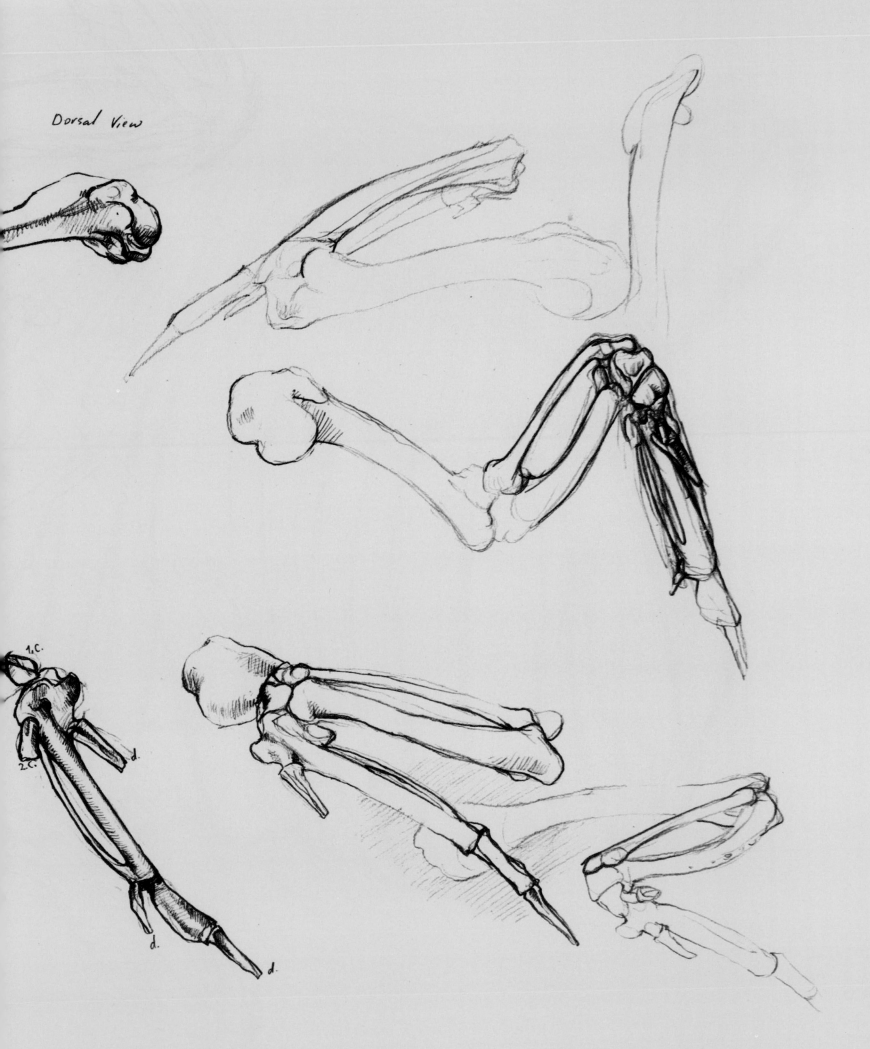

Dorsal View

1.c.

2.c.

d.

d.

d.

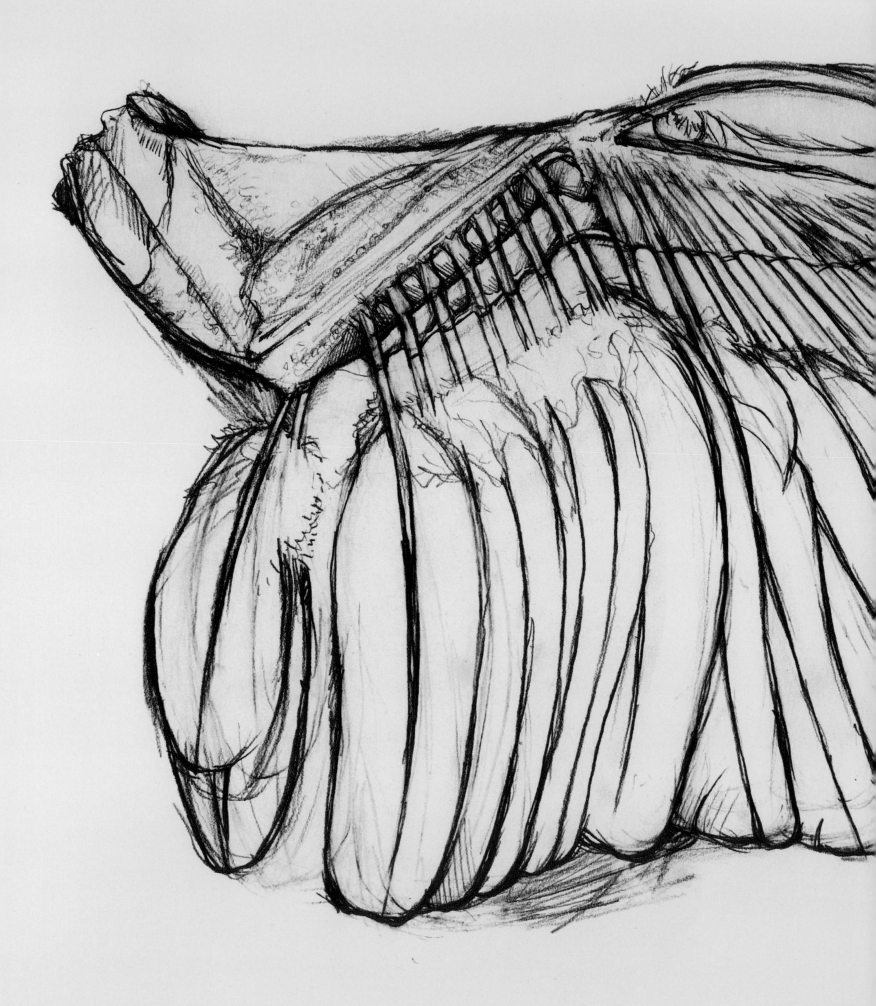

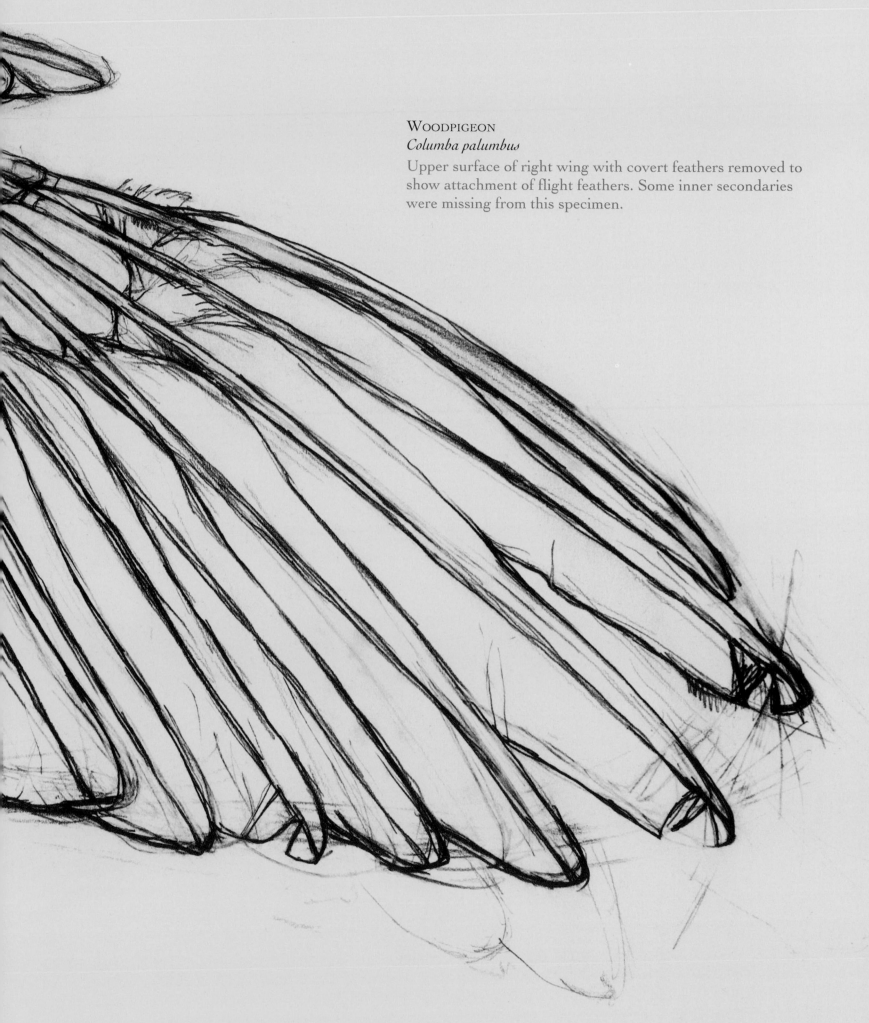

WOODPIGEON
Columba palumbus
Upper surface of right wing with covert feathers removed to
show attachment of flight feathers. Some inner secondaries
were missing from this specimen.

This is also why flying birds have a keeled breastbone to contain the "engine"—keeping the bulky flight muscles responsible for the basic upstroke and downstroke in the center of the bird to reduce drag to a minimum. But flight requires much, much more than the simple upward and downward flapping of the wings. Many other smaller muscles exist on the wing itself whose task it is to fold and spread the wing and control the subtle maneuvers necessary for flight.

The upper arm, or humerus, is attached to the body at the junction of three bones that together make up the pectoral girdle: the wishbone, the strut-like coracoids, and the scapulars or shoulder blades. The head of the humerus sits in a shallow cavity that allows a range of movement, and here a broad, flattened crest provides ample surface area for the attachment of the muscles controlling its actions. All the muscle bulk is concentrated at the top end, where it meets the body, with only tendons extending down toward the elbow. It's not a straight bone but curved into a very shallow "S" shape, lying close against the rib cage on the resting bird—more on the back than on its sides—and rotating outward through 90° as the bird spreads its wings.

The forearm, like our own, is comprised of two bones—the slender radius at the leading edge and the much thicker ulna. They are not parallel along their length but bowed near their base, the gap between them being taken up with the muscles controlling the hand. A series of raised bumps along the upper surface of the ulna mark the points where the secondary flight feathers and their coverts are attached.

The wrist bones—the carpals—like those of the ankle, have undergone extensive fusion, and only the first row exists as independent bones. The farthest has become absorbed into the bone of the hand.

The first digit is the thumb, or alula, which is situated near the wrist joint on the leading edge of the wing, with its flight feathers resting on the wing's upper surface. It's capable of a wide range of independent movement and plays a vital role in flight, preventing stalling while flying at low speeds and during aerial maneuvers. The next digit is the longest and is attached to the end of the hand, forming a natural extension of the length of the wing. It is usually comprised of two bones, though occasionally there may be a tiny third one at its tip. The third digit is represented by only a single bone and lies nestled close to the base of the longest finger.

Several bird groups have spurs or raised knobs on their wings, used in fighting, which are comparable to the spurs on the legs of gamebirds. These usually take the form of thorn-shaped outgrowths of the bone of the hand, and although they may be covered in a horny sheath as claws are, they should not be confused with the true wing claws possessed by some species, which arise from the tips of the digits, as claws should.

Movement of the elbow and wrist is mainly of simple flexion and extension, that is, altering the angle between two bones in one plane only. But other muscles on the upper side and underside of the wing raise and lower the wing's trailing edge to control lift, just like the aileron on an airplane, and other muscles make subtle adjustments to the positions of the digits—particularly the all-important "thumb." Individual feathers

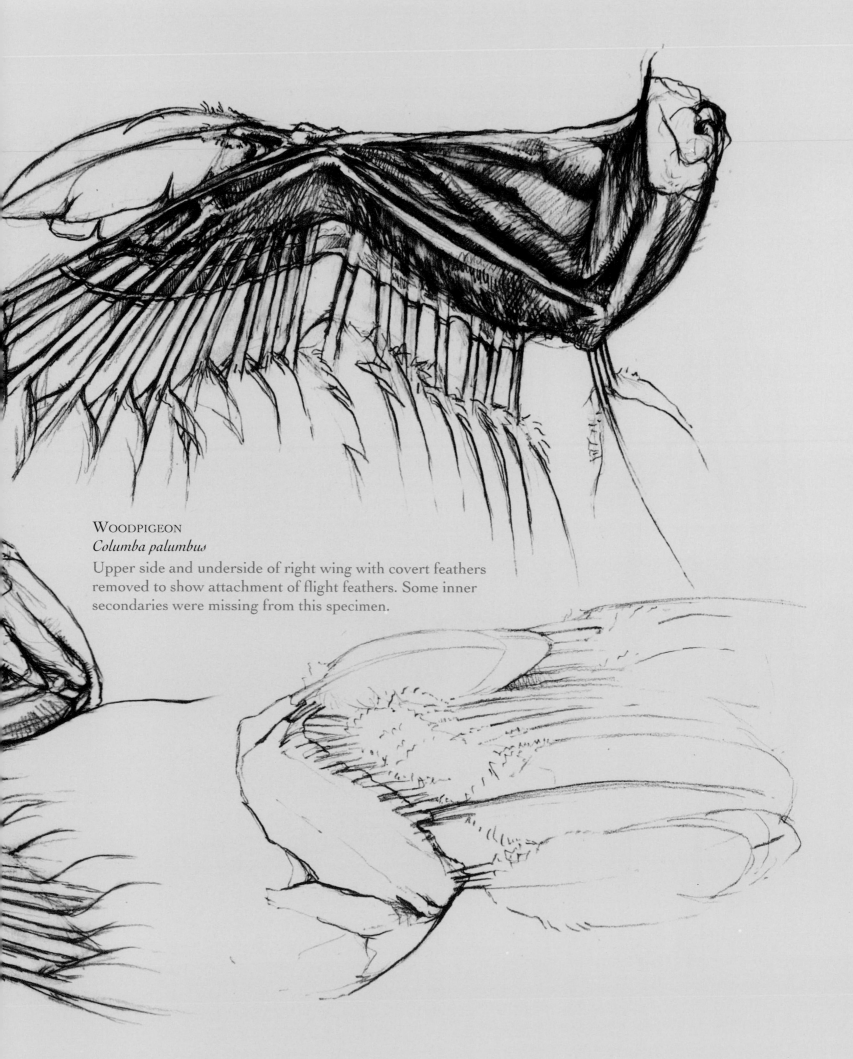

WOODPIGEON
Columba palumbus
Upper side and underside of right wing with covert feathers removed to show attachment of flight feathers. Some inner secondaries were missing from this specimen.

are controlled by muscle action, too: even the flight feathers that are firmly anchored onto the bone itself can be rotated outward when the wing is spread. This is achieved by the contraction of a muscle inserted onto the very end of the longest digit, causing the outermost primary feather to swing outward in an arc. And because all the flight feathers are connected by a single ligament at their base, when one feather rotates, all the rest follow—exactly like opening a fan.

The flight feathers of the wing form two principal groups: secondaries are attached to the forearm and are angled slightly backward, and primaries are attached to the hand and are angled forward. When the wing is closed, the primaries slide neatly beneath the secondaries. Viewed from the wing's upper surface, the leading edge of each flight feather and its major covert overlaps the trailing edge of the one in front to create a surface that is convex on its upper side and concave on its lower side—the perfect airfoil for generating lift. The minor covert feathers may overlap the opposite way.

The number of primaries is fairly constant; there are usually ten. Six or seven are attached to the hand, one to the minor digit and the remainder to the longest digit. There may also be an eleventh, poorly developed primary attached to the very tip of the longest finger, or alternatively the tenth primary may be much reduced. Both the primaries and secondaries have corresponding covert feathers that share the same point of origin, firmly attached at their base adjoining the bone. The covert feathers don't lie parallel to the flight feathers, however, but are angled slightly forward, covering the space between each feather and its neighbor in front. An extra flight feather, with its very own covert, is sometimes present between the primaries and secondaries, attached to one of the bones of the wrist.

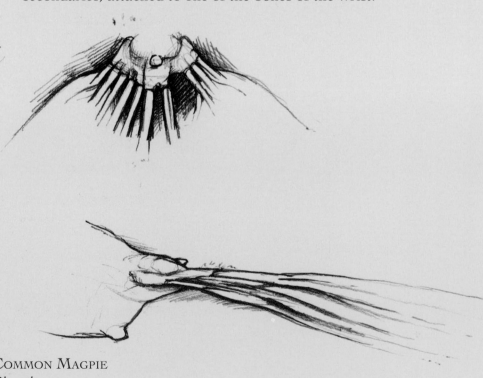

COMMON MAGPIE
Pica pica
Tail with covert feathers removed to show attachment of flight feathers. Notice the preen gland and position of the cloaca. Some tail feathers were missing from this specimen.

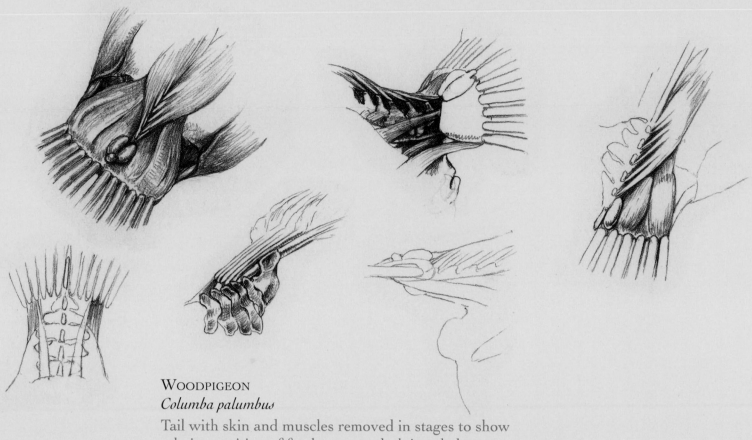

WOODPIGEON
Columba palumbus
Tail with skin and muscles removed in stages to show
relative position of feathers to underlying skeleton.

Secondaries are much more variable in number than the primaries, depending on the length of the forearm.
For example, hummingbirds may possess only six or seven and most passerines have nine while an albatross
may have up to forty. The three secondaries closest to the body, called the tertials, tend to be shorter in
length, less robust, and more curved at their tip, rounding off the inner edge of the wing. In the long gliding
wing of albatrosses and other seabirds, the feathers arising from the skin overlying the humerus may be
enlarged to form a wing vane more or less continuous with the secondaries. These are not true flight feathers,
however: all secondaries, including the tertials, originate at the ulna and are attached to the bone. In many
bird families, including the pigeons and nightjars pictured here, a slight gap exists between the fourth and
fifth secondaries, with an extra covert feather overlying the gap almost as though a feather were missing. As
this is a factor that's not influenced by ecological adaptations, it's a useful tool for taxonomists attempting to
trace the true relationships between bird groups.

The tail of a bird is vital to flight and acts as a rudder, influencing the pitch and angle of stall, acting as an
air brake, and affecting changes in direction. Birds have six or more free tail vertebrae separated by discs of
ligament, which allows limited movement in all directions. The remaining vertebrae are fused together into
the blade-like "pygostyle," the central point around which the rectrices—the tail feathers—are arranged. The
bases of these feathers are cemented together into the tail bulb, a mass of fat and fiber, penetrated by and
encircled with muscle allowing movement of individual feathers as well as of the tail as a whole.

There are usually twelve tail feathers, but there can be as few as four or even over forty in some domestic
pigeons (arranged in a double row); but the number is always an even one. They are arranged in pairs, the
central pair lying on top and closely attached to the pygostyle. Even within their pairs, however, they overlie
one another; a single, most dorsal feather partly conceals its opposite neighbor so that they form an alternately
layered column, a little wider than a single feather, when folded.

On the upper surface of the pygostyle lies the preen gland, a raised knob of skin that secretes an oily
substance from two oval globular masses on either side. This substance is vital to feather maintenance, though
it may be supplemented, or even replaced, by powder produced by specialized patches of down feathers.

PART TWO:

specific

I ACCIPITRES

Bill somewhat hooked downwards, the upper mandible dilated near the point, or armed with a tooth; *nostrils* open; *legs* short, strong; feet formed for perching, having 3 toes forwards and one backwards; toes warty under the joints; claws hooked and sharp-pointed; *body* muscular; flesh tough and not fit to be eaten; *food* the carcasses of other animals, which they seize and tear; *nest* in high places; *eggs* about 4; *female* larger than the male. They live in pairs.

Technically speaking, most birds are predators. Almost all of them eat meat or fish or insects of some kind, or at some stage in their life. But the term "birds of prey" traditionally refers to those with a hooked beak and talons, though the question remains whether this should, or should not, include the owls. Linnaeus thought it should. But he and other early taxonomists also thought it should include the shrikes (which we now know to be songbirds) and even the bats!

It's now fairly well accepted that the similarities between the day- and night-flying raptors arose independently. But whereas the Old World vultures (which feed on carrion, so are not predators) share the same family as the hawks and eagles, the remarkably similar vultures of the New World are probably unrelated and were even recently considered to be close relatives of the storks.

Linnaeus's Accipitres is the perfect example of the paradox of convergent evolution.

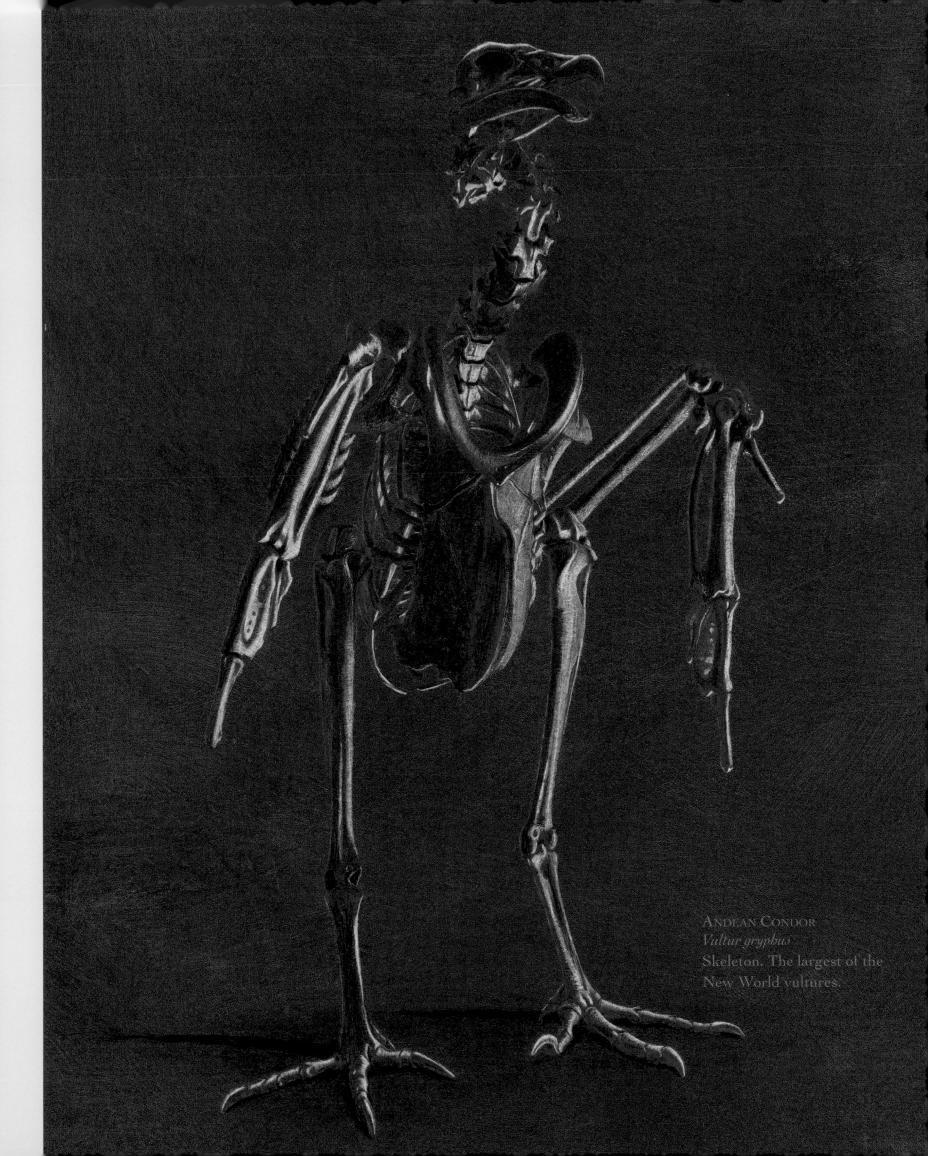

ANDEAN CONDOR
Vultur gryphus
Skeleton. The largest of the
New World vultures.

Vultures

The universal truths about vultures are, as every schoolchild knows, as follows: they have a bare head, a hooked beak, and long, broad wings, and they eat things they find dead. Few definitions could be more cut and dried. All over the Americas, Europe, and Asia this very uniform group of birds can be instantly recognized and, on a group level at least, poses no problems of identification.

So when, in the 1980s, the newly developed techniques for hybridizing strands of DNA revealed that the New World vultures may not be vultures at all but close relatives of the storks, it created something of a sensation. Indeed, to the average birdwatcher the concept seemed to symbolize the chaos that test-tube technology would drag their world into without the steadying hand of empirical common sense. What many birdwatchers didn't realize was that this concept wasn't new. In fact, by the time the DNA experiments were taking place, it had already been around for over a hundred years, based on a range of complex anatomical features: the musculature of the wings, formation of the intestines, and so forth. More recent DNA research has once again made the position of the New World vultures uncertain. They are probably not, after all, stork relatives, and for the time being some authorities have tentatively returned them to the company of other hook-billed birds.

What is perhaps most remarkable, however, is not that New and Old World vultures may not be related but that two possibly unrelated groups of birds have come to look so alike. They differ externally only in the longer and functional hind toe of the Old World vultures and the open nostrils (you can see right through from one side to the other) of the New World vultures.

This similarity is the result of a process called convergent evolution. It's the selective pressures of the lifestyle that shape an animal, not the shape of an animal that dictates the lifestyle—given sufficient time, that is. So when different animal groups share the same ecological niche independently of one another there is a tendency for them to reinvent the wheel, finding the same solutions to the same challenges and ultimately coming to look very much alike.

Now the ecological challenges of finding dead meat to eat doesn't, at first, seem that specialized. But the very similarity between the two groups of vultures actually proves that it is. In order to feed from the carcasses of dead animals you need to avoid getting your head feathers soiled with blood. You also need to be able to retain heat while soaring at high altitudes but to lose it quickly again in the burning sun of the desert or savannah. A bare head and neck is the perfect solution. And the bare skin can be flushed with blood or inflated with air to act as a visual signal to other vultures, reducing the need for physical interaction.

Carcasses are an unreliable food source—you never know where and when you might find the next one, so vultures need to be able to cover vast distances and spend prolonged periods in the air with a minimum of effort. That calls for a specialized soaring wing that can utilize every updraft of rising warm air and carry the bird from thermal to thermal without losing height and without the need for costly flapping flight. Most eagles and hawks soar, but not to the same extent—they need to retain maneuverability in order to be able to catch prey. Vulture wings, by comparison, are longer and broader than those of any raptorial predator and do not allow for rapid changes of direction. But dead things don't tend to move much anyway.

Now animals don't always have the decency to die out in the open where they can be spotted by vultures. In thickly forested areas a bird soaring above the canopy stands little chance of locating carrion on the forest floor—a bird without a sense of smell, that is. In the Americas, the Turkey-Vulture and its near relatives in the genus *Cathartes* are among the few birds that do have a very well-developed sense of smell, and they can detect carrion hidden from view with pinpoint accuracy.

And the other American forest vultures? Well, they just follow the Turkey-Vultures!

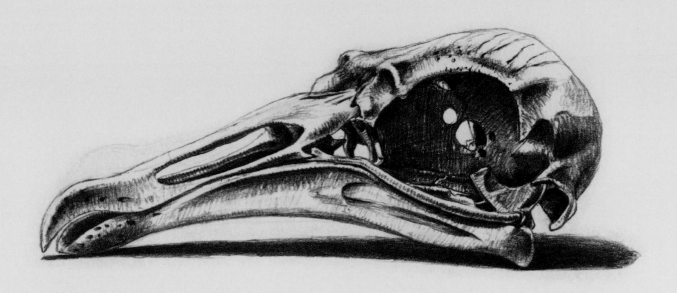

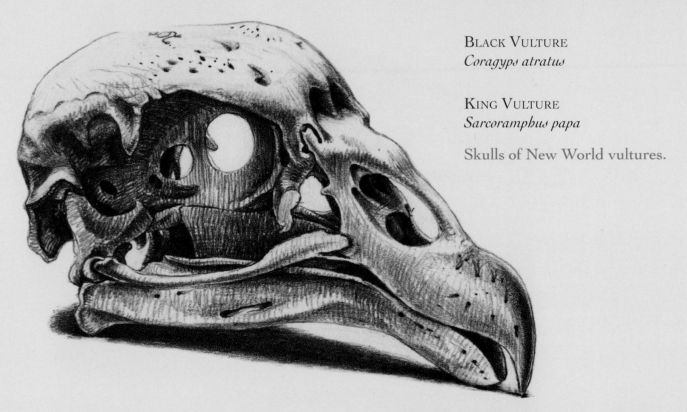

Black Vulture
Coragyps atratus

King Vulture
Sarcoramphus papa

Skulls of New World vultures.

On both sides of the Atlantic there is a division of labor between the large, thick-billed tearers of flesh and the smaller, narrow-billed pickers of scraps. Both will feed amicably from the same carcass, thereby keeping competition to a minimum. The scrap-pickers can use their thin bill to remove the finest shreds of meat and probe inside bones to get to the marrow. The more aloof and solitary Lammergeier in the Old World habitually eats the bones, too, and has particularly acidic digestive juices to deal with them. Lammergeiers even carry carcasses into the air and drop them onto bare rocks to break the bones into bite-sized pieces. Egyptian Vultures have taken things a step further and actually use tools. Their specialty is Ostrich eggs, which they will hit repeatedly with stones to break them open. Once a hole has been made,

their narrow bill is perfect for cleaning the egg of its contents.

Competition at a carcass can be fierce, and as vultures may need to wait a long time for the next one they need to be able to gorge themselves fast. Often their crop is so full and heavy that the bird is unable to take off until its meal is at least partially digested.

The geographical division between the New and Old World vultures is so distinct that one would imagine it to be ancestral in origin, but this is in fact not the case. Fossil evidence has shown that early in their evolutionary history there were "New World–type vultures" in the Old World and "Old World–type vultures" in the New World. Extinctions on both sides of the Atlantic spanning millions of years have produced the current parallel communities with so many startling similarities.

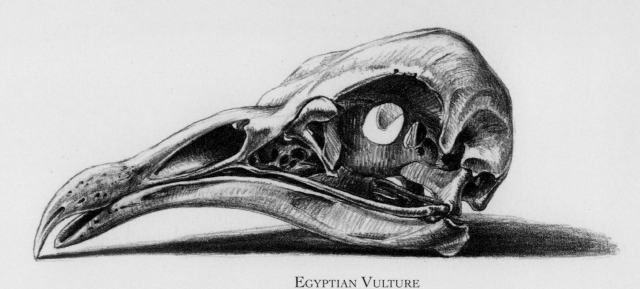

EGYPTIAN VULTURE
Neophron percnopterus

LAPPET-FACED VULTURE
Torgos tracheliotus

Skulls of Old World vultures.

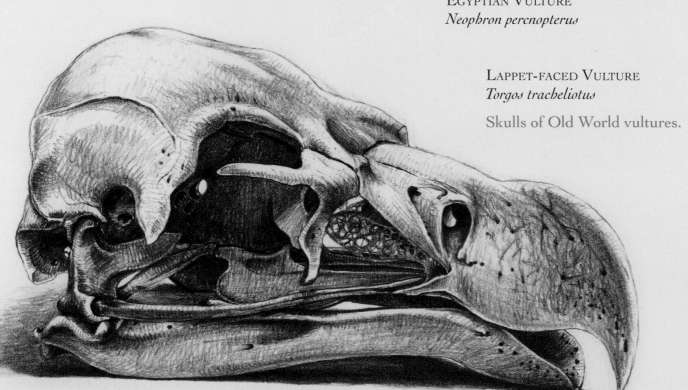

Birds of Prey

The day-flying predatory birds—the Falconiformes—are a bewilderingly diverse group whose appearance is governed by a variety of factors: foraging habits, food preference, and habitat, not to mention occasionally reflecting their evolutionary relationships. Their similarity to the nocturnal hunters, the owls, is probably no more than a coincidence of shared lifestyle. But within the Falconiformes are birds that feed on everything from wasps to monkeys; huge eagles to falconets no bigger than a thrush; birds that stab their prey and birds that stamp on it; and carrion-eating birds that are not predators at all. The order is traditionally divided into two very large families and two small ones—very small ones indeed, of a single species each.

The largest family is the Accipitridae, and this includes all the broad-winged hawks and buzzards, the eagles, sea eagles, snake eagles, kites, harriers, and so on, along with the Old World vultures that diverged from a predatory lifestyle early in their evolutionary history and have been discussed elsewhere in this chapter. Then there's the family Falconidae—the falcons, falconets, forest falcons, and caracaras. And the odd ones out are the Osprey and the Secretary Bird, which are so unique—especially the Secretary Bird—that they fit in nowhere else.

Birds of prey in general have a hooked bill for tearing flesh and strongly hooked talons for catching and grasping prey. The division is quite clear-cut—they do not catch prey with their bill nor tear with their talons, although falcons may use their deeply notched bill edge to break the neck of small animals, and larger prey may be killed by pecks on the head. The base of the upper mandible is covered by a soft fleshy pad called a cere surrounding the usually circular nostrils, similar to that of parrots. The gape is large, so that prey items can often be swallowed whole, and any indigestible parts such as bones, fur, and the wing-cases of insects are regurgitated later as pellets. Secretary Birds eat virtually everything whole: snakes, sizable mammals such as hares, and even small tortoises!

Most birds of prey are characterized by their fierce-looking eyes. The eyes are indeed very large and often an intense piercing yellow. But what gives them their intimidating glare is their overhanging "eyebrows"; ridges made of two adjoining plates of bone that protrude from the skull and may serve to protect the eyes from damage while pursuing prey. In some groups, however, including the Osprey, honey buzzards, Bat Hawk, and a few of the insectivorous kites, there is only a single, small projection, a possible indication of their more primitive ancestry.

Eyesight is the primary sense used in hunting, and it is formidably well developed, especially in fine focusing over vast distances and in the detection of movement. The receptors in the retina of the eye are densely packed into two distinct regions called fovea, and the large and elongated eyeballs maximize the size of the image. Night vision is rather poor, however, and dusk-hunters tend to have even larger eyes to compensate. Like owls, which also have tubular eyeballs, movement of the eye is even more severely restricted than in other birds, so raptors have a still greater need to move their head to look around them. The harriers and forest falcons both hunt prey shielded from view by vegetation, and they need to rely not just on eyesight but also on hearing. Both have independently developed an owl-like ruff of feathers surrounding their face and have asymmetric or enlarged ear openings for accurately pinpointing sound.

Beneath the feathers, the body of raptors is unimpressively small. The breastbone is often surprisingly short in proportion to body size, though usually broad and deeply keeled and with a wide, sturdy wishbone. Although they are powerful fliers in pursuit of prey, most raptors are not capable of long periods of sustained flight; they need to conserve their energy for the chase. So the majority of groups rely on a passive approach to hunting: gazing out from a perch, hovering motionless in the wind, or using rising updrafts of warm air to keep them aloft while they look around them in search of food. This is why there is such a preponderance of

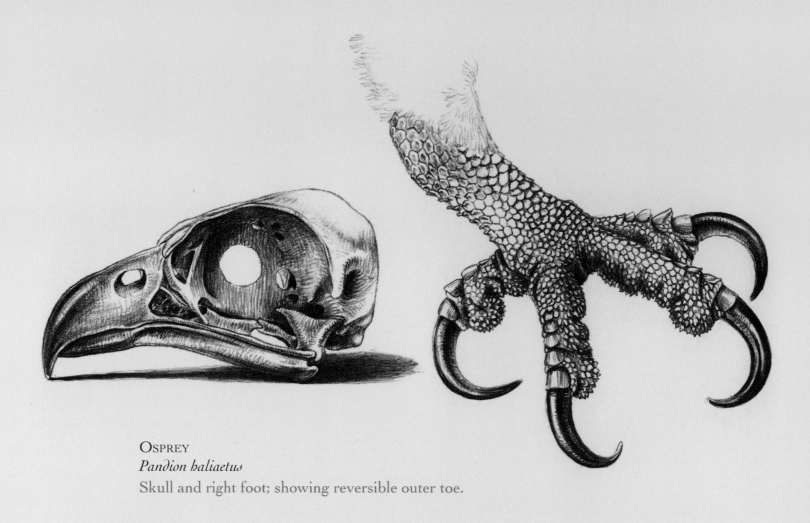

OSPREY
Pandion haliaetus
Skull and right foot; showing reversible outer toe.

birds of prey in mountainous and desert areas, where the landscape itself produces the optimal air conditions for effortless flying.

Soaring birds have long, broad wings to provide an ample surface area to generate lift, and their deeply notched primary feathers create turbulence around the wingtips, which prevents stalling at low speeds. The ability to soar comes at a price, however. The perfect build for soaring is not great for maneuverability, so the bird must trade off one for another. The Old World vultures went down the soaring route and lost much of their aerial maneuverability altogether.

The Osprey has a long but narrow wing, making it a moderate soarer but efficient in long-haul flapping flight. This accounts for its broad geographical distribution and long-distance migrations. Most soaring birds are restricted to following landmasses during migration, as warm air does not rise over water. Ospreys, of course, hunt over water too—feeding exclusively on fish—so a wing devoted to soaring would be of little use.

The pointed-winged falcons have the most powerful flight among the birds of prey, but although they achieve great speed in aerial dives, their flight is by no means as agile as that of the broad-winged hawks of the genus *Accipiter*, inhabiting the forest understory. They really need all the maneuverability they can get and have short, rounded wings, although they can also soar when necessary. Their breastbone tends to be longer than that of the exclusively soaring species, though not quite as wide. These ruthlessly efficient killers hunt by ambushing and pursuing other birds in flight. It's exciting stuff to watch as the hawk repeatedly changes its direction, sometimes diving through bushes, sometimes dodging overhanging branches in the chase. They rely on short bursts of powered flight but save energy by alternating flapping with gliding.

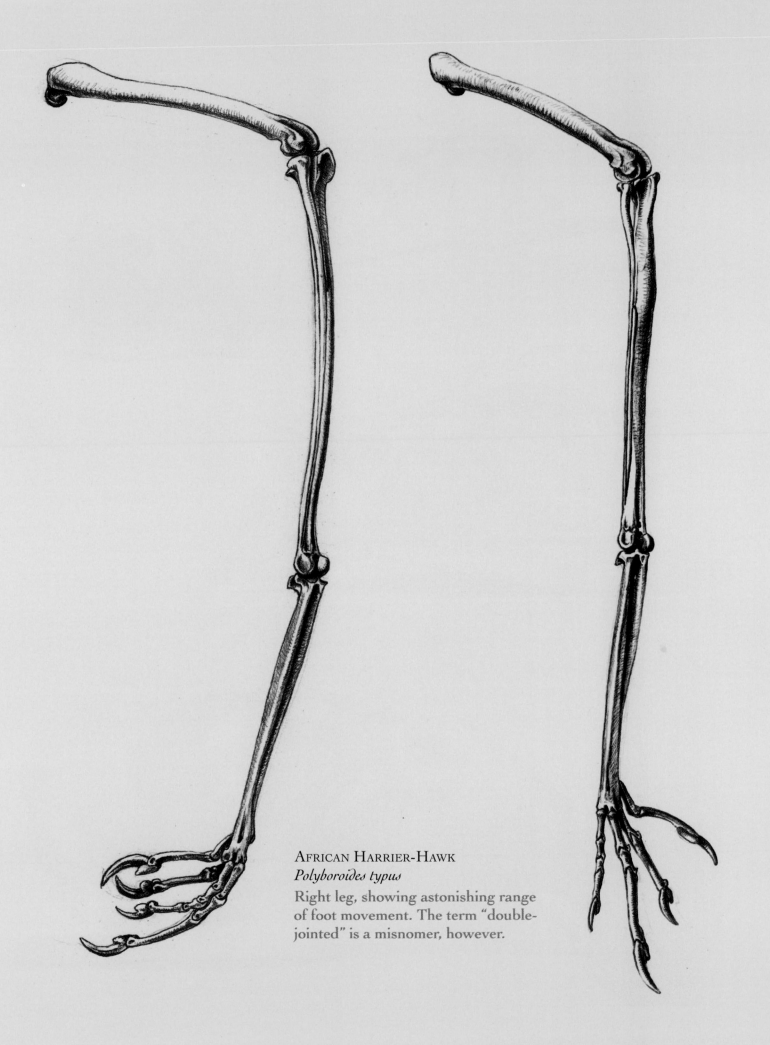

AFRICAN HARRIER-HAWK
Polyboroïdes typus
Right leg, showing astonishing range
of foot movement. The term "double-
jointed" is a misnomer, however.

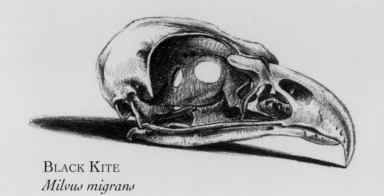

BLACK KITE
Milvus migrans

PEREGRINE FALCON
Falco peregrinus

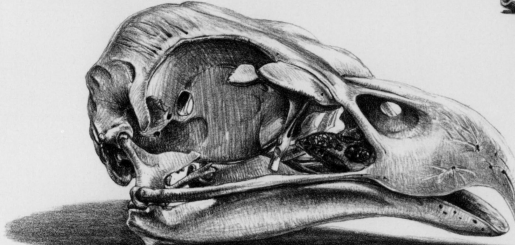

BALD EAGLE
Haliaeetus leucocephalus

PHILIPPINE EAGLE
Pithecophaga jefferyi

Skulls.

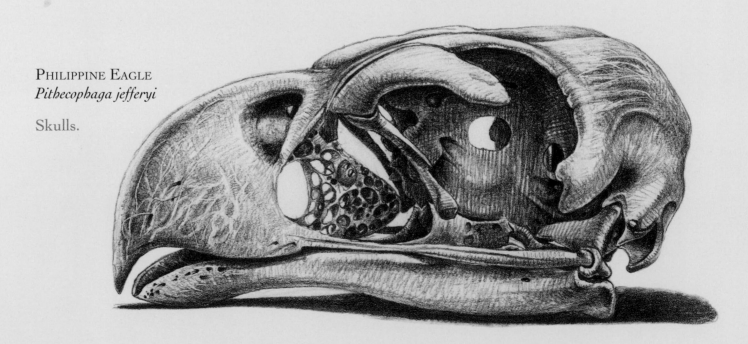

38

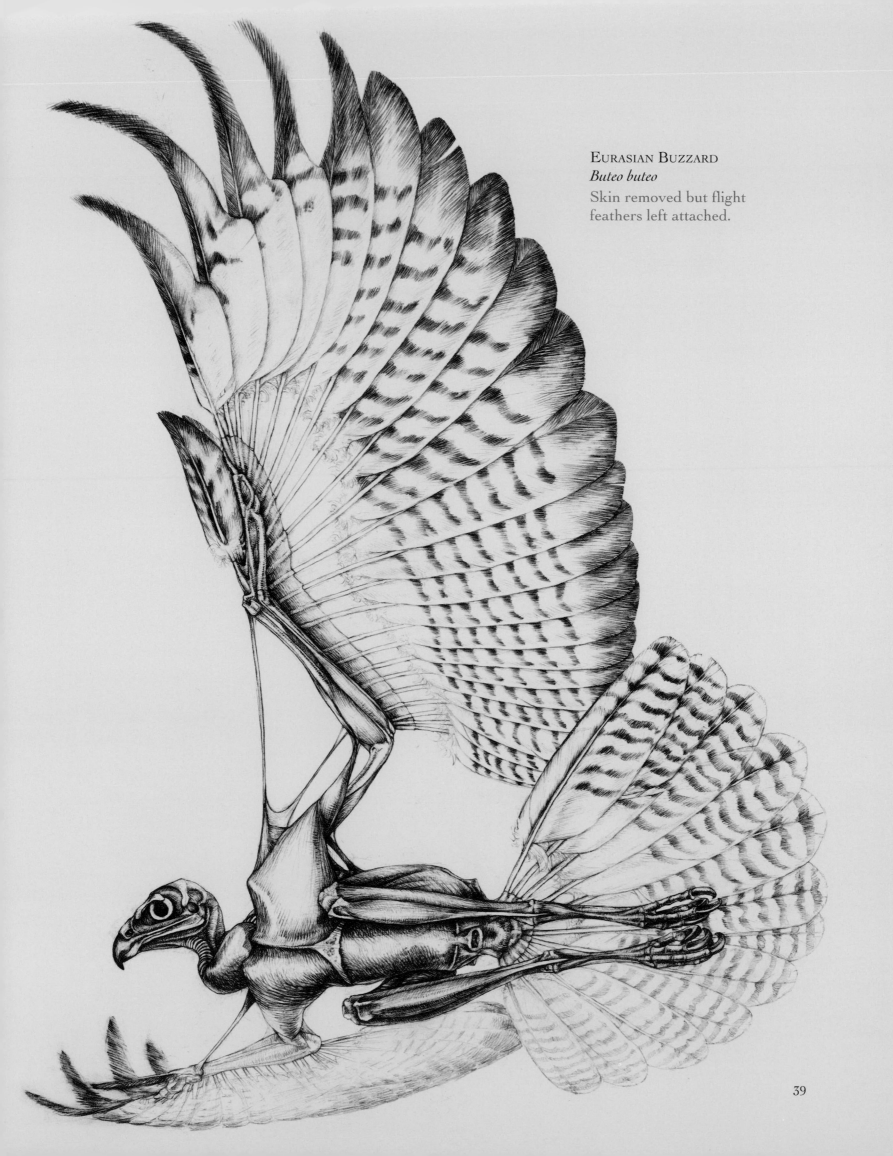

EURASIAN BUZZARD
Buteo buteo
Skin removed but flight feathers left attached.

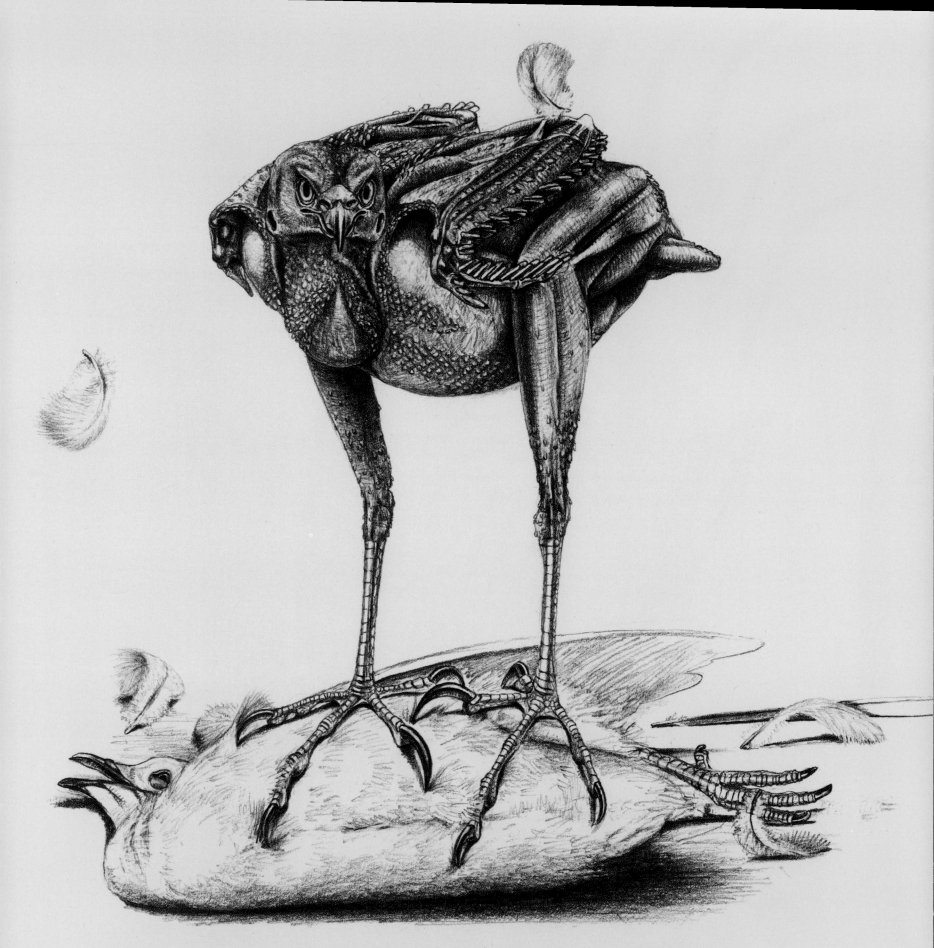

Eurasian Sparrowhawk with a Eurasian Collared Dove
Accipiter nisus with *Streptopelia decaocto*
Feathers removed; and feathers *being* removed.

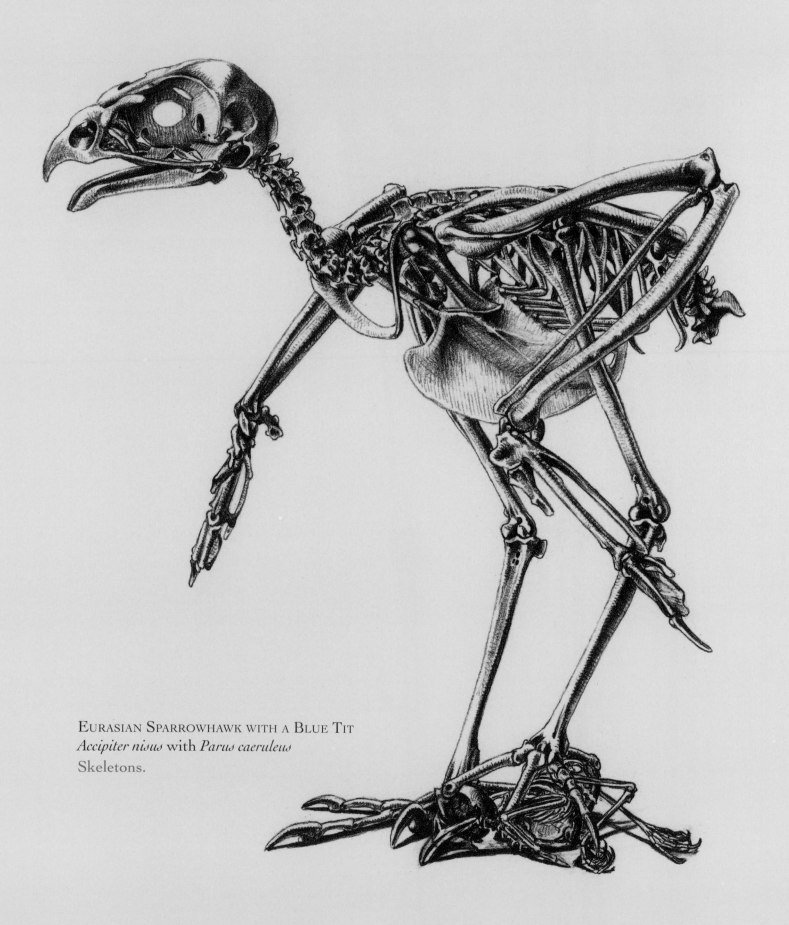

Eurasian Sparrowhawk with a Blue Tit
Accipiter nisus with *Parus caeruleus*
Skeletons.

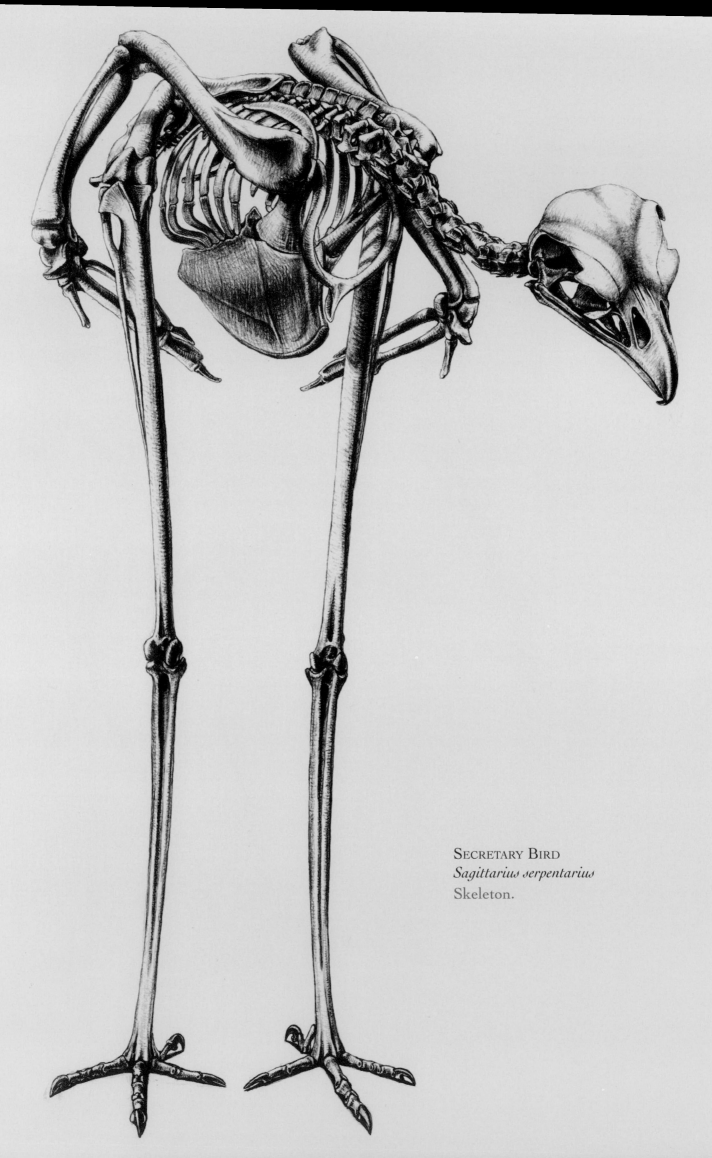

SECRETARY BIRD
Sagittarius serpentarius
Skeleton.

Such minutely accurate changes in direction would not be possible without a long, strong tail to act as a rudder. The tail vertebrae have well-developed projections and end in a very large pygostyle (the fused terminal vertebra of the tail) to maximize the area for muscle attachment.

The pelvis of raptors is short and broad and tends to be angled sharply downward to give greater strength to the all-important legs. Birds of prey may have short, thick legs and feet or long, slender ones, and both are equally efficient as weapons. The larger eagles, with their sausage-like digits, rely on the element of surprise to catch their substantial mammalian prey, and the bulk of the effort required is in holding and subduing it. The Osprey, too, has stout legs and feet (covered in spiny scales for gripping slippery fish) and is unique in possessing a reversible outer toe as owls do.

In the *Accipiters*, by comparison, it's all about reach. They have long thighs, long tibia, long tarsi, and long toes—everything to give that extra advantage over the fleeing quarry. Even the very tip of the central toe can be closed in a pincer-like grip, the claw making contact with a fleshy pad on its underside so that it can grasp tightly at the fullest extent of its reach. The slender outer toe can be used in a similar way, but the stouter, stronger inner and hind toes are employed for a different purpose. They are the killing toes and are furnished with formidable curved, razor-sharp talons.

Another raptor group that relies on reaching with its legs is the harrier hawks. But it's not the distance that's the problem; it's the angle. Harrier hawks don't hunt in flight. They probe and feel into cracks in trees, among palm fronds, and into the communal nests of weaver birds. For this they don't need long thighs, and long toes would simply get in the way. But they do need legs that can bend backward and sideways in contortions that are seemingly anatomically impossible. The popular term for this ability is "double-jointed," but an examination of the skeleton of their legs will show that they have exactly the same number and formation of joints as any other bird group. The condition, as it is in humans, is simply a result of unusually flexible tendons.

But it's the Secretary Bird that takes the prize for having the longest and most unique legs of any bird of prey. And, unlike almost all other long-legged birds, it has a relatively short neck. This keeps the head end safely away from dangerous snakes but causes problems of access—the bird has to bend its legs to reach the ground to eat and drink, which probably accounts for its aforementioned habit of swallowing everything whole. Like the seriamas and ground hornbills, which share a similar niche, Secretary Birds walk great distances in search of food and consequently have rather short toes—especially the hind toe—and short claws. For a bird of prey a nongripping foot is highly irregular, but Secretary Birds are irregular in every way. Their technique is to stealthily approach their prey then put the boot in—literally kicking and stamping it to death!

Owls

As nocturnal birds of prey, owls have features associated with being predators *and* features associated with being nocturnal. Now this could mean that they are related to the day-feeding birds of prey or to the night-feeding nightjars. Or these features could all have arisen as adaptations to their lifestyle, meaning that they may be related to neither. Taxonomists are still uncertain where owls actually belong, though DNA evidence strongly suggests affinities with nightjars.

The characters shared with other raptors are a hooked bill for tearing flesh—with a fleshy cere surrounding the nostrils—and hooked talons for catching and holding prey. They also have the long, strong legs and stout and rather angled pelvis common to birds that hunt with their feet.

Owls have a particularly long fibula—the toothpick-like spike of bone on the outer side of the leg. This feature is normally so well developed only in swimming birds, and presumably in owls it helps with the rotation of the legs and feet while hunting. The toes are shorter than those of diurnal raptors, particularly the central toe, though they are no less powerful. Indeed, the bones themselves are thick and chunky. In the "typical" owls, all but the farthest bone in each toe are reduced in length, so the toes are made up of the claw, one long bone, then one to three little bones adjoining the tarsus. Owls can rotate their outer toe so that it faces backward in line with the hind toe, in a "two forward, two back" arrangement, like the toucans and parrots. So a perched owl may be seen to have two or three toes facing the front. This may be an adaptation to gripping prey or simply for perching in trees. Among the diurnal birds of prey, the Osprey is alone in having this ability, as an adaptation to gripping fish.

Like their day-flying counterparts, owls have a wide gape and swallow much of their food whole, regurgitating the indigestible fur, bones, and wing-cases as pellets. Owl pellets are large enough to be studied with ease in the classroom or laboratory, giving a good indication of exactly what the bird ate for its last meal. So strongly associated are pellets with owls that many people don't realize that they are not exclusive to them—virtually all meat-eating birds produce pellets, even small insectivorous species.

The body of all raptors is deceptively small but in owls particularly so; their breastbone is tiny compared to that of similar-sized birds, though the keel is quite well developed, and the small size is further accentuated by their very large head and long limbs. Not surprisingly, owls are not strong fliers over large distances, but their low body weight is easily accommodated by their ample wing surface during aerial foraging and enables them to maneuver well while flying at low speeds.

Owls are silent in flight. The usual sound of beating wings is muffled by having soft fringes and a downy surface to the feathers, as well as a comb-like leading edge to the primaries, a feature also present in some nightjars. This enables them to be undetected by prey but also cuts out superfluous sounds for the listening owl. The fishing-owls in Africa and the fish-owls in Asia, however, have no need for these precautions: fish cannot hear, and these owls hunt by dropping down from an overhanging perch, so the plumage has reverted to its original, less specialized condition. These fish-eating groups are the only owls that have bare, unfeathered tarsi, and both also have raised spiny scales on their foot pads, as the Osprey does, for gripping fish.

The owls can be divided into two groups: the very uniform barn owls and bay owls of the family Tytonidae, and the much more varied "typical" owls comprising the large family Strigidae. Despite the diversity displayed by the latter group, its distinction from the barn owls is immediately obvious, even to a casual observer: barn owls have a narrow, heart-shaped face, whereas the face of "typical" owls is rounded at the bottom. A glance at the skulls and the difference is still clearer. The skull of a "typical" owl is bulbous and rounded, whereas a barn owl's is tapered and elongated.

There are other, structural differences, too. In barn owls the wishbone is fused to the keel of the breastbone, and the breastbone itself has a different shape, with only two notches instead of four in its trailing edge. Barn

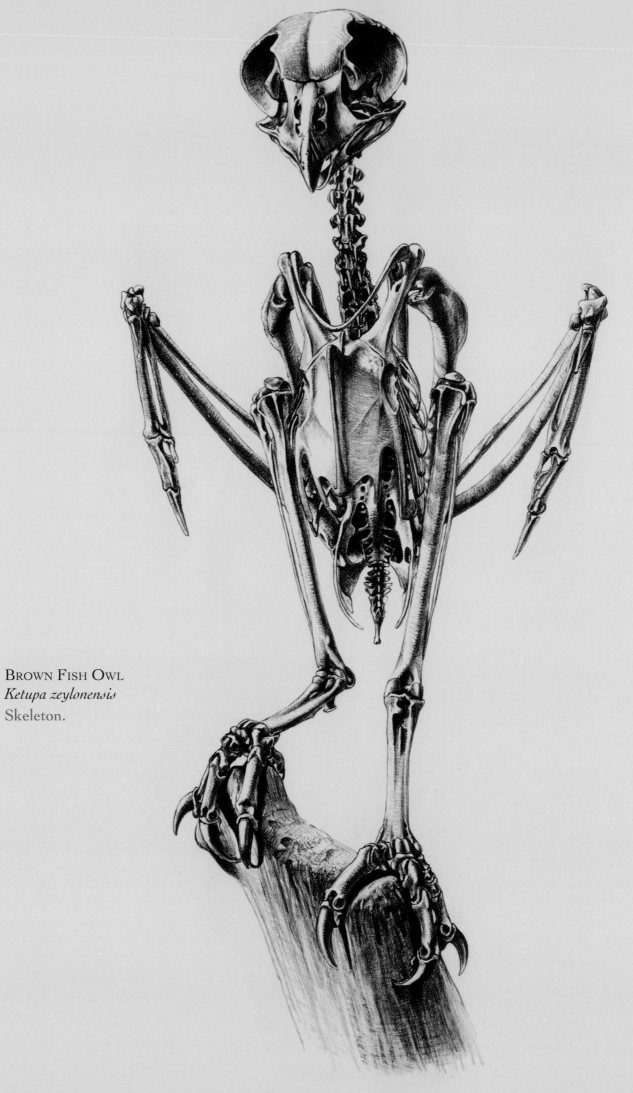

BROWN FISH OWL
Ketupa zeylonensis
Skeleton.

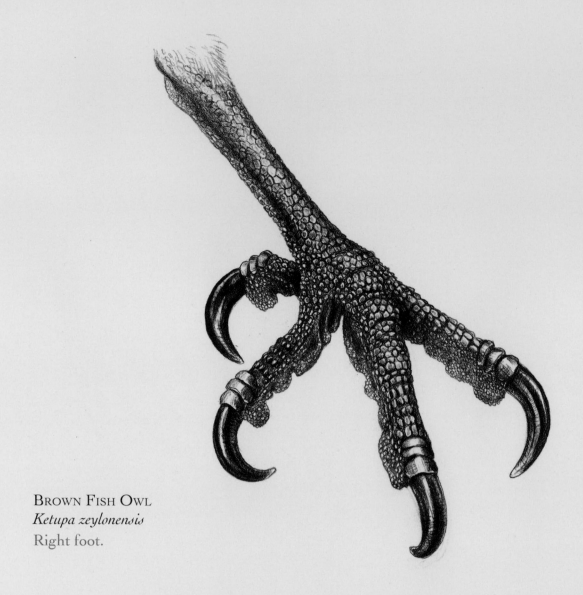

Brown Fish Owl
Ketupa zeylonensis
Right foot.

owls have inordinately long legs that are often carried dangling beneath the body in flight. They also have what is known as a pectinated middle claw, bearing comb-like serrations on its inner edge. This is present in a disparate assortment of birds including the herons, finfoots, pratincoles, nightjars, and several seabirds, and its function is not wholly understood though it seems to have a role in preening. Indeed in some, but not all, groups the serrations exactly match the thickness of the feather barbs.

Owls owe much of their popularity to their forward-facing eyes and flat, almost humanesque face. The eyes are in fact angled slightly apart, giving a wide field of view, though with only a small angle of overlap. However, the birds compensate for this narrow angle of binocular vision by bobbing their head, which enables them to accurately judge distances; another endearing idiosyncrasy.

In all birds the size, shape, and structure of the eyeball prevents it from moving much within its socket, which is one reason why birds need such a long and flexible neck. In owls this is even more paramount: the eyes are virtually immovable, so the neck is correspondingly super-flexible; so much so that they can turn their head in almost a full circle. The ring of tiny bones that surrounds the eye of birds, in owls is flattened to form a rigid tube extending outward from the orbits of the skull. In conjunction with the almost spherical lens, this increases the size of the image that the bird receives on the eye's retina, the same principle as moving a projector away from a screen. The eyes themselves are also very large, particularly in the most nocturnal

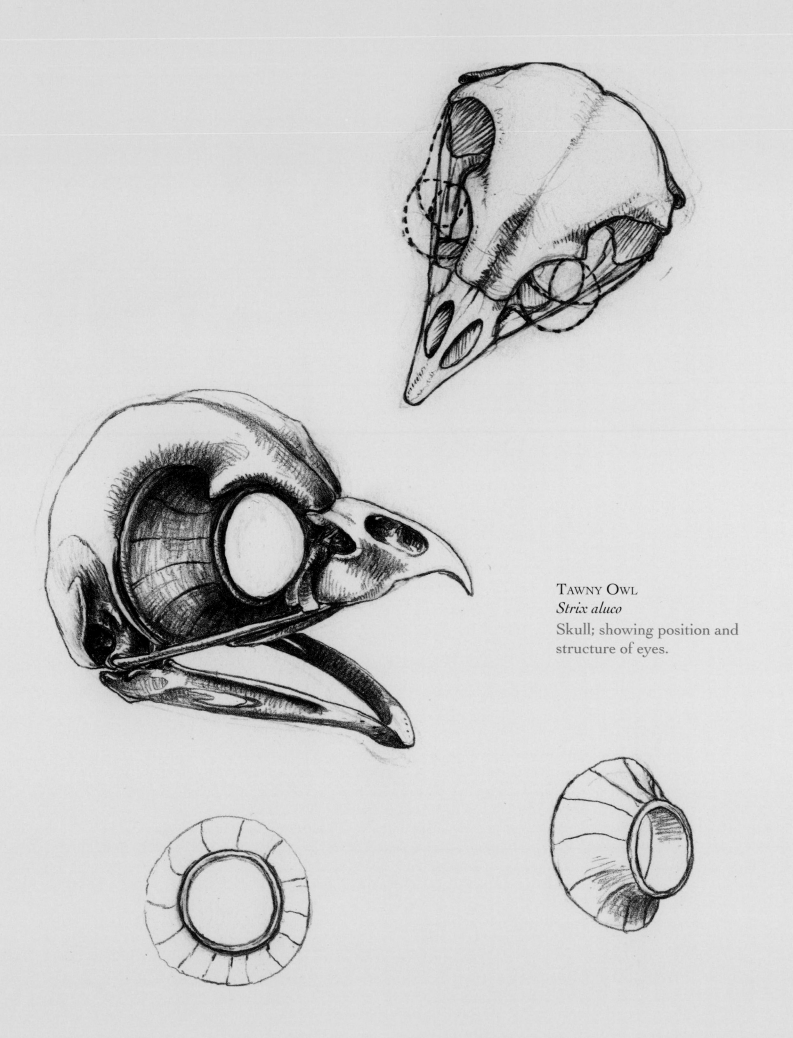

TAWNY OWL
Strix aluco
Skull; showing position and
structure of eyes.

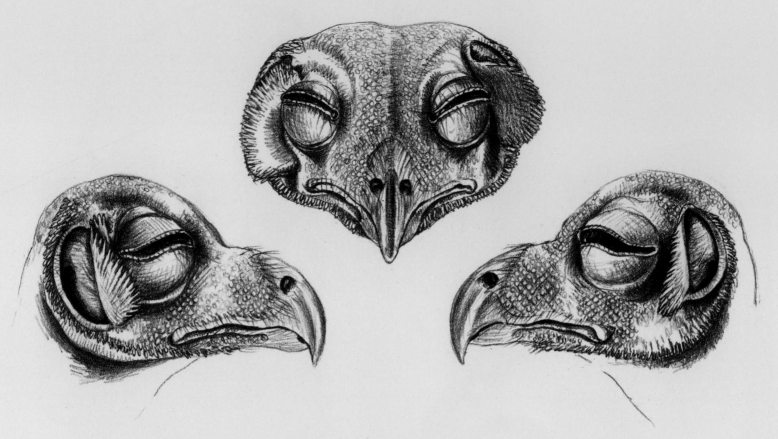

Tawny Owl
Strix aluco
Feathers removed from head to show asymmetrical orientation of ear openings. The left ear is higher than the right in this genus. The skull shows little asymmetry, however.

species. This maximizes the light entering through the correspondingly large pupil. And they have a high density of rod cells in their retina, which improves their vision under dark conditions, though at the cost of some color perception.

In fact owl eyesight is not as exceptional as one might suppose. They can certainly see in the dark far better than we can, though not as well as a cat or a nightjar. Most nocturnal mammals, and nightjars alone of all the birds, have a specialized structure called a tapetum, which really does the trick when it comes to night vision. This is what makes their eyes glow when a light is shone on them. But owls can see well enough to avoid obstacles in their path while hunting, and they have an excellent memory for spatial details.

It is in their sense of hearing that the owls really excel. Owls have large ears, but they have nothing whatever to do with the tufts of feathers on top of the head of some species. These merely serve as camouflage, breaking up the bird's outline as it roosts by day. An owl's ears are on the sides of its head, within the area known as the facial disc.

In most groups the shape and outline of this disc are immediately obvious and it's possibly the single feature that truly defines the character of owls. The feathers within the facial area are loose and wiry in structure and are directed outward in a ring from the center, while those surrounding it are narrow and stiffened and

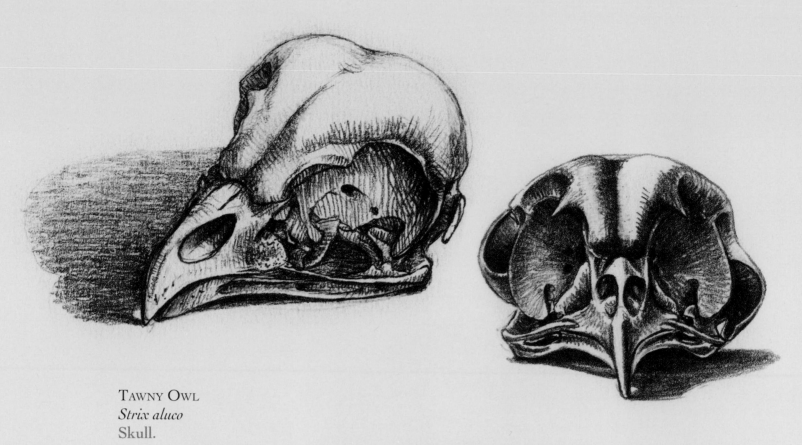

TAWNY OWL
Strix aluco
Skull.

NORTHERN SAW-WHET OWL
Aegolius acadicus
Skull; showing extreme asymmetry of ears in this genus.
Notice that the right ear is higher; the opposite of owls
in the genus *Strix*.

slightly turned inward at their tip, creating a concave dish on either side of the head. Think of a parabolic reflector—the big, bowl-shaped instrument used by sound recorders to receive and amplify sound waves; this is exactly what the facial disc on an owl is doing. And because it's divided into two sections, or rather two separate dishes, the owl can direct the two sides toward sounds independently of one another.

In all other birds the ear openings are simply a pair of small oval holes, but most owls actually have an external ear, too, a semicircular flap of feathered skin that covers the hole. The openings are also far larger than in other birds and are often asymmetric: in size, position, or both. For example, they may be in the same position but of a different shape, or the same shape but in different positions. In some groups the left ear might be higher, and in other groups, the right. One may point downward and the other upward or, in the owls of the genus *Aegolius*, the external openings may be identical wide slits beneath which the skull itself is asymmetrical!

Having asymmetrical ears results in a time lapse between the left and right sides, and that means that an owl can pinpoint the precise location of prey, whether buried beneath the leaf litter, under several inches of snow, or in pitch darkness in the dead of night.

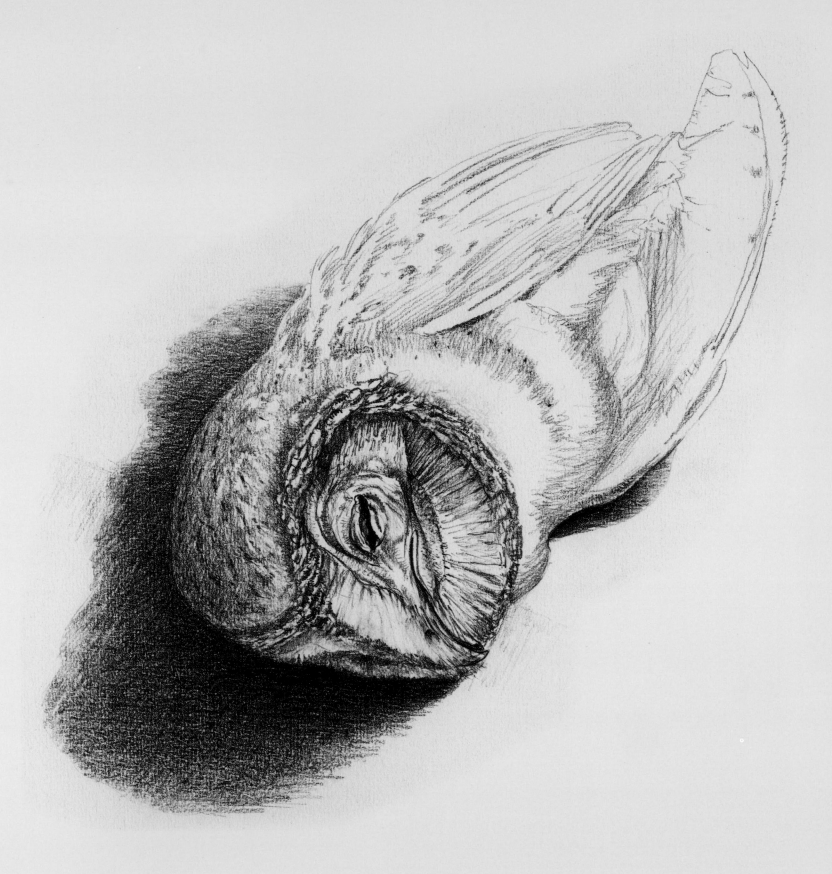

Barn Owl
Tyto alba
Facial feathers, skin, and muscles removed in stages to show ear flap, ear opening, underlying muscles, and skull.

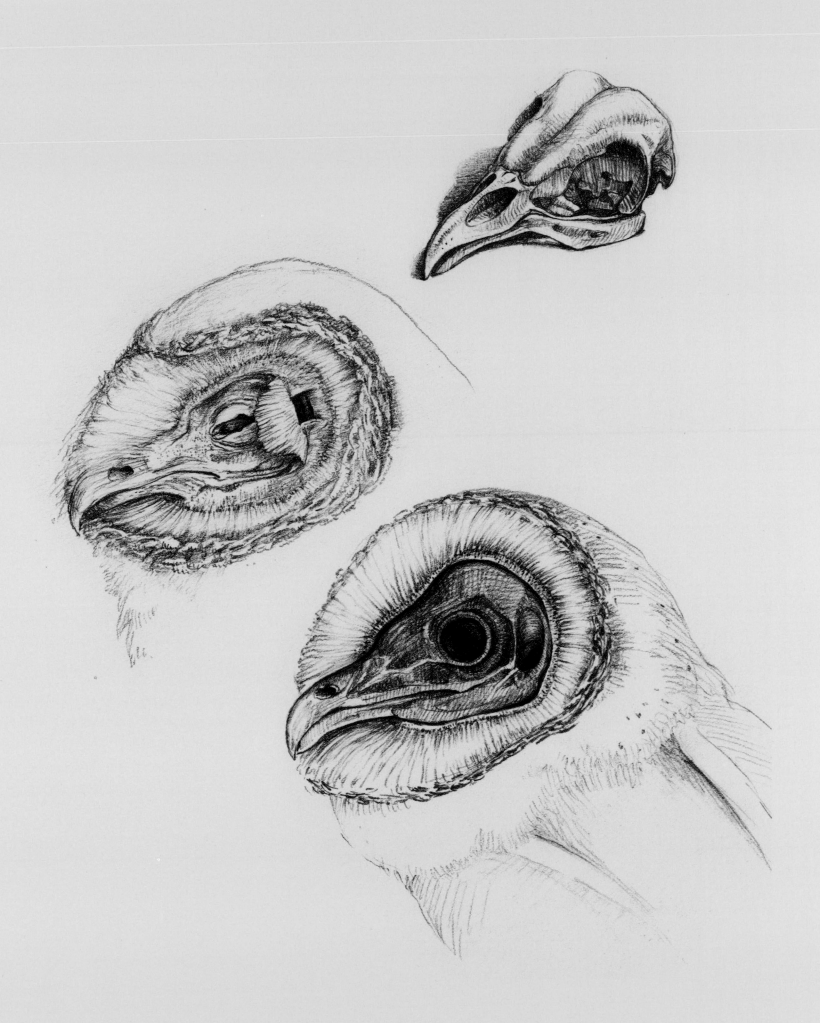

II PICAE

Bill sharp-edged, convex above; *legs* short, strong;
feet formed for walking, perching or climbing; *body*
toughish, impure; *food* various filthy substances;
nest in trees; the *male* feeds the female while she is
sitting. They live in pairs.

Tree dwellers, hole-nesters, birds that climb and leap, or anything that seemed too large or too unusual for the perching birds were placed in the order Picae. In fact, various revisions of his work saw Linnaeus repeatedly move bird families to and fro between Picae and Passeres. Regardless of that, this diverse assortment of odds and ends actually correlates rather well with the taxonomy traditionally followed right up until modern times, and many of its groups are still considered closely related.

It is indeed an order of perching birds, but birds whose feet differ in structure from the normal perching foot. Its members have a highly specialized lifestyle and a highly specialized structure to match.

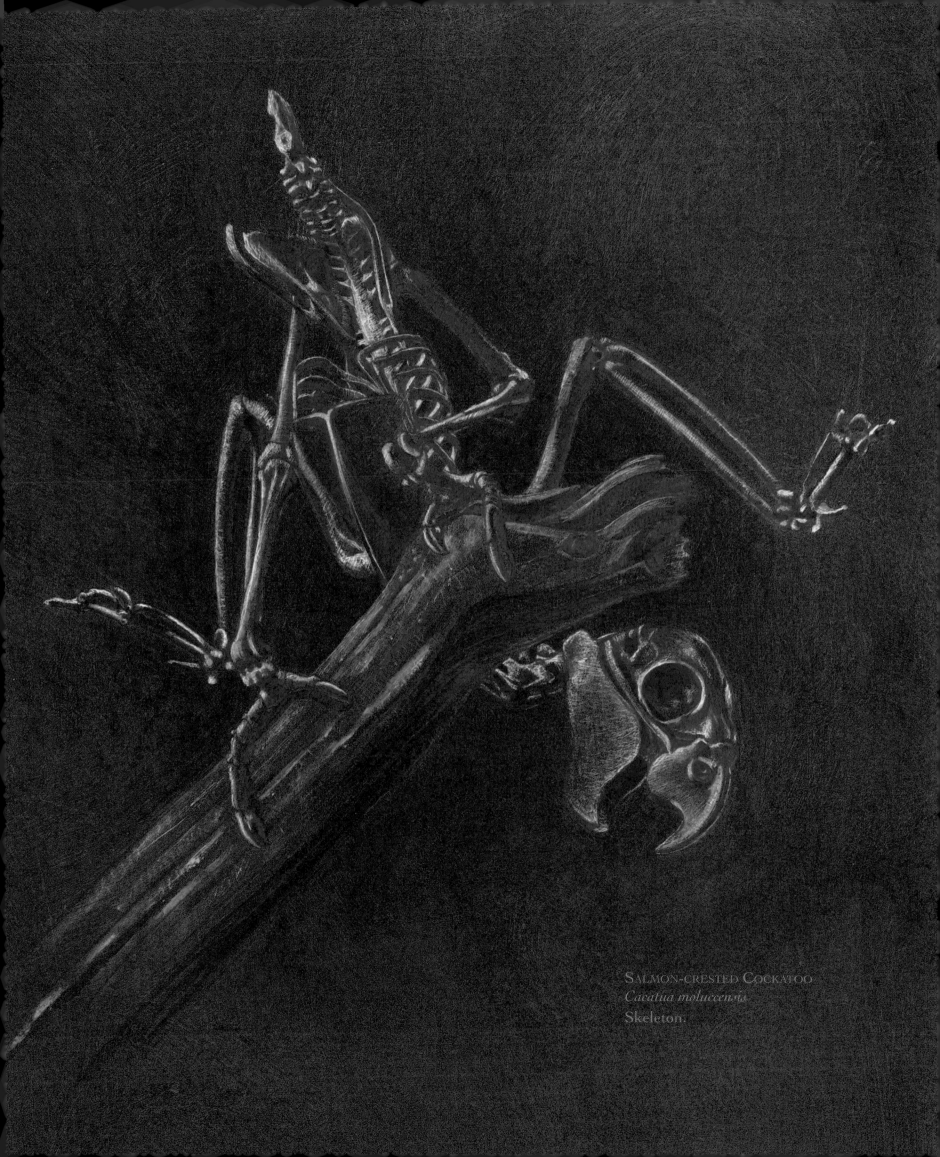

SALMON-CRESTED COCKATOO
Cacatua moluccensis
Skeleton.

Parrots

Everyone can recognize a parrot. And although the order that comprises the true parrots and cockatoos contains over 350 species—some colorful, others black or white all over; some with a long tail, others with barely any tail at all; some with a crest, others without—they are all, without any argument, parrots.

Parrots have no close relatives; there's nothing even slightly similar, so taxonomists have had a difficult task placing them in correct evolutionary sequence with other bird orders. It's generally accepted that they should follow pigeons, though the two groups share few anatomical characteristics.

The head and the foot are the most distinguishing features. The head is large and very broad, and the short, curved bill and particularly deep lower jaw make the proportions of the skull rather box-like. There is a well-defined line between the skull and the upper mandible of the bill. This is a hinge of flexible bone that allows the upper mandible to be flipped upward. Unlike mammals, which can articulate only their lower jaw, birds can raise either all or part of their upper mandible to some extent, too. Parrots do it frequently and with ease—to climb, eat, call, stretch, yawn, or sharpen their bill. The movement is no doubt helped by having a soft, fleshy pad, or cere (in most species at least), at the junction of their bill and forehead and surrounding the circular nostrils, instead of the horny bill covering extending all the way to the forehead of most birds.

RED LORY
Eos rubra
Left foot.

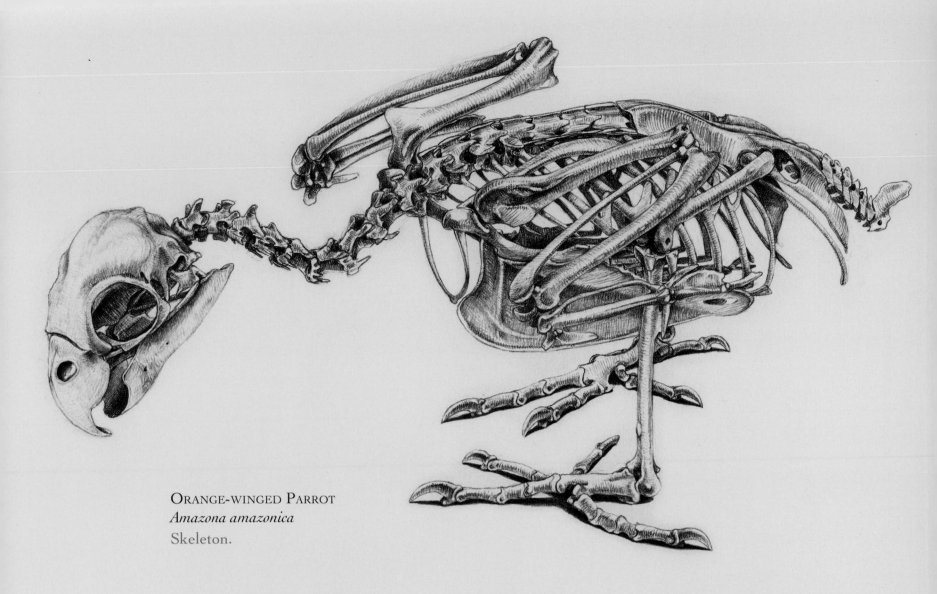

ORANGE-WINGED PARROT
Amazona amazonica
Skeleton.

The upper mandible is long and pointed at the tip. The lower is, in contrast, squared at the end, rather like the blade of a chisel, and sits snugly enclosed between the sides of the upper, though in the Palm Cockatoo there is a wide gap between the jaws for part of their length, like the arms of a nutcracker. At the opposite extreme, the lories have a fine, slender bill for feeding on pollen and nectar. Their tongue is much longer than that of other parrots and has brushlike filaments on its upper surface.

The skull of parrots is unique in having the orbits of the eyes completely encircled by bone. This gives the skull greater strength to withstand the crushing action of the jaws. Anyone who has been bitten by a parrot will be familiar with the throbbing, eye-watering agony caused by the pressure of those jaws; it's an experience to make anyone think twice about putting their fingers through the bars in future. But more than being simply a crude instrument of torture, the bill is actually a highly specialized seed-eating, nut-cracking tool. It works rather like a mortar and pestle; the lower mandible exerts the pressure to crush seeds against the solid inner sides of the upper, in a movement of the jaws reminiscent of a cow chewing the cud. The upper mandible is also stepped to provide cracking surfaces for seeds of different sizes and the food is held in place by the muscular and very sensitive tongue, which is then used to separate and discard the husk.

It takes considerable strength to crush and grind like that, and the deep jaws, robust skull, and substantial neck vertebrae all support well-developed musculature. With the contours smoothed by feathers, this gives parrots their short-necked appearance, though from the skeleton it is evident that it is not particularly so.

A strong neck and hooked bill have other uses besides cracking nuts. Parrots are skillful climbers and use their bill as a third limb—reaching out for branches and pulling themselves upward. Despite their adeptness, they could not be described as agile. Parrot movements are slow and ponderous. The front toes are directed slightly inward, giving them an endearing side-to-side waddling gait, and their tarsi are extraordinarily short

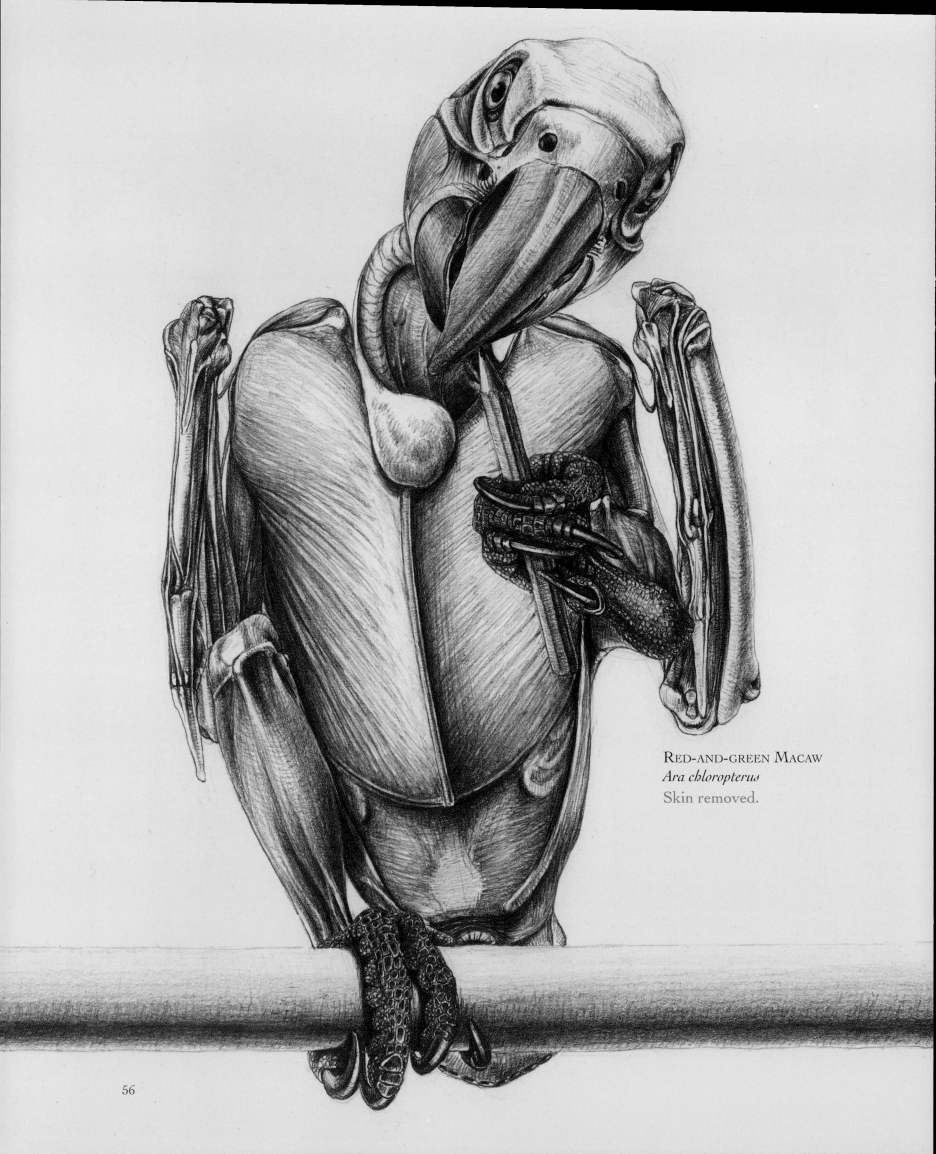

RED-AND-GREEN MACAW
Ara chloropterus
Skin removed.

BUDGERIGAR
Melopsittacus undulatus
Skeleton.

and held close to the ground when walking, forming a right angle with the lower leg at the ankle joint.

Parrot toes are arranged in a way typical of climbing birds, with the two innermost facing forward and the outermost turned 180° to lie parallel with the hind toe. The surface of the tarsi and toes is comprised of tiny raised nodules rather than flat scales. Another of the parrots' charming qualities is the ability to use their feet as hands to hold food and other objects. Like us, parrots are either right "handed" or left "handed," never ambidextrous, though the overwhelming majority are left "handed."

There are many, many characteristics of parrots that endear them to humans: their colors, their ability to mimic the human voice, their extreme intelligence, and their devotion to a single owner. Sadly, the capture of wild birds for the pet trade has had a disastrous effect on wild populations already decimated by habitat loss. And such a demanding pet frequently proves too much for the most well-intentioned and informed owner. More often than not the result is a pitifully bored and frustrated animal eking out a long and unhappy existence in the corner of an empty room.

Turacos and Others

Throughout sub-Saharan Africa, turacos are to be found wherever there are trees. They move about the branches with the agility of squirrels and indeed look very squirrel-like as they scurry and leap from bough to bough, using their long tail to balance.

Their bill is short, with a rounded upper mandible, and in many species it is enlarged into a wide shield on the forehead. Unlike the frontal shield of coots or the bill knob of swans, which are filled with fatty tissue, this is very much an extension of the bill itself and has an unbroken surface of bone beneath its outer covering.

Turacos have a broad back to accommodate the musculature required to clamber about in the treetops; it is even slightly decurved, with a marked dip in the middle.

Their feet are unique in arrangement. They do not have the "zygodactyl" climbing foot of woodpeckers and toucans, in which two toes face forward and two backward. Neither do they have the "three forward, one backward" arrangement of passerines. In turacos the outermost toe is highly maneuverable, and although it may face forward in the usual perching fashion, it is most usually held out to the side at a right angle to the others. This condition is often known as "semi-zygodactyl" though the word misleadingly implies that the toe can be turned 180° when necessary—it cannot. All the toes are, additionally, rather long. Turacos have long been considered, perhaps erroneously, to be closely related to cuckoos. However, cuckoos have a truly zygodactyl foot, with the outer toe permanently backward-facing to lie parallel with the hind toe.

But not all birds with two backward-facing toes have *the same* toes facing backward. In trogons, for example, it is the inner toe, not the outer one, which has turned. Mousebirds, another group of acrobatic tree-dwellers, have the usual perching toe arrangement—but with a twist: their hind toe can be rotated forward to lie alongside the others (though facing toward them a little) rather like a swift.

But back to turacos. Although more than adept when it comes to running, leaping, and bounding from branch to branch, they do of course sometimes need to travel across spaces too big to jump, and turacos are pitifully poor fliers. They use gliding to full advantage and have very rounded wings to maximize lift, flapping only in a vain attempt to maintain height. Their flights are thus typically in a downward direction, from which the bird needs to clamber up into the canopy again before attempting the next tree. In all these respects turacos very closely resemble toucans, and for precisely the same reason: toucans and turacos both have a dysfunctional wishbone. The two halves of the structure do not meet in the middle as they do in other birds but are separated by a distinct gap, weakening the effect of the wingbeats. But some turaco species—the plantain-eaters and go-away-birds—inhabit more open areas of savannah and cannot rely on short flights to get them from tree to tree. As well as taking to the air more readily, these open-country turacos descend to the ground to drink with greater frequency than do their rainforest relatives but, conversely, are less agile in the trees. As one might expect, in these birds the wishbone is complete—but only just. The two halves articulate in the midline but are nevertheless not fused together into a solid curve as they would be in a stronger flyer.

These species are also separable by their color—or rather by the lack of the bright coloration of the forest species—and there is a direct correlation between the birds' habitat and the pigments appearing in their feathers. Turacos as a family have two unique, copper-based pigments that occur nowhere else in the animal kingdom. One of them is vivid green and affords excellent camouflage against the foliage. Indeed, turacos are often very difficult to spot, despite calling loudly and persistently. The other is intense red and, if it is present at all, is concentrated on the primary flight feathers and is thus usually hidden out of sight. On the infrequent and brief occasions when forest turacos fly, the birds are instantly transformed in a dramatic flash of color. There is a popular myth that this pigment, called turacin—which gives the family its name—is water soluble and will wash out of the feathers in heavy rain. This is, nonetheless, a myth: the red coloration is soluble only in alkali.

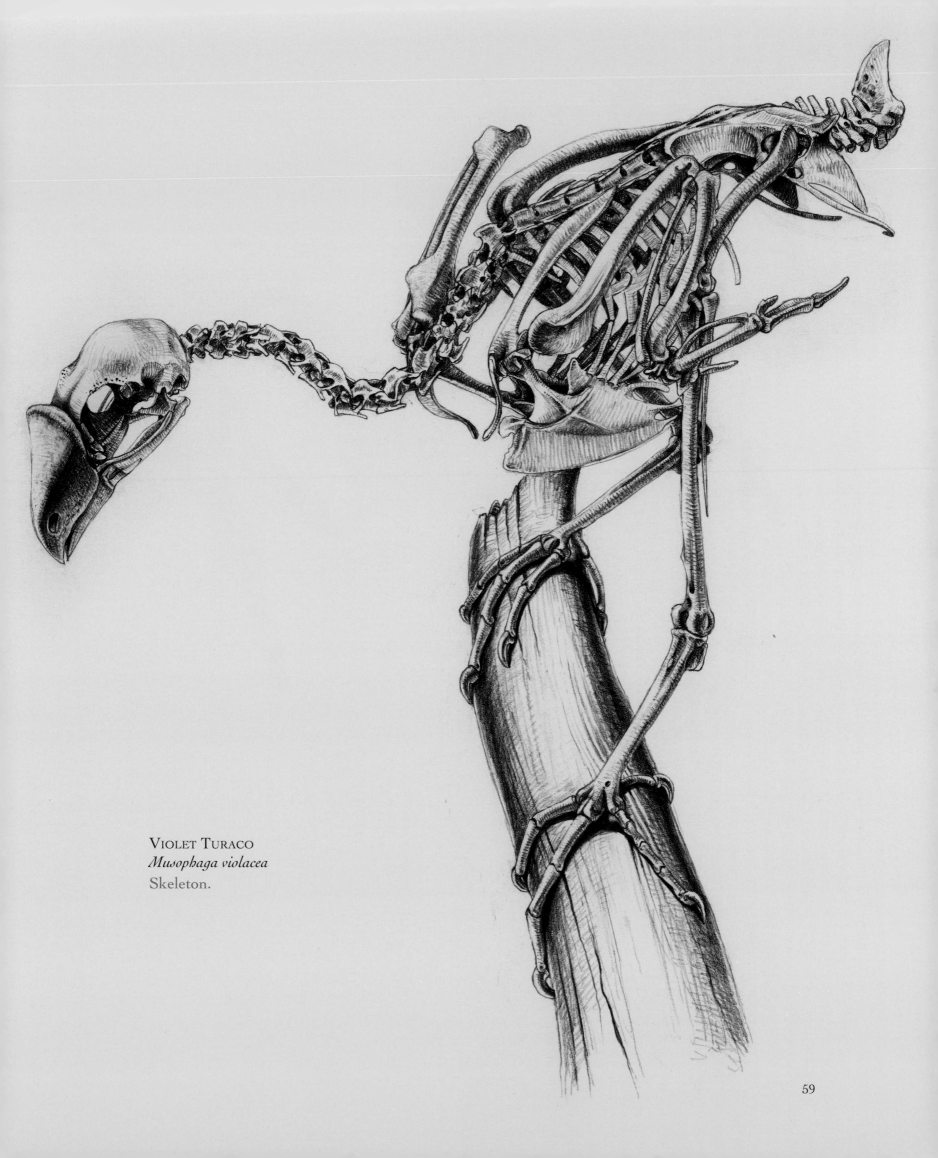

VIOLET TURACO
Musophaga violacea
Skeleton.

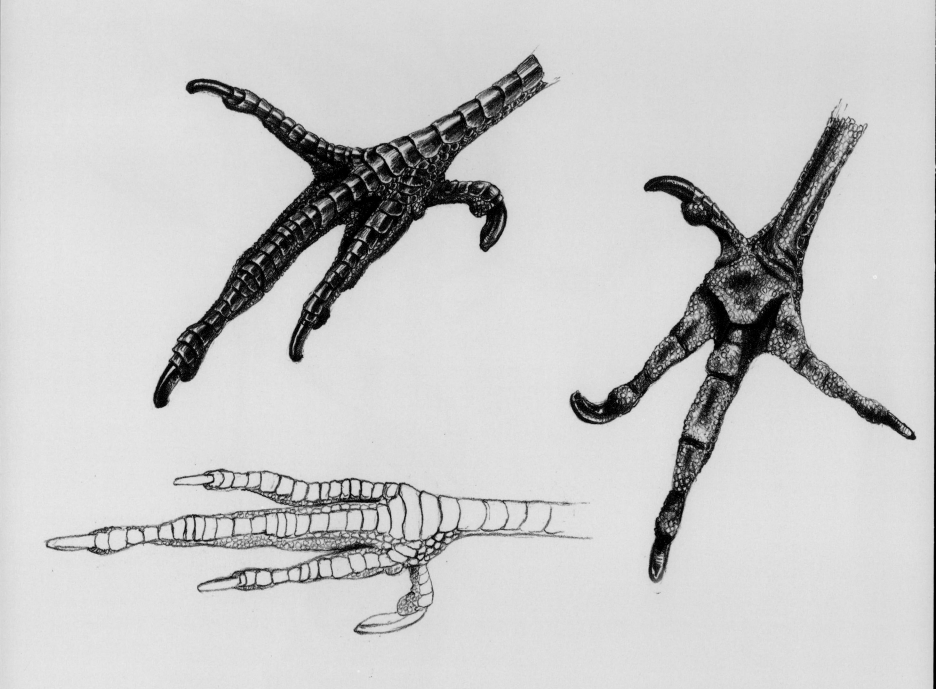

GREAT BLUE TURACO
Corythaeola cristata
Right foot; showing lateral rotation of outer toe.

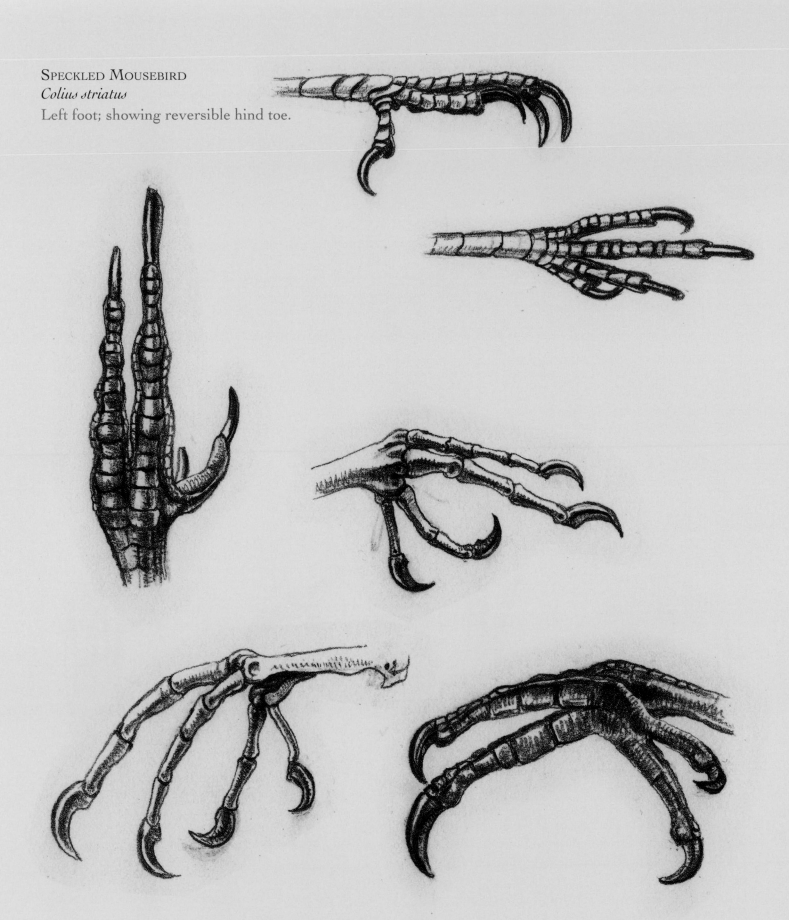

SPECKLED MOUSEBIRD
Colius striatus
Left foot; showing reversible hind toe.

RESPLENDENT QUETZAL
Pharomachrus mocinno
Left foot; showing toe arrangement unique to trogons: the *inner* toe
turned backward to lie alongside the hind toe.

Kingfishers

Despite the name and our associations with them, by no means do all kingfishers fish. In fact, the family as a whole consumes just about every sort of animal available: insects, earthworms, crabs, crayfish, amphibians, snakes and other reptiles, and even birds and small mammals. Neither are they all found near water. Some kingfishers inhabit desert and scrub, and a large proportion of the family is found only in tropical forest, far from watercourses.

Wherever they live and whatever they eat, kingfishers predominantly hunt by watching intently from an elevated perch and then dropping down onto their prey. They invariably return with their prey to the perch to eat it, bashing it a few times first to break the bones and any dangerous spines. (The Pied Kingfisher is the notable exception; its ability to hover allows it to hunt over wide expanses of open water and consume smaller prey items on the wing.) Fish are then turned so that the head end goes down first, in the direction of the scales. Snakes pose rather more of a problem. Sometimes a bird just has to sit and wait, with the tail end of a long snake dangling from its bill, while the head end is digested.

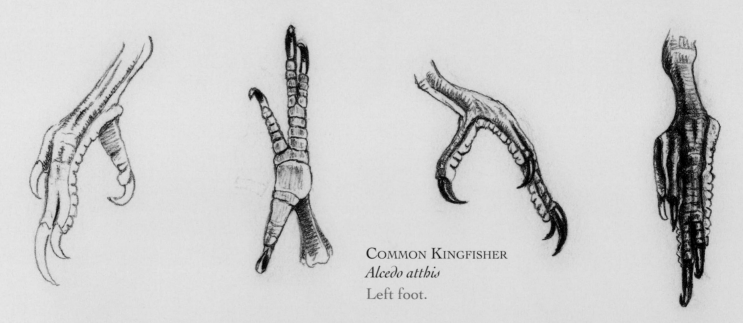

COMMON KINGFISHER
Alcedo atthis
Left foot.

Kingfisher bills are long and dagger-like. In the insectivorous forest species the bill is flattened at the sides, but it is flattened horizontally in those that feed on fish and other vertebrates. In the most terrestrial hunters, such as kookaburras, it is relatively short and broad. The jaws need to accommodate some bulky prey items, so the skull is correspondingly large and appears disproportionate to the body. And of course, so large a skull requires a strong neck to support it. The neck vertebrae of kingfishers are sturdy and robust and have long bony projections for the attachment of muscles.

Their eyesight is excellent: kingfishers can spot the minutest movement over considerable distances and have specialized oil droplets in their retina to enable them to correct the optical effects of water. The eyes are capable of little rotation within their orbits, so prey is followed by movements of the head. As they dive, a transparent nictitating membrane is drawn across the eye. This membrane, sometimes known as the "third

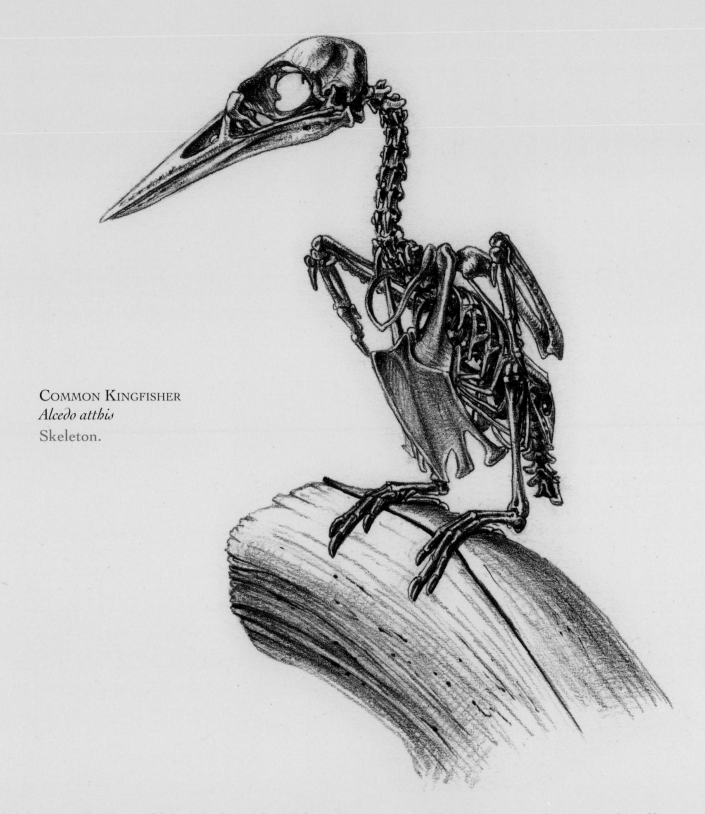

COMMON KINGFISHER
Alcedo atthis
Skeleton.

eyelid," is actually situated beneath the real eyelids. It is present in all birds but is used to particular effect in those that habitually hunt underwater.

During dives the wings are swept back at the very last moment, like a gannet, to give a streamlined, unimpeded, arrow-like assault. At all times flight is fast and direct, with rapid beats of their short, rounded wings. The breastbone is correspondingly large and has a prominent triangular keel to accommodate the bulky flight muscles required.

The outsized head is made even more incongruous by the smallness of the feet; they are tiny in all but the most terrestrial kingfishers. The tarsi are so short that bird banders need to use a unique band design for many species, and other smaller species cannot be banded at all.

Ceyx melanura
left foot.

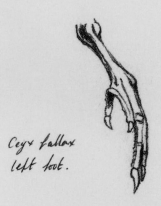

Ceyx fallax
left foot.

PHILIPPINE DWARF KINGFISHER
Ceyx melanurus
Left foot with missing inner toe.

SULAWESI DWARF KINGFISHER
Ceyx fallax
Left foot with vestigial inner toe.

The feet are also remarkable in the structure of their toes. As in many perching birds, they have three forward-facing toes, opposing a backward-facing hind toe. But in kingfishers and other Coraciiformes the three forward-facing toes are fused at their base, the inner toe up to a third and the outer toe two-thirds of the length of the central toe. This creates a large central pad beneath, which extends beyond the sides of the foot and presumably has a function in relation to gripping the edges of the nest hole. Some kingfishers have an even smaller foot. In several diminutive forest species the inner toe is missing, leaving the bird with just two forward-facing toes, fused along most of their length. The Sulawesi Dwarf Kingfisher is in a halfway stage, with a vestigial inner toe containing just a single bone.

All Coraciiformes are hole-nesters, and kingfishers prefer to nest in a chamber at the end of a long tunnel. This has obvious advantages in offering some protection against predators and external damage but is less practical when it comes to housekeeping. Kingfisher nest holes are filthy; full of excrement and food remains. Adult birds are able to bathe after exiting the nest, but it is important to avoid soiling the newly emerging feathers of the chicks. So nestlings of Coraciiform birds circumvent this by spending a prolonged period in the pin-feather stage before the emerging feathers break through their waxy sheath. Meanwhile looking more like little hedgehogs than birds!

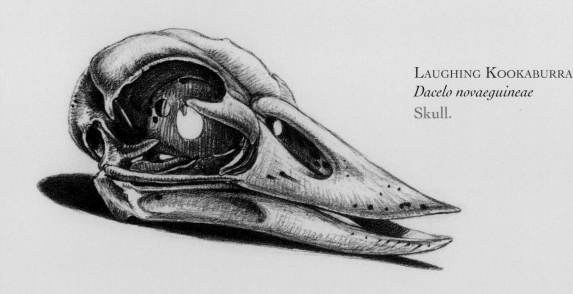

LAUGHING KOOKABURRA
Dacelo novaeguineae
Skull.

Hornbills and Allies

Hornbills and toucans are so unlike other birds and so similar to one another in appearance and habits that they are easily confused by the layperson. The two groups share a similar niche and can regarded as ecological counterparts: toucans in the Neotropics and hornbills in the Old World. Both feed on fruit and small animals, taking their food delicately in the bill tip and tossing it into the throat. Both are conspicuous and vocal. Both nest in holes. And, of course, both have a most remarkable bill.

The bill of hornbills is more obviously curved than that of toucans. The latter's is straighter and curved mainly at the tip. Although in hornbills the tips meet and can be used with precision to pick up the tiniest objects, in many species the mandibles have a wide gap along their length like a pair of nutcrackers. They also lack the clean-cut, zigzag serrations of toucans; if hornbill bills are serrated at all, it is with an irregular, deckled edge. Most important, only hornbills have a casque.

The casque is present in all species; in some, as a bulky and curiously shaped appendage, while in others it appears simply as a thickened ridge along the upper edge of the bill. It is used for display and is significantly larger in males than in females. It may, however, have an additional function: the casque has an internal opening into the mouth cavity, which suggests that it could act as a vocal resonating chamber, rather like the body of a stringed instrument, for amplifying sound.

Although it appears cumbersome, its structure is relatively lightweight and formed from a honeycomb of bony filaments. But despite being lighter than it looks, the large bill and casque do nevertheless demand some anatomical modifications. The orbits of the eyes are almost, but not quite, completely encircled in bone to strengthen the skull, and the combined weight of the skull, bill, and casque is sustained by particularly sturdy neck vertebrae. The two vertebrae closest to the skull—the atlas and axis—are fused together to provide still greater strength. Hornbills also have a rather long tail, supported by an unusually broad and thickened tailbone, or pygostyle, and tail vertebrae that extend well out to the sides. Presumably the long tail acts as a counterbalance to offset the weight of the front end. In the Helmeted Hornbill, the only species to have a casque of solid bone, the tail is especially long.

Despite the similarity in bill size and feeding strategy, the tongue of hornbills is also very different from that of toucans. Toucans have a long, spear-like tongue with a feathery edge, whereas in hornbills it is short, rounded, and unremarkable.

Their relatively long neck allows them to reach their own feathers to preen, unhampered by their large bill, but they also readily preen one another. The group has no bright plumage colors, despite the often highly colorful bill and casque, and most are predominantly black and white, forming conspicuous bold patterns. However, in some of the larger species, including the Great Hornbill, there's a definite yellowish hue to the pale areas that is not caused by pigment. It's painted on. These birds use oil from the preen gland above the tail to apply color not only to their feathers but also to their bill and casque. The gland even has a specialized tuft of particularly silky feathers like a cosmetic makeup brush that they use to smear the oil on. Another rather feminine trait—luxuriously long eyelashes—is among the most endearing characteristics of the family.

Unlike toucans, the two halves of a hornbill's wishbone do meet in the middle, and hornbills are consequently somewhat stronger fliers. The two halves are, however, incompletely fused, and the breastbone, too, is disproportionately small for so large a bird. Not surprisingly, therefore, hornbills are incapable of feats of sustained flight. They are impressive birds in the air, however, and can be heard in flight at a considerable distance, even without calling—the stiffened outer flight feathers make a rushing sound as the air passes in between. The forearm is substantially longer than the upper arm, causing the wings to sit well forward on the resting bird, on either side of its neck, and the bones of the hand section are short and stumpy. The wings are

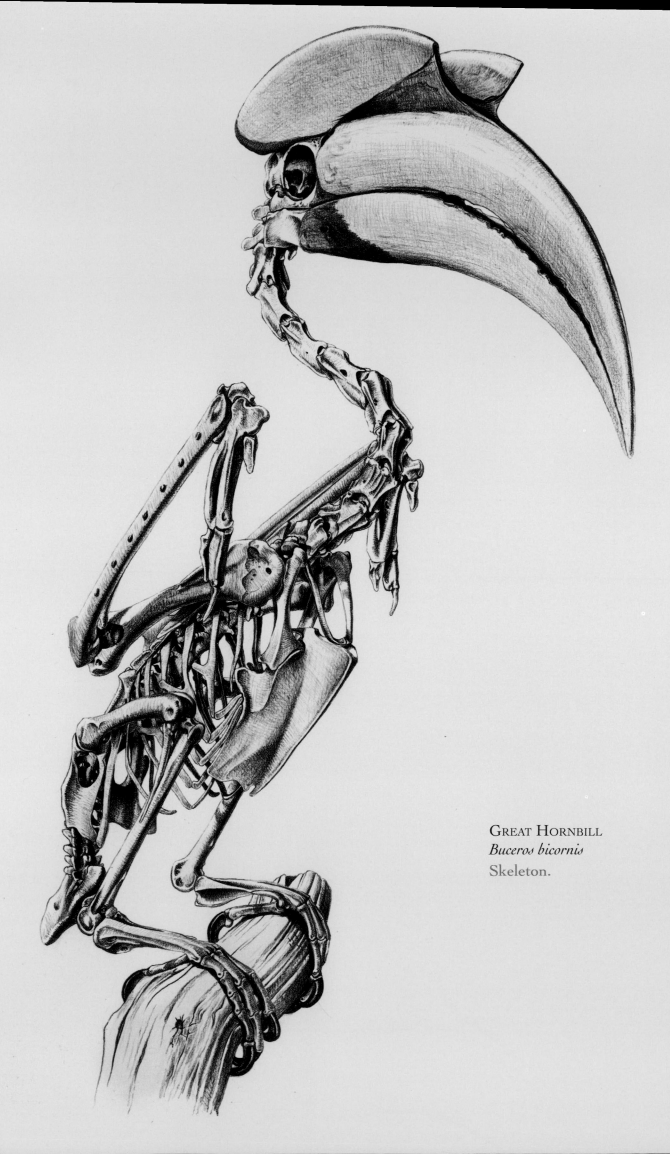

GREAT HORNBILL
Buceros bicornis
Skeleton.

also unusual in that their undersides are virtually naked, lacking many of the covert feathers found on other birds.

Hornbills and toucans belong to two separate orders; toucans, to the Piciformes, which they share with woodpeckers, honeyguides, and barbets, while hornbills are traditionally included in the Coraciiformes, along with hoopoes, rollers, kingfishers, and bee-eaters. Hornbills, however, have many exclusive characteristics and should perhaps be placed in an order of their own.

Toucans, like other Piciformes, have a foot adapted for climbing, with two toes facing forward and two — the outermost toe and the hind toe — directed backward. By comparison, Coraciiformes, including hornbills, have three toes directed forward and only the hind toe pointing backward — but with a distinct difference from the normal perching foot. The forward-pointing toes are fused together at their base — the innermost almost to the first knuckle of the middle toe and the outermost almost to the second knuckle. The underside of the foot thus has a large central foot pad that extends out to the sides, like a cushion; possibly an adaptation to hole-nesting.

Most hornbills are highly arboreal and have rather long toes and a short, curiously flattened and rather downcurved tarsus, both covered in thick, horny scales. The tarsi are held almost horizontally when perched and lie virtually hidden by the long, fluffy feathering of the lower legs. The more terrestrial species have

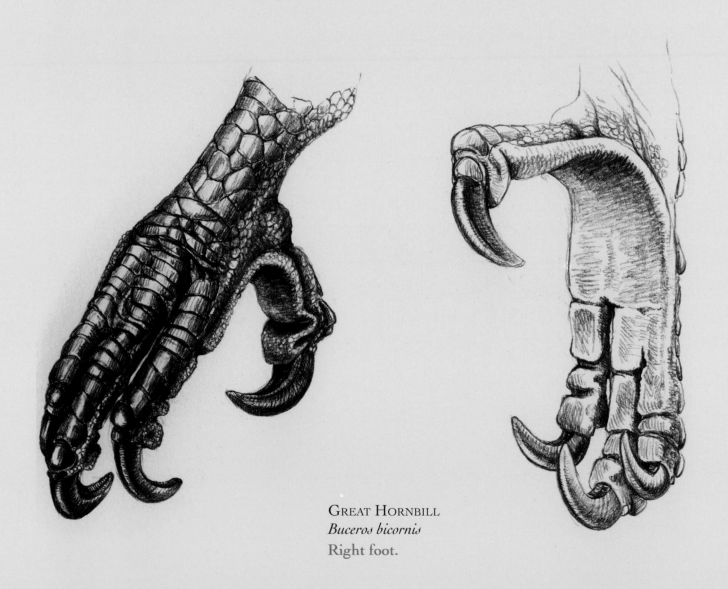

GREAT HORNBILL
Buceros bicornis
Right foot.

longer legs and walk, as opposed to hopping. The most notable of these are the ground hornbills, a primitive branch of the family that probably deserves separate family status, despite having only two extant species. Huge and stately birds, ground hornbills have very long tarsi and very short toes and walk prodigious distances, picking up ground-living prey en route. They are almost exclusively carnivorous, and their long, scaled legs afford them some protection against snakes, which they tackle readily.

All Coraciiformes nest in holes, but the hornbills (with the exception of the ground hornbills) are unique in actually incarcerating the female inside the hole. As soon as she is settled inside, the male seals up the entrance with mud, using the flat sides of his bill as a builder's trowel and leaving only a narrow slit through which he passes in food, and she and the chicks squirt out droppings. There she stays for up to four months, and even extends her confinement by delaying egg-laying for several weeks.

The young have a small bill and casque—a necessity for the confined space of a nest hole—and the lower mandible protrudes some distance beyond the upper for the first few weeks of life. The legs and feet are quick to develop, however, and this enables them to move comfortably around the nest hole and to raise up their hind end to deposit droppings outside. In all Coraciiformes the feathers remain in the quill phase for an extended period as a precaution against feather soiling (and some Coraciiform families keep a very unsavory household), but the hornbills—at least with the exception of the more primitive ground hornbills—nevertheless keep their nests scrupulously clean.

GREAT HORNBILL
Buceros bicornis
Tongue.

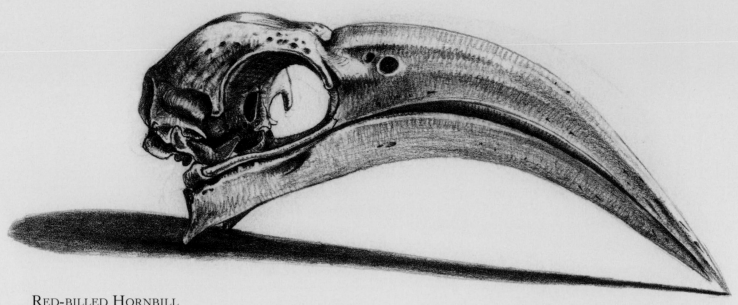

RED-BILLED HORNBILL
Tockus erythrorhynchus

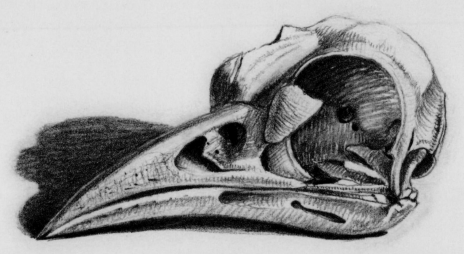

INDIAN ROLLER
Coracias benghalensis

Skulls.

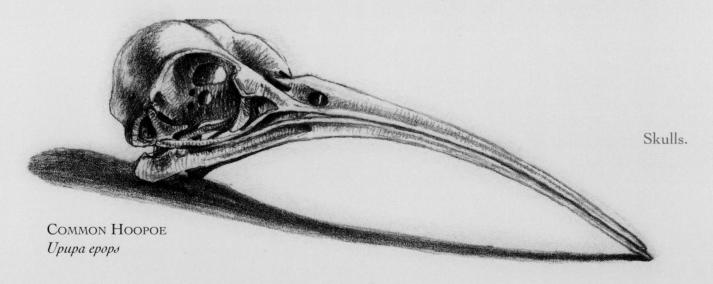

COMMON HOOPOE
Upupa epops

Toucans and Barbets

With their arresting appearance and their association with certain popular brands, toucans have universal appeal. Their gaudily colored bill is instantly recognizable and truly enormous, often equal in length to the body. It's deep but narrow; straight for most of its length, but both mandibles are strongly downcurved at the tip. At first sight it appears that toucans have no nostrils, but they do—well concealed, tucked side by side beneath the uppermost edge of the bill sheath near its junction with the skull, and facing backward toward the head.

Despite its size the bill is lightweight. It is composed more of air than bone, and the horny bill sheath covers nothing but a honeycomb of fine bony filaments.

The precise purpose of so distinctive a bill is still not fully understood. It is equally bright in both sexes and is known to play no particular role in courtship or territorial disputes, though it may serve as an intimidating banner to deter predators and reduce the mobbing behavior of other birds. Its great length is certainly advantageous for reaching fruit growing on branches too slender to hold much weight and for robbing the pendulous hanging nests of caciques and oropendolas.

The bill edges are armed with vicious-looking serrations. When early explorers in the Neotropics brought specimens back to Europe, it was supposed that these serrations were an adaptation to holding slippery fish—a not unreasonable assumption, as they are a feature shared by several fish-eating birds. But a toucan could not hold a fish for long: the serrations are pointing in the wrong direction. The serrations on a toucan's bill face forward, away from the body, and probably perform the more likely function of assisting in grasping and tearing fruit from trees.

Toucans take food in their bill tip, then, tossing it gently backward, allow it to fall into the back of the mouth, where it is swallowed. They are omnivorous, supplementing a diet of fruit with insects and small vertebrates including the eggs and young of other birds. Their tongue is unique: long and fine, with feather-like bristles along its edges.

Toucans may indeed be unmistakable, but they are often confused with their Old World counterparts, the hornbills, which likewise have an enormous, brightly colored bill. Toucans, however, always lack the hornbill's additional appendage, their "horn" or casque.

Toucans and hornbills are not, in fact, closely related, and their many similarities are due to their comparable lifestyle rather than immediate common ancestry. Hornbills are traditionally grouped with the hoopoes, rollers, kingfishers, and bee-eaters in the order Coraciiformes, whereas toucans share the order Piciformes with the woodpeckers, honeyguides and barbets.

The barbets are an interesting group widely spread across the tropics of Asia, South America, and Africa, though it is likely that the toucans and New World barbets are more closely related than the New and Old World barbets are to each other. The barbs hinted at in their name are on their bill and, like the serrations of toucans, are forward-facing and more effective for handling fruit than holding wriggling prey. They are present on the outer bill sheath only. The underlying bone is smooth-edged, with a wide gap between the curved upper mandible and the remarkably straight lower one.

But back to toucans.

Despite their large, rounded wings toucans are weak flyers. They are incapable of traveling

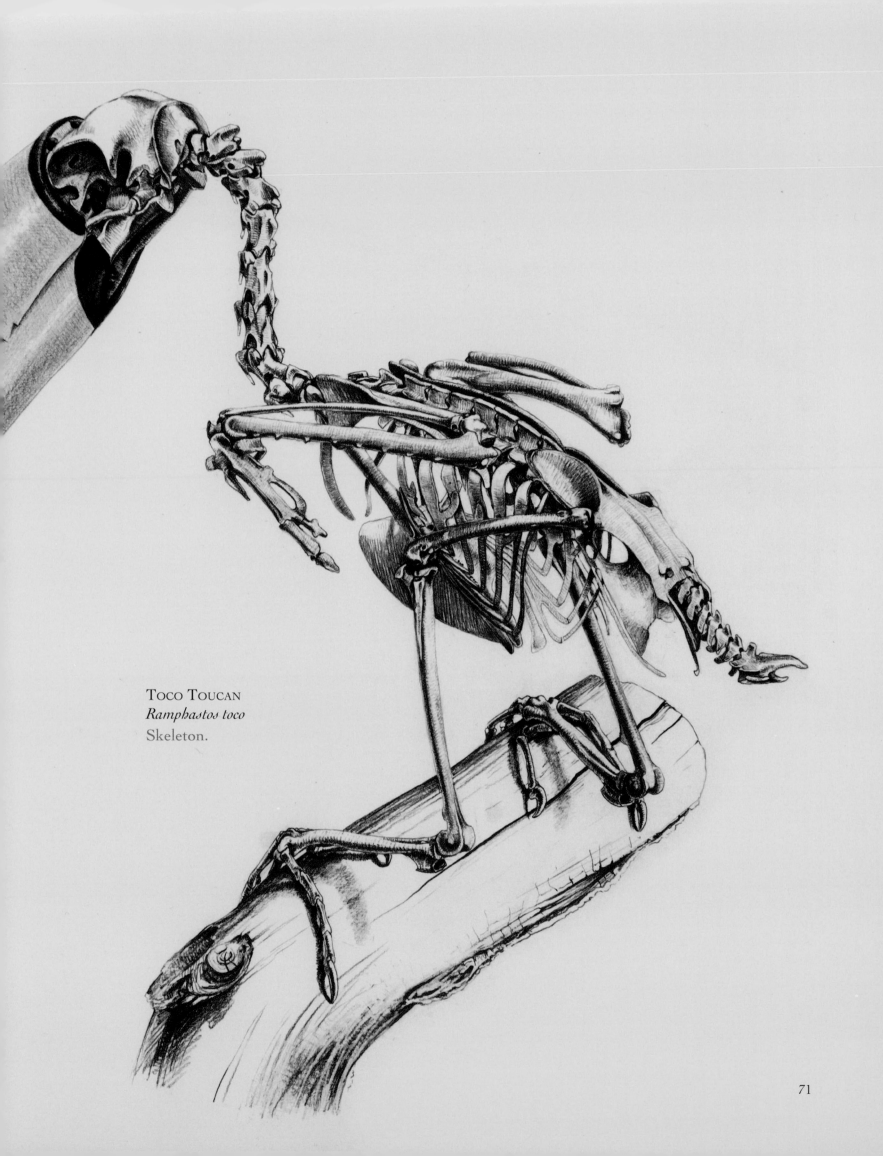

TOCO TOUCAN
Ramphastos toco
Skeleton.

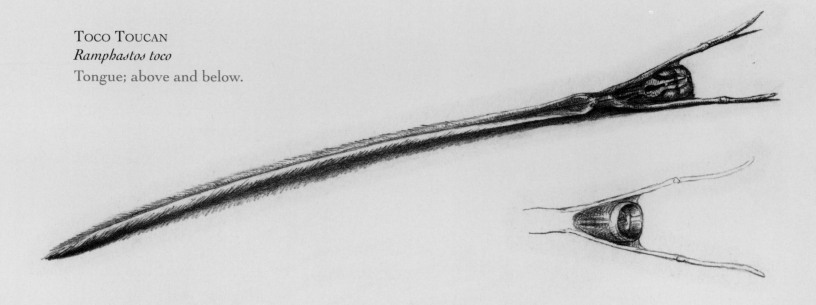

more than the shortest distances without stopping to perch, and sometimes even efforts to cross wide rivers end in tragedy. Indeed, the indigenous human populations have learned to exploit this shortcoming, deliberately driving birds to take flight until they fall down exhausted and can be harvested for their meat and feathers. Their breastbone is short and the keel too shallow to support large flight muscles. But what is perhaps most significant is that the two sides of the wishbone—the furcula—do not meet in the middle as those of most other birds do, which severely limits their capacity for sustained flight. This characteristic is shared with the forest-dwelling turacos, also remarkably poor fliers.

Toucans are, nevertheless, highly mobile birds, capable of negotiating their forest habitat with bounding leaps and short flights from tree to tree. Their legs are strong and their pelvis is wide to support the associated musculature. Toucans perch with their tarsus held horizontally, forming an angle of 90° or less with the lower leg—the same attitude adopted by many other arboreal acrobats including hornbills and cotingas.

Toucans, like other Piciformes, have two toes pointing forward and two opposing them, pointing backward—an arrangement known as zygodactyl. It is the outermost toe that has become realigned and lies almost parallel with the hind toe. Hornbills and other Coraciiformes, by comparison, have a "three forward, one backward" arrangement, of which the two innermost forward-facing toes are partially fused together at their base.

Like many other hole-nesting birds, young toucans have a fleshy pad beneath their heel to protect them from abrasion from the hard floor of the nest cavity. This degenerates and disappears after fledging.

The tailbone, or pygostyle, has an enlarged, flattened base for the attachment of muscles controlling the tail. The hindmost of the tail vertebrae are fused to it, and this single enlarged unit articulates by a ball and socket joint, giving the tail the ability to flip forward in a wide arc. Nesting in cramped tree cavities as they do, toucans are able to save space, and protect their tail from abrasion, by folding it conveniently above their head. They sleep that way, too, laying their bill along their back and their tail on top of it so that they resemble a shapeless ball of feathers.

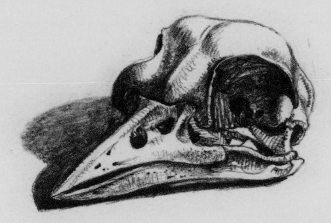

BLUE-THROATED BARBET
Megalaima asiatica

GREAT BARBET
Megalaima virens

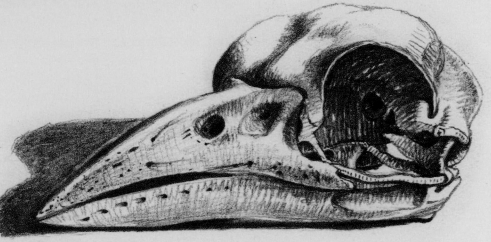

DOUBLE-TOOTHED BARBET
Lybius bidentatus

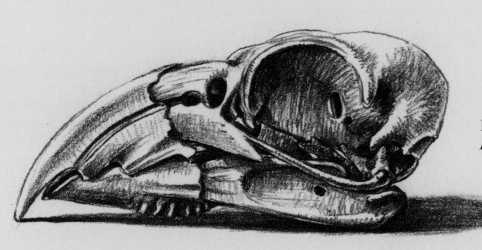

Skulls, with partial bill sheath shown on Double-toothed. Line drawing shows upper mandible with bill sheath removed. The "teeth" are on the bill sheath only, not on the underlying mandible.

Woodpeckers

There are several bird groups that climb and forage on the trunks of trees, probing into crevices in the bark or tearing it away. But there is only one that is able to conquer the forces of gravity so effortlessly and at the same time has the strength to bore into solid wood. Those qualities that make woodpeckers worthy of the name set them apart from all other bird groups, making them instantly recognizable. Every part of their anatomy is finely tuned for vertical hammering, though this specialism has not prevented some from turning their talents to more terrestrial challenges.

Like other members of the order Piciformes—which includes the toucans and barbets—and the unrelated parrots and cuckoos, woodpeckers have what is sometimes called "yoke-toed" feet. The correct term is "zygodactyl" and means that the outer toe has changed its rotation to point backward alongside the hind toe to form a sort of narrow "X" shape. Now, as a powerful gripping foot for an arboreal bird the advantages are obvious. But perhaps not for flattened, vertical surfaces like tree trunks.

In evolutionary terms, woodpecker feet are in a state of flux. The stereotypic "X" shape is only truly found in the groups that have undergone secondary adaptation to ground-living. In all the climbing woodpeckers, the position of the toes shows some variation on the theme. There are two trends: one toward smaller body size and thus fewer gravitational problems; the other toward large size and better equipment for dealing with gravity. The minimal weight of the smaller woodpeckers enables them to grip vertical surfaces with comparative ease. The hind toe is rather redundant and tends to be reduced, vestigial, or absent altogether and in these three-toed species, the outer toe faces backward in line with the forward-facing pair, making the birds look rather as though their feet are on the wrong sides. But where a hind toe *is* present, the outer toe is held not in line with the others but out at a sideways angle where it is more effective to counteract gravity. The larger the bird, the greater the angle. And in the largest woodpeckers of all—most notably those of the genus *Campephilus*, which includes the extinct giants, the Imperial and Ivory-billed Woodpeckers—the outer toe, which is greatly increased in length, can actually be oriented to face forward. Their hind toe, too, is held at an angle. So, from having two toes each pointing forward and back, woodpeckers as a group are on their way to possessing either three toes only or four toes all forward-facing!

The toes are armed with formidable-looking curved claws for clinging on. The feet are not used in foraging: they have enough to do with maintaining connection with the tree. In the smaller species the feet are held beneath the bird, but larger ones spread their weight by holding their legs extended and their feet out to the sides, increasing stability by resting their heels, protected with a thickened pad of skin, against the trunk. All but the wrynecks and tiny piculets also use their tail as a brace. The pointed and stiffened feathers curve downward toward their tip to provide a springy prop to prevent the body from tilting backward, and tail and feet work together as the bird moves up the trunk in a series of jerky hops.

Now a tail is not just a convenient bundle of feathers to lean on. It takes muscle power to function effectively as a brace, and large muscles need large bony surfaces to anchor to. The tail vertebrae of a woodpecker do not diminish in size toward the tip, and the final bone—called the pygostyle—is enormous, with a broad flattened underside for the muscles to really pull those tail feathers against the tree.

Everything about woodpeckers is tough, even their skin—presumably as a protection against biting and stinging insects. They certainly need a strong physique to withstand the rigors of hammering as they forage for food and excavate their nest holes. The force exerted as they strike the wood is tremendous. But it's more than the result of strength alone; you have to be a woodpecker to do it.

The anatomical requirements of hammering affect the bird's whole structure, not just the bill and head. Some groups excavate more than others, and in these the features are better developed, clearly identifying

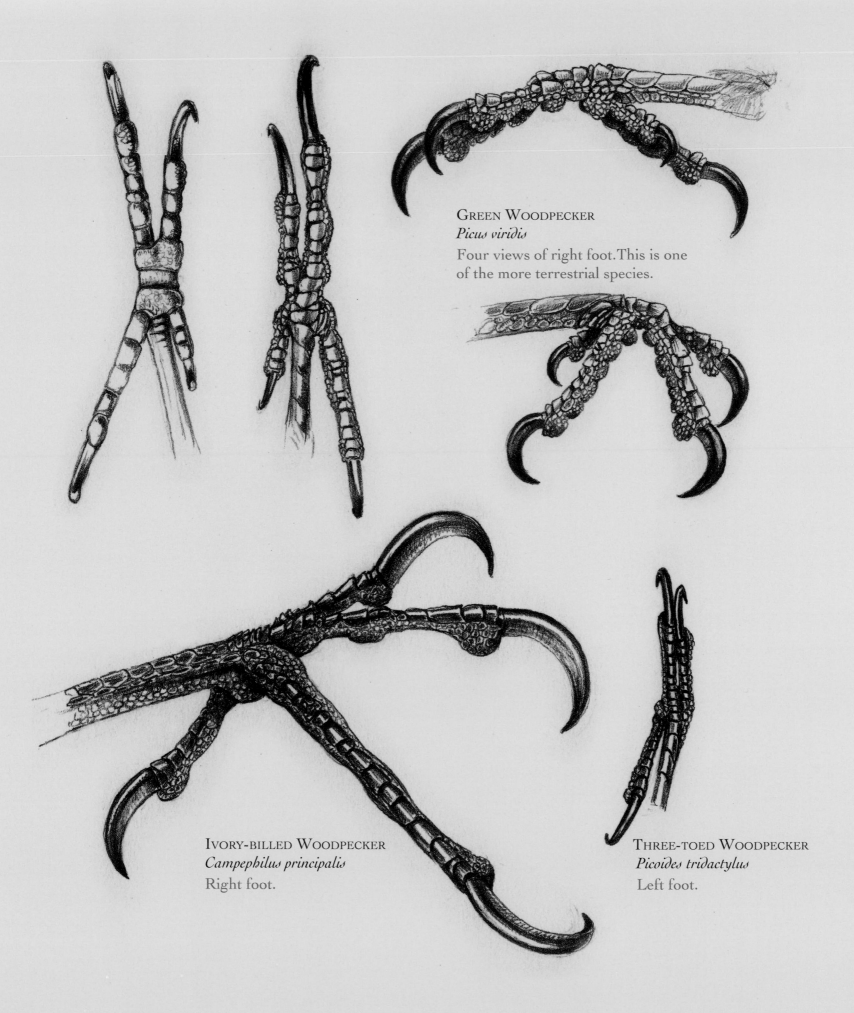

GREEN WOODPECKER
Picus viridis
Four views of right foot. This is one
of the more terrestrial species.

IVORY-BILLED WOODPECKER
Campephilus principalis
Right foot.

THREE-TOED WOODPECKER
Picoides tridactylus
Left foot.

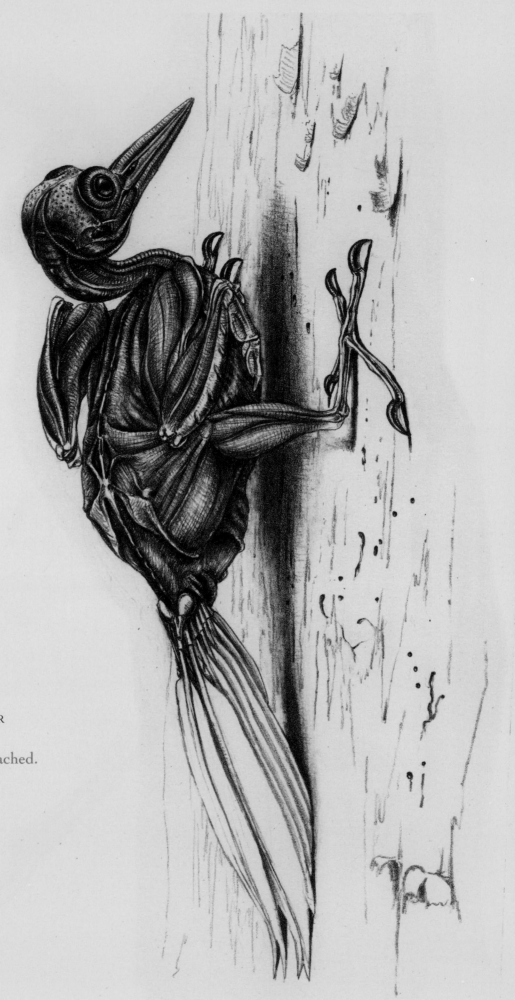

GREAT SPOTTED WOODPECKER
Dendrocopos major
Skin removed but tail left attached.

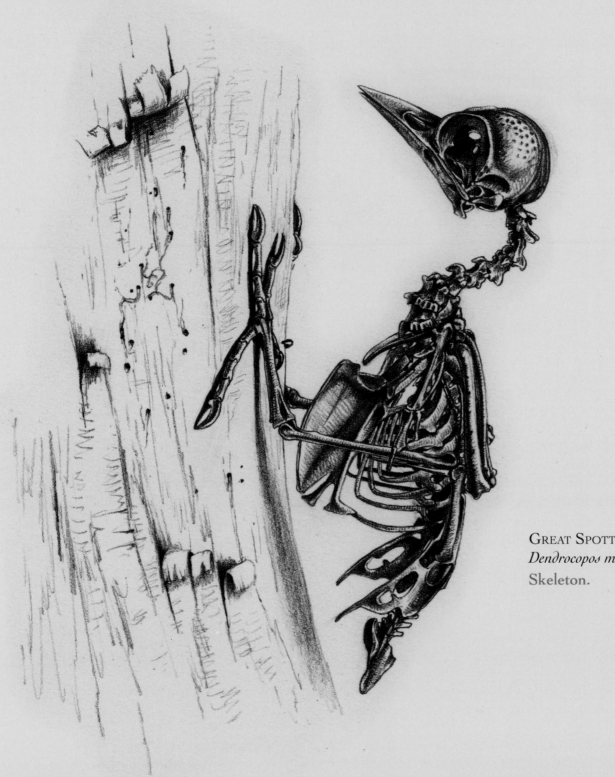

GREAT SPOTTED WOODPECKER
Dendrocopos major
Skeleton.

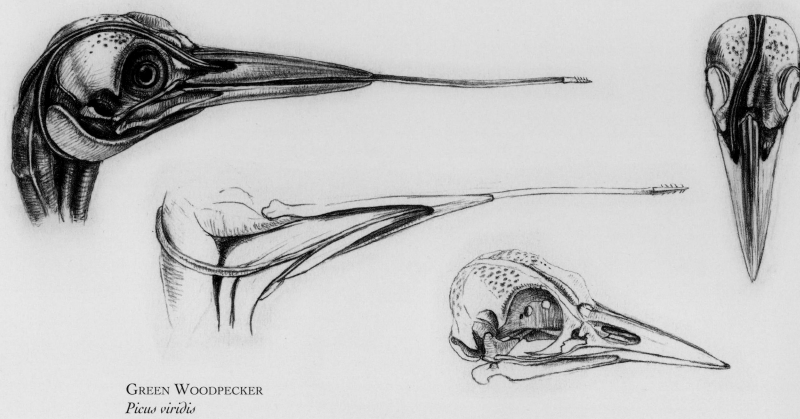

GREEN WOODPECKER
Picus viridis
Head and skull showing salivary gland and position of tongue. Notice the furrows in the cranium—a channel for the elongated hyoid horns of the tongue.

the specialized adaptations to that mode of life. The top-rank excavators have a straight bill, very broad at the base to spread the force of impact, and with a chisel-like tip. The cutting edge is self-sharpening and there are strengthening ridges that run along the sides and shelter the nostrils. The nostrils themselves are reduced to slits to prevent the entry of wood dust and are further protected by a covering of bristle-like feathers. Along the junction of the bill and forehead, the bone folds inward in a straight line. This fold is vitally important and acts as a shock absorber, conducting the force of the blows outward. It looks rather like the hinged joint on a parrot's skull. But with a difference. Whereas a parrot's upper mandible is capable of flipping upward along this junction, a woodpecker's is specifically prevented from doing this by the steeply overhanging bone of the forehead. Otherwise a potentially fatal injury could occur should the bill be forced open by the impact.

The characteristic head shape of wood-pecking woodpeckers—with the braincase above the level of the bill—is another clue to their specialism. Simple but effective; this is to place the brain safely above the trajectory of impact. Any forces that do reach the cranium are absorbed by the thickened bone; its pock-marked surface a distinctive feature of woodpecker skulls. The skull of the excavating specialists also meets the neck at an almost perpendicular angle so that the bill faces the tree trunk rather than pointing vertically upward. This enables the bill to strike the wood at right angles to it with a smooth swinging motion like using a hammer and to avoid the jarring that would result from a forward thrust.

The tremors of impact are transmitted across the entire body: down the muscular neck, across the shoulders to the ribcage, and beyond. Even the ribs of woodpeckers are especially modified for hammering. The second and third pairs adjoining the backbone are considerably broader than all their neighbors, and all the ribs' lower sections are substantially built to conduct the forces down into the breastbone to be absorbed by the muscles.

For all their fitness for an arboreal existence, some woodpecker groups have nevertheless colonized treeless habitats, excavating for ants and other underground insects instead of the grubs that form the staple diet of the wood-boring specialists. With a longer, narrower bill, lacking the chisel-like end, a more streamlined head shape, facing gracefully forward from the neck, and a straightforward X-shaped arrangement of toes, these species lack many of the characteristic features of their arboreal counterparts. They do, however, share one important attribute that has been the key to their success—an extensible tongue.

The basic structure of this organ is the same as in all birds: a tongue anchored to the floor of the mouth just in front of the opening to the windpipe, where it divides into two branches called hyoid horns. These "horns" extend backward along the inside of the lower jaw and behind the ear openings, hugging the back of the skull. In most birds the tongue cannot be extended beyond the tip of the bill, but woodpeckers, among others, are an exception. Their long tongue, tipped with various barbs or bristles and coated with sticky saliva from a well-developed salivary gland at the base of the jaw, can be shot out rapidly to trap insects. It's all achieved by the action of the muscles surrounding the flexible and whip-like hyoid horns. But the horns do need to be considerably longer than those of other birds. So long are they in some species that they meet at the back of the head, extending right over the top of the cranium along a channel in the skull and may even twirl around the right eyeball or plunge into the right nostril. When the bird is feeding the slack in the hyoid horns is pulled sharply taut, thrusting the tongue forward.

Hummingbirds

In many ways more like insects than birds, hummingbirds really do hum. The sound is generated by their rapidly whirring wings, which, in some species, beat up to eighty times per second and may reach an astonishing two hundred beats per second during flight displays. Like many insects, they can hang motionless in the air or move directly upward, downward, sideways, and even backward, without changing their orientation, as they dart about from flower to flower feeding on nectar. Hummingbirds fly like no other birds.

The skeletal structure of the wings is similar to that of swifts, with which they share the order Apodiformes: a short, stout, and queerly shaped upper arm, a short forearm, and a long and much enlarged hand section. Hummingbirds, however, move their wings in an entirely different way. Their wingtips describe a figure-eight shape in the air, generating lift on the backward as well as forward strokes rather like a helicopter, whereas most birds power themselves with the downward beat of their wings, using the upstroke merely as a recovery motion.

Even other hovering species bear no similarities. Hovering birds, such as kestrels and the Pied Kingfisher, barely flap their wings at all, using subtle adjustments of their wings and tail to keep them stationary in the air and relying heavily on the stiff feathers of their "thumb"—the alula—to prevent stalling. In hummingbirds, however, the wings are rotated vigorously and the "thumb" is no more than the tiniest spike enclosed within the skin of the hand. It is represented externally by a single elongated contour feather with little or no aerodynamic function.

Most of the movement of the wing is from the shoulder and elbow, with little flexion at the wrist joint. The wing is slender and blade-like, with ten long primaries tapering down to six short secondaries that terminate well short of the elbow.

In all other birds, the upper arm is attached to the body via a shallow cavity formed where the shoulder blade meets the outer edge of the coracoid. (The coracoids are the struts that project from either side of the breastbone and brace the wings apart.) This gives the wings considerable movement in all the directions necessary for normal flapping flight but does not allow the propeller action employed by hummingbirds. *Their* wings, by comparison, sit in a highly developed ball and socket joint at the apex of the coracoids, allowing them full rotation through 360°.

The short upper arm gives maximum leverage for the flight muscles, situated on either side of the long and deeply keeled breastbone, or sternum. In relation to hummingbirds' diminutive size, the flight muscles are truly enormous, accounting for a higher percentage of the body mass than that of any other bird. The bone of the sternum is thickened, giving an irregular, pock-marked surface. There are eight pairs of ribs, a greater number than in many bird groups, which provides stability to the thorax from the powerful contractions of the flight muscles.

The feet are so tiny that walking is out of the question; the feet are for perching only, though they can be used in preening, particularly in species whose bill is too long to be employed for this purpose. The toes are arranged in the typical perching bird fashion, with three in front and one behind, though all but the most distal bone in each toe are much reduced in size.

Most hummingbirds have ten tail feathers. The tail acts as a rudder and is important to the birds' maneuverability, particularly in the transitions between motionless hovering and direct flight. One species, however—the Marvelous Spatuletail—has devoted its marvelous tail solely to the purpose of display and has only four tail feathers, none of which is particularly functional for flying.

Only male hummingbirds bear the glittering iridescent plumage for which the group is famous, and not all species are thus endowed. It tends to be present, if at all, on the head, body, and tail and never on the flight feathers of the wings. Iridescent feathers are structurally weak, and the flight feathers need to be of maximum strength.

Hummingbirds form one of the largest of all bird families and are entirely restricted to the Americas. They are no relation to those other tiny, iridescent, nectar-feeders—the sunbirds of the Old World. Sunbirds are song-

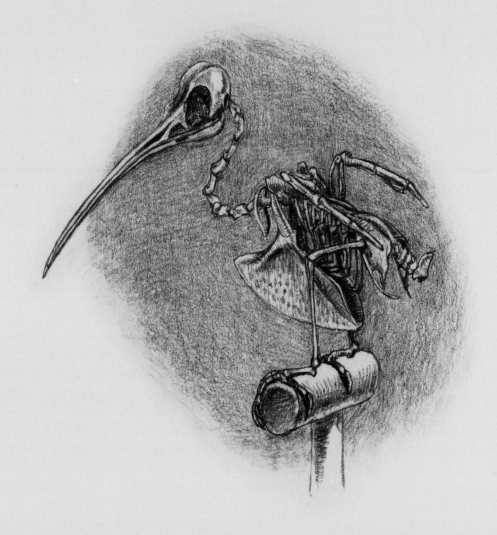

WHITE -THROATED HUMMINGBIRD
Leucochloris albicollis
Skeleton.

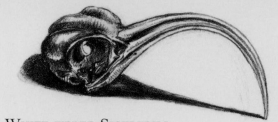

Sword-billed Hummingbird
Ensifera ensifera

White-tipped Sicklebill
Eutoxeres aquila

Skulls; the furrow in the cranium of Sword-billed is a channel for the elongated hyoid horns of the tongue.

birds, which rightly belong in the order Passeriformes. They have much longer legs and are able to use them to acrobatically swing and hop about the branches in search of food instead of feeding entirely in flight as hummingbirds do. Consequently they lack the hummingbirds' unique flight capabilities and wing structure.

Nectar is extracted from flowers by means of a long tongue with a brushlike tip, which can be darted out to project well beyond the end of the bill. This is achieved by taking up the slack in the basal sections of the tongue—called the hyoid horns—which are greatly elongated as they are in woodpeckers. The Sword-billed Hummingbird, which has the longest bill of all, has hyoid apparatus comparable to that of the longest-tongued of the woodpeckers, extending behind the jaw, over the back of the skull, between the eyes, and into the right nostril.

The edges of a hummingbird's tongue are rolled together to form two parallel tubes through which the nectar passes by capillary action, possibly assisted by pressure applied by the bird "squeezing in" the sides of its bill. The tongue fits snugly into the narrow gutter of the lower mandible, which in turn sits closely within the upper one, giving the false impression that the bill itself is a long, thin tube.

Many plants rely on nectar-feeders—whether birds or insects—for their reproduction and have adapted their flowers to give them the best possible chance of pollination; some by specializing, others by generalizing. Hummingbird-pollinated flowers are often markedly different from insect-pollinated flowers. Birds have better vision at the red end of the color spectrum, so plants that rely on them tend to have red flowers, whereas blue is the color to attract insects. Hummingbird species have a complex range of territorial and feeding strategies, and for every variation there is a flower to use it to its own advantage. The inevitable result of this continuing process is an ecological arms race in which both birds and plants are constantly competing and co-evolving—lengthening or curving of flower shapes, matched equally by lengthening or curving of hummingbird bills. There are also "nectar thieves," however, who simply nip a hole in the base of the flower and eat their fill without contributing a thing!

Hummingbirds are extremists, living at the very limit of their physical and physiological capabilities. Their small size, necessitated by their lifestyle, brings problems of heat loss, and their high metabolism demands a constant supply of energy-rich food. Their principal difficulty is storing sufficient energy to survive the night. Although many species prolong their hours of feeding to well after dusk, or before dawn, the critical factor is the drop in external temperature. But they have a survival mechanism. When energy levels fall below a certain threshold, most hummingbird species will automatically enter a state of torpor: their heart rate slows, and their temperature drops. They will remain in this comatose state until the morning's warmth revives them and they can zoom off in search of a "quick fix" of high-energy nectar.

The longer hours of daylight solve the problem of night survival for some northern species—at least in summer. But at the onset of winter they face a more challenging prospect: the migration south and the seemingly impossible one-thousand-kilometer nonstop flight across the Gulf of Mexico.

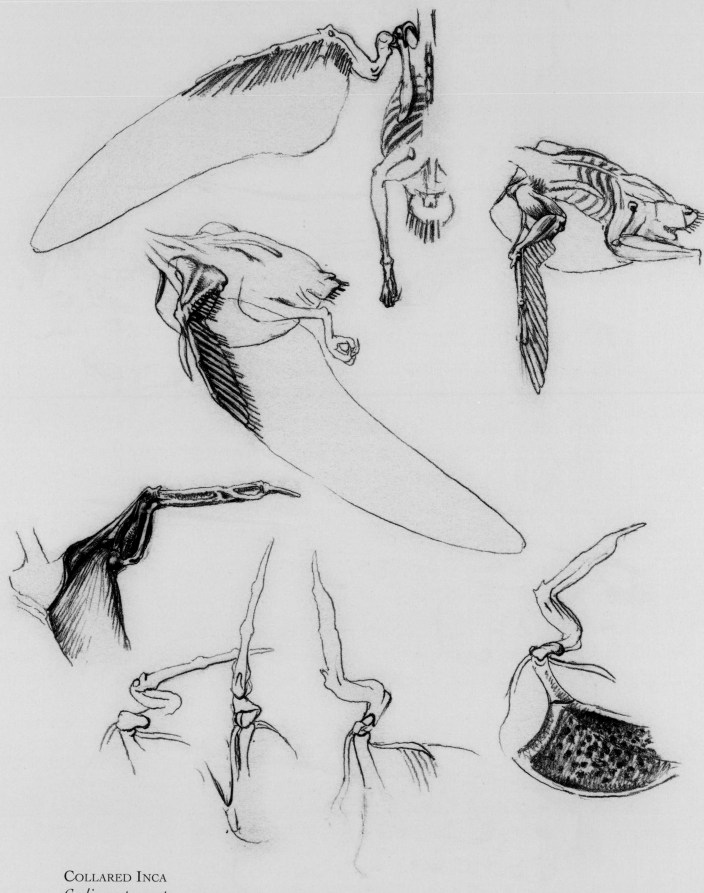

COLLARED INCA
Coeligena torquata
Skin and muscles removed in stages to show articulation of left wing with the pectoral girdle.

III ANSERES

Bill smooth, covered with a soft skin and broader at the point; *feet* formed for swimming; toes palmate, connected by a membrane; shanks short, compressed; *body* fat, downy; flesh mostly tough; *food* fish, frogs, aquatic plants, worms &c.; *nest* mostly on the ground; the *mother* takes but little care in providing for the young. They are frequently polygamous.

Linnaeus's description best fits the waterfowl—the ducks, geese, and swans—although his order grouped together everything with the combination of webbed feet and short legs.

Different bird groups have adapted to an aquatic existence independently of each other and thus have come to appear outwardly alike. We now know that the possession of shared features like these does not necessarily mean that birds are closely related. The skuas, gulls, and auks, for example, probably evolved far more recently than most other webbed-footed groups. Screamers—near cousins of the waterfowl—have feet that are unwebbed. And grebes —for many years included with the loons—are now thought to share a common ancestor with flamingos!

Despite having webbed feet, flamingos' long legs persuaded Linnaeus to classify them with the storks and spoonbills, while the lobed-footed grebes were "allowed in" under the loon umbrella.

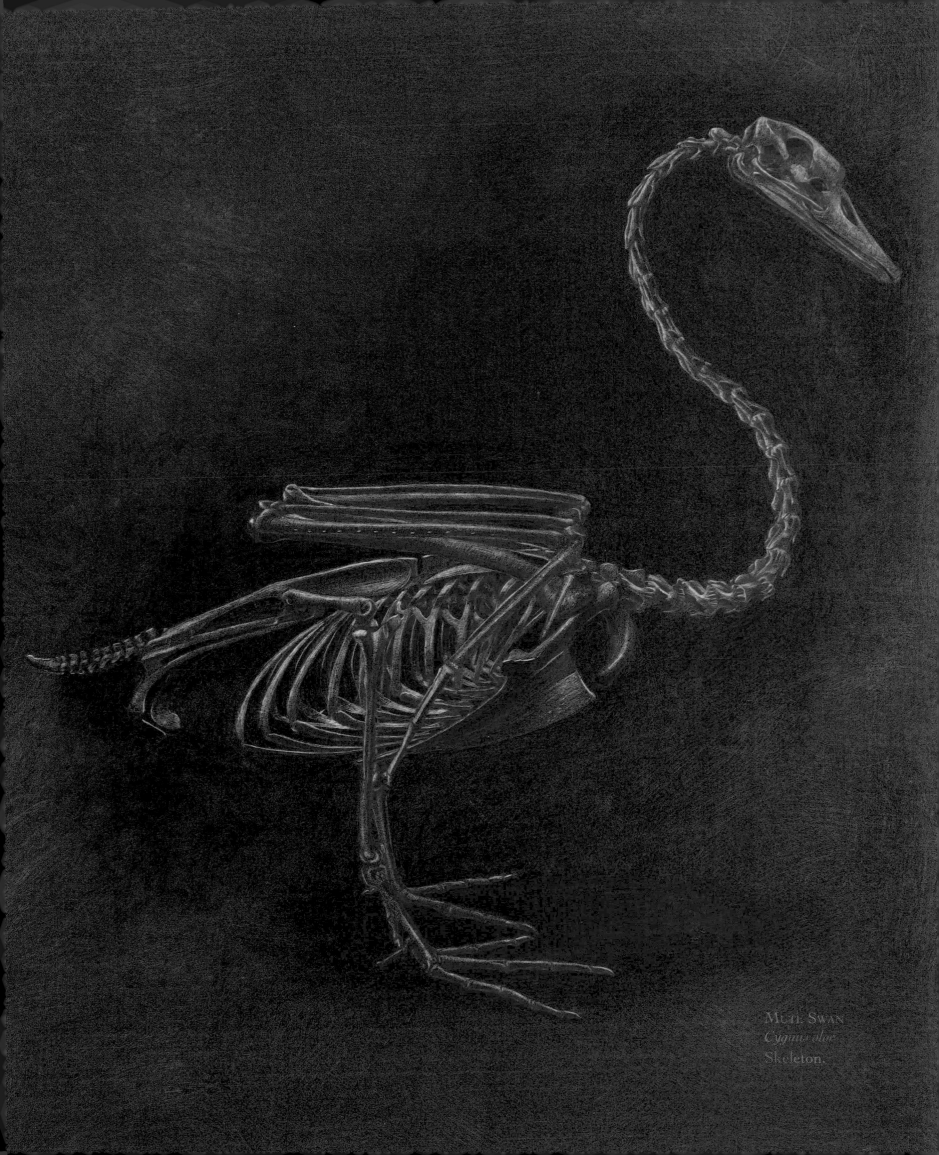

MUTE SWAN
Cygnus olor
Skeleton.

Waterfowl

The ducks, geese, and swans, collectively known as waterfowl or wildfowl, have, ever since Linnaeus's time, usually been lumped together by taxonomists into a single large family. However, there is obviously a huge difference between and within the three respective groups, so the family—Anatidae—has been further divided into subfamilies and tribes. There are nearly 150 species of waterfowl, but their nearest relatives— the screamers—number only three species. Nowadays these two, disproportionately sized families together make up the order Anseriformes.

All the waterfowl share the common traits of having a body well adapted for swimming, legs that are proficient for walking, and a long neck. But perhaps most important, they all have a soft leathery bill sheath that bears fine filtering apparatus along its inside edges, corresponding with spiny projections on a thick fleshy tongue. This basic blueprint has enabled the waterfowl to adapt to a bewildering array of subtly different niches around the globe in both fresh- and saltwater and has allowed similar species to coexist in the same habitat without direct competition.

Swans are unmistakable with their long neck and short legs. The widely curved, S-shaped neck allows the head to be lowered into the water from above to reach food items at the bottom, and in deeper water they will "up-end" to extend their reach farther. (Long-necked birds of tall grassland, such as cranes and ratites, raise and lower their head from below in order to keep a vigilant lookout for predators.)

In the majority of waterfowl species there is a bony resonating chamber called a "bulla" at the point where the windpipe divides to enter the lungs. This produces a sound when air is passed over it—rather like blowing over the top of a bottle—and is what gives many of the waterfowl their characteristic loud calls. In some of the more vocal swan species the windpipe is also greatly increased in length and makes several convolutions, like a tuba or a trumpet, deeply embedded within the bony tissue of the breastbone, before dividing. Swans are not the only birds to have an elongated windpipe; cranes and, more surprisingly, birds of paradise are dealt with elsewhere in this book.

Waterfowl legs are muscular and set well back for swimming. As in other water birds the feet are moved alternately on the surface and simultaneously during underwater dives. Not all ducks dive. Some—the surface-feeding or dabbling ducks such as Mallards and Shovelers—feed at the water's surface and, like swans, frequently "up-end" to reach food items in the shallows. The three forward-facing toes are webbed, and the hind toe is raised above the ground and shaped into a flattened lobe. Most diving ducks are foot propelled, keeping their wings firmly closed underwater and using their feet for both propulsion and steering, though "stifftail" ducks steer with their tail as cormorants and darters do. In most diving species the toes, particularly the outer toe, are elongated so as to maximize the surface area of webbing. Eiders have "normal-sized" feet but assist these with wing propulsion.

Although the body is ideally shaped for buoyancy, the waterfowl are not such specialized swimmers as the grebes and loons. For their mastery of the water they have sacrificed virtually all mobility on land. The waterfowl have retained the ability to move comfortably out of the water, but the combination of short legs and a broad body favored for efficient swimming means that ducks and swans nevertheless walk with a side-to-side waddle. Geese, however, have longer legs and are more terrestrial than ducks or swans, finding most of their food on land, and are correspondingly more adept there. The better the swimmer, the worse on land and in the air. So diving ducks, whose legs are shorter, farther back, and farther apart than those of surface-feeding ducks, walk with even greater difficulty and need a pattering run across the surface in order to take off. The latter, meanwhile, can spring vertically into the air with a minimum of effort and are agile and

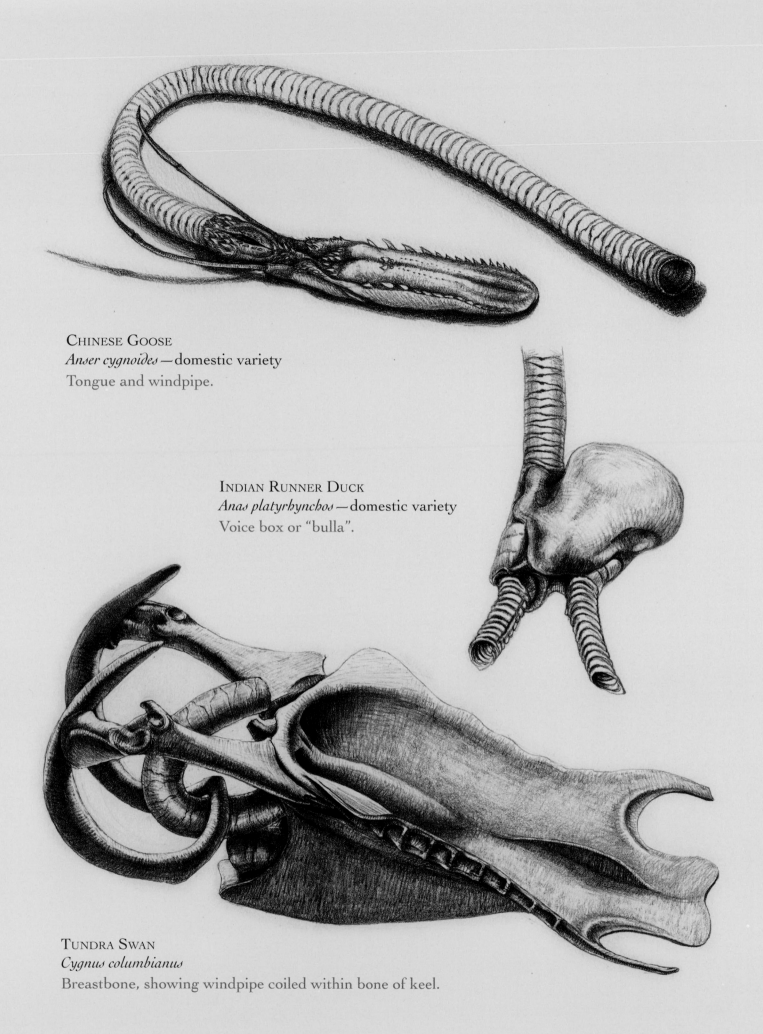

CHINESE GOOSE
Anser cygnoides—domestic variety
Tongue and windpipe.

INDIAN RUNNER DUCK
Anas platyrhynchos—domestic variety
Voice box or "bulla".

TUNDRA SWAN
Cygnus columbianus
Breastbone, showing windpipe coiled within bone of keel.

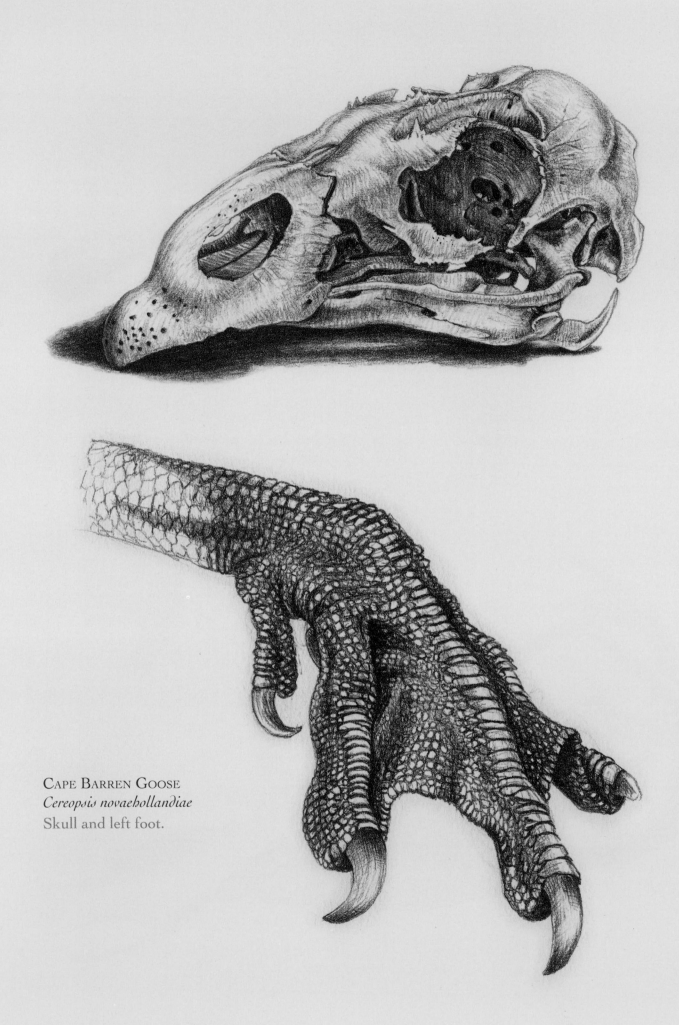

CAPE BARREN GOOSE
Cereopsis novaehollandiae
Skull and left foot.

BRENT GOOSE
Branta bernicla

CANADA GOOSE
Branta canadensis

Skulls.

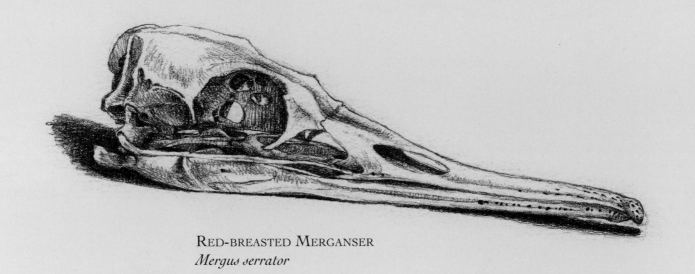

RED-BREASTED MERGANSER
Mergus serrator

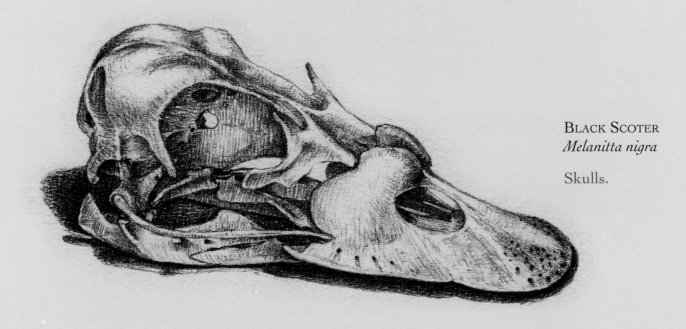

COMMON EIDER
Somateria mollissima

BLACK SCOTER
Melanitta nigra

Skulls.

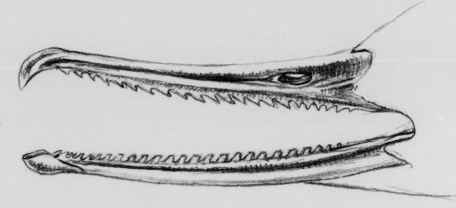

RED-BREASTED MERGANSER
Mergus serrator
Bill sheath.

COMMON GOLDENEYE
Bucephala clangula

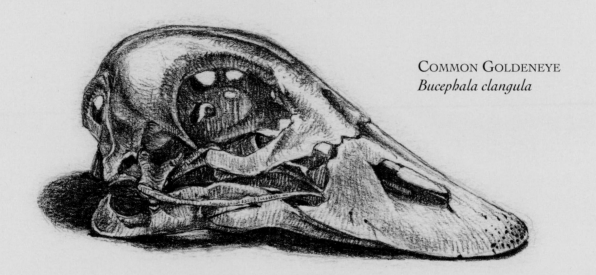

COMMON SHELDUCK
Tadorna tadorna
Skulls; and line drawing show-
ing front view of Shelduck bill.

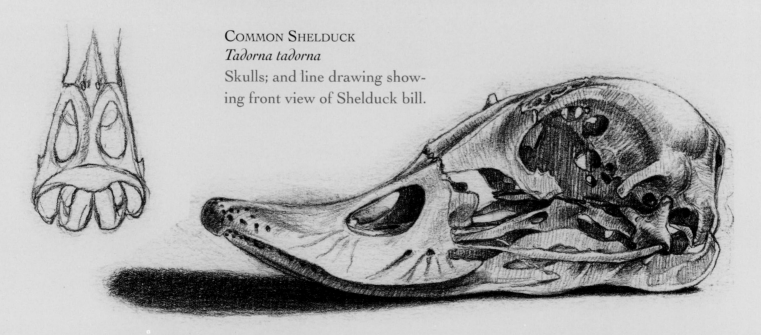

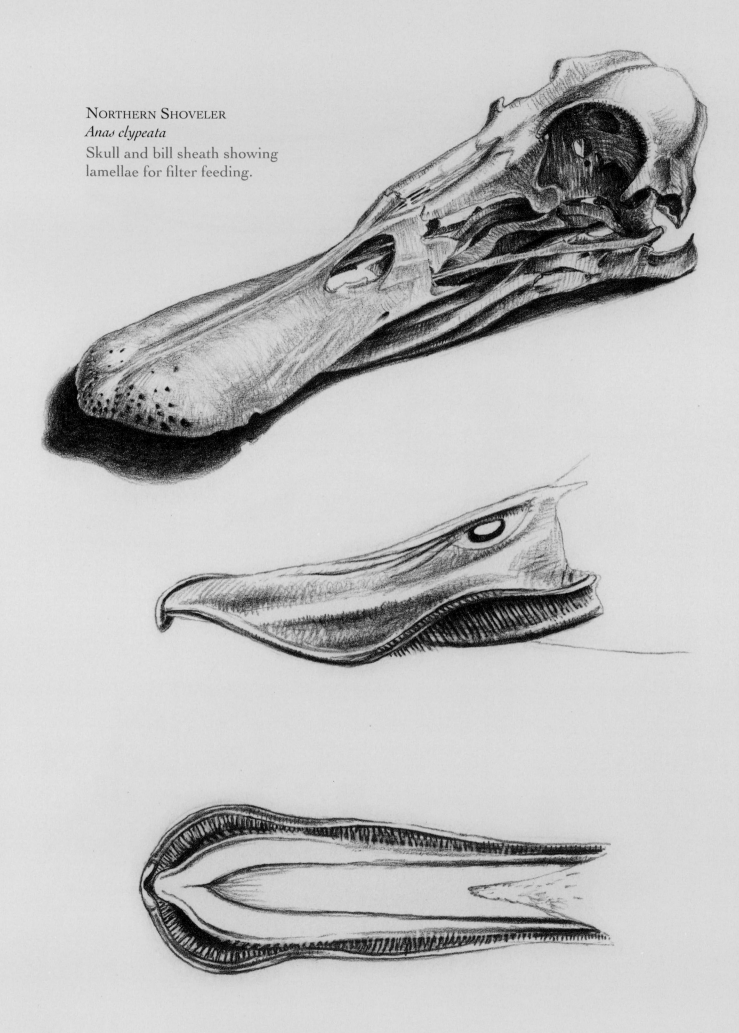

NORTHERN SHOVELER
Anas clypeata
Skull and bill sheath showing
lamellae for filter feeding.

maneuverable in flight. Ducks have small wings compared to their heavy body, so gliding and soaring are out of the question. However, their long, broad, and relatively deeply keeled breastbone can accommodate large flight muscles, and with rapid, direct wingbeats they prove themselves powerful fliers.

The basic principle for feeding in waterfowl is by pressing the tongue against the upper palate to suck in water or mud and ejecting it again through the sides of the bill. Tiny plants and organisms trapped in the comb-like filtering structures—called lamellae—are then swallowed. Dabbling ducks, with their long, flattened bill, excel at this feeding method. Shovelers in particular, whose lamellae are so fine as to be almost hair-like, can filter out even microscopic plankton. However, other waterfowl groups have adapted the lamellate bill structure to different ends. In the sawbills like the Red-breasted Merganser, the lamellae have taken on the form of tiny serrations resembling teeth, which they use to hold fish, and the bill itself is long and fine like that of a cormorant. Sea ducks, such as the goldeneyes, scoters, and eiders, feed chiefly on mollusks and other invertebrates. The large wedge-shaped bill of eiders is used predominantly to detach and open mussel shells. Common Shelducks feed exclusively on saltwater snails, which they find by dabbling in estuarine mud. Their bill tip is angled sharply upward like the end of an old shoe.

The bill of geese is less flattened than in ducks; it is more triangular shaped, but still with the soft, leathery covering and a horny nail at its end. The comb-like filtering apparatus—so characteristic of ducks and swans—is also present, but it is enlarged to resemble blunt teeth, perfect for clipping vegetation close to the ground. It works in harmony with the serrated edges of the muscular tongue to hold and tear off plant stems. Geese are mostly vegetarian, grazing on grassland and digging for roots and tubers in arable fields, but they also feed in the water and on aquatic animals on the shoreline. The species that are predominantly black in plumage, such as Canada and Brent Geese—of the genus *Branta*—tend to have finer, more pointed bills than the "gray geese" of the genus *Anser*.

The Cereopsis or Cape Barren Goose is an endemic Australian species and something of an anomaly. In appearance it bears a closer resemblance to the sheldgeese from South America than to the "true" geese, and its actual affinities are still under debate. Because of its preference for grazing on land rather than swimming, the toes are only partially webbed, and the birds have powerful claws to maintain a good grip as they clamber about on tussock grass and other rough ground. Cereopsis Geese are remarkable in their ability to inhabit areas far from a regular supply of freshwater, but like marine species such as eiders and other sea ducks, they manage to compensate by excreting excess salts from their body via the well-developed glands above the eye orbits.

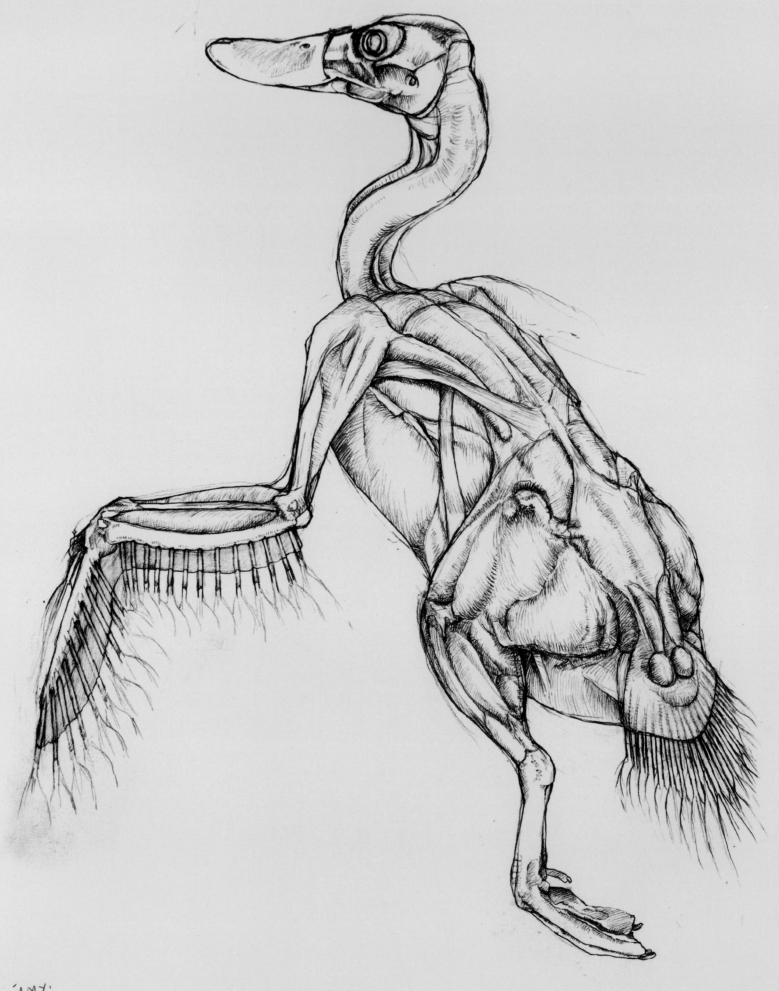

'AMY'

94

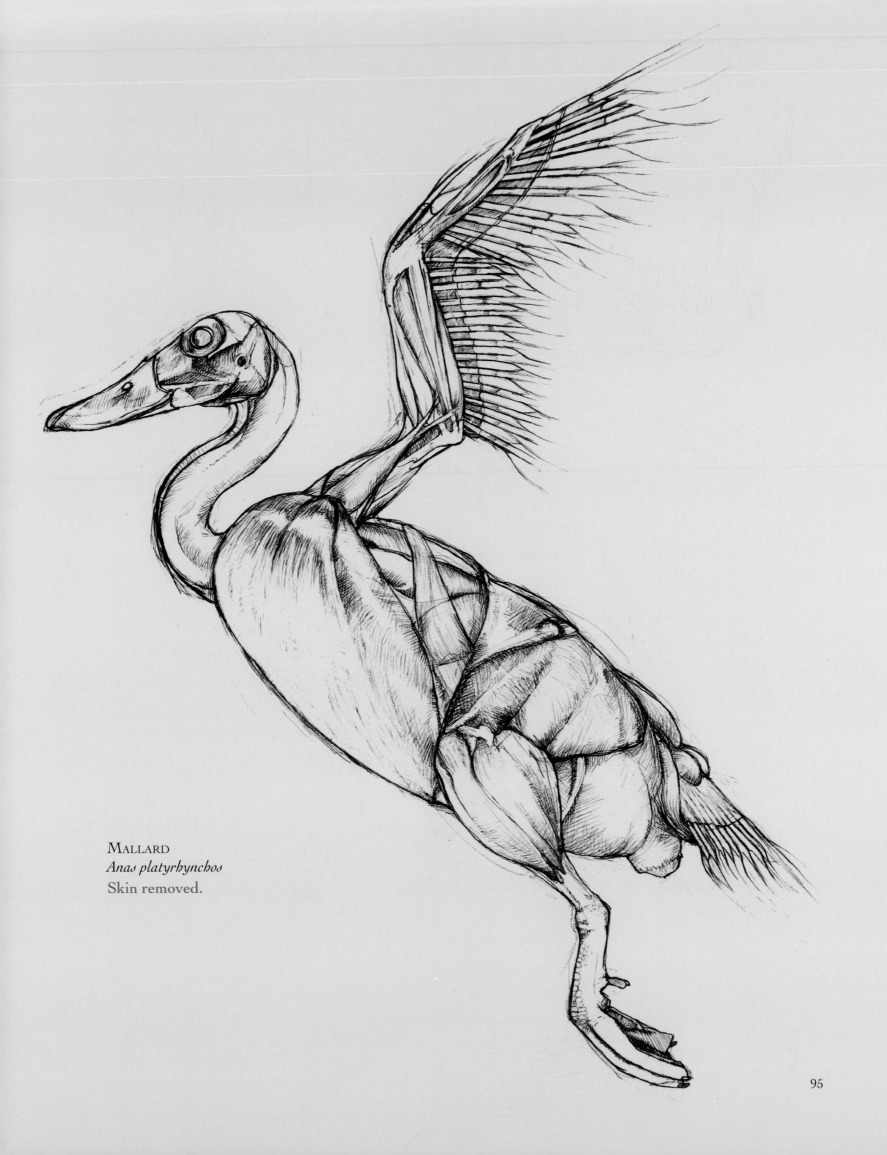

MALLARD
Anas platyrhynchos
Skin removed.

95

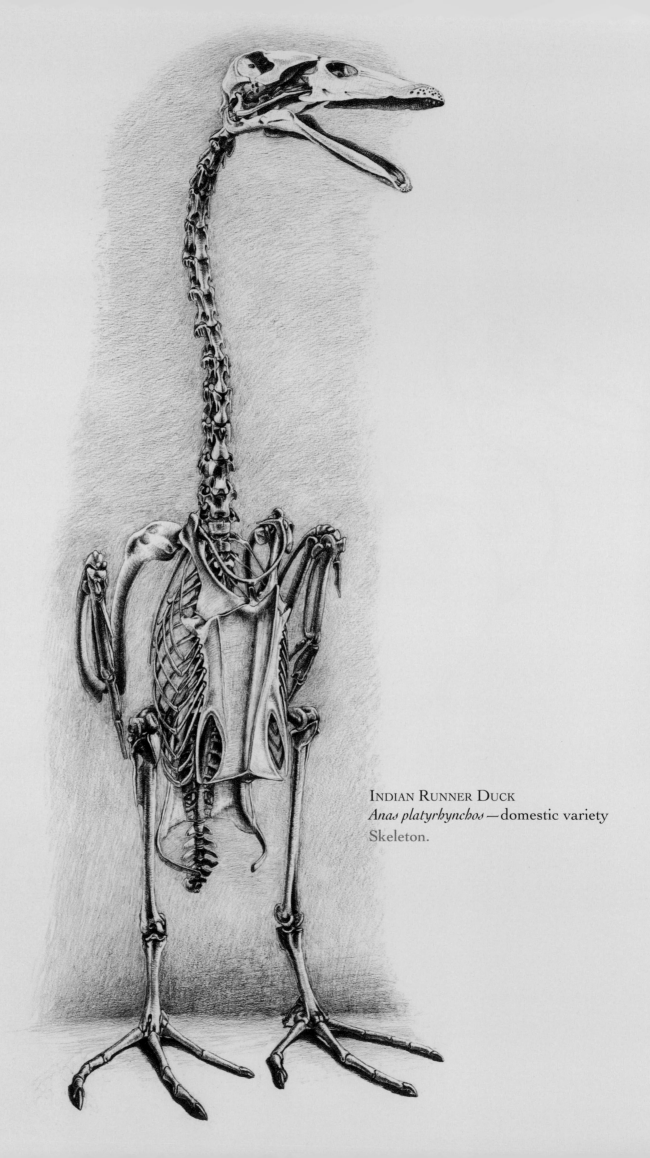

INDIAN RUNNER DUCK
Anas platyrhynchos —domestic variety
Skeleton.

96

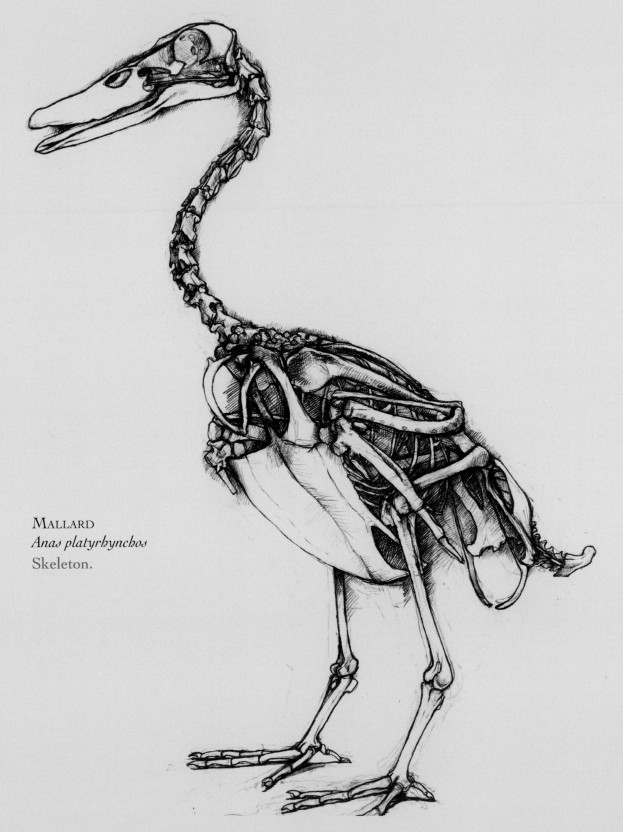

MALLARD
Anas platyrhynchos
Skeleton.

Domestic Waterfowl

Domesticated geese are unusual in having not one but two wild ancestors: the Greylag Goose from Central Europe and the Swan Goose from Central Asia. The Greylag has a thick-set, brownish-gray neck on which the feathering forms a rippled or grooved surface, and the bill is stout and powerful. The Swan Goose's neck is smooth in texture, long and slender like a swan's, and is two-tone with a darker brown upper surface and buff below. The bill also resembles a swan's, being longer and flatter than that of other goose species and with a slight knob at its base.

Some domestic goose varieties descend solely from one or other of their wild ancestors. The Tula Goose is an ancient Russian breed originally created for competitive fighting—like cock-fighting—by selective breeding from the largest-billed Greylag Geese. The result is a heavy bird with a broad, deep, slightly curved bill with which it holds its opponent while beating him vigorously with its wings. From Swan Geese, by comparison, we have the Chinese Goose—elegant and decorative; the slender, curved, swanlike neck and knobbed bill have been accentuated by man purely for aesthetic reasons.

However, most varieties carry genes of *both* wild species, which is why we see many birds with combinations of all the characteristics—bills of varying depth, grooved necks with a neck stripe, and knobbed foreheads— all mixed together.

With the exception of Muscovy Ducks, which are little changed from their wild counterparts, all domestic duck varieties are descended from the Mallard. One of the most remarkable is the Hook-billed Duck, a rare and ancient breed from The Netherlands but which probably originated from the Far East. Indian Runner Ducks stand erect like penguins and instead of waddling, as their name suggests, they run. They were first bred on the Indonesian Islands of Lombok, Java, and Bali, where they were walked—or rather run—to market and sold as egg-layers or for meat. Their name refers to these islands in the East Indies rather than to India. However, the first published record of these birds in Britain, an 1837 catalogue of animals kept in the London Zoo, Regent's Park, refers to them as: "Penguin ducks . . . a variety of the common duck remarkable for the resemblance which its attitude bears to that of a penguin."

Call Ducks, originally only a little smaller than a Mallard but with a loud and persistent voice, were used to attract wild ducks into decoys. Nowadays they are kept solely as ornamental birds, and their appearance is much changed. Diminutive, chubby-faced, and with a disproportionately short bill, they are nevertheless still very noisy!

Crested Ducks (not to be confused with the natural species of the same name) have a ridiculous-looking feathery pompom on their head. They, too, are an Old Dutch breed created for ornamental purposes and were frequently depicted in the paintings of Jan Steen and Melchior d'Hondecoeter in the seventeenth century. It would be easy to imagine that this pompom covers a bony protuberance as it does in the Crested Chicken, but the truth is rather more extraordinary. These ducks are selectively bred for a genetic defect—a hole in their skull. Not the hole where the neck is attached but an additional one, higher up. With the brain left exposed and vulnerable, fatty tissue is deposited around it as part of the body's defense system to protect the site of supposed injury. It's this fatty tissue, pushing upward beneath the skin, which gives the duck its cute-looking top knot. But the story is more sinister still. In an attempt to repair itself, the bone sometimes forms snake-like tendrils that grow outward into the fatty lump and even inward through the brain. (These are regarded as a show fault in modern exhibition birds and the judges give the pompoms a good feel to discover if they are present.) Not surprisingly, Crested ducks often suffer from poor coordination and seldom attain a great age.

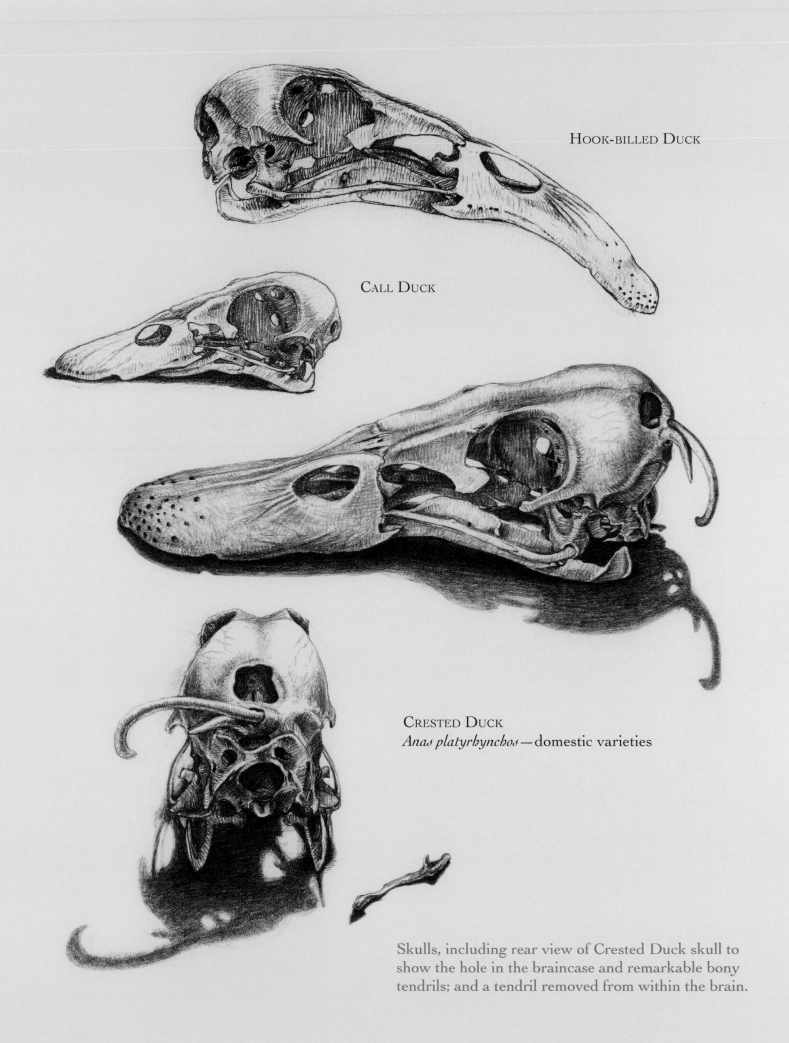

CALL DUCK

CRESTED DUCK
Anas platyrhynchos — domestic varieties

Skulls, including rear view of Crested Duck skull to show the hole in the braincase and remarkable bony tendrils; and a tendril removed from within the brain.

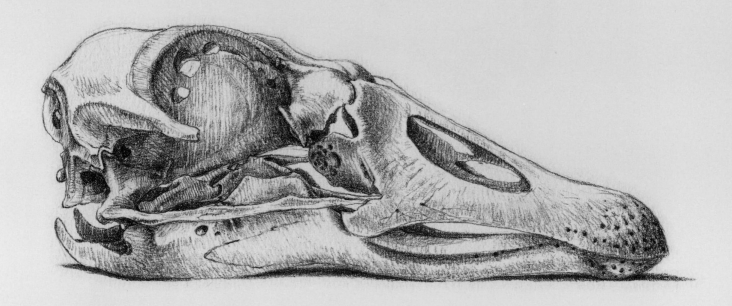

GREYLAG GOOSE
Anser anser

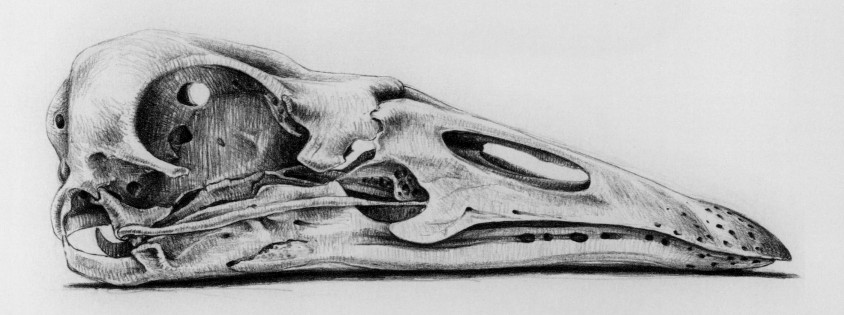

SWAN GOOSE
Anser cygnoïdes

Skulls.

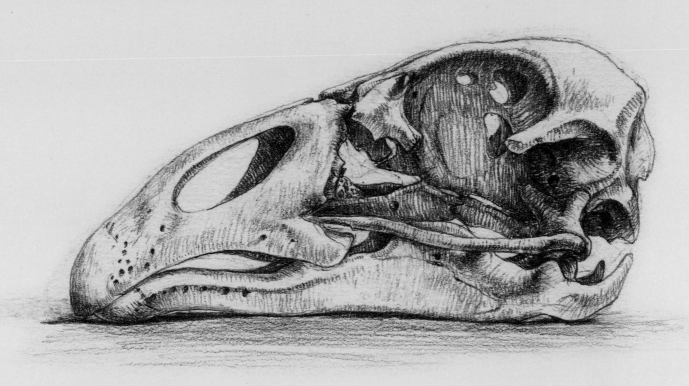

TULA GOOSE
Anser anser —domestic variety

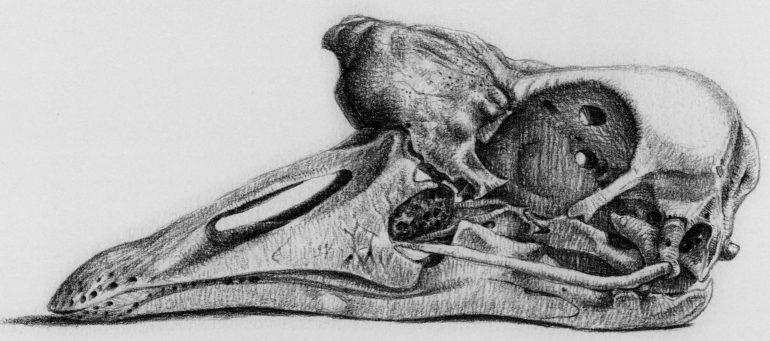

CHINESE GOOSE
Anser cygnoïdes —domestic variety

Skulls: purebred domestic varieties of the
natural species pictured opposite.

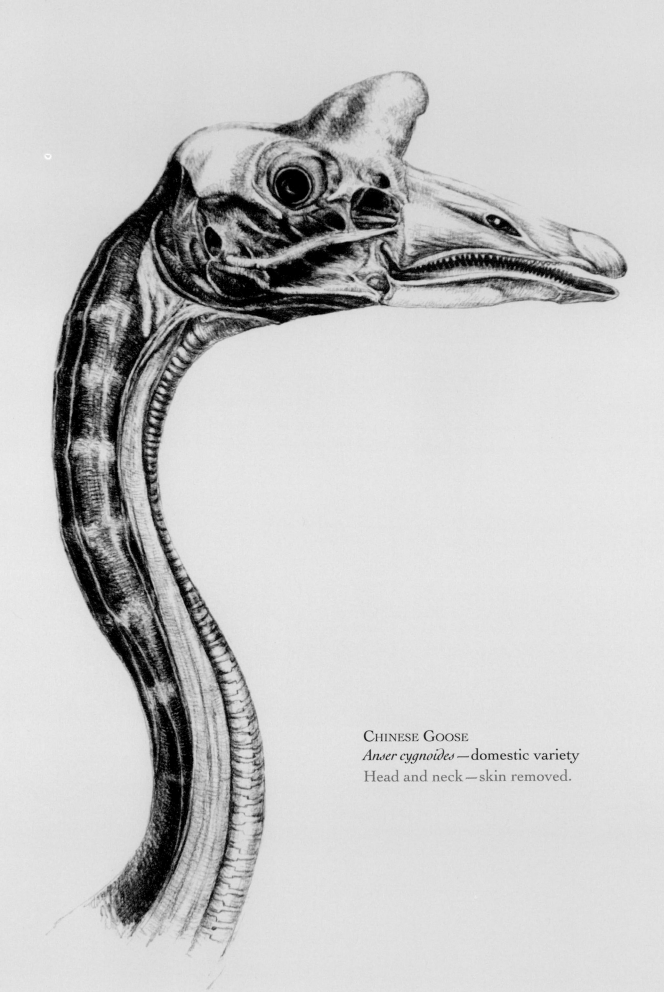

CHINESE GOOSE
Anser cygnoïdes —domestic variety
Head and neck —skin removed.

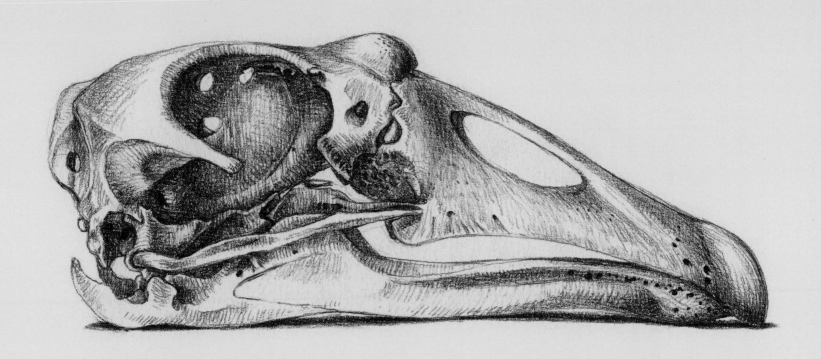

DOMESTICATED GOOSE HYBRIDS
Anser anser x *Anser cygnoides*
Skulls showing features of both domestic goose types.

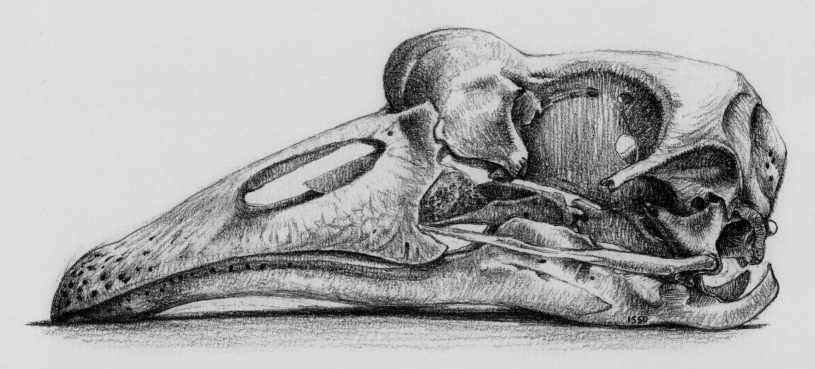

Penguins

Penguins are unmistakable and quite possibly the best known and best loved of all birds. With their smart "dinner jacket" markings, waddling walk, and upright stance they positively invite anthropomorphism. Part of their appeal is perhaps the temptation to sympathize with them, seeing them as mini-humans, unable to fly and making the best of a cold climate, instead of as the highly specialized seabirds that they are. It would take an objectively minded ornithologist, indeed, not to feel a *bit* sorry for male Emperor Penguins, which spend four months of the year without food, huddled together for warmth in the depths of the Antarctic winter.

However, pushing sentimentality aside, there is actually nothing to pity about penguins.

In order to understand penguins, it's necessary to take a look at their northern hemisphere counterparts, the auks—an entirely unrelated family, which is able to both swim underwater using their wings *and* fly. Now, flying and swimming make conflicting demands. Flying requires lightness and a large wing area, whereas the optimal conditions for swimming are increased body weight and, for wing-propelled birds, a small wing area. Long wings create turbulence and drag underwater, which is why auks, when they swim, do so with half-closed wings. Auk wings are as small as flight will allow, but even so, their dual purpose means that their effectiveness at both swimming and flying is compromised.

It's no coincidence that the largest of the flying auks—the Guillemot—is about the same size as the smallest of the penguins. Guillemots are the maximum size possible for a bird whose wings are able to thus multitask; any larger and the wrist joint would simply not have sufficient strength to propel the bird underwater. The ancestors of penguins were able to fly and were probably about the same size as a guillemot or smaller; similar to a modern auk or diving petrel.

In an environment free from terrestrial predators there is little selective advantage in retaining the powers of flight. Once relieved of these constraints, the ancestral penguin was able to develop the perfect physique for its underwater environment, exclusively and without compromise. And this included attaining a larger size. Indeed fossil remains have revealed a penguin that would have stood nearly as tall as a man.

It takes little more effort to propel a large streamlined body underwater than a small one, so body size was able to develop independently of wing size, leaving penguins with wings often disproportionately small. Meanwhile, wing *area* was able to decrease. The long primary and secondary feathers necessary for flight play no part in underwater locomotion and merely hamper a bird's progress. Penguins have neither, leaving them with a wing area that is small and narrow—ideal for swimming. The bone structure of the wing has also undergone radical modification to become the flipper-like front limb of a modern penguin. The alula—equivalent to a human thumb and used to prevent stalling in flight—has been discarded, while the remaining wing bones are flattened to form a rigid blade with a razor-like leading edge offering no resistance to the water. The joints of the elbow, wrist, and hand are virtually immovable, increasing the wing's strength as a paddle, so virtually all mobility is from the shoulder. The shoulder blades are correspondingly enormous for a bird; broad and rounded to support the tremendous musculature required to assist with the raising of the wing. This is unusual in birds: in air, the upstroke of the wing is merely the recovery stroke and does little to push the bird along and in most birds the raising and lowering of the wing is powered by muscles not on the back but on the breastbone, one overlying the other. In water, however, both the upstroke and the downstroke provide forward momentum. This means that the wings of penguins need all the muscle power they can get—from their shoulders *and* their breast. The breast muscles of penguins are correspondingly well

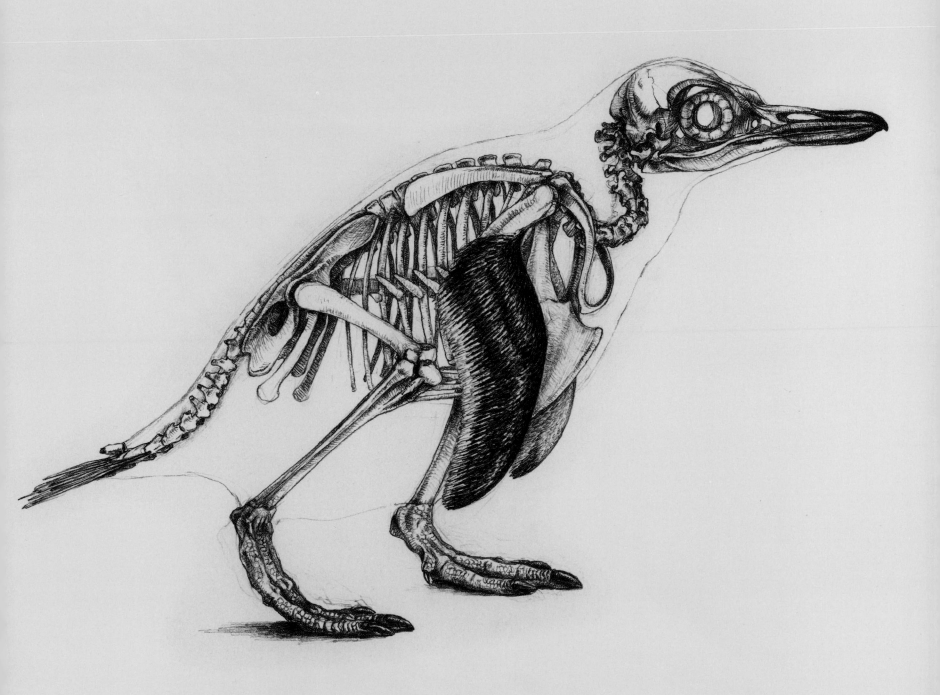

LITTLE PENGUIN
Eudyptula minor
Skeleton, with skin of wings and feet intact,
and tail feathers and preen gland left attached.

GENTOO PENGUIN
Pygoscelis papua
Skin removed.

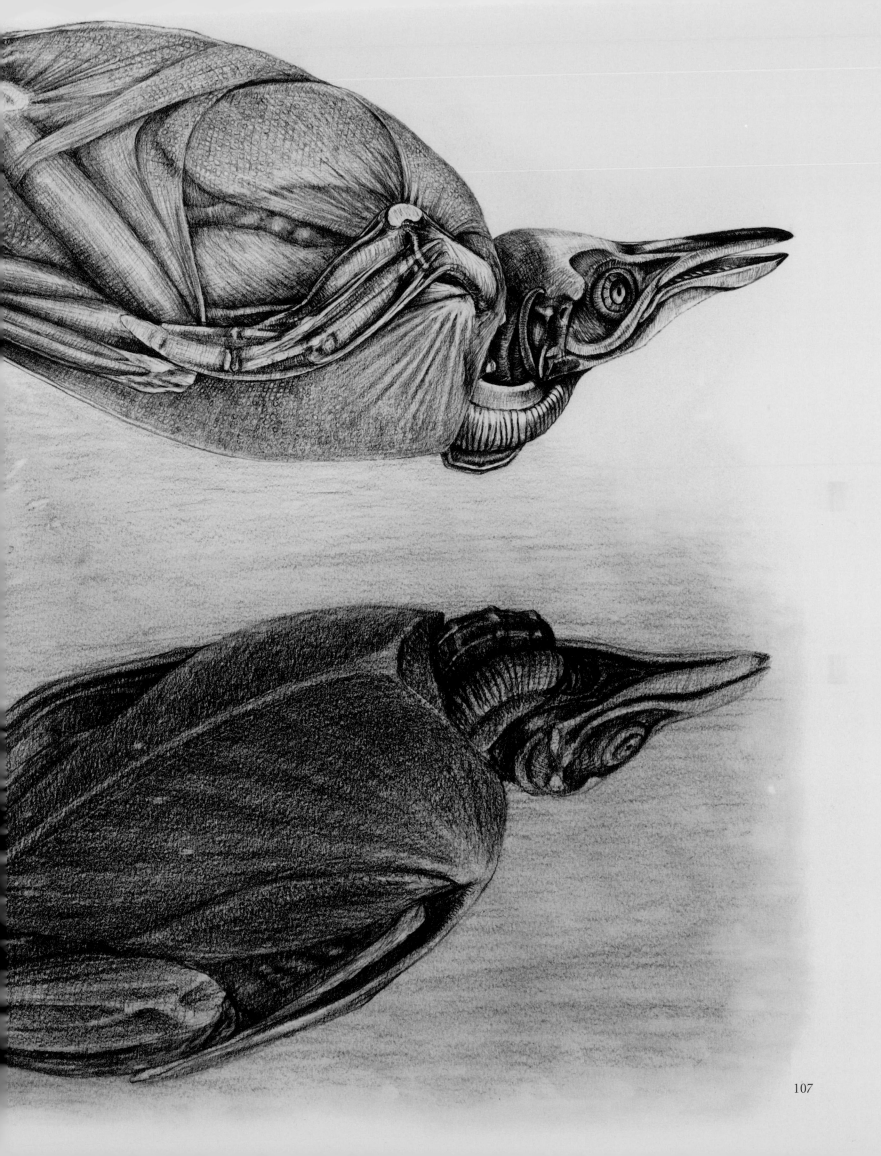

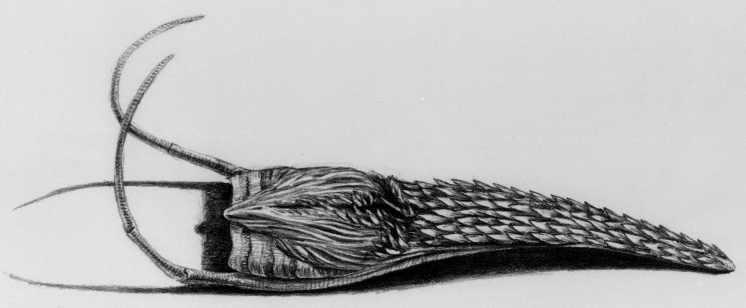

GENTOO PENGUIN
Pygoscelis papua
Tongue.

developed, and the keeled breastbone is therefore no less substantial than that of any flying bird. Beneath the water penguins move almost effortlessly and with astonishing grace and agility. But they do need to come up to breathe, of course, and to navigate their surroundings. On the water's surface their progress is rather more labored. So, if they have any distance to cover, penguins will travel by "porpoising"—leaping in and out of the water and allowing their momentum to carry them briskly along their undulating path.

Penguins steer with their feet and tail. The tailbone—or fusion of bones—is particularly long and tapers to a point, and the tail feathers, although narrow, are long and stiff.

The legs are positioned well back on the body, which gives penguins their upright stance. Although the tibia is long, the tarsus is uniquely short and broad, as it is in the feet of mammals. Although they walk only on their toes as other birds do, penguins will often rest with their whole foot in contact with the ground or on their heels. The hind toe is tiny and vestigial.

From their waddling gait it's easy to assume that penguins move with difficulty on land. In fact they are prodigious walkers and climbers. They can also jump remarkably well (and toboggan along on their belly!). They have strong claws for clinging to slippery, wave-washed rocks and may traverse formidable physical barriers between their colony and the sea each day.

The most southerly species face a different set of problems. Adelie Penguins have only a small window of time in which to breed before the encroaching pack ice cuts off access to the sea. Penguins need to be on land, or at least on reliably stable pack ice, to breed and molt. So they begin early, walking many miles before the previous year's pack ice has yet broken up to reach their colony in time for early spring.

Penguins have a thick layer of fat beneath the skin, which provides insulation against the cold and sustains them during the periods of molt and incubation when they are not able to enter the water to feed. It also streamlines the body, giving the birds their short-necked appearance, though the neck is, in actuality, rather long. The feathers are tiny and scale-like, with a thick layer of down at their base. Unlike those of the majority of birds, the feathers of penguins are packed densely over the entire body's surface and not arranged in tracts. This reduces the amount of air trapped beneath them, making the bird less buoyant in the water.

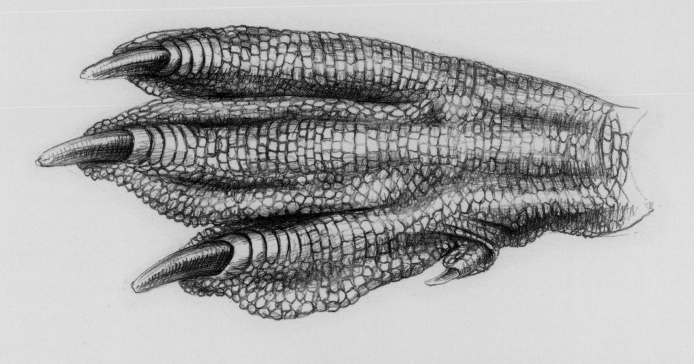

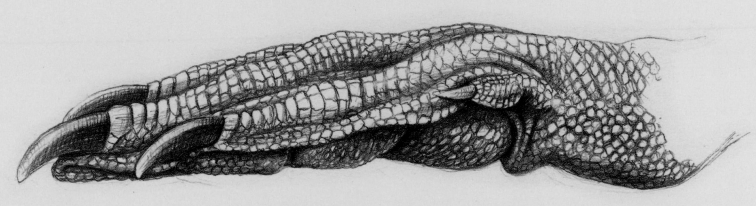

GENTOO PENGUIN
Pygoscelis papua
Right foot.

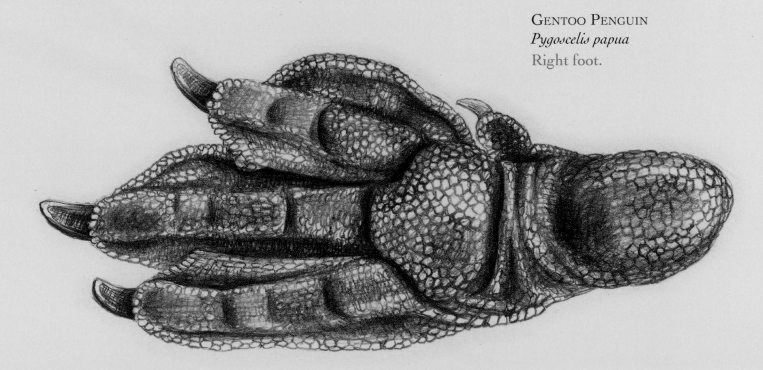

Buoyancy is a major problem for diving birds as it uses valuable energy reserves to remain submerged against the laws of physics. Birds that have lost the power of flight, however, are able to employ strategies for negative buoyancy that would not be viable for a flying bird: large, solid bones without air spaces, and no air sacs except their lungs for breathing. Penguins breathe out before diving and flatten their feathers to push out excess air. They have evolved several physiological adaptations, however, to counteract the problems of respiration during their extended periods underwater.

By no means do all penguins live in polar conditions. Galapagos Penguins are slap bang on the Equator, and most other species are found between the Antarctic Circle and Tropic of Capricorn. Keeping cool actually poses as much of a problem as staying warm, and many of the features evolved for insulation and remaining submerged have a negative effect for thermoregulation while the penguin is inactive on land. Penguins counteract this by using the upper surface of their feet and inner surface of their wings as radiators, lifting them to allow the air to cool them in the same way that an elephant uses its ears. Warm-climate species tend to have somewhat larger wings to facilitate this. They also lose heat from their face and bill, which explains the tendency for the most southerly species to have a narrower bill and more feathered face, while farther north the bill is deep, and the face is often bare.

Only the Adelie Penguin and the Emperor Penguin inhabit the Antarctic continent itself. Whereas Adelies cram breeding into the short Antarctic summer, Emperor Penguin males incubate their single egg throughout the winter, huddled together in tightly packed colonies against the cold. As their egg is balanced on top of their feet, beneath a flap of skin, they are able to shuffle about and change position, so the outermost ranks, most exposed to the cold, are constantly -changing.

The females spend the winter at sea, arriving at the colony to relieve the males just as the eggs are hatching. Although this appears to be a most unreasonable

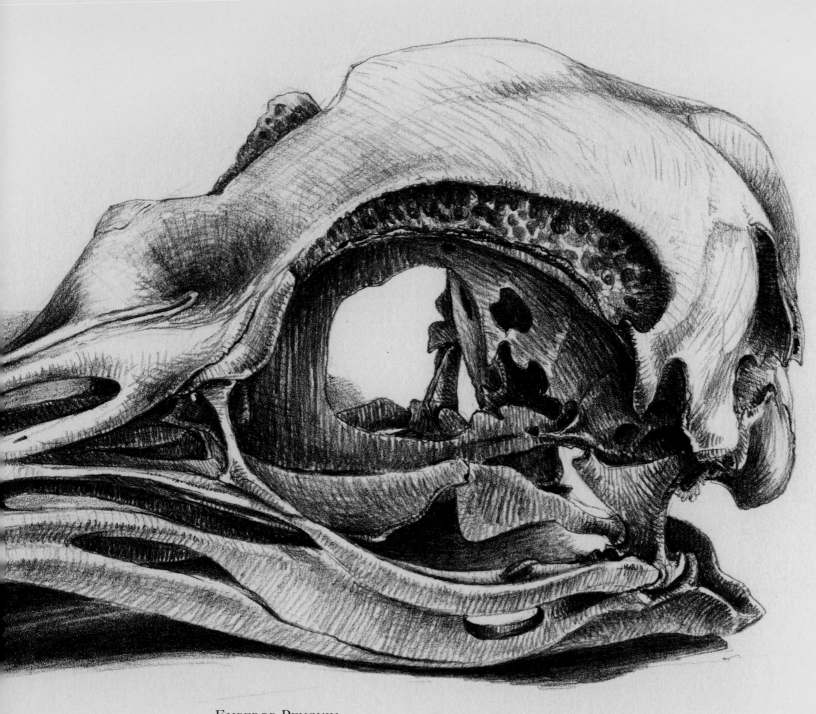

EMPEROR PENGUIN
Aptenodytes forsteri
Skull.

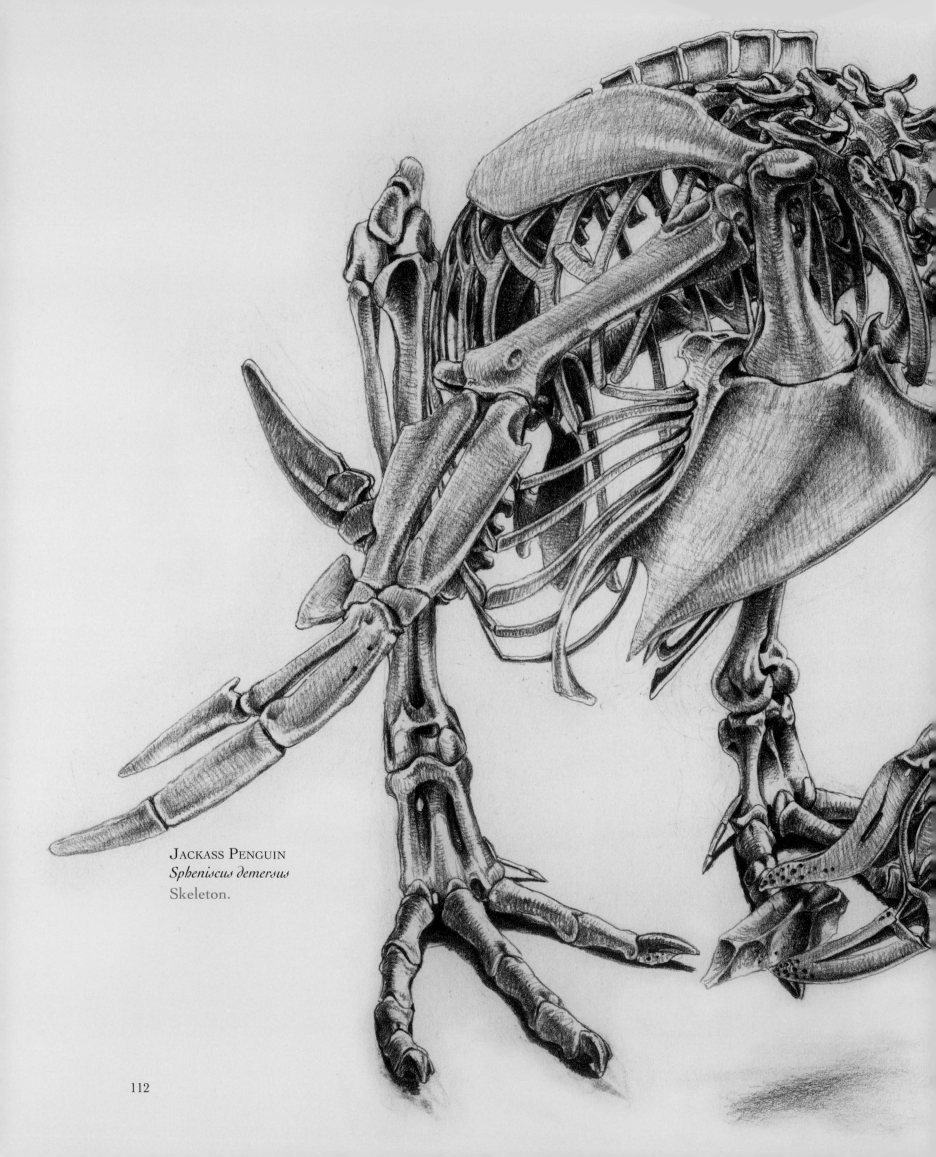

JACKASS PENGUIN
Spheniscus demersus
Skeleton.

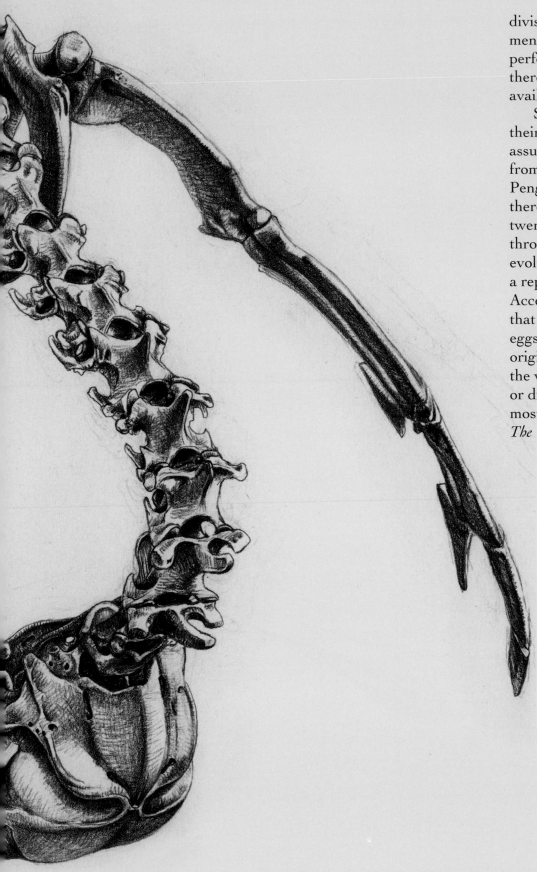

division of labor, it is the optimal arrangement for Emperor Penguins and timed to perfection so that the chicks fledge when there is access to the sea and plenty of food available.

So perfectly are penguins adapted to their nonaerial lifestyle that they were long assumed to be primitive birds, descended from flightless ancestors—with Emperor Penguins the most primitive of all. Now there was a theory, popular in the early twentieth century, that an embryo passes through each of the stages of vertebrate evolution—resembling a fish, an amphibian, a reptile, and so on—in turn, as it develops. According to this theory it was expected that an examination of Emperor Penguin eggs would yield vital information about the origin of birds. Three men's epic journey, in the winter of 1910, to collect eggs to prove, or disprove, this theory is told in one of the most awe-inspiring travel books of all time, *The Worst Journey in the World*.

Loons

With their long, boat-shaped body and powerful legs set well back, loons are supremely adapted to their aquatic lifestyle. Their entire life is spent on or under the water. They come ashore only to breed, and as the nest is situated right next to the water's edge, they rarely need to walk and can get to and from their nest perfectly well by shuffling along on their belly. So they have traded their mobility on land for supreme dominion over the water.

Loons are foot-propelled diving birds, seldom if ever opening their wings underwater, so the feet provide all the propulsive force necessary for fast and agile movement through their watery environment. Their legs are truly remarkable and built for maximum strength. They are situated more on the sides of the body than underneath it and too far back to enable the bird to stand.

The thigh bone is short and thick and is curved backward in an arc while the long bone of the tibia, the lower leg, has a thick ridge running partway up its leading edge. This ends in an immense forward-pointing bony projection like a spearhead at the knee for the attachment of muscles needed to power the feet. The entire leg is enclosed within the tissues of the trunk, virtually down to the ankle joint, with only the foot section free. This adds even greater width to the body and gives it increased stability in the water. The pelvis is long and narrow and has a razor-thin upper edge. The side processes of the pelvis, called the pubic bones, have enlarged ends to provide greater surface area for muscle attachment.

The three forward-facing toes are webbed—not lobed as they are in grebes. The toes, particularly the outer toe, are long to provide the maximum surface area of webbing to power the bird through the water, but the leading edge of the tarsi and toes is flattened to offer the least resistance as the feet are brought forward

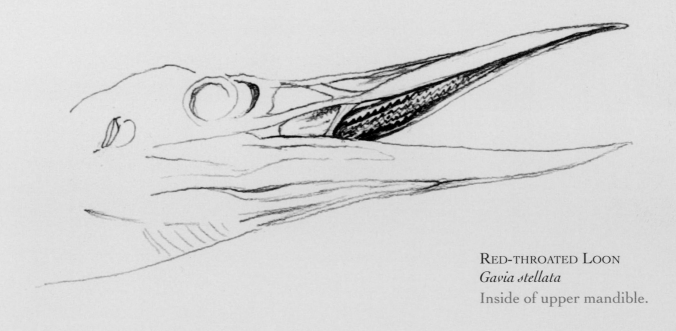

RED-THROATED LOON
Gavia stellata
Inside of upper mandible.

114

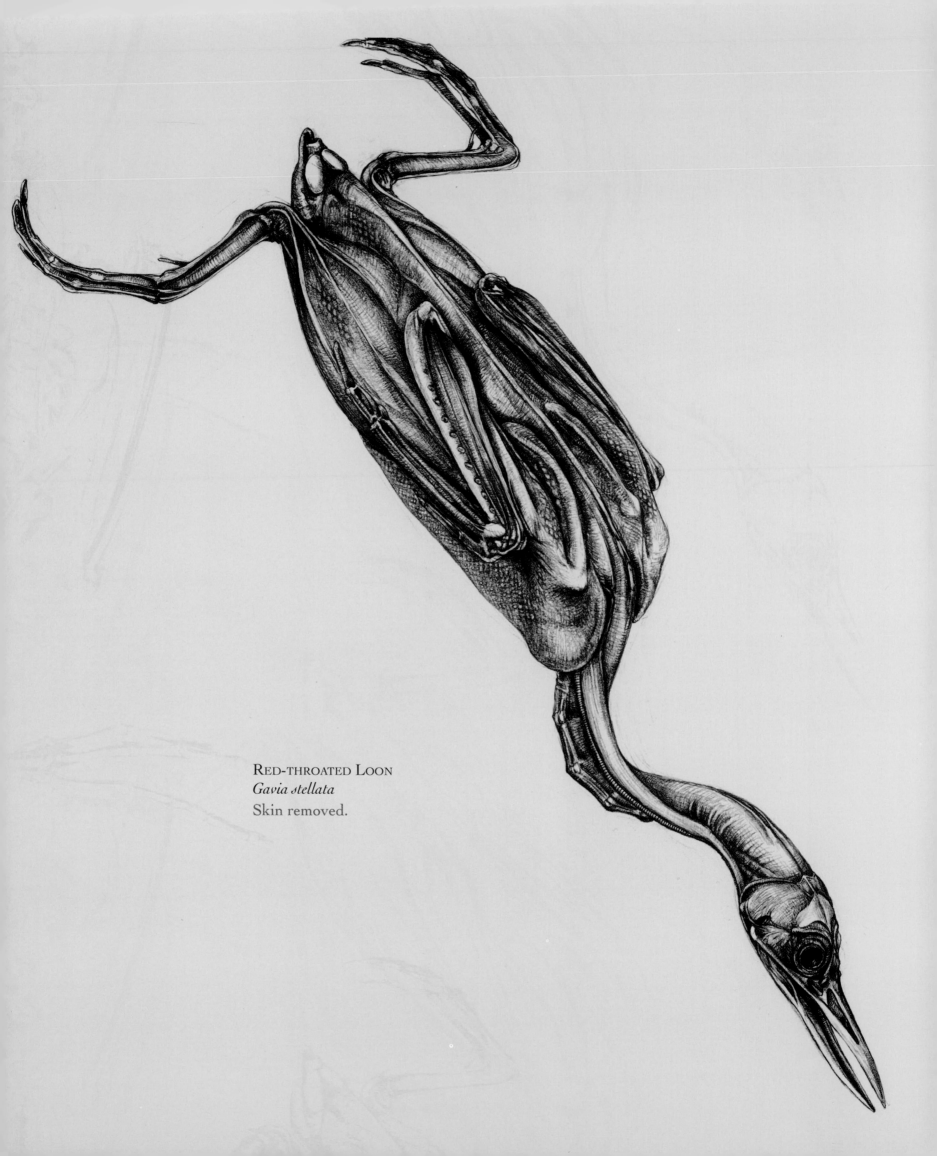

RED-THROATED LOON
Gavia stellata
Skin removed.

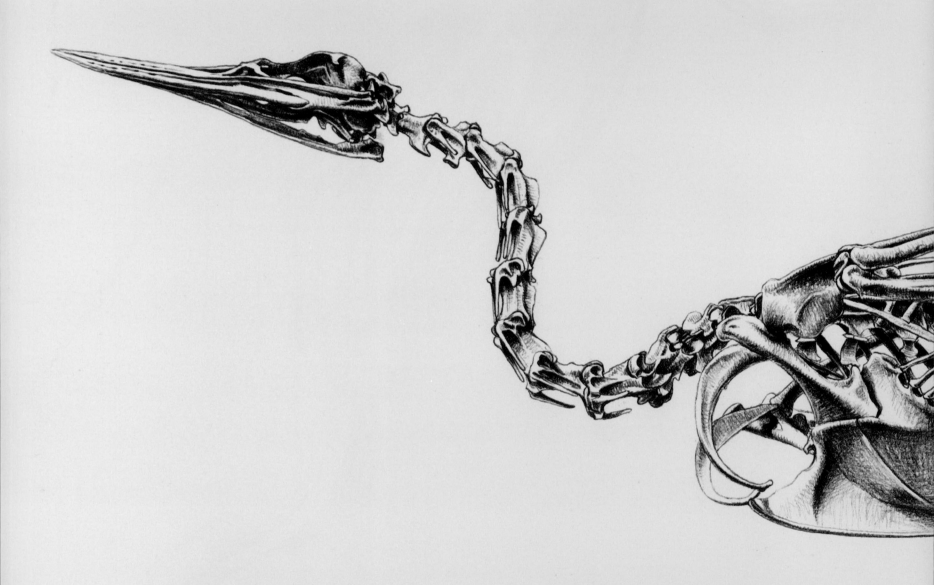

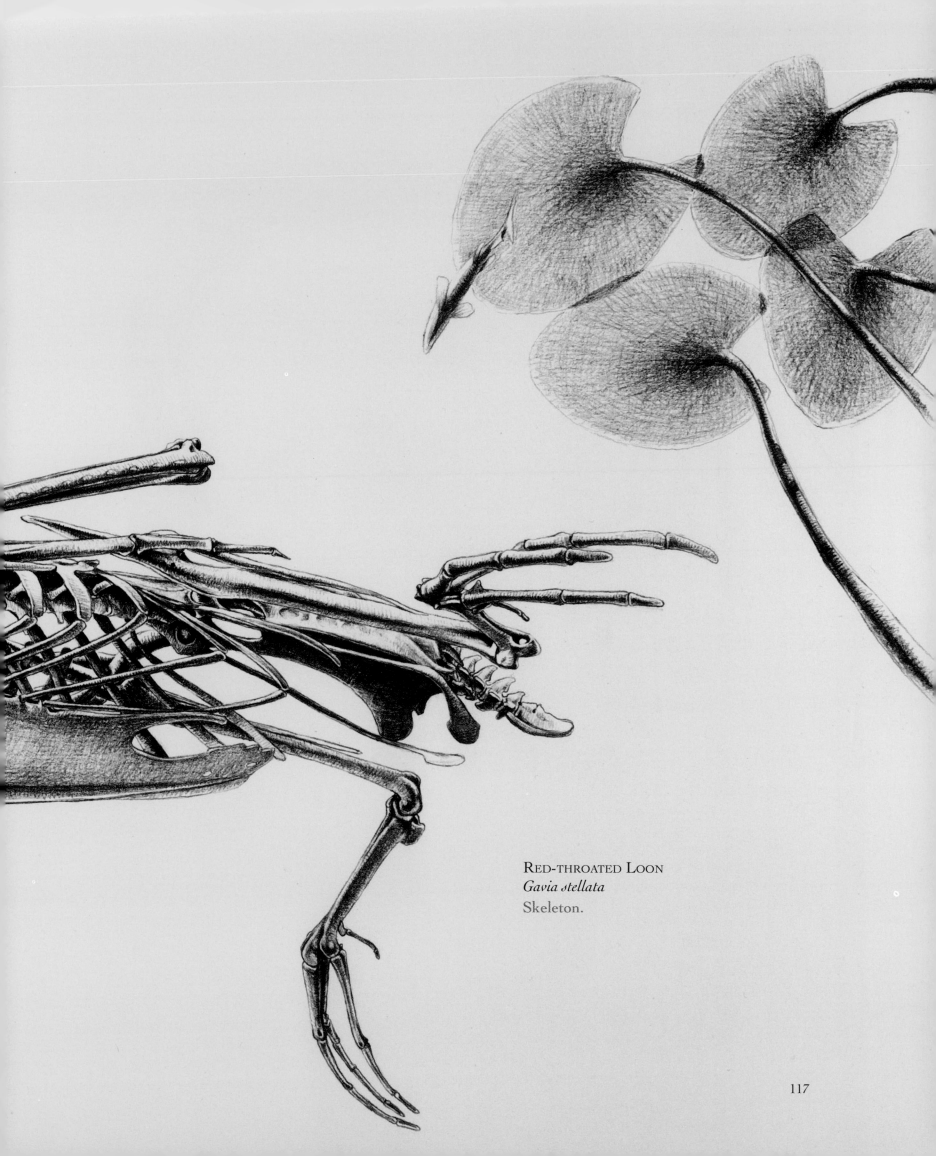

RED-THROATED LOON
Gavia stellata
Skeleton.

117

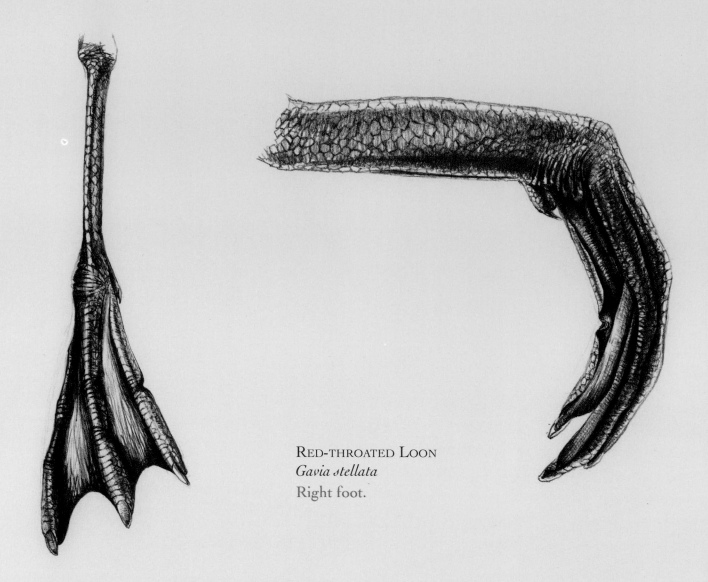

RED-THROATED LOON
Gavia stellata
Right foot.

on the recovery stroke. The feet, like the plumage, are countershaded—dark on their upper side and pale below. This is a common theme in aquatic animals, providing camouflage from above and beneath the water.

The feet serve as the rudder as well as the propellers; the tail is very small and plays no part in steering as it does in cormorants, darters, and "stifftail" ducks.

The relatively small head perched at the end of the long, thick neck gives the bird a primitive, snake-like appearance, accentuated in Red-throated Loons by the upward-angled bill, which may give the bird a greater field of view below. The neck vertebrae are furnished with long bony projections for the attachment of the muscles needed to seize and hold struggling prey. The bill has no hook at its end; instead, backward-pointing spines on the tongue and upper palate prevent the fish from escaping.

Loons swim low, with the water sometimes covering part of their back—so low on occasion that only the top of their head can be seen protruding like a submarine's periscope, a habit they share with darters and grebes. Remaining underwater for long periods uses considerable energy. Birds are naturally buoyant as their bones contain air spaces as an adaptation for flight. But loons, grebes, penguins, and darters have the densest bones of all birds to reduce buoyancy to a minimum. They dive with scarcely a ripple, disappearing without a trace only to reappear, after a minute or more, a great distance away, so that one wonders whether it can possibly be the same bird.

Grebes

Grebes and loons occupy similar niches and bear a very close resemblance to one another. Both are foot-propelled diving birds par excellence, with legs situated far back on their body; both swim low in the water and have a rather small head, a long neck, and a sharply pointed bill. So it's not surprising that taxonomists have long been in controversy over whether they are indeed closely related or whether their similarities are the result of their shared lifestyle—a process called convergent evolution. Linnaeus thought them sufficiently alike to place them in the same group, though it is probable that they originated from entirely different backgrounds: loons sharing a common ancestor with penguins and petrels, and grebes descending from rail-like birds that may have walked or swum through wetland vegetation. DNA evidence suggests that grebes may even share a common ancestor with flamingos.

The principal difference between the two groups is that while loons' forward-facing toes are webbed, the toes of grebes are expanded into large, flattened lobes, webbed just at their base. But lobed feet are certainly not "poor man's webbed feet." They engage a different mechanism for propulsion and, if anything, offer even greater maneuverability and control—especially through underwater foliage. Unlike webbed toes, which can only be opened and closed, lobed toes can be rotated individually to manipulate the passage of water through them, keeping drag to a minimum while maximizing the propelling force. The most specialized of all foot-propelled water birds, grebes are the ultimate bathroom toy.

Grebes' legs are positioned, like those of loons, far back on the body and more at the sides than underneath. They also have a surprising degree of rotational movement. Grebes, especially the smaller species, frequently feed while stationary, picking off invertebrates from underwater plants. Although this appears effortless, the bird's legs meanwhile are working hard to maintain this position, waving rather comically above and below the body in a sort of underwater equivalent of hovering. Like other diving birds, grebes use their legs simultaneously while underwater and alternately at the surface, though they are used independently of one another during slow underwater foraging maneuvers. The trailing edge bears a bizarre row of serrations that may be used to help the bird force its way through vegetation.

Grebes and loons differ also in their diving behavior: whereas loons seem to evaporate from the water's surface with scarcely a ripple, grebes do a little surface dive and disappear with a "plop," which gives them a steeper angle of descent. Like loons and darters, they are able to swim underwater with just their head showing and may also swim along at the surface with their head submerged. Their bones have fewer air spaces than those of most other birds and before diving they squeeze the air out of their dense plumage to keep buoyancy to a minimum. They have well-developed preen glands which, surprisingly, secrete a substance composed mostly of paraffin!

Grebes have virtually no tail so their legs appear to be almost at the very back of the body, like an outboard motor. Indeed, this has earned them the dubious honor of the description "bum-foot" preserved in the scientific name of *Podiceps*. Like loons, they steer underwater entirely with their feet and may even use them, in lieu of a tail, to steer while flying.

The breastbone is much shorter than the loons'. The back vertebrae are fused together to form a stout rod, but any rigidity in the body is amply compensated by their extraordinarily long, thin neck. The pelvis has long side projections, called pubic bones, and is slender and blade-like; this is particularly so in the larger species, which tend to be more active underwater—pursuing fish rather than seeking out invertebrates. The thighs are short and curved to maximize power to the legs. Grebes, like loons, have an elongated crest of bone that protrudes from the lower leg at the knee, but grebes have an additional spike-like "knee cap"

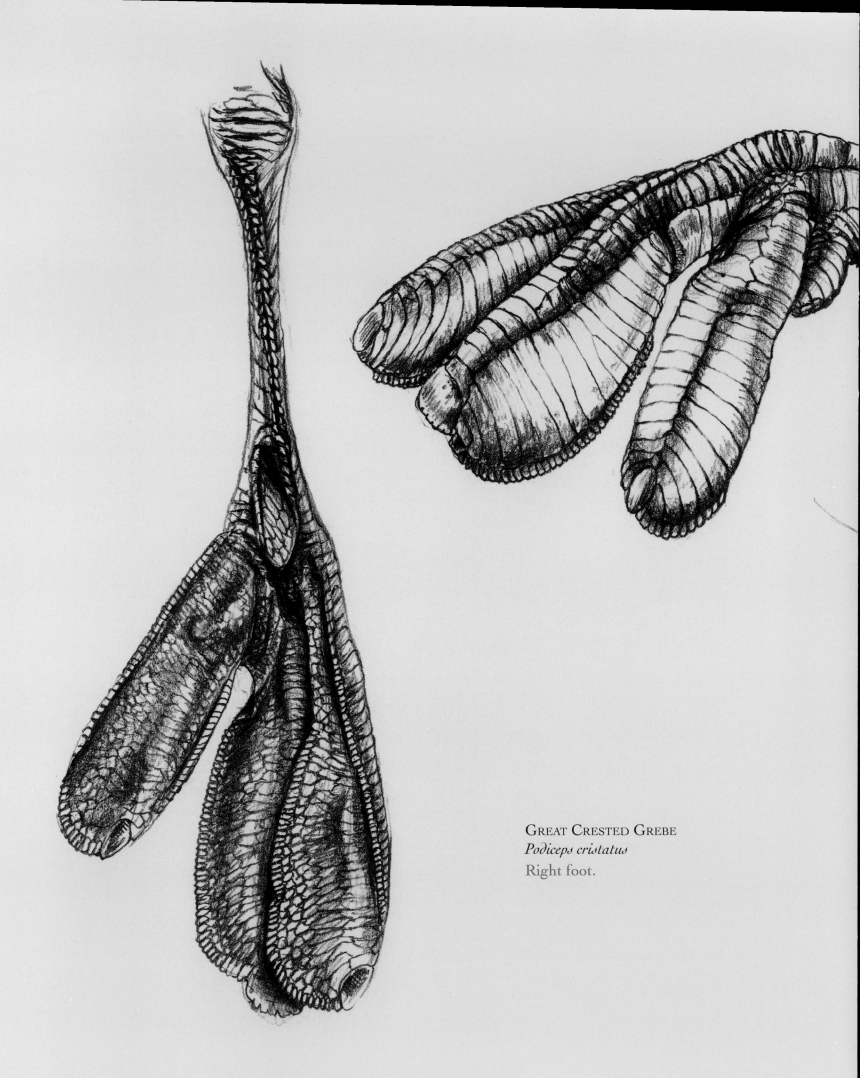

GREAT CRESTED GREBE
Podiceps cristatus
Right foot.

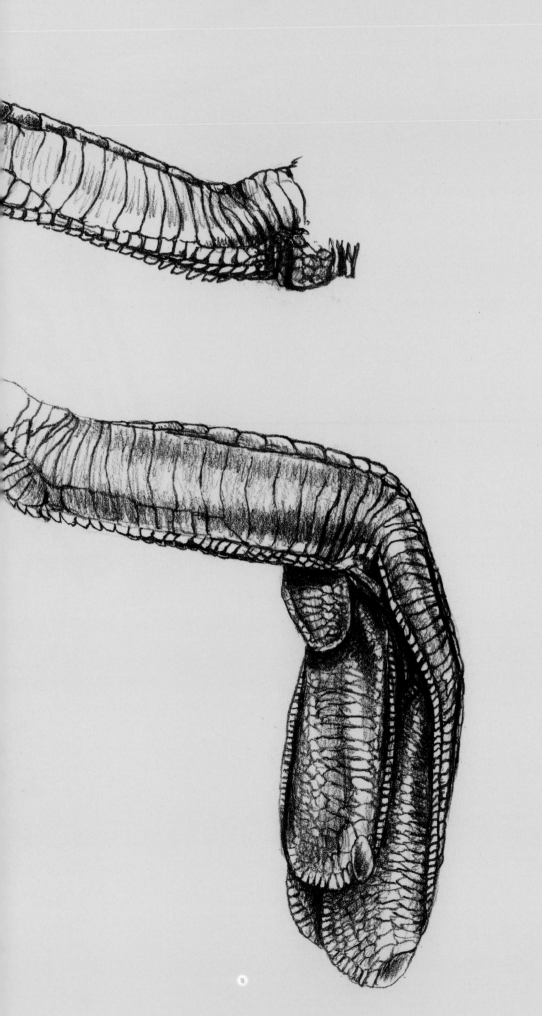
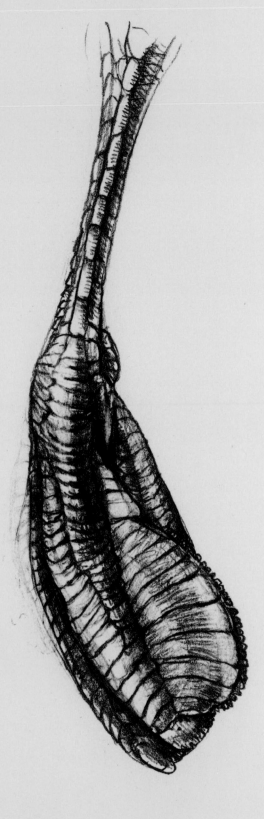

behind it. The skull can be distinguished from the skull of loons, apart from the smaller size, by having only a minimal depression above the eye for the salt excretion gland, reflected in their predominantly freshwater lifestyle.

Although they are marginally more adept on land than loons, grebes are entirely independent of it and do not need to come ashore to breed. They nest on floating islands of vegetation and even build separate islands on which to copulate. They are well-known for their beautiful synchronized courtship displays, which include the delightfully named "cat posture," "weed rush," and "ghostly penguin dance." The attractively striped chicks spend their first few weeks of life being carried on their parents' back. Among more "normal" foodstuffs, the chicks are fed on feathers that the adults pluck from their breast and flanks. The adults eat these, too, and they are thought to serve as a wrapping for fish bones and other indigestible material ejected from the mouth as pellets.

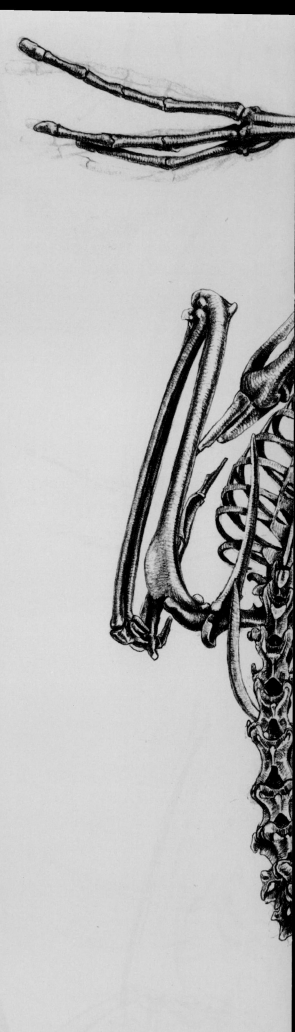

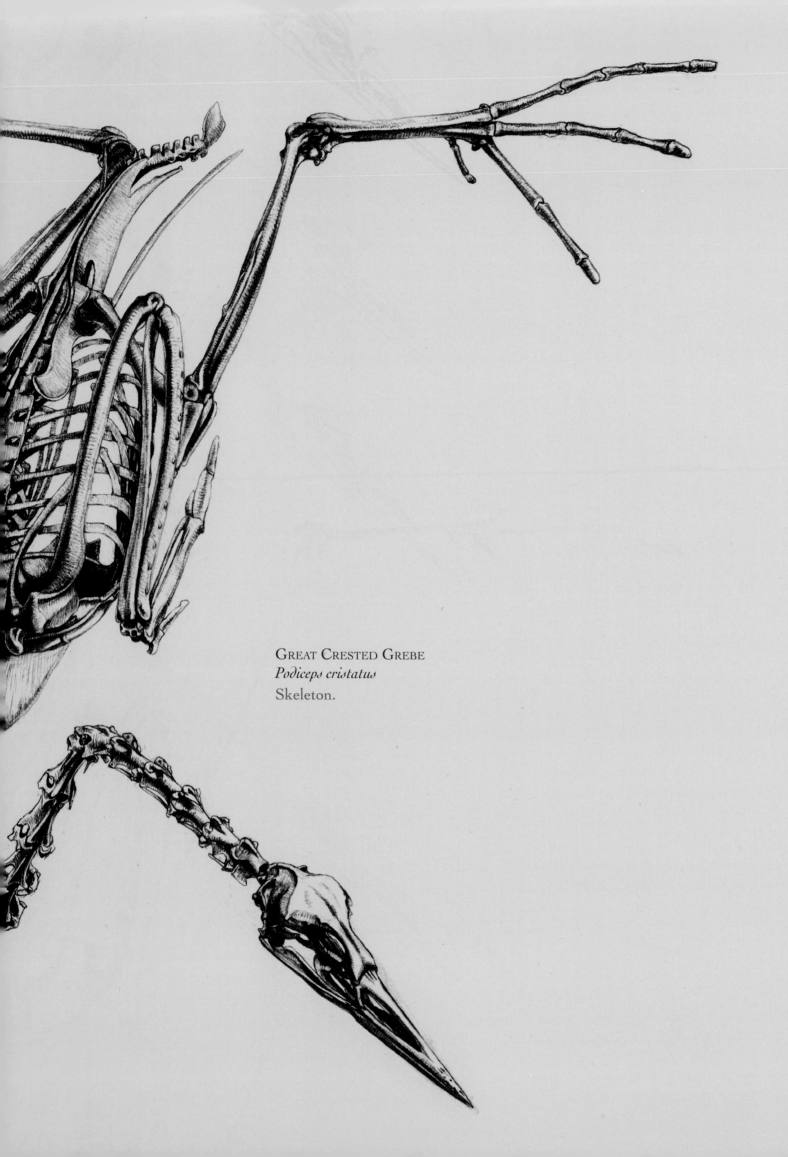

GREAT CRESTED GREBE
Podiceps cristatus
Skeleton.

Albatrosses, Petrels, and Storm Petrels

The Roaring Forties and Furious Fifties: the latitudes at the bottom end of the earth did not get these names for nothing. The southern oceans—south of Australia and South Africa and around the infamous Cape Horn—are synonymous with howling gales, storms, and monstrous waves. But riding the winds with ease, scarcely even needing to move their wings—the good omen of sailors—are albatrosses.

Albatrosses don't just cope in these conditions; they rely on them. They are super-specialized gliders, their whole biology finely tuned into the strong winds and air currents over the sea. Instead of using muscle power to battle the elements, their wings work as a rigid airfoil to take advantage of the updraft of air generated by each wave before gliding downward again at right angles to the wind. Although this "dynamic soaring" means that the birds follow a longer, zigzag path, the energy used is minimal. Albatrosses actually have comparatively small flight muscles and the breastbone is correspondingly short. Flapping flight is restricted to takeoff and landing, which the birds accomplish only with difficulty. Without wind they are virtually grounded.

The long wings are mostly the result of elongated bones in the upper arm and forearm, which are of approximately equal length, as they are in all petrels. The bones of the forearm are straighter and closer together than they are in other petrels, however, and the large number of secondary flight feathers arranged along it are supplemented by additional feather groups along the upper arm—though these "humeral" feathers are not true flight feathers, as they are not attached to the wing bones. The increase in the length of the arm bones is balanced by a decrease in the length of the hand section—another petrel trait—to produce an aerodynamically efficient wing that's great for gliding but gives virtually no aerial maneuverability.

Even without flapping flight, maintaining an open-winged position for long periods is tiring on the muscles. But albatrosses have ways of dealing with this. The flight muscles on either side of the breast incorporate a layer of slower-acting "tonic muscle" that supports the extended wings. They also have a tiny bone embedded in the tendons at the leading edge of the wing that keeps the skin taut against the oncoming wind, as well as locking mechanisms in the elbow and shoulder joints that keep the wings spread and prevent them from being pushed upward above their optimum horizontal position.

Albatrosses are members of the order Procellariiformes, which includes the true petrels (and shearwaters), storm petrels, and diving petrels. A feature common to the order is the tube-like passage to the nostrils that runs along the upper edge of the bill and has given the group the alternative name of "tubenoses." Most petrels have a single tube divided internally into two halves. In albatrosses, however, the nostrils are separated; one on either side of the bill, but they are still contained within little tubes.

All petrels are exclusively pelagic and take in high volumes of salt via their diet. This needs to be excreted from their body, and they do this by means of glands situated on top of the skull above the eyes. The saline solution is channeled out via the bill and is periodically flicked off the bill tip.

Albatrosses are among the few petrels that can stand upright. They can walk, run, and even dance! Unlike the many nocturnal-breeding species that rely on voice and scent to communicate, albatrosses are active on land by day, which means that they can communicate visually. And they do so by means of ritualized movements—sky pointing, with wings open, synchronized display flights, head-shaking, and curious swaying walks—sometimes comical; always fascinating; often deeply moving.

Albatrosses pair for life and usually return to breed in the same colony where they were reared, despite having traveled many thousands of miles in between. They are slow breeders, raising only a single chick, and then not even every year; and the young may take many years to reach sexual maturity. But they have few

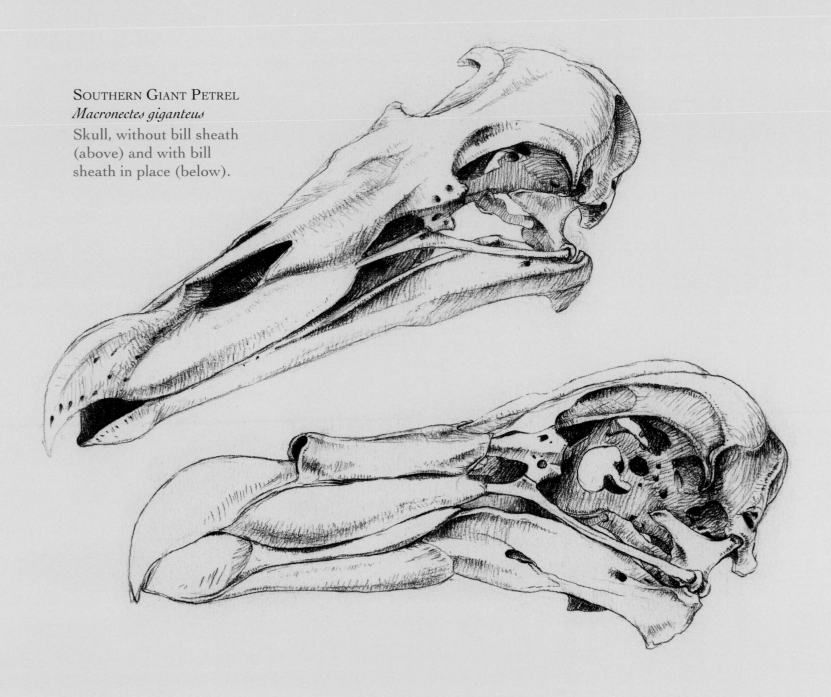

SOUTHERN GIANT PETREL
Macronectes giganteus
Skull, without bill sheath
(above) and with bill
sheath in place (below).

natural predators and, despite the hardships of their environment, have a long life expectancy. So, until recently at least, they could afford to take their time. That was until the practice of commercial long-line fishing using baited hooks began to take its toll on seabird populations. Today the majority of the world's albatross species are threatened with extinction.

Of the four families that make up the order Procellariiformes, the true petrels—which includes the shearwaters—are the most diverse. Like others in the order, they have tubular nostrils, but unlike albatrosses, both nostrils are enclosed within a single tube on the upper surface of the bill. In all families the bill is also sharply hooked and deeply grooved to form clearly marked sections. In some, such as the predatory-looking Giant Petrels, these features are much exaggerated, while in the benignly innocent-looking shearwaters they are more subtle. The tubular nostrils are associated with the birds' sense of smell, which is particularly well developed, and with the excretion of salt, which may be ejected through the tubes. A pungent, musky-smelling oil secreted from the digestive tract may also trickle from them. But when a petrel really wants to

expel the partially digested contents of its sack-like gullet—for example, if a predator or an ornithologist is approaching its nest—it does so in a spectacular, full-on vomit, straight from its mouth.

Most petrels are nocturnal breeders and use scent to locate their burrows in the darkness. They also use it to find food in the vastness of the ocean—a quality that oceangoing birdwatchers have learned to use to their advantage, tossing a liquefied fishy mixture called "chum" overboard to attract petrels from far and wide. The majority of species feed at the surface of the water. Giant Petrels are unusual in having taken on the scavenging role of vultures, feeding largely from washed-up carcasses on the shore, and are therefore much more mobile on land than other petrels. Others, most notably some shearwaters, are accomplished divers, and this distinction is reflected by differences in their internal anatomy.

Shearwaters propel themselves underwater with both their feet and their wings, and consequently share several features in common with wing-propelled species such as auks and foot-propelled birds like loons and cormorants. Like auks, they swim underwater with the wings in a half-closed position, and the bones of both the wing and the feet are flattened and blade-like to cut through the water with ease. The legs are

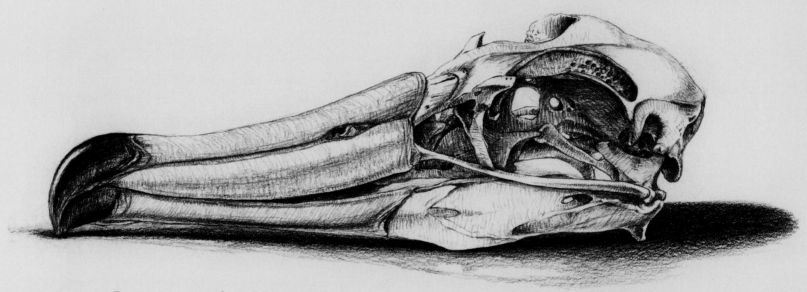

BLACK-BROWED ALBATROSS
Thalassarche melanophrys
Skull.

positioned more on the sides of the body than underneath, a feature that also helps them in excavating their burrows. The legs are also countershaded—dark on the upper side and pale below, an attribute shared by many swimming animals to aid in camouflage. As in all Procellariiformes only the three forward-facing toes are webbed and the hind toe is virtually nonexistent. The pelvis is narrow, with long projecting bones for the attachment of muscles to power the legs. Like loons and grebes, shearwaters have short, curved thighs for maximum strength and share the spike-like bony projection at the knee.

However, legs set far back for swimming and digging are of little use for moving around on land. Most petrels cannot walk upright for more than a few tottering steps before falling back into their resting position flat on their belly. With such long wings, too, they are unable to take off from the ground and need to literally throw themselves off cliffs or other high points to become airborne. Their helplessness makes them easy victims for piratical gulls and skuas and accounts for the nocturnal breeding behavior of most species.

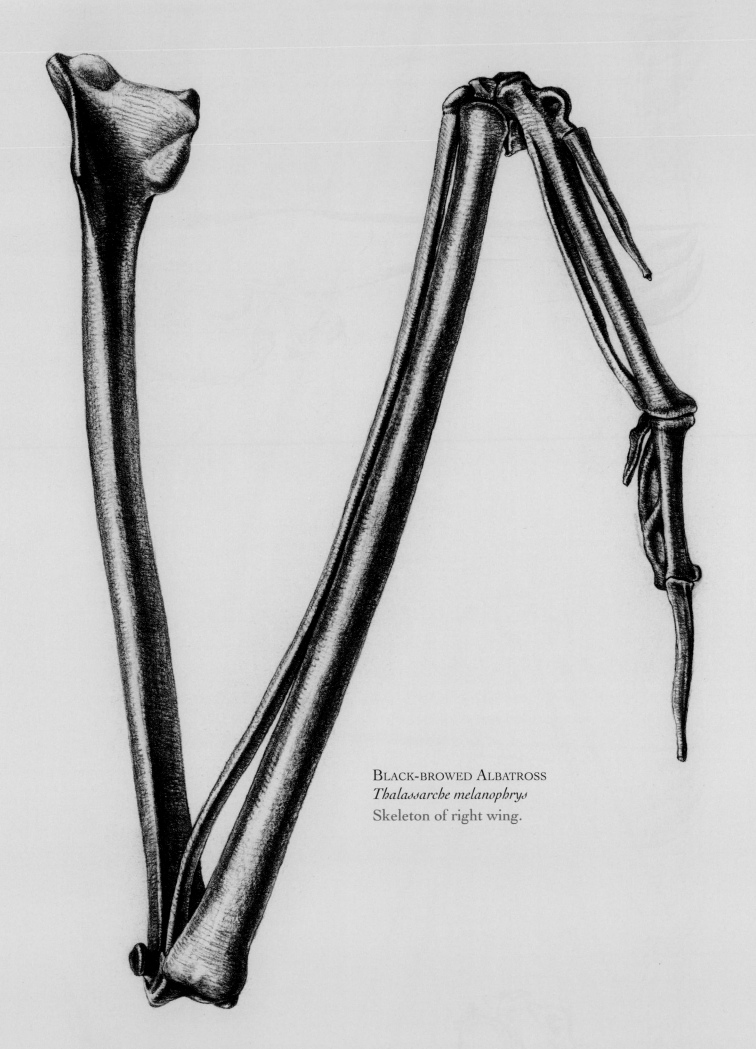

BLACK-BROWED ALBATROSS
Thalassarche melanophrys
Skeleton of right wing.

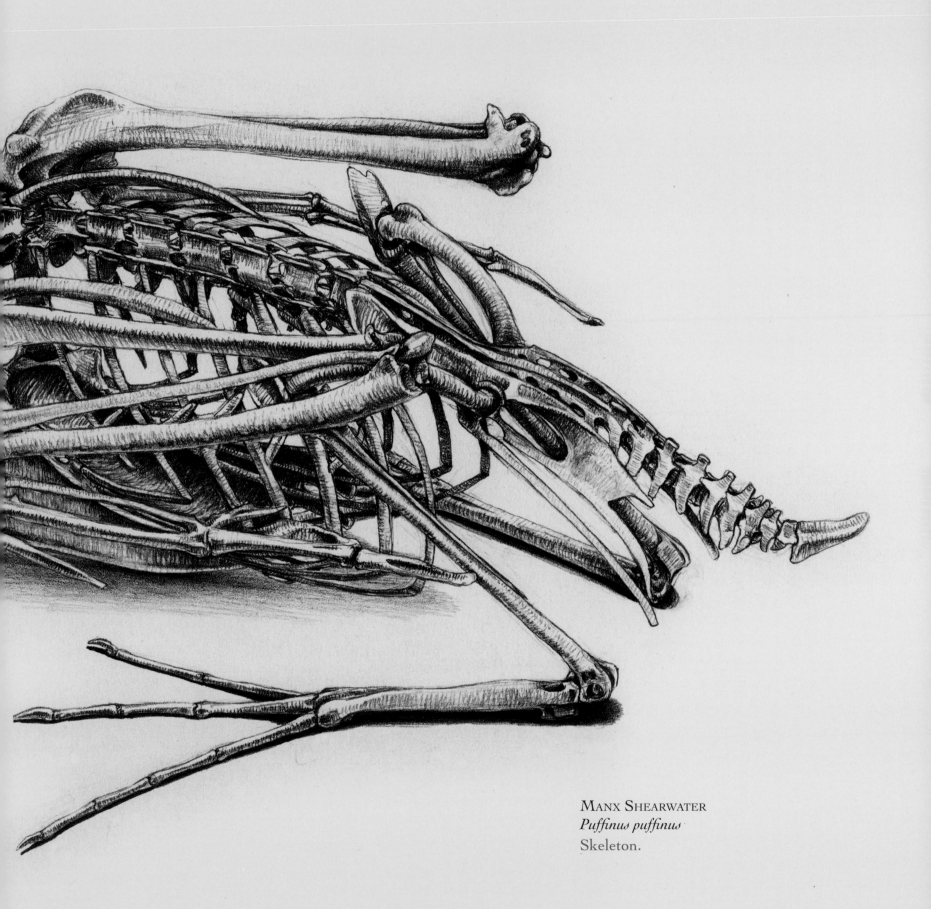

Manx Shearwater
Puffinus puffinus
Skeleton.

On summer evenings, Manx Shearwaters gather in huge numbers on the sea, waiting to return to their colonies. The majority of the world's population breeds on the tiny islands off the west coast of Britain and Ireland, and it is only comparatively recently that they have begun to colonize the Atlantic coast of North America. However, they over-winter in the offshore waters of southern South America and are estimated to fly at least thirty-two thousand miles every year. Ringing recoveries have shown them to be among the longest-lived birds in the world.

Mysterious, romantic, little understood, and seldom seen by the majority of people, the storm petrels are nevertheless among the most abundant and widespread birds in the world. Scarcely the size of a starling, and much, much lighter, they appear to be delicate, fragile things, with their disproportionately long, thin legs and dainty webbed feet. Not so. Storm petrels spend the majority of their existence far from the sight of land, in raging winds and bitterly cold squally seas, in conditions that no other bird of comparable size could tolerate. They find what shelter they need in the troughs of waves and seldom alight on the water's surface. But they do seem to dance over it, patting the water with their feet, fluttering, hovering, pouncing, and dipping, as they feed on tiny marine organisms disturbed by the turbulence. They are supremely aerial birds, and although they are in many ways the aerodynamic opposite of the albatrosses, their mastery of flight is equally suited to the demands of a totally marine environment.

In all petrels the upper arm and forearm bones are of approximately equal length. It's the length of the hand that varies, and in general, the larger the bird, the smaller the hand. Albatrosses have really long "arms" but small "hands." But in storm petrels it's the other way around. The section from the wrist to the wingtip is significantly longer than the bones of the upper and lower arm. They correspondingly have more functional primary flight feathers (attached to the hand) and fewer secondary flight feathers (attached to the arm) than do albatrosses. The breastbone, too, is long, and the wishbone curves outward to give the maximum area for the attachment of the well-developed flight muscles. Storm petrels may not be able to soar effortlessly for long periods like their long-winged cousins, but they can fly like butterflies and change direction with the slightest movement.

Robust as they are, storm petrels are nevertheless small birds and would be easy prey for gulls and skuas were it not for their habit of approaching their breeding colonies only under cover of darkness. At other times they forage far from land, safely out of range of avian predators. They nest in burrows and crevices in rocks, dry stone walls, and scree slopes. With their long thin legs, they move clumsily on land and stand with their tarsus resting on the ground. After landing they quickly shuffle to their nest. By day the presence of storm petrels is betrayed by only a faint musky scent. But by night the colony becomes alive with their curious chattering calls, whirring wings, and the occasional soft thud of birds colliding in the air. Their nocturnal habits are facilitated by their strong sense of smell—unusual in birds but common to most petrels whose well-developed olfactory apparatus is linked with the characteristic tubular nostrils. The birds use their sense of smell to locate and identify their nest site, find food, and even recognize one another. Indeed, most petrels have a pungent odor, but most breed in inaccessible areas such as islands and stacks, free from mammalian predators that would be able to detect them in this way. The aroma of storm petrels is sensual and complex; as enigmatic as the birds themselves.

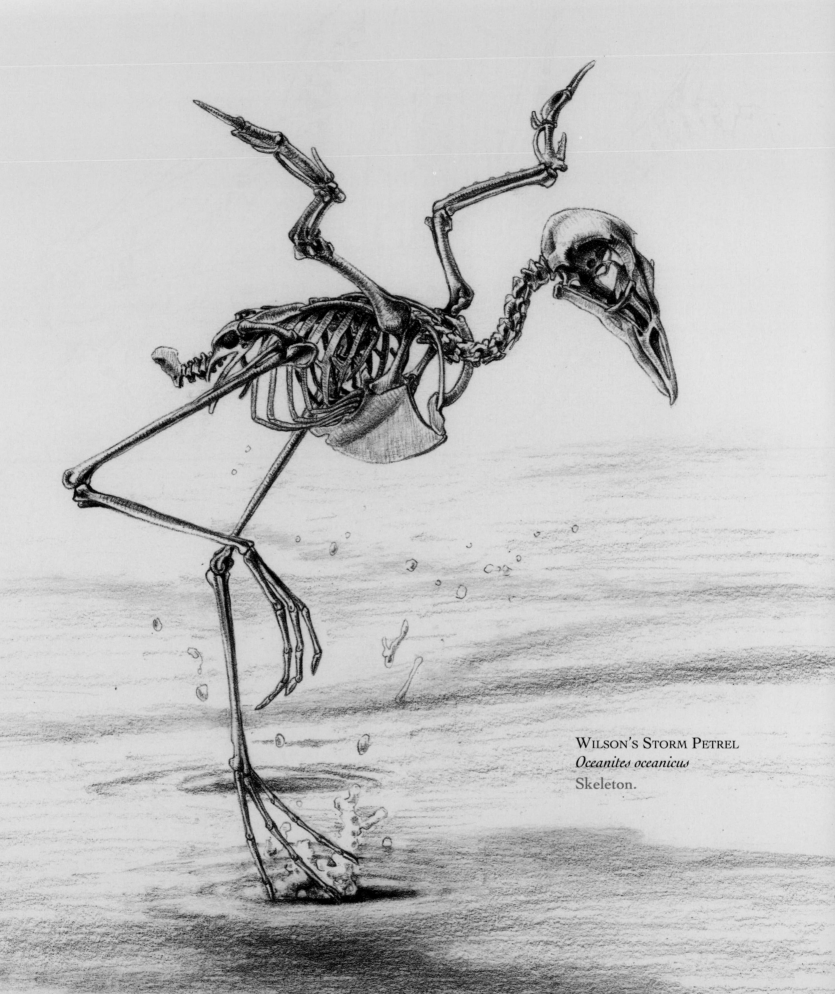

WILSON'S STORM PETREL
Oceanites oceanicus
Skeleton.

131

Tropicbirds and Frigatebirds

Although traditionally placed in the same order as the pelicans, gannets, and cormorants, tropicbirds and frigatebirds are the mavericks of the Pelecaniformes; between them, they flaunt almost every rule that defines the group. Their neck is shorter by two vertebrae and without a Z-shaped kink. They both have all four toes webbed, but in frigatebirds the webbing is reduced to just a basal section in the angle of the toes. Frigatebirds indeed share the serrated middle claw with the rest of the order—except tropicbirds. They have little in common with any other bird family, or with each other. In fact the current opinion is that the Pelecaniformes as an order is invalid and that the frigatebirds and tropicbirds have more widely separated origins.

Whatever their affinities, tropicbirds are probably the most beautiful birds of the tropical oceans, and frigatebirds are certainly the most exciting.

Tropicbirds are all front end. They have a deeply keeled breastbone equipped with powerful flight muscles, long wings, and a large skull, but the pelvis and hind limbs are disproportionately small and weedy. Not surprisingly, they move about on land only with difficulty; but they are accomplished fliers, particularly during their sublime aerial courtship displays, their long tail streamers trailing comet-like behind them. But despite their mastery of the air, they are no match for the predations of frigatebirds.

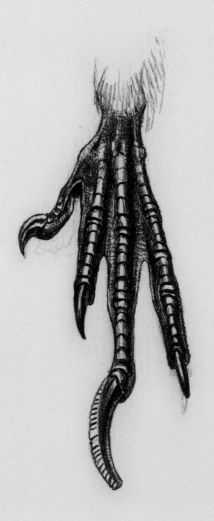

MAGNIFICENT FRIGATEBIRD
Fregata magnificens
Left foot, showing the pectinated middle claw.

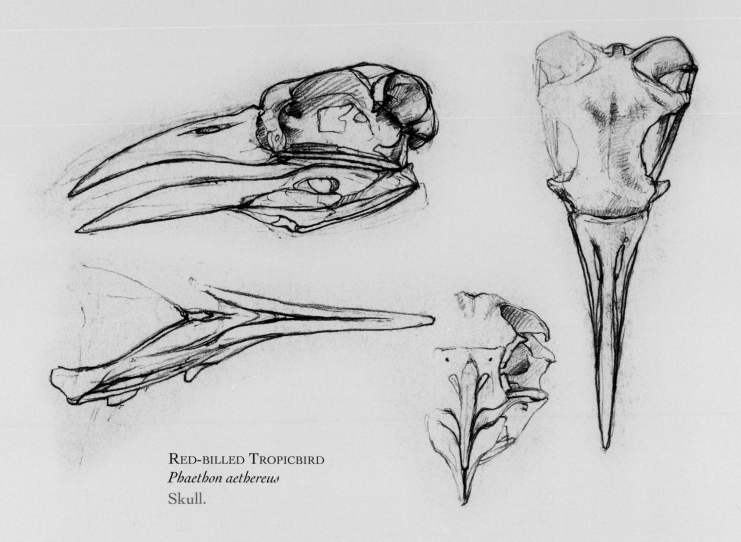

RED-BILLED TROPICBIRD
Phaethon aethereus
Skull.

Enormous; dark; with huge, angular, primitive-looking wings, a deeply forked tail and a long, hooked bill—frigatebirds are the pirates of the tropics and they look every inch the part. They feed entirely on the wing and although they spend their whole life at sea, their plumage is not waterproof and they rarely swim or even alight on the water's surface. Instead they snatch their prey as they fly, swinging their head through 90° with incredible accuracy to grab at flying fish or small morsels from the surface. More often than not, however, their victims are other birds—tropicbirds, terns, or boobies—which they bully and molest relentlessly to make them regurgitate their last meal.

Like tropicbirds, frigatebirds have a poorly developed pelvis and small, weak hind limbs; not surprising for a bird that seldom needs to move its legs. Even at the breeding colonies on the tops of low trees they remain largely inert and do not clamber around in the vegetation. Again like tropicbirds, they have a broad and deeply keeled breastbone for the attachment of flight muscles and are correspondingly very strong fliers. But frigatebirds are not simply a larger version of tropicbirds. Their wishbone is fused to the keel of the breastbone as it is in pelicans, giving greater rigidity to the pectoral girdle. And whereas tropicbirds have a long upper arm and shorter forearm and hand for sustained powered flight, the wing of frigatebirds is engineered in the opposite way, with a relatively short upper arm and long forearm. This makes flight unstable, giving them the superior powers of aerial maneuverability needed for their piratical lifestyle.

Even the bones of frigatebirds are composed mostly of air! They are among the lightest of any bird's and enable the frigatebirds to remain airborne out at sea for long periods in search of prey and new victims.

Another Pelecaniforme feature is the pouch of loose skin in the angle formed by the lower jaw. This is, of course, developed to its extreme in pelicans but is also present to a lesser degree in gannets, boobies, cormorants, and darters, and in each case it plays a key role in feeding. Tropicbirds lack this feature, but in frigatebirds it is used not for feeding but by the males in courtship displays when it is inflated like an enormous red balloon.

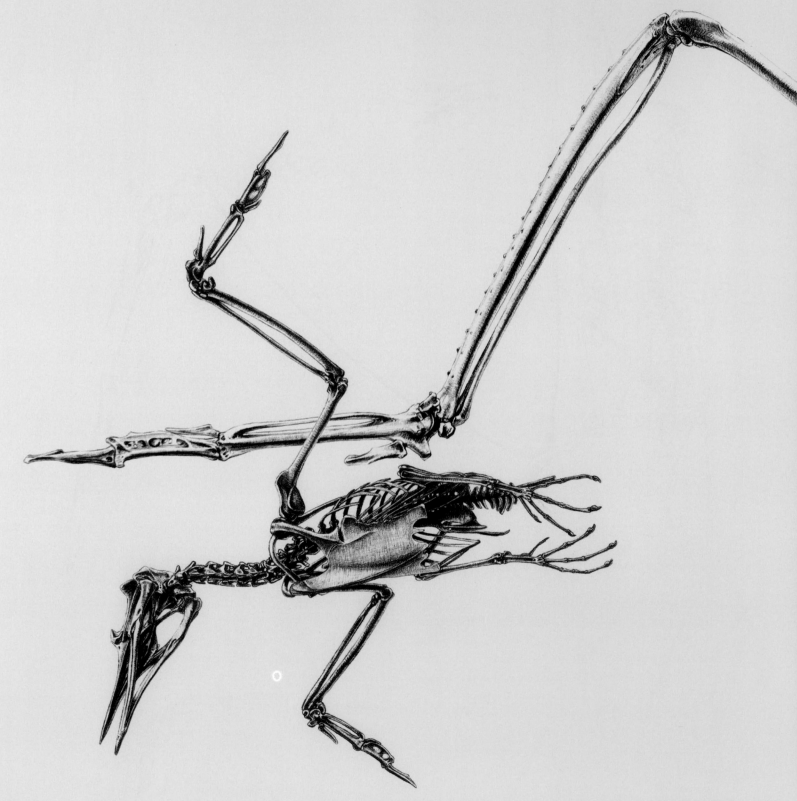

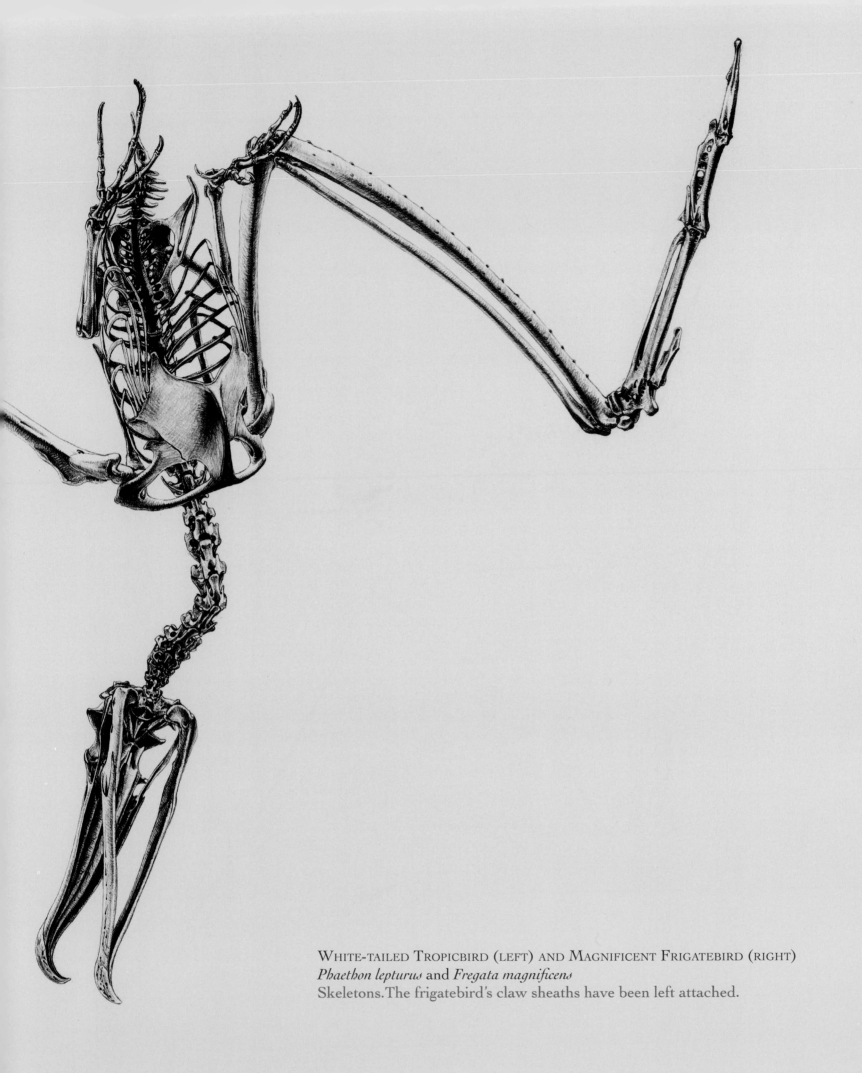

WHITE-TAILED TROPICBIRD (LEFT) AND MAGNIFICENT FRIGATEBIRD (RIGHT)
Phaethon lepturus and *Fregata magnificens*
Skeletons. The frigatebird's claw sheaths have been left attached.

Pelicans

With their enormous throat pouch distended like a sack beneath their bill, pelicans are among the most familiar of any bird and instantly recognizable. Pelicans' bills, and in particular the Australian Pelican's, are in fact the longest of all birds'. The two bony sides of the lower jaw are joined only at their tip and the pouch is formed by the loose skin in between. It's quite elastic, so although it can hold up to ten liters of water and fish when full, it springs back into position against the floor of the mouth when empty, giving the bird an altogether different appearance. Despite the popular myths, pelicans do not store or carry fish in this pouch. It's used solely as a fishing net to scoop up prey, either from just below the surface of the water or, in the case of the Brown Pelican, in spectacular aerial dives. The upper mandible is hinged at its base, allowing upward movement, and the sides of the lower jaw are flexible, bending outward to increase the size of the "net" even further. When the fish are caught, the pouch is contracted to expel the surplus water from the sides of the bill. Smaller fish are often accidentally ejected along with the water, which is why feeding pelicans are frequently accompanied by opportunistic gulls, terns, and noddies, which lose no time in snapping these up.

Pelicans are heavy birds, with long, broad wings and short legs, so they take to the air only with difficulty. The keel of the breastbone is also relatively shallow and the flight muscles poorly developed for so large a bird. However, their keel is fused to the wishbone, giving increased rigidity to the pectoral girdle. Once airborne, pelicans are competent fliers, particularly adept at soaring using rising thermals of warm air. The bones of the forearm are far longer than that of the upper arm and consequently bear more secondary flight feathers than do many other birds—between thirty and thirty-five—providing a large surface area to take full advantage of the pockets of rising air.

The pelvis is broad but supports comparatively small leg muscles for sustained swimming and the short, stout legs are set far back on the body, giving pelicans their rather grand upright stance and enabling them to walk and perch comfortably well. Having all four toes webbed does not seem to hinder their ability to perch in trees, and despite the webbing they often manage to turn their hind toe to oppose the others to grip onto branches.

When it comes to locomotion, pelicans are great all-rounders; competent but not excellent on land, in water, and in the air. Having a pouch enables them to maximize their catch with the minimum of effort, thus providing the high volume of nutritious food needed to feed their chicks in the vicinity of the colony. Further specialization is not required.

Pelicans, gannets, cormorants, darters, tropicbirds, and frigatebirds are traditionally grouped together into the order Pelecaniformes. They indeed share many anatomical features, though with plenty of exceptions, and it's likely that the similarities are the result of convergent evolution rather than reflecting actual relationships. Pelicans are, in all probability, more closely related to the bizarre Shoebill within the order Ciconiiformes, despite the unwebbed feet of the latter, than to the formerly accepted seabirds.

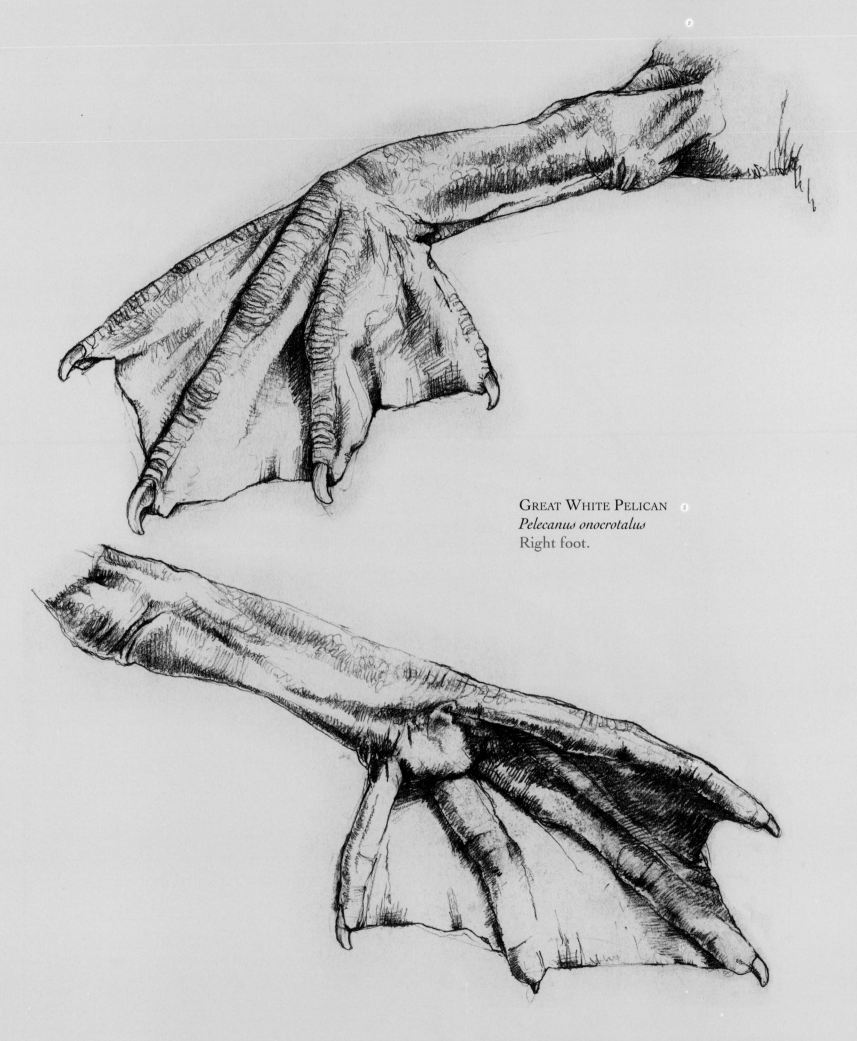

GREAT WHITE PELICAN
Pelecanus onocrotalus
Right foot.

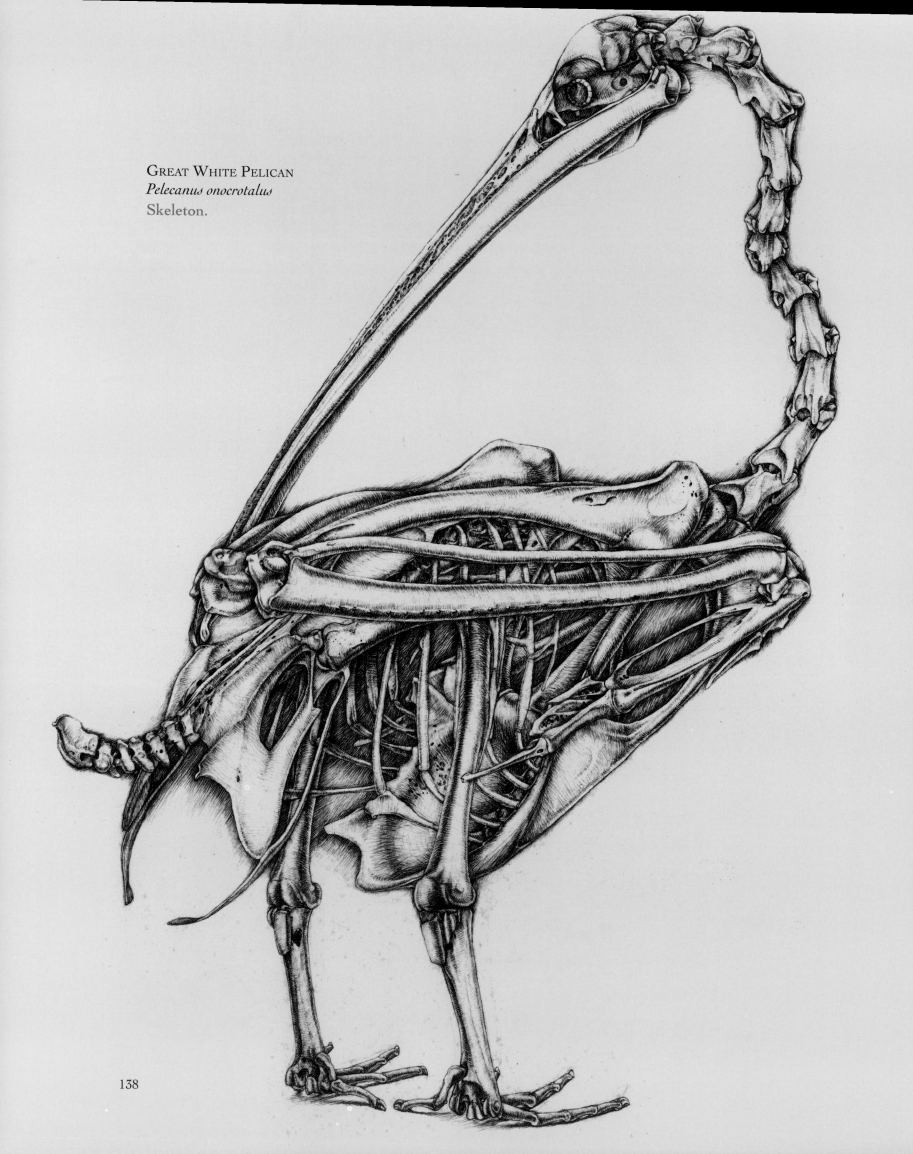

GREAT WHITE PELICAN
Pelecanus onocrotalus
Skeleton.

138

Gannets

With their pointed bill at one end and pointed tail at the other, the gannets' body is often, quite accurately, described as "cigar shaped," the long slender wings completing the picture of streamlined power. But despite the birds' great size and apparent strength they are not strong fliers and are more suited to gliding than to flapping flight.

The "arm" section of the wing—particularly the upper arm, from shoulder to elbow—is especially long, while the "hand" section—from the wrist to the tip of the wing—is relatively short. This is great for taking advantage of high winds to carry the bird long distances using barely any energy but gives little maneuverability in the air. The breastbone is not large and the muscles for flight are not well developed.

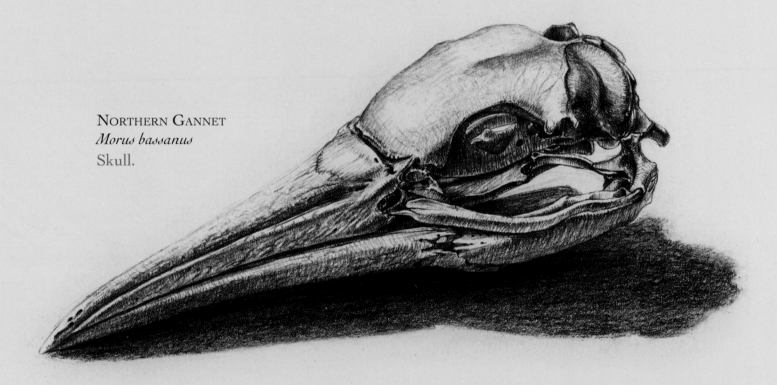

NORTHERN GANNET
Morus bassanus
Skull.

Gannets need wind in order to fly. Takeoff and landing are particularly problematic, which is why gannet colonies are always situated on windy cliff tops and islands where the birds can launch themselves over the edge and into the air. And their ascent from the water's surface after a dive is accomplished only with some difficulty.

Gannets run the gauntlet every time they make their way to and from their nest. Despite being colonial, they are fiercely territorial and can inflict serious wounds with their long, serrated bill. Each adjoining territory is the exact distance that a gannet can reach from its nest, and not an inch of space is wasted in between. A complex series of rituals maintaining the hierarchy within the colony helps minimize actual bodily harm.

When hunting, however, it's to the birds' mutual advantage to be sociable. Gannets prey on fish shoals and, as every herring fisherman knows, there's no better way of locating a shoal than by making your way toward the brilliant white streak of a diving gannet. As more and more birds join the fray they work themselves into a feeding frenzy, plummeting from the sky like a rain of arrows.

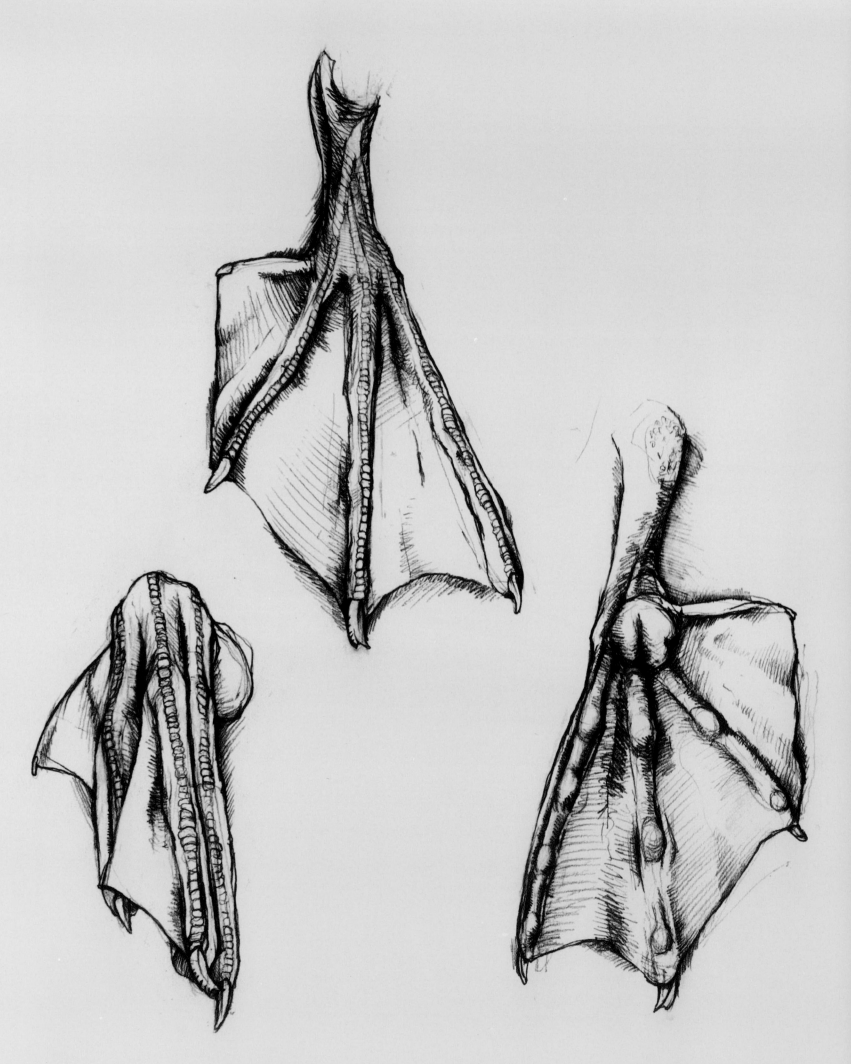

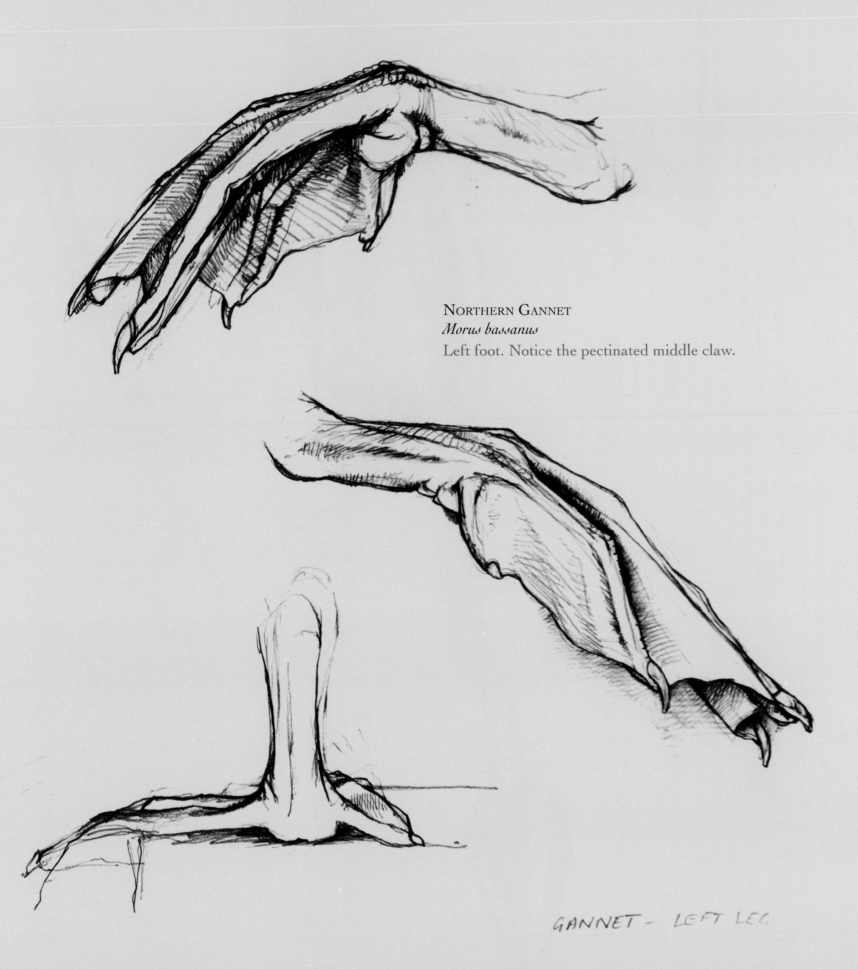

NORTHERN GANNET
Morus bassanus
Left foot. Notice the pectinated middle claw.

GANNET - LEFT LEG

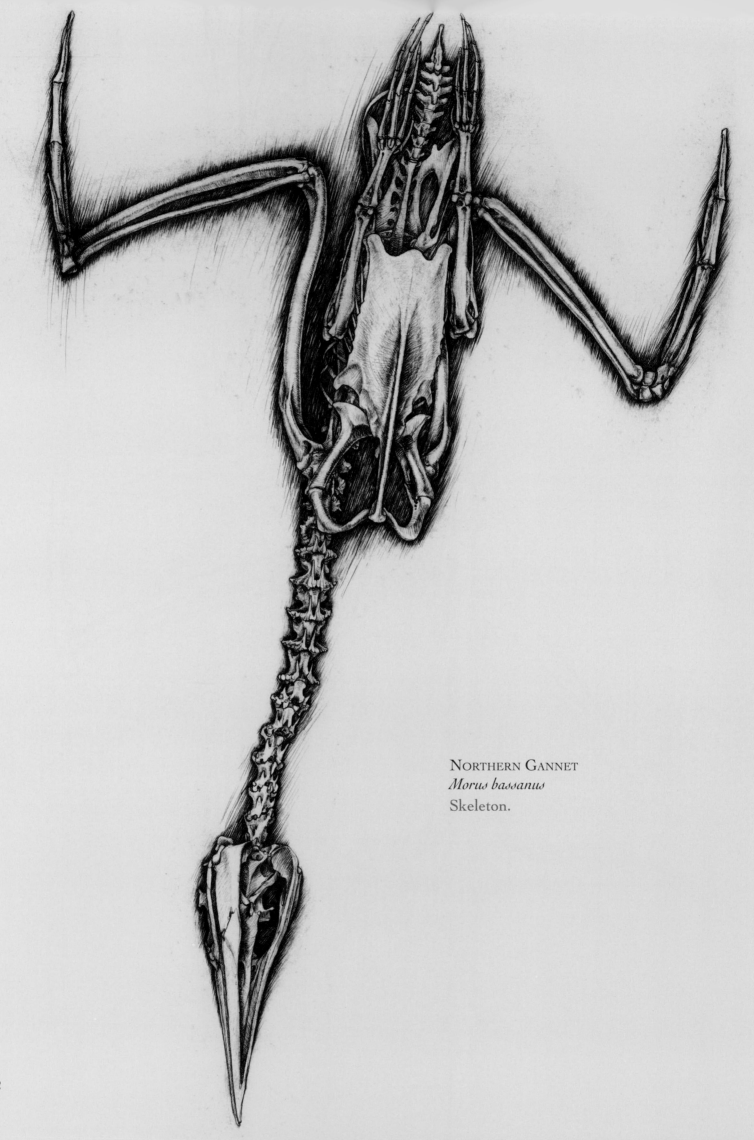

NORTHERN GANNET
Morus bassanus
Skeleton.

Gannets' eyes are situated facing forward within the skull, giving them binocular vision, which enables them to judge distances accurately. When a fish is spied the bird folds back its wings halfway and drops vertically, maintaining sight of the fish during the descent and subtly adjusting its angle and position before finally sweeping back the entire length of its wings the moment before impact with the water.

Shallow grooves running along the length of the bill may function as sighting lines to aid in accurately targeting prey. Gannets have no external nostrils to permit the sudden entrance of water, and air sacs beneath the skin act as shock absorbers to cushion the body from the force. Dives may be from as high as twenty-seven meters, though nine to fifteen meters is most usual, and may reach speeds of over one hundred kilometers per hour. They are not deep, however, and the bird is not submerged for more than a few seconds. While underwater they propel themselves with both wings and feet, though they lack the adaptations to excel at either. The wings are much too long to be efficient underwater, and the legs are positioned too far forward. The gannets' strength lies in sudden surprise assault and not in underwater pursuit.

A hinged upper mandible, special adaptations in the articulation of the lower jaw, and flexible plates making up the bill's surface enable the large bill to open into an even larger gape, allowing the passage of all but the biggest fish.

Like all seabirds, gannets must excrete excess salt from their body. Most birds do this via their nostrils, but in gannets, which have no external nostrils, the highly saline solution is excreted through the inside of the upper mandible until it eventually drips off from the end of the bill.

Gannets have all four toes webbed and have a serrated middle claw that is thought to help with preening. These are among the features common to several groups of waterbirds including the pelicans, cormorants, and darters, which are traditionally grouped together into the order Pelecaniformes. This order is now considered to be invalid, though it is likely that the gannets, cormorants, and darters are indeed closely related.

Cormorants and Darters

It's difficult to conceive that a bird that spends so much of its time pursuing fish underwater would have plumage that is not waterproof. The characteristic wing-drying posture of cormorants has been the cause of much confusion among ornithologists; are they really drying their wings or is there something else going on? Cormorants have well-developed preen glands and like other birds spend a great deal of time preening and rubbing the oily secretions over their feathers. Why then do the feathers become waterlogged and need to be dried in this rather primitive way?

The answer is, yes; cormorants are indeed drying their wings, and when they are facing the wind, it works remarkably well. Much is still unknown about the extent of water absorbency by the plumage, but it's likely that the answer lies in the bird's adaptation to its underwater environment, not *in spite of* it. Wet feathers will trap less air than dry ones so it's probable that this has a function in decreasing buoyancy when diving. And heat loss may be minimized by retaining a dry layer of down close to the body while only the outer part of the contour feathers gets wet. The birds may also undertake deeper dives while the plumage is still relatively dry. The proof remains that cormorants are highly successful waterbirds and are clearly not handicapped by this idiosyncrasy of their feathers.

Their internal structure, too, is finely tuned to an underwater lifestyle, with a long neck, a streamlined and somewhat boat-shaped body, and legs positioned far back, which gives them their upright posture on land, though not so far back as to hamper their ability to perch in trees. As in many diving birds, the pelvis is narrow but with long bony processes for the attachment of muscles to power the legs, which are stout and strong. The knees too are especially well developed to accommodate bulky leg muscles. Cormorants are foot-propelled diving birds, so they don't have the deep-keeled breastbone of the wing-propelled auks or penguins. They keep their wings firmly closed underwater and steer using their feet and long, stiff tail as a rudder. The feet are angled at the sides of the body and are used simultaneously to push the bird through the water with a single powerful thrust, though on the water's surface the legs are used alternately. The outer toe is longer than the others, and particularly so in the more marine species, the shags. This provides enough webbed surface area for a really efficient power stroke. Like the pelicans and gannets, all four toes are webbed. Even the ribcage is more than usually robust to withstand the pressure of the water; this is a bird supremely adapted for deep diving.

Every scuba diver knows that without a diving mask, underwater vision is blurred and out of focus. Cormorants, however, have a highly adapted eye with muscles controlling both the pupil and the lens that gives them excellent underwater vision and the ability to focus sharply on close-up objects. Above the water, and near the surface, the pupil is contracted to a tiny black dot in the eye, but in the relatively dark environment of deep water it expands to allow sufficient light to hit the retina. The ear opening is reduced to a tiny slit to prevent the entry of water and, for the same reason, cormorants have no external nostrils.

Perhaps the most striking feature of the cormorants' head anatomy is the extra bone projecting from the rear of the skull. This bone provides additional support for the muscles of the jaw to enable the bird to keep a firm grip on its prey. Although the bill has a stout hook at its tip, its sides are smooth and unserrated, so a strong hold is necessary to prevent the powerful, writhing fish from slipping. Cormorants need to maximize the efficiency of every pursuit in order to avoid losing heat through repeated dives. This often means taking very large fish, which their enormous gape can comfortably accommodate, a quality that has made them valued tools of fishermen in China and Japan.

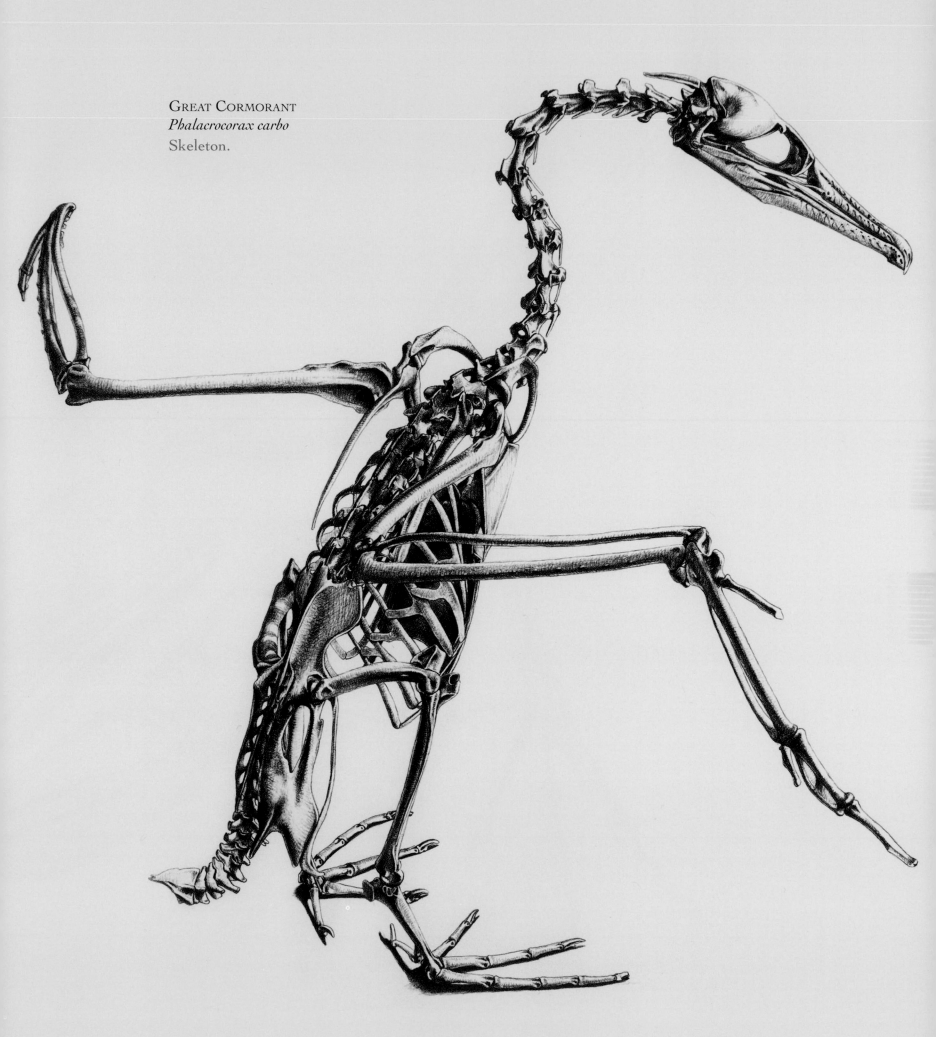

GREAT CORMORANT
Phalacrocorax carbo
Skeleton.

145

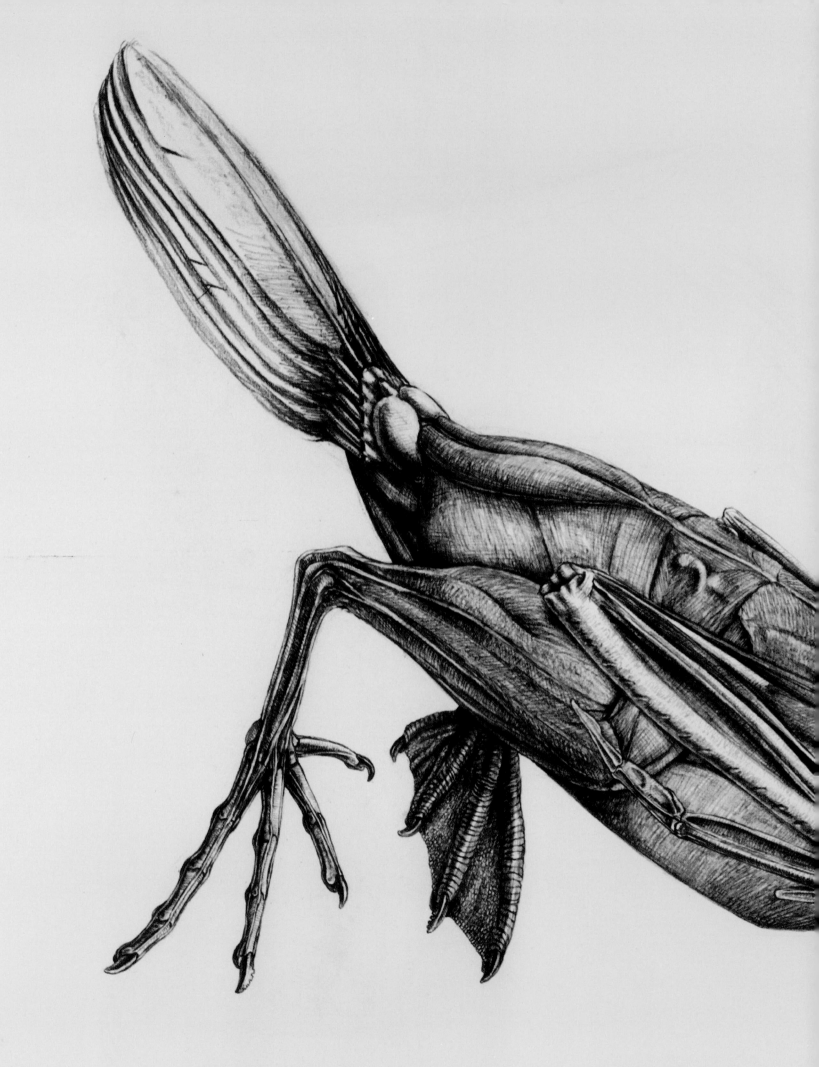

GREAT CORMORANT
Phalacrocorax carbo
Skin removed; except from left foot.

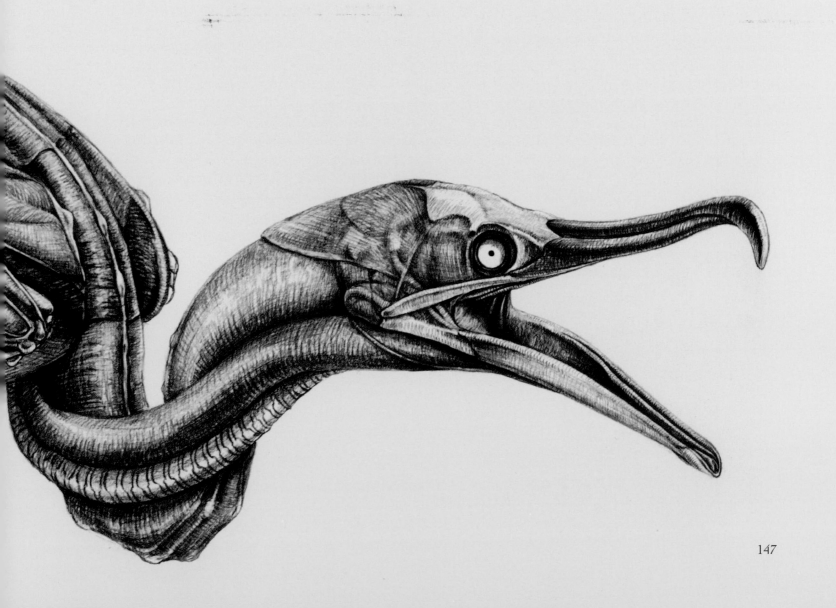

Darters share many similarities with cormorants. They, too, are superbly efficient underwater divers; they also propel themselves with strong, stout legs and use their long, stiff tail as a rudder, and have a slender skull on the end of a long, sharply angled neck. They, too, have no external nostrils and share the cormorants' tiny ear openings and large gape for swallowing big fish. They also nest in trees and have the same upright posture on land. They even share the peculiar feature of water-absorbent plumage. Long considered close cousins of the cormorants, darters are, however, sufficiently different to merit being placed in a family of their own.

The principal difference is in their feeding habits; cormorants grab their prey, holding it fast with their sharply hooked bill, while darters spear it with a harpoon-like mechanism. The impaled fish is then flipped neatly into the air, caught, and swallowed. The bill of darters is therefore straight and pointed, without the hooked end, and bears serrations along its edges to prevent the fish from escaping. In many ways these adaptations have more in common with the unrelated herons than with cormorants, but whereas herons have downward-angled eyes to stalk their prey on foot, darters' eyes are forward-facing to hunt while swimming. All three families share the characteristic Z-shaped neck, which acts as a quick-release mechanism to thrust the head forward with alarming speed and precision. But in darters this feature is supremely accentuated. It's achieved by modifications in a single elongated bone that articulates with its neighbors on its upper and lower surfaces instead of at its ends. Simple but effective! In herons this is the sixth vertebrae, but in darters it's the eighth, which places the kink at the lower end of the neck, farther from the head. Presumably the explanation again lies in the darters' method of hunting while swimming, giving a different trajectory to the thrusting bill.

All three families—the cormorants, darters, and herons—also have a serrated inner edge to the claw of the middle forward-facing toe, which they use for cleaning fish slime from their feathers, and again this feature is particularly well developed in darters. Indeed, the serrations have been shown to be of exactly the same width as the feather barbs, though this is not consistent with all the bird groups that possess the feature.

Darters are freshwater birds of tropical swamps overhung with vegetation, and some of their differences from the more ubiquitous cormorants, which are both freshwater and pelagic, are the result of their adaptation to this specialized environment. For example, in order to steer the bird through the underwater maze of tree roots, the tail is especially long and powerful and may be aided by the wings, which are kept partially open underwater. The longer upper arm in proportion to the lower may play a part in this. The thighs, too, are longer and straighter than in cormorants to enable them to climb out of the water onto tree branches more efficiently. Darters habitually drop silently from an overhanging branch straight into the water in pursuit of prey and, despite having all four toes webbed, they are perfectly suited to their arboreal existence.

One very special feature of darters is their habit of swimming with only their head above the water's surface like a submarine's periscope, sometimes gradually disappearing altogether. Birds are naturally buoyant, due in part to the air spaces in their bones, and to remain submerged uses valuable energy. But darters' bones are among the densest of all birds' and have been described as positively sinkable! The thin neck and head protruding eerily from the water's surface have given them the alternative and very appropriate name of snakebird.

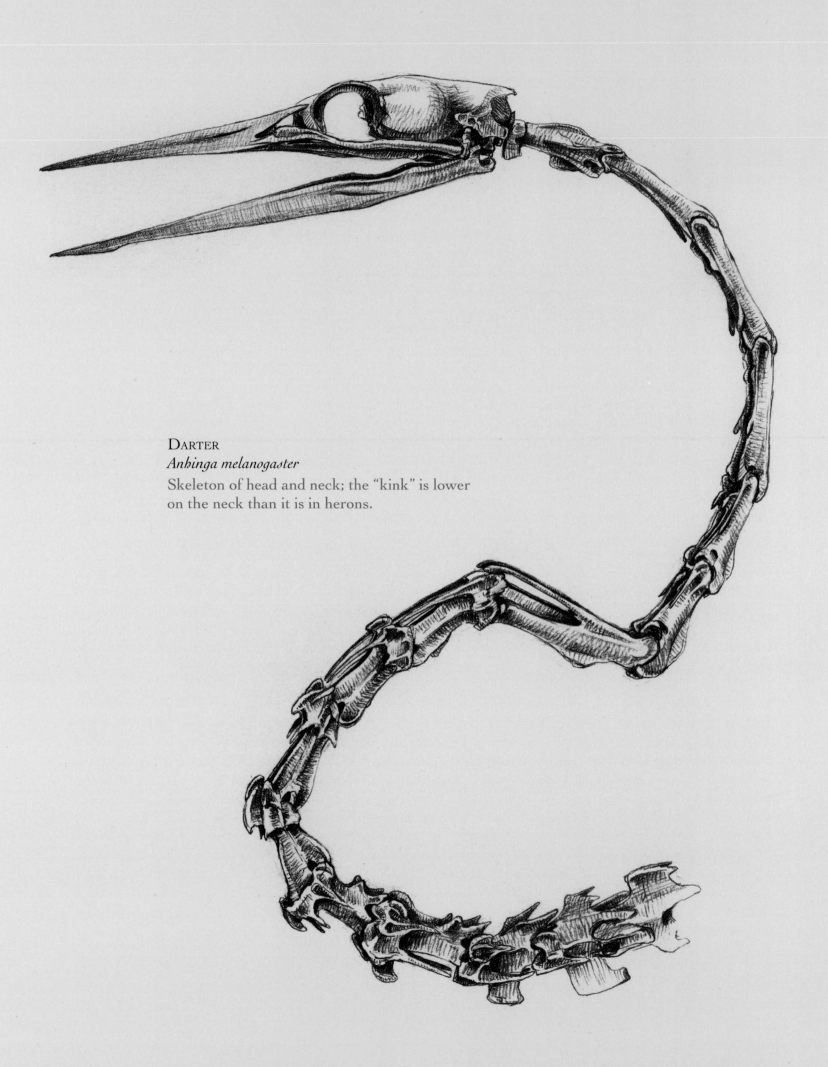

DARTER
Anhinga melanogaster
Skeleton of head and neck; the "kink" is lower
on the neck than it is in herons.

Gulls, Terns, Skimmers, and Skuas

"Specialism" is not a word that springs to mind in relation to gulls. Cosmopolitan, omnivorous, adaptable, and opportunistic, gulls have colonized the earth from the deserts to the poles, from teeming inner cities to remote wetlands. They are the great generalists of the bird world.

Their success owes a great deal to their anatomy. Gulls are equally at home on water, in the air, and on land. They run and walk with agility on long straight legs. The hind toe is small or even absent, giving them speed on the ground and allowing them to nest on flat surfaces such as the rooftops of buildings or on narrow ledges. They have webbed feet for swimming and long wings and powerful breast muscles for flight. They can take off almost vertically, maneuver in the air at low speeds while they locate food items, and drop down again with a minimum of effort.

Gulls are gregarious birds, and their predominantly white coloring advertises their presence to other gulls, so they can fully exploit available food sources. Their eyes contain minute oil droplets that filter out the effects of the sun's haze, allowing them to see over great distances. Long-distance vision is complemented by a long neck, a particular asset for incubating birds needing to keep a sharp lookout for predators while remaining concealed.

Their neck is wide, too, with a gullet and gape to match, enabling gulls to eat just about anything: fish large and small; frogs, worms, and other small animals; eggs, chicks, and even adult seabirds that they catch as they enter or leave their burrows; offal; carrion; discarded takeaways, household rubbish, maggots, and many more items too foul to mention.

Terns are altogether different birds, although they are closely related to gulls. Delicate and slender-looking, everything is longer: skull, bill, wings, and body—except their legs or, to be precise, their tarsi. Terns have disproportionately tiny feet and toes. They walk tolerably well but are less likely to run than gulls, and although the toes are webbed, terns never swim and some do not even have waterproof plumage. In contrast to gulls, terns have gone down the route toward specialization. They are only found near water and only eat fish or other aquatic animals, although one species has extended its menu to include marshland flying insects.

Similar in attitude to terns, with long wings and short legs, skimmers are nevertheless slightly more distantly related than terns are to gulls. Their streamlined appearance is accentuated by their remarkable bill, which sets them apart from all other birds. Viewed from the side the bill appears deep and looks a little like a bayonet at the end of a rifle—albeit a sharp-ended rifle and a very blunt bayonet—the lower mandible extending well beyond the tip of the upper one. From below, however, it's more like a letter opener; the sides of the bill suddenly shrink inward from their wide base to a wafer-thin blade. Skimmers use this blade like a ploughshare, flying back and forth along the same stretch of water with the lower mandible just breaking the surface. When they come in contact with a fish or small crustacean, their bill snaps shut, seizing it instantly.

The disparity in length between the two mandibles is all down to the horny bill sheath that overlies the bone of the jaws; beneath this sheath, there is little difference. The bill sheath grows continuously, the lower one at a faster rate than the upper, and is kept in check by constant abrasion against sand and submerged objects. Thus the relative length of the mandibles will change significantly throughout a bird's life, and no two birds are exactly alike.

Because their foraging method is predominantly tactile rather than visual, skimmers are able to feed both by day and by night. Their eyes are correspondingly highly adapted to both extremes; the enormous

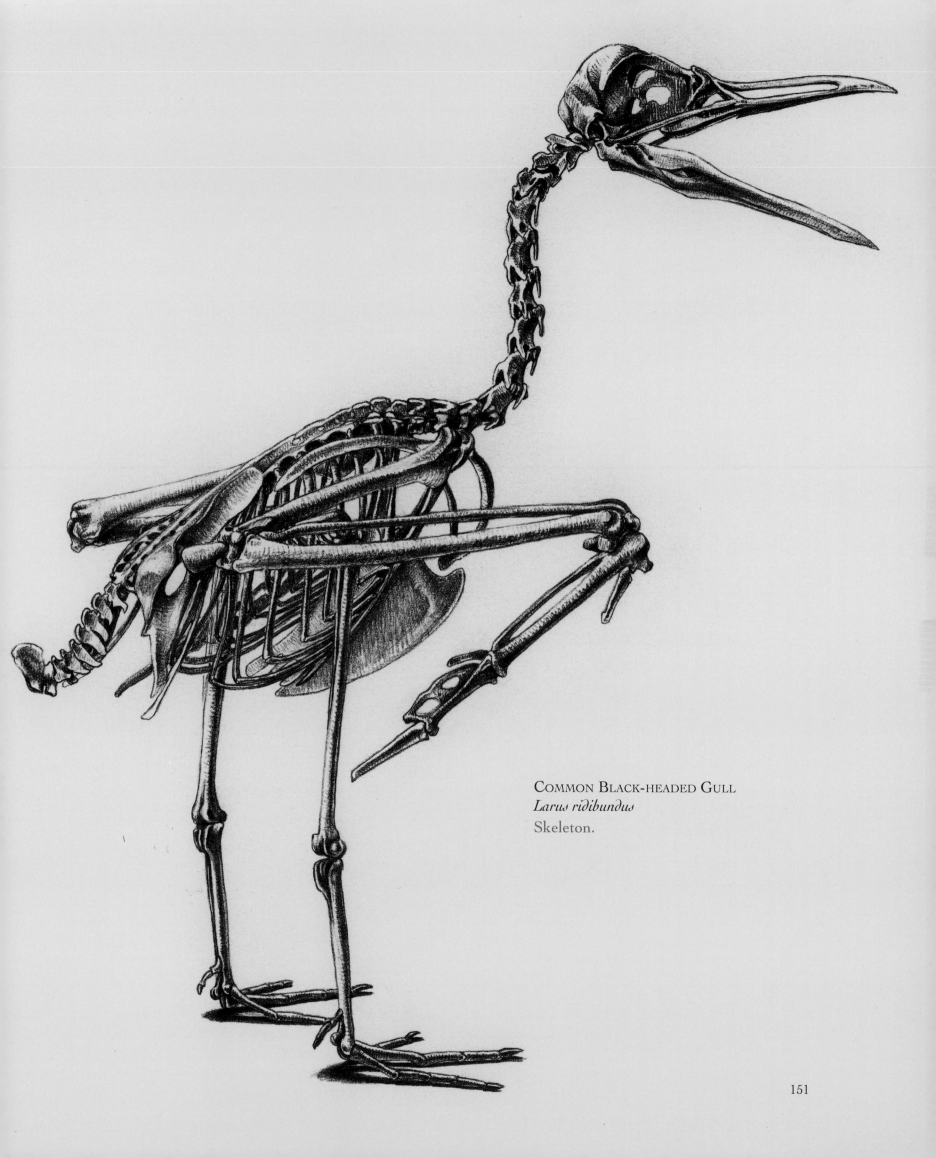

COMMON BLACK-HEADED GULL
Larus ridibundus
Skeleton.

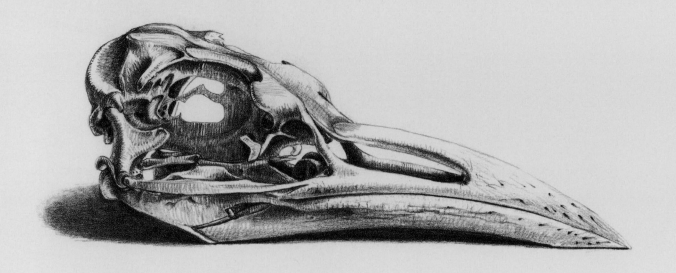

CASPIAN TERN
Sterna caspia

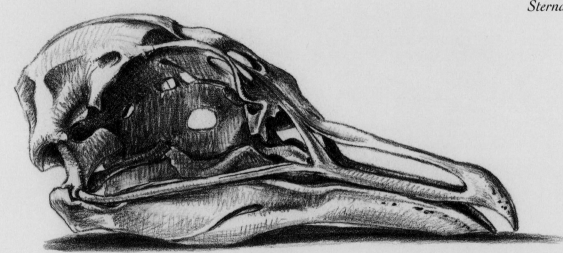

GREAT SKUA
Stercorarius skua

Skulls; and left foot of skua.

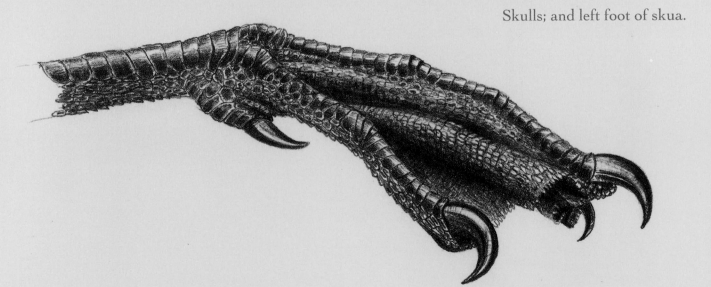

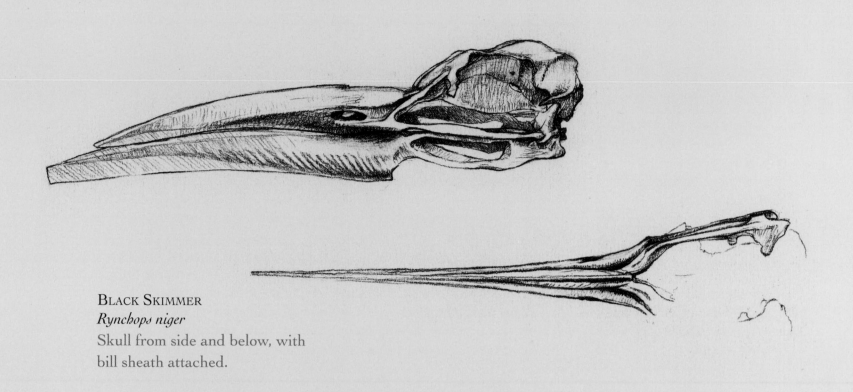

BLACK SKIMMER
Rynchops niger
Skull from side and below, with
bill sheath attached.

pupil contracting down to a thin vertical slit by day to protect the retina from the blinding glare of the tropical sun. Skimmers are the only birds to have vertical pupils.

Skuas are the fourth in the group of gull-like birds, and the relationships between gulls, terns, skimmers, and skuas has been much debated by taxonomists. Gulls are nevertheless the closest relatives of skuas and the two share many behavioral traits. But whereas piracy and predation are only two of many feeding strategies employed by gulls, skuas are specialized "seabirds of prey." They have a deeper breastbone for faster, more powerful flight, a shorter, more muscular neck for tearing, large talons on their webbed feet, and a powerful, hook-tipped bill.

Auks

Auks are the northern hemisphere's answer to penguins. They have the same upright posture on land, they're more or less black and white, they breed in colonies, and both are perfectly suited to a life in pursuit of marine fish. However, this is where the similarity ends. All these features are simply adaptations to their common niche and occurred independently of one another—a process called convergent evolution. Auks and penguins are not closely related at all and, despite the features common to most wing-propelled diving birds, their internal structure reveals some marked differences.

The principal difference is, of course, that penguins are flightless. They lost the power of flight far back in their evolutionary history in favor of adapting their wings and body to specialize in underwater propulsion. Flying and swimming make conflicting demands on a bird. The perfect body for flight is light and with a large wing surface, while the ideal swimming body is heavy and with small wings. Large wings underwater just create unnecessary drag, which is why auks, whose wings are as small as flight will allow, nevertheless swim with their wings half closed. Auk wings, however, are a compromise, enabling them to swim with excellence and fly with competence. The Guillemot, the largest of the living auks, is about the maximum size possible for a flying, wing-propelled diving bird, and it's no coincidence that it's roughly the same size as the smallest of the penguins. Any larger and the wrist joints would simply not be strong enough to propel the bird through the water.

But retaining the powers of flight has enabled the auks to colonize breeding sites far above sea level, exploiting narrow ledges on near vertical rock faces, out of reach of all but flying predators. And they have learned to compensate for the limitations of their small, narrow wings by utilizing the updrafts and air currents to full advantage.

However, not all of the auks could fly. By sacrificing their powers of flight Great Auks were able to reach a greater size than their flying cousins, and though their wings appear disproportionately small, they were of the perfect size to propel the birds swiftly and efficiently through water. Great Auks bred in colonies on low-lying rocky islands in the North Atlantic, and there they fared very nicely until their potential as an easy supply of food and feathers for passing sailors was discovered. They were harvested indiscriminately. Auks breed at a limited number of traditional sites that they slowly colonize over many years, so the rapid destruction of a single accessible species like the Great Auk was a simple accomplishment. One of the few remaining strongholds in the early nineteenth century was the island of Geirfuglasker, off Iceland, and by a cruel twist of fate the entire island was destroyed—sunk, by volcanic activity in 1830. Tragically, the species was ultimately annihilated—not for food but for its rarity value; large sums of money being offered for specimens or eggs by wealthy collectors. The last recorded pair was killed "to order" on July 3, 1844, on the island of Eldey where a few birds had continued to breed after the destruction of neighboring Geirfuglasker. Allegedly the female was incubating, but the egg was smashed in the scramble to procure the specimens.

The broken skull of the bird pictured here was presumably caused when it was bludgeoned to death for one such collector. This individual has also been mounted incorrectly, with the ribcage unnaturally expanded.

The similarity between the Great Auk's original name (also part of its scientific name)—Pinguinus—and the word "penguin" is not accidental. Early travelers in Antarctica, familiar with the auks of the northern hemisphere, immediately recognized the likeness between the two groups and simply applied the same name to both.

When swimming underwater, auks raise and lower their wings in a half-closed position, with the leading edge doing most of the work, effectively using them as short, stout paddles. The action is completely different from that used in flapping flight. In flight, the downstroke encounters the most resistance from the air, with

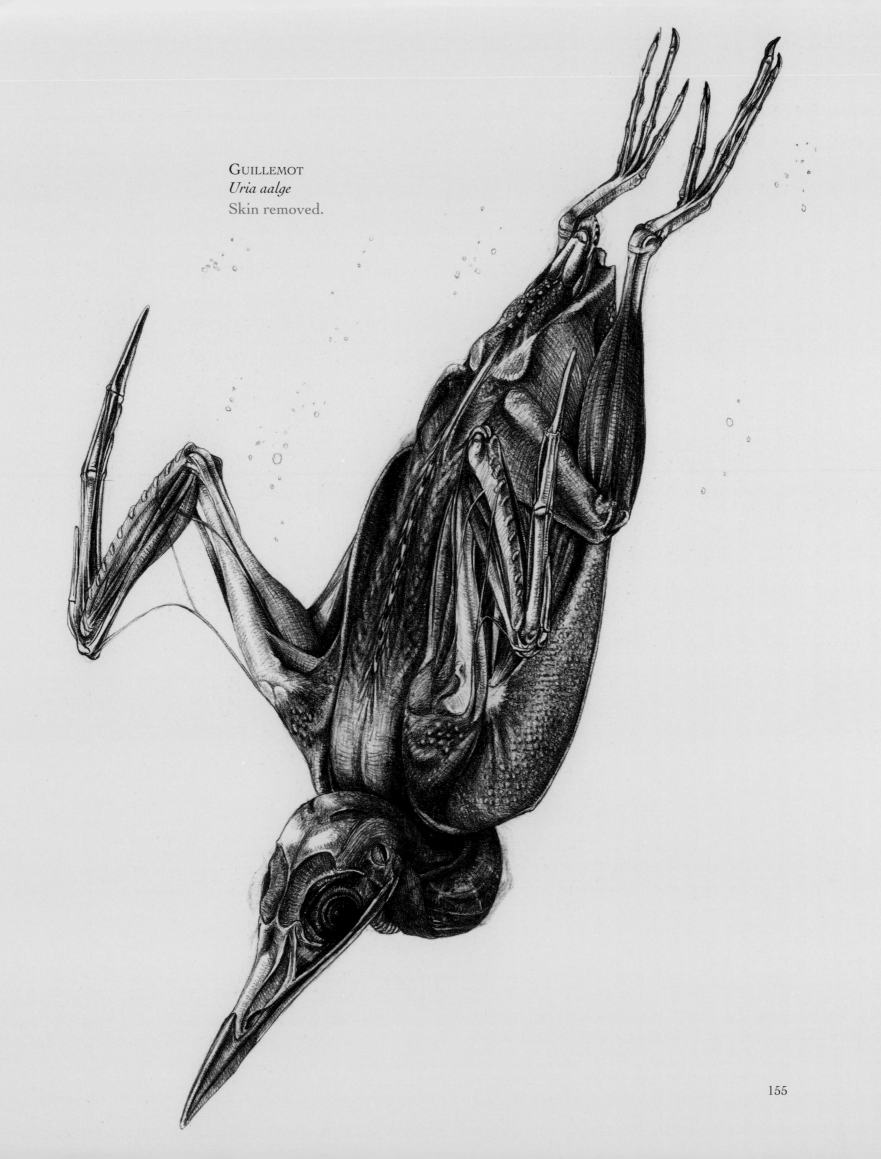

GUILLEMOT
Uria aalge
Skin removed.

155

the upstroke being mostly a recovery movement. Underwater, however, both the up and down movements of the wing push the bird along. The muscles required for both the upstroke and the downstroke are situated, one above the other, along the bird's breastbone, which has a well-developed keel to accommodate this. So even flightless species, such as the Great Auk, had a large keel like a flying bird, but for an entirely different purpose.

The wing bones of auks are also rather broad and flattened, maintaining strength but reducing drag as they cut through the water with their narrow leading edge, though nowhere near to the same degree as those of penguins.

Many seabirds have a depression in the skull above each eye socket where the salt excretion glands are situated, and in the auks this is especially extreme. The perforations in the bone in this region may be an indication of the bird's age, with the holes gradually becoming smaller as the bone continues to develop.

The brightly colored, grooved bill of the Atlantic Puffin makes it one of the most popular of birds. However, after the breeding season, the bill takes on an altogether different appearance, which for many

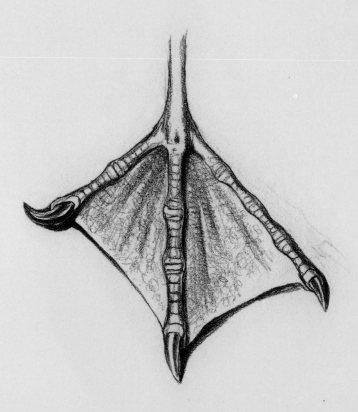

ATLANTIC PUFFIN
Fratercula arctica
Left foot showing inward-pointing inner claw.

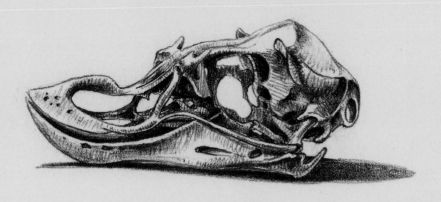

PARAKEET AUKLET
Aethia psittacula

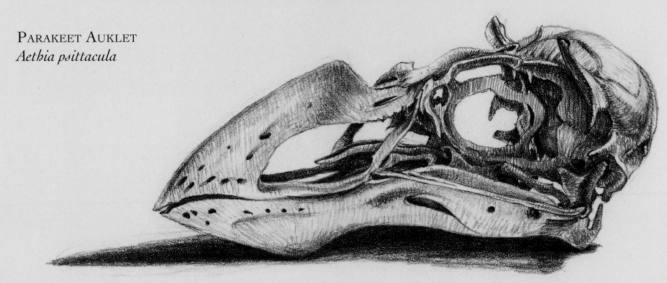

ATLANTIC PUFFIN
Fratercula arctica
Skulls; puffin bill sheath in winter (left)
and summer (below).

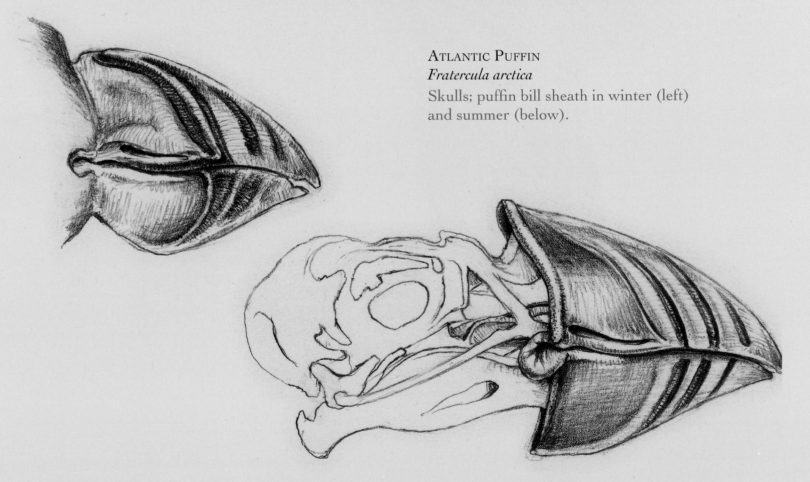

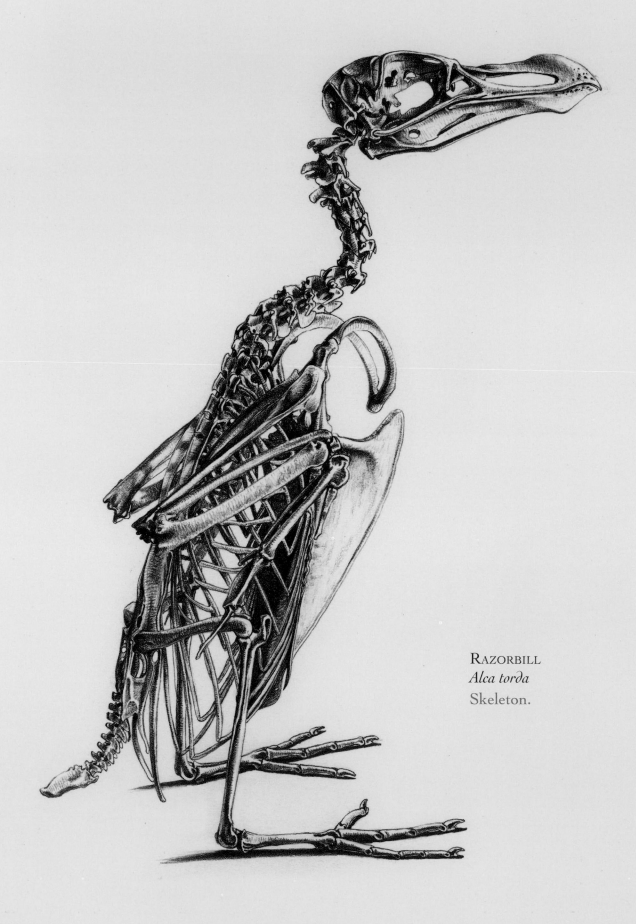

RAZORBILL
Alca torda
Skeleton.

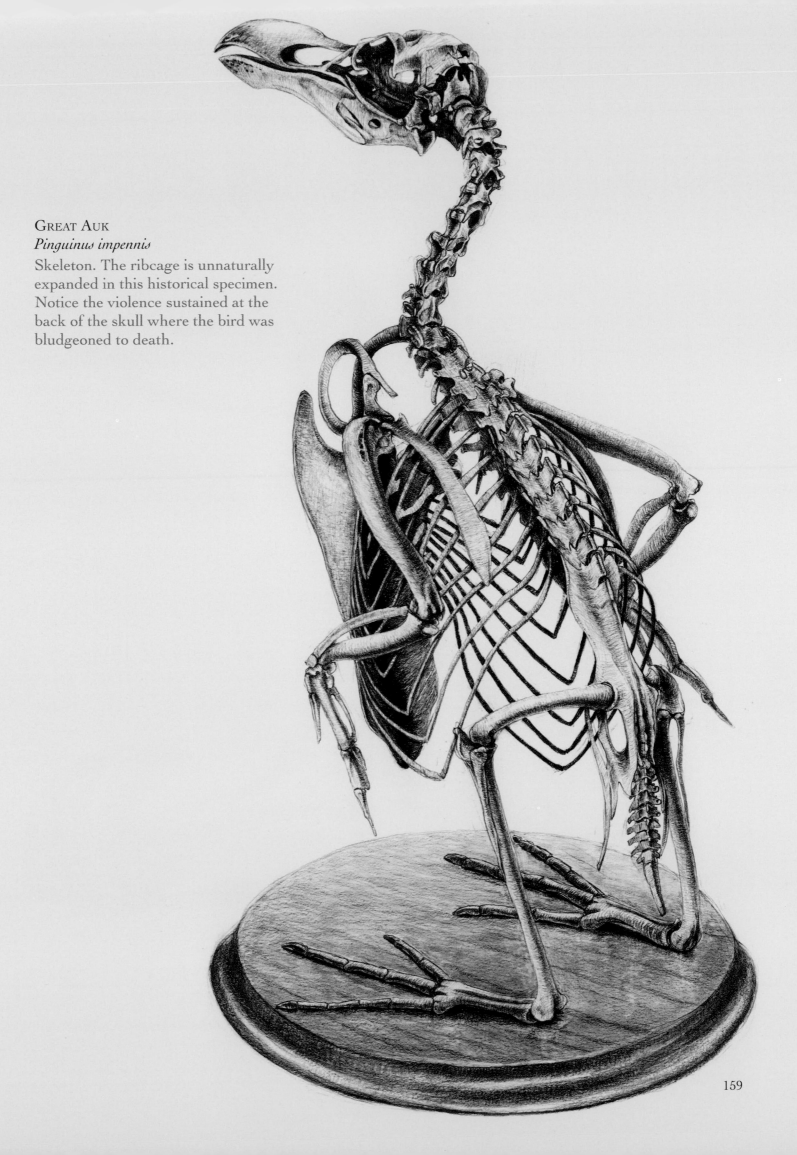

GREAT AUK
Pinguinus impennis
Skeleton. The ribcage is unnaturally expanded in this historical specimen. Notice the violence sustained at the back of the skull where the bird was bludgeoned to death.

GUILLEMOT
Uria aalge

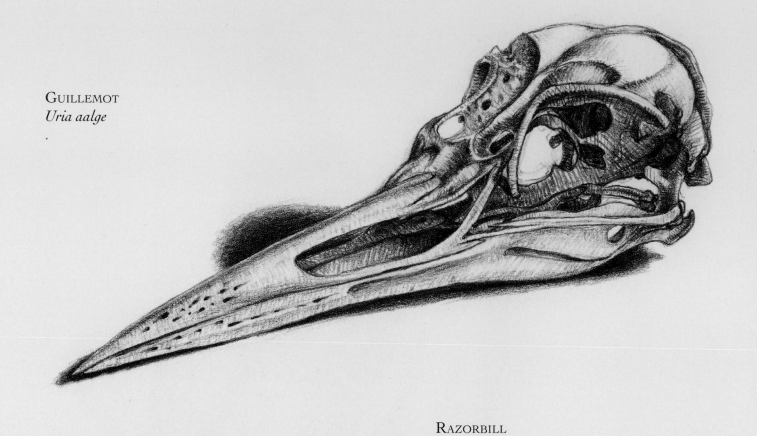

RAZORBILL
Alca torða

Skulls; Razorbill has bill sheath still attached.

years convinced scientists that they were observing two distinct species. Although the bill sheath itself remains in place, the nine plates of yellow and blue that cover the base of the bill, along with the ornamentation above and below the eye, are shed separately, revealing dark skin beneath from which new plates will have grown by the following spring. The bill's large size is for display only and has no connection with their ability to carry multiple fish. This is achieved by trapping the fish between their long, fleshy tongue and horny spines protruding from the upper palate.

Auks have three forward-facing, webbed toes with the hind toe absent or poorly developed. In puffins, which need strong claws to excavate burrows, the inner claw is turned inward, which prevents it from becoming worn down on rocky surfaces. As auks do not use their feet to propel them while diving, their tarsus is short and rather rounded in cross section—not flattened like a loon or a shearwater. Birds needing to propel themselves quickly across the water's surface are most likely to do so with a "paddle steamer" motion of their wings—a particularly endearing habit of puffins.

IV GRALLAE

Bill subcylindrical; *legs* formed for wading, having all the toes distinct; thighs half naked; *body* compressed, covered with a thin skin; flesh delicate; *tail* short; *food* marsh animalcules; *nest* chiefly on the ground. They live variously.

This was an order of long-legged waterbirds: large ones like flamingos, storks, and herons, and the more diminutive waders and rails. It fits in rather well with the traditional modern orders—the Ciconiiformes, Gruiformes, and Charadriiformes—if you ignore the odd gull, auk, and hemipode, that is. But it's likely that the taxonomists of the near future will really throw the cat among the pigeons. The Shoebill is almost certainly more closely related to pelicans than it is to storks, though this was suggested at the very beginning. Meanwhile the storks' relationship to the New World vultures is still under debate, and no one really knows what a flamingo is!

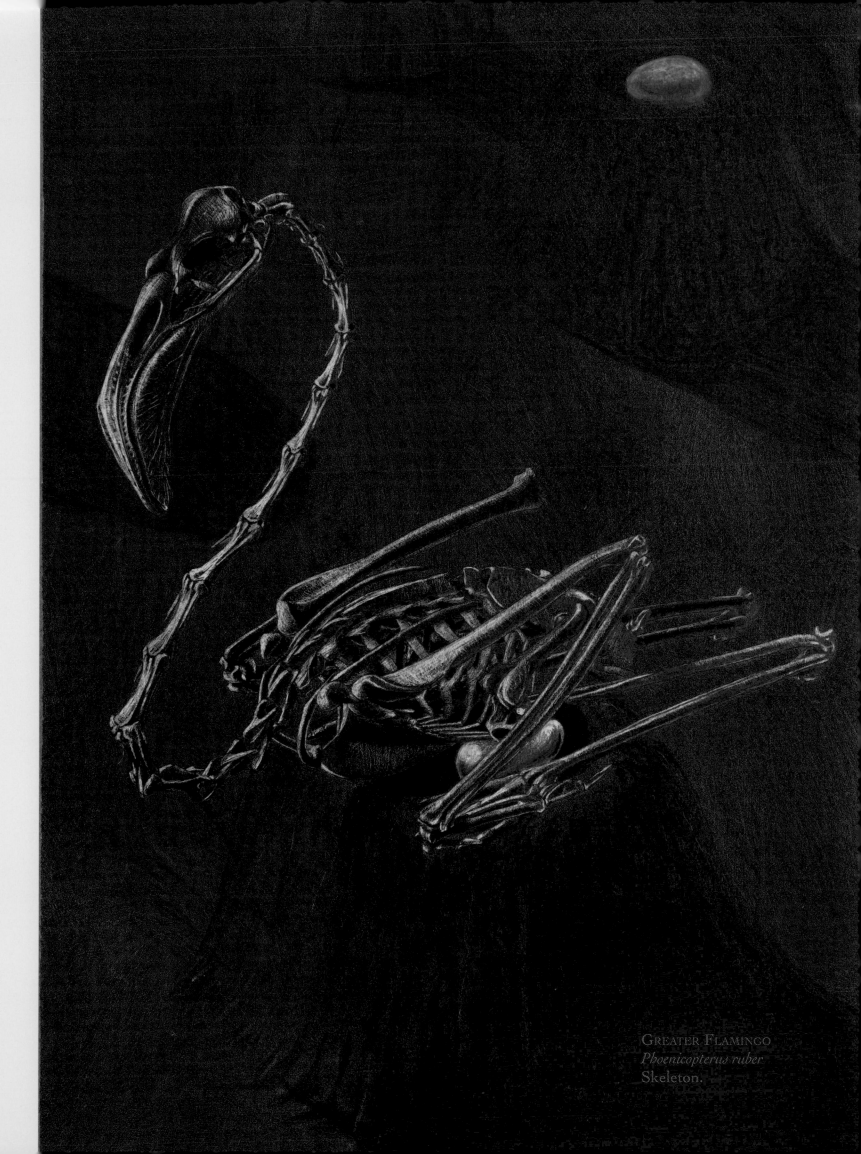

GREATER FLAMINGO
Phoenicopterus ruber
Skeleton.

Flamingos

It's a pity we take flamingos so much for granted. Their color and proportions are almost too bizarre for the imagination, and their tolerance for extreme environmental conditions approaches the supernatural. It's not surprising that they have long been steeped in folklore and even identified with the mythical phoenix. The family name—Phoenicopteridae—actually stems from the word "phoenix." They are certainly unlike any other bird, and even after decades of research, taxonomists still have little idea where to put them.

Superficially long-legged, long-necked waterbirds, flamingos were traditionally placed alongside storks, herons, and ibises in the order Ciconiiformes. The skeletal and muscular anatomy certainly has much in common with these, but flamingos have other characteristics that raise questions as to whether they should, instead, be classified with the geese: their voice, for one; their nesting behavior and the development of the chicks; and, perhaps most significantly, the structure of the bill and tongue. Geese and flamingos also share the same feather parasites—an important clue to their affinities, as feather parasites are host-specific and cannot change from one bird group to another. It's also possible that flamingos are related to the avocets and stilts. These come closest in the matters of feeding strategy and habitat, and the similarities shared with the Australian Banded Stilt, in particular, do seem to be more than coincidental. But just as taxonomists had decided that it was perhaps best to simply create a new order just for flamingos and have done with it, DNA research began to yield still more outlandish and conflicting results, suggesting common ancestors with the grebes and, still more bizarrely, with the nightjars, swifts, and pigeons!

Whatever they are, flamingos are certainly different. The very long, thin legs and long neck are longer, in relation to body size, than those of any other bird. The legs appear longer still, as the soft tissues covered in feathered skin (i.e., the muscles controlling the lower leg) are confined to the very top of the tibia, just below the knees. (Remember that the knees are concealed within the skin of the trunk.) In other words, flamingo legs are scaled right up to the level of their belly, allowing them to wade in *very* deep water.

The majority of long-legged birds need a long neck so that they can reach the ground (although there are plenty of short-legged birds with a long neck and even a few long-legged birds with a short neck). The long neck of flamingos not only enables them to submerge their head to reach the mud at the bottom of deep water but has sufficient length for them to sweep their head from side to side in a wide arc when feeding in shallow water.

Although their neck is long, flamingos actually have fewer neck vertebrae than many other long-necked birds; only seventeen compared with a swan's twenty-four, for example. But having fewer vertebrae doesn't necessarily mean that the neck is shorter. The bones themselves are longer. This shows as a series of angles like a dot-to-dot puzzle when the bird bends its neck rather than as a continuous smooth curve.

In addition to wading, flamingos can also swim. It presents a strange spectacle, the birds swimming high in the water and looking for all the world like pink swans. Like swans, too, they sometimes up-end while swimming in order to reach the bottom with their bill. Their three forward-pointing toes are fully webbed—not incompletely so like those of avocets—and the hind toe, not present in all species, is small and raised above the ground. Like other long-legged waterbirds, flamingos readily stand on one leg to rest and have been observed to "lock" their raised leg in this position.

The bill is shaped rather like a boomerang: sharply angled downward in the middle. After the bend, the upper mandible flattens out like a lid on top of the much deeper lower mandible. In the usual feeding posture the head hangs directly downward, facing the water, so that the bill tip is horizontal. Flamingos don't feed with their head upside down, as is commonly believed—it's only the bill tip that is upside down.

The thin upper mandible enables the bird to feed both in really shallow water and close to the bottom in

deep water. This is particularly important in Greater Flamingos, which are essentially bottom-feeders. The Lesser Flamingo has a somewhat thicker upper mandible (as well as a subtly different bill structure) and therefore specializes in surface feeding, predominantly on floating algae, allowing the two species to share the same habitat with a minimum of competition.

Flamingos are filter-feeders, like baleen whales. The deep lower mandible houses a large and muscular tongue that moves backward and forward to create suction and expulsion forces in exactly the same way as a plunger in a syringe. Microscopic food particles—algae, small mollusks, and other invertebrates—are mechanically sucked in with the water or mud and trapped in the comb-like and hairy lamellae that protrude inward from the bill's sides. The water is then ejected at the rear of the mouth, and the organisms can

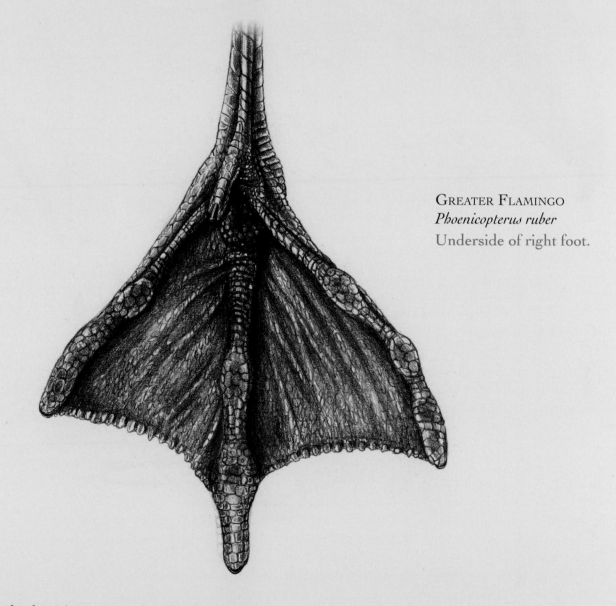

GREATER FLAMINGO
Phoenicopterus ruber
Underside of right foot.

be swallowed. To do this it's important to closely control the gap between the two mandibles, keeping the distance between them consistent throughout their length, and it has been suggested that the L-shaped bill is of benefit here, as a straight bill would open in a wide arc.

Flamingos get their pink coloration from the carotenoid proteins contained in their food—either directly from the algae that produces it or indirectly from the animals that feed on the algae. The proteins are then deposited in the feathers and skin as pigment. Although their coloration is a byproduct of what they eat,

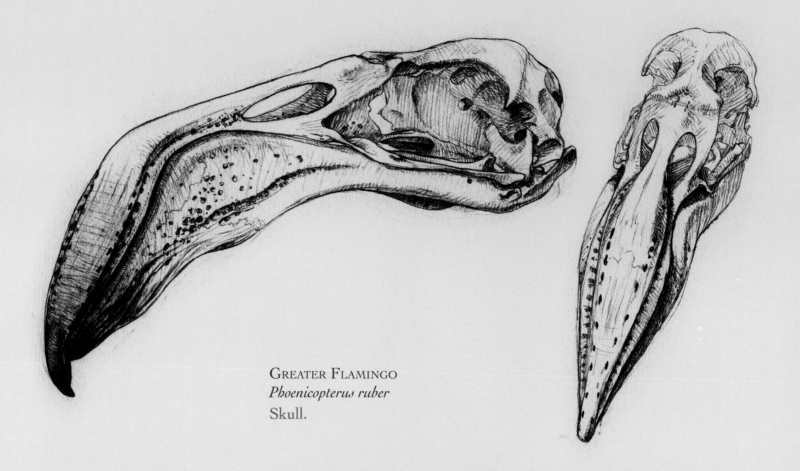

GREATER FLAMINGO
Phoenicopterus ruber
Skull.

flamingos nevertheless need to be pink in order to stimulate breeding. In zoos, before the appropriate pigment became commercially available as an artificial food supplement, captive birds quickly faded to grayish-white and would not breed.

Flamingo chicks—like the chicks of pigeons—are fed by their parents on a protein-rich, fatty "milk" of the consistency of cottage cheese, produced by the lining of the upper digestive tract. Despite our familiarity, through the media and popular imagery, with flocks reaching vast numbers, flamingo *breeding* behavior has, until recently, been shrouded in mystery and there are still many questions left unanswered. Their colonies are often situated in some of the most inhospitable places on earth—saline lagoons and soda lakes whose corrosive atmosphere would literally strip the flesh off of most vertebrates. Flamingos are seemingly as resilient as the algae and invertebrates they feed on, and are able to thrive under conditions impossible for any other animal to even survive. They will even drink water that is virtually at boiling point. Like seabirds, they excrete excess salt from glands situated above their eyes, which is then ejected via their bill. But the saline conditions favored by flamingos may have over twice the salt concentration of seawater. Flamingos really are very special birds indeed and, with their carmine wings, emerging from the intense chemical heat of the tropical salt lakes, certainly worthy of the name "phoenix."

Herons

With their large rounded wings, flamboyant plumes, and great height when standing, herons give the impression of being sizable birds. In flight in particular, they appear enormous. But in fact, beneath the extravagantly long and loose feathering, a heron's body is deceptively small.

It is also remarkably narrow; in fact the whole bird is rather flattened. Even the coracoids—the struts of bone that extend on either side of the breastbone to support the wings—are overlapped at their base in some species, to minimize the width of the bird. With a little cryptic camouflage, from head-on a heron can virtually disappear, compressing its feathers against its sides and freezing motionless; perhaps even swaying a little with the surrounding vegetation. Bitterns—a shorter-necked subgroup of the heron family—are particularly adept at disappearing. When threatened a bittern will point its bill directly upward and stiffen its body; invisible except for its piercing yellow eyes directed forward toward the source of danger.

Herons are built around the forward thrusting action of their dagger-like bill. Their neck, like the neck of cormorants and darters, has a permanent kink in it, the result of a single elongated vertebra that attaches to its neighbors at a right angle instead of end to end. In herons, however, this is the sixth vertebra from the skull, whereas in cormorants and darters it is the eighth, meaning that the kink in a heron's neck is slightly higher up the neck, closer to its head. The kink forms a sort of hinge mechanism, enabling the bird to lunge forward with lightning speed and astonishing precision. The shock of impact is absorbed by ligaments between the vertebrae. Considering the strength required, the bones of the neck are perhaps surprisingly slender, but they have well-developed backward-pointing spines that act as points of attachment for long, thin muscles and tendons running along the neck. These give tremendous power to the forward thrust but considerably reduce the capacity for lateral movement.

The relative lack of flexibility in the neck, however, is compensated by exceptional vision and an extensive field of view. The eyes are large, especially in nocturnal species, and have a degree of maneuverability within the eye socket unusual in birds. They have not only virtually all-around monocular vision but a narrow angle of binocular vision directly ahead and below. This allows them to accurately pinpoint the precise location of prey, judge distances, and compensate for the refraction of the water while looking out for predators at the same time!

Most herons hunt in either a crouched or an upright posture. They have the uncanny ability to keep their head motionless while their body is moving, enabling them to maintain visual contact with their prey while they position themselves for the attack. Similarly, when lunging, the body may remain still while only the neck is thrust forward or, in shorter-necked species, the feet may remain as though glued to the spot while the entire body is hurled forward. They often seem to defy gravity, hunting from steep banks or overhanging branches as though suspended from invisible wires. The family has also employed a wide variety of less conventional hunting techniques including agitating the water with their feet, using bait to attract fishes, and forming a sheltered canopy, like an umbrella with their outspread wings. The streamlined bill, head, and neck cause a minimum of disturbance to the water's surface, allowing the bird to make repeated lunges in the same area without the need to move on.

Herons have a subtle variation in bill shape according to the prey taken and the feeding method employed, though (in all but the Boat-billed Heron) it is always long, straight, and sharply pointed. Writhing, slippery prey is prevented from escaping by serrated edges to the horny bill sheath.

The legs are long, particularly the tarsi, though they are shorter in species that feed from overhanging vegetation or riverbanks. The toes, too, are long and well developed even in young nestlings, enabling them

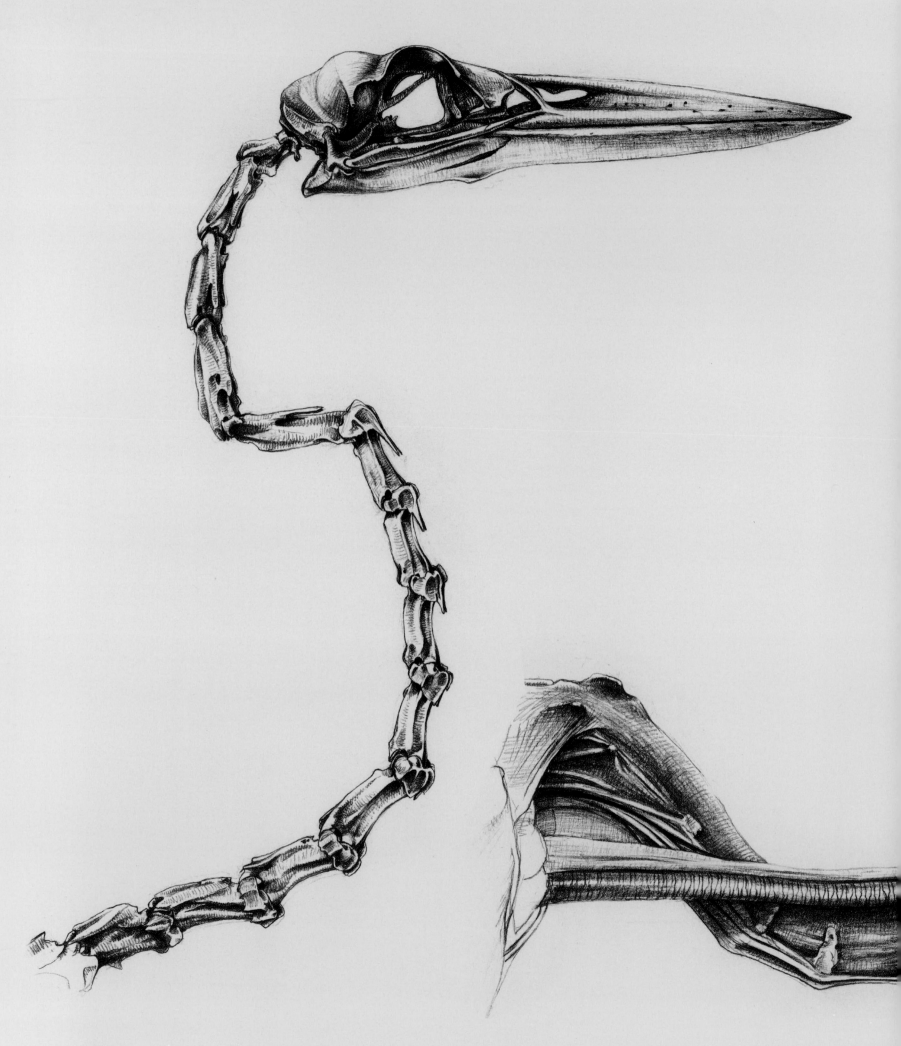

to leave the nest and clamber about in the treetops long before they are capable of flight. The more terrestrial species have the shortest toes. Bitterns, which climb about in thick reed-beds as much as they wade, have the longest, as well as proportionally longer claws. Bitterns are moreover unusual in that their inner toe is longer than the outer—the reverse of true herons and most birds in general. With such an apparently awkward arrangement, it's not unusual for them to tread on their own toes when standing.

All herons have a serrated, or pectinated, inner edge to their middle claw that they use for preening and cleaning fish oil from their plumage. This feature has a disparate occurrence throughout the bird world that cannot be easily explained. In some groups it has a clear link to feather maintenance, with the serrations neatly corresponding to the width of the individual feather barbs, though in others the reason is more obscure.

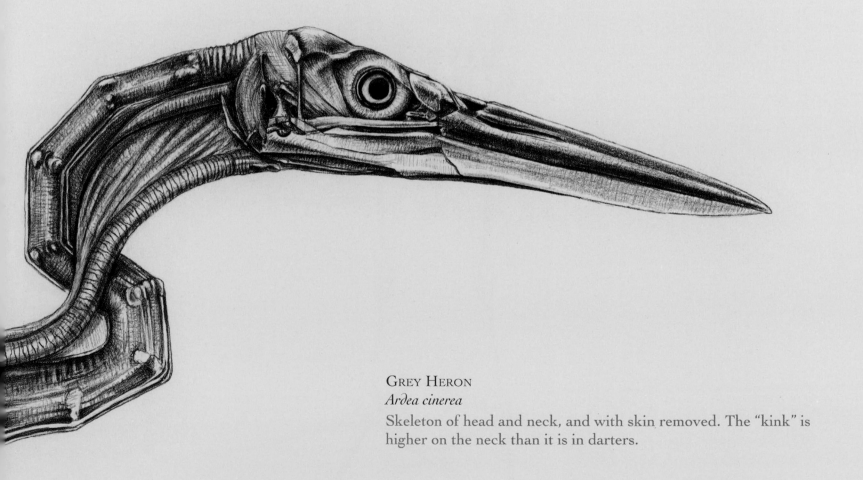

GREY HERON
Ardea cinerea
Skeleton of head and neck, and with skin removed. The "kink" is higher on the neck than it is in darters.

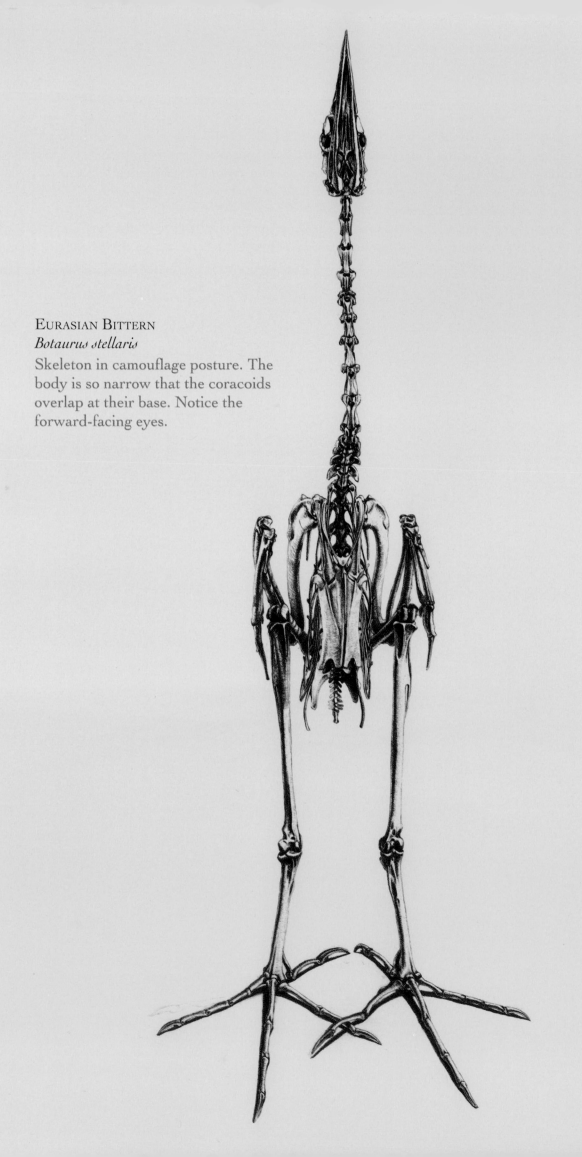

EURASIAN BITTERN
Botaurus stellaris
Skeleton in camouflage posture. The
body is so narrow that the coracoids
overlap at their base. Notice the
forward-facing eyes.

Most birds maintain their feathers primarily with oily secretions from their preen gland, situated above the tail, and herons, too, have a small preen gland. However, some groups of birds, including herons, supplement or even replace this by preening their feathers with a fine powder generated by specialized patches of downy feathers called powder down. Powder down feathers are in a constant phase of growth and disintegration; as fast as they grow, they break down to powder. In herons they are arranged in pairs in strange, mossy-looking clumps. Bitterns have only two pairs and the majority of true heron species, three. Storks, ibises, and spoonbills lack powder down, though it is present in another stork-like bird whose affinities are something of a mystery—the enigmatic Shoebill.

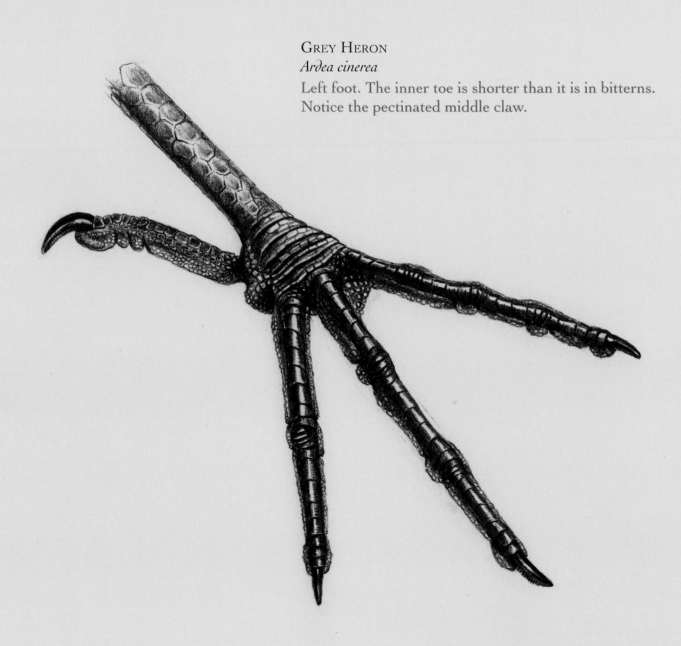

GREY HERON
Ardea cinerea
Left foot. The inner toe is shorter than it is in bitterns. Notice the pectinated middle claw.

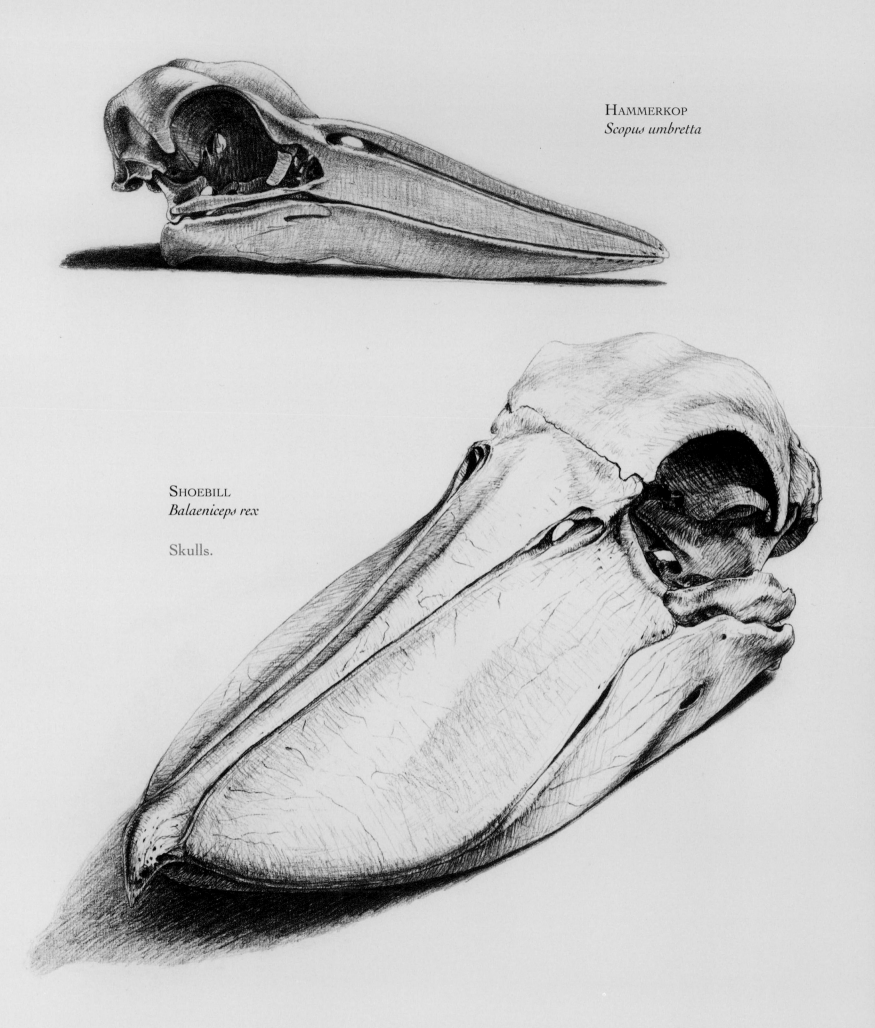

HAMMERKOP
Scopus umbretta

SHOEBILL
Balaeniceps rex

Skulls.

172

Shoebill

The jury is still out as to what a Shoebill actually is. For the present it has been placed in a family of its own within the order Ciconiiformes, alongside storks, herons, ibises, spoonbills, and another bizarre heron-like bird, the Hammerkop. It has long been considered a type of stork, giving occasion to its alternative names of "Shoe-billed Stork" and "Whale-headed Stork."

It was the nineteenth-century English ornithologist and publisher John Gould who first described the species, and he who suggested that the Shoebill might actually be most closely related to the pelicans, a theory now positively supported by DNA and osteological evidence. The current opinion is that the pelicans probably belong with the Ciconiiformes (and not with the cormorants, gannets, etc.), with the Shoebill and Hammerkop representing a link between them.

The bird, as its name suggests, has a wide, heavy bill, rather upturned like a wooden shoe. Adapted primarily for hunting large prey, the curious bill is also used to carry water to the nest to cool the eggs and chicks. The skull does indeed share similarities with that of the pelicans, and the bill is likewise tipped with a strongly hooked nail, though it also bears a superficial resemblance to the Boat-billed Heron.

But unlike pelicans and other members of the Pelecaniformes, Shoebills do not have all four toes webbed. In fact the toes, which are very long for walking in swampy terrain and on rafts of floating vegetation, are not webbed at all. Like herons, Shoebills have powder down, a feature again not shared by storks or pelicans and their traditional allies.

In flight Shoebills tuck their head far back on their shoulders—necessary, presumably, because of the tremendous weight of their bill. In this they resemble both herons and pelicans but not storks, which fly with their neck fully outstretched. The heavy-billed Marabou Stork, however, is the exception to this rule, so clearly this is not a reliable characteristic in an argument against the Shoebill being allied with the storks.

Whatever it is, the Shoebill remains one of the most bizarre and iconic of all birds. Rare, shy, and seldom seen, it remained undiscovered until the middle of the nineteenth century. It inhabits the dense papyrus swamps of tropical east Africa where it preys on a variety of aquatic vertebrates, most notably the large and powerful lungfish. Although so bulky and large-headed a bird does not have the powers of concealment of a slender heron, Shoebills nevertheless approach their prey with considerable stealth. They hunt by either waiting motionless or walking slowly forward, their head pointing downward. They have excellent binocular vision, with both eyes facing forward, to perfectly judge their striking distance and compensate for the water's refraction. A striking Shoebill throws its entire weight at its prey, lunging forward into the water on top of it. The enormous bill not only engulfs the victim but acts as a shock absorber against the impact. But there all dignity is left behind. With a writhing fish to contend with, regaining its legs is a clumsy matter and the bird rights itself only with difficulty, often with the help of its wings.

Storks, Ibises, and Spoonbills

The Ciconiidae—the storks—together with the ibises and spoonbills, which form the family Threskiornithidae, traditionally share the order Ciconiiformes with the herons (and a few unique oddities—the Shoebill and Hammerkop—thrown in). All long-billed, long-legged, long-necked wading birds, storks, ibises, and spoonbills are superficially similar in structure to the herons but are more *three-dimensional*. Herons are lightweight in form and flattened at the sides—for camouflage and for walking among reeds and other vegetation. Their entire anatomy is geared toward looking for, lunging after, and catching prey in a *forward* direction. Storks, by comparison, are birds of more open areas and consequently have a much broader, more thick-set body. The neck vertebrae are also very different in structure—each bone is shorter and stouter, and the neck lacks the herons' distinctive kink. Herons rely on a mechanical forward thrust of their neck to catch prey, whereas storks, ibises, and spoonbills have different feeding strategies, and all employ a greater degree of sideways movement of their head and neck while foraging.

Their methods vary. The large-billed Marabou Storks are part of the crowd among hyenas, jackals, and vultures feeding on the carcasses of large mammals on the African plains, though they feel equally at home hanging around abattoirs and village rubbish dumps. They will happily wade through long grass, snapping up all the small birds they flush out along the way, and even habitually catch and kill adult flamingos! White Storks and other "normal-billed" species are omnivorous and will forage on land or in water for a variety of small animal and vegetable material, while the curved-billed storks of the genus *Mycteria* are more specialized hunters of aquatic organisms. Once thought to be ibises rather than storks, they earned the name "wood ibises," a name that was translated to "Wood Stork" (for the American species) when their true affinities were realized. But the *Mycteria* storks do have much in common with ibises. Like them they inhabit murky swamps where the underwater visibility is poor, and the birds rely heavily on their highly sensitive bill to feel for the presence of living prey. This means that they can also hunt at night. They walk through the water, head down and bill slightly open, and the moment contact is made—it automatically snaps shut. And finally the spoonbills. Rather than probing or trawling, they sweep the surface of the water in a scythe-like motion with their flattened, spatula-shaped bill, filtering out tiny organisms.

Storks have a broad but very short breastbone, with a deep and rounded keel that is firmly attached to the wishbone. The body appears tiny compared to the long wings, neck, and legs. But storks are nevertheless strong fliers and, once airborne, conserve energy by soaring on motionless wings using thermals of warm rising air. Herons, by comparison, seldom utilize thermals, despite their similarly broad wings; indeed the relative length of their wing bones are very different. The forearm of storks greatly exceeds the upper arm and hand sections in length, whereas in herons it is only slightly longer, giving storks ample space for the attachment of a wide airfoil of secondary flight feathers. Unlike herons, which fly with their head pulled back close to the body, storks, ibises, and spoonbills fly with their neck extended, though the Marabou Stork, with a truly enormous bill to carry, is, not surprisingly, an exception to this rule.

Like many "top-heavy" birds, storks support the weight of their head and bill by strong muscles anchored to the vertebrae between their shoulders. These vertebrae have prominent crests to increase the area for muscle attachment, giving the birds their hunchbacked appearance.

The legs of storks are exceptionally long—for taking long strides, as well as for wading in deep water—but with proportionately short thighs. This gives the family its upright posture, as the body needs to be held almost vertical to keep the center of gravity above the feet. Because most storks are generally less aquatic in their habits than herons, the toes are somewhat shorter, and the hind toe is raised slightly above

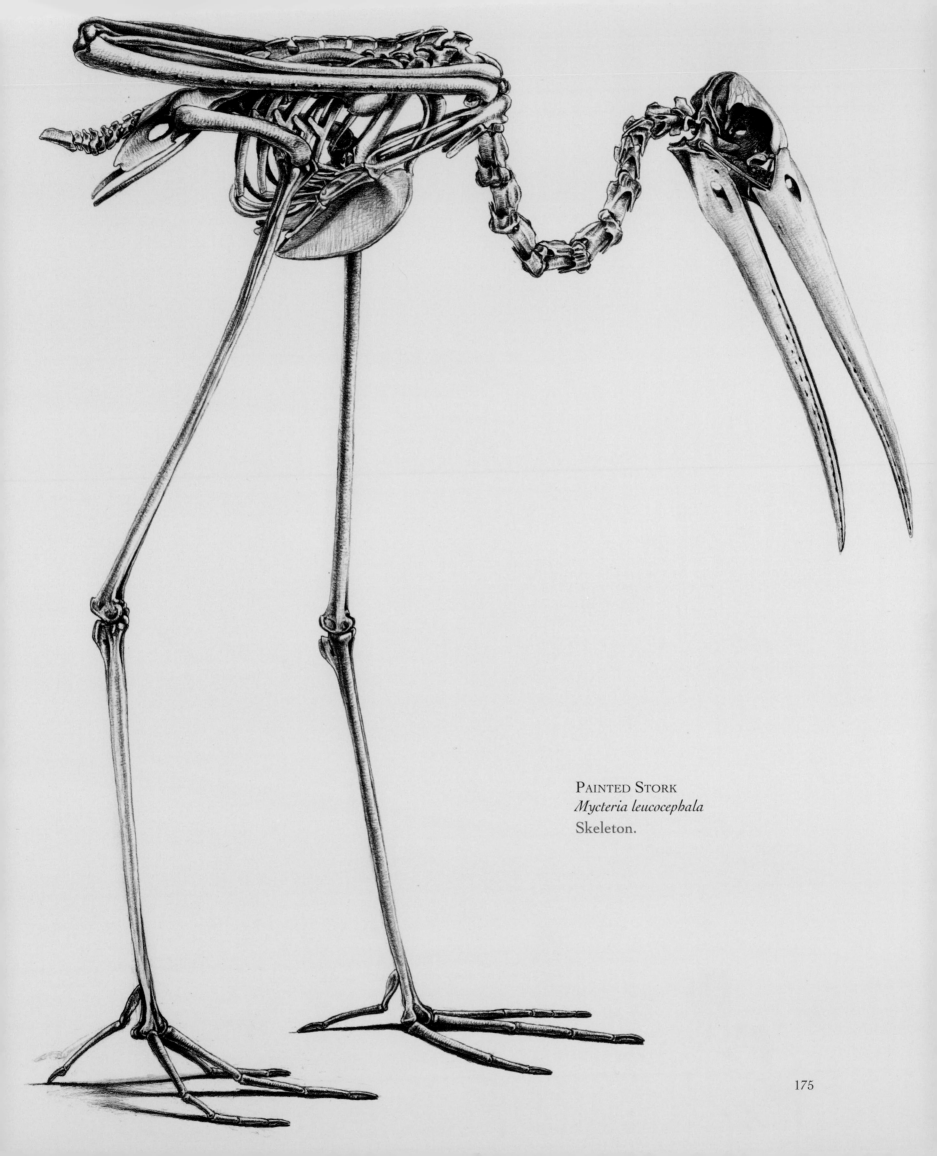

PAINTED STORK
Mycteria leucocephala
Skeleton.

175

MARABOU
Leptoptilos crumeniferus

Skulls.

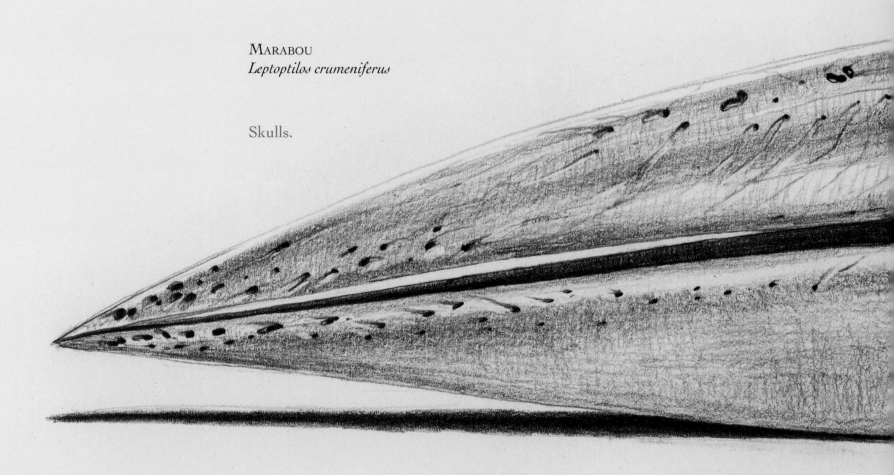

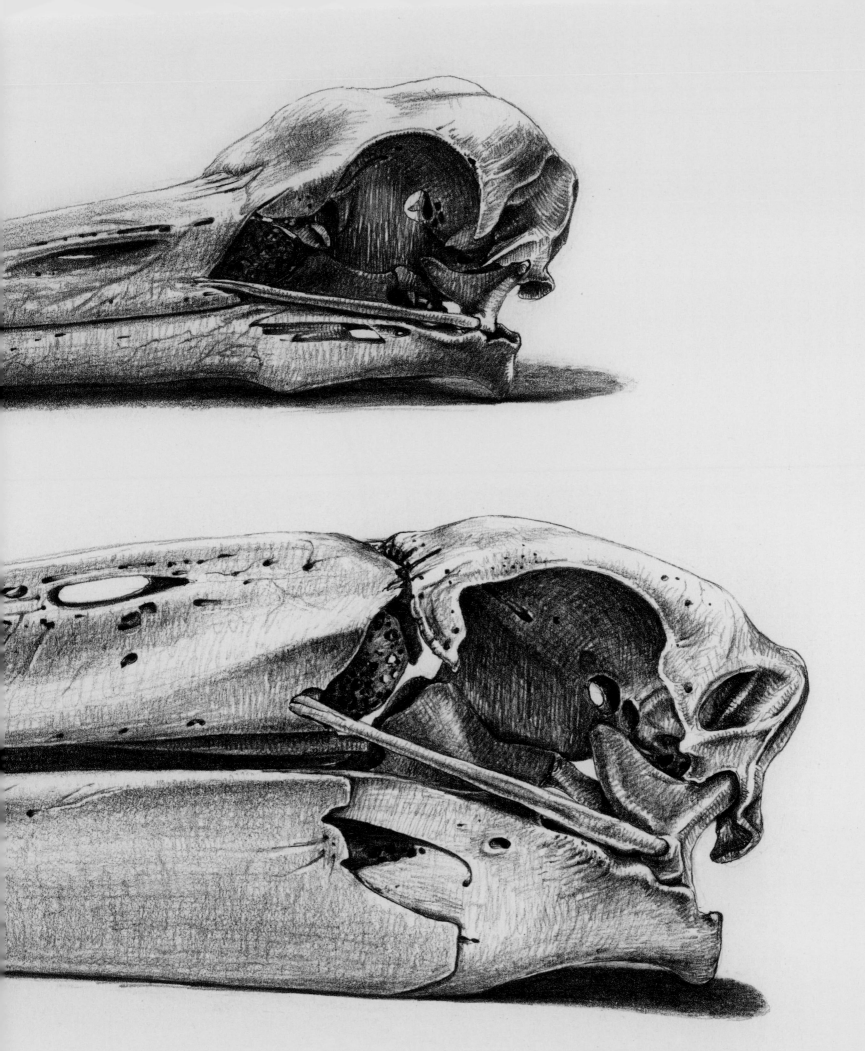

the ground. The more aquatic ibises, by comparison, have rather longer toes, including the hind toe. Storks, spoonbills, and most ibises also lack the herons' comb-like middle claw, though this may have nothing to do with not being specialist fish-eaters; there are plenty of non-piscivores that inexplicably possess this feature.

Considering storks as waterbirds, the carrion-eating habits of Marabou Storks seem rather incongruous. This habit was conveniently rationalized when researchers pioneering DNA hybridization techniques in the 1980s revealed the storks' closest living relatives to be, not the herons, nor even the ibises and spoonbills, but the New World vultures. In fact, some late nineteenth-century taxonomists had arrived at the same conclusion from a purely anatomical standpoint. The two groups certainly do share many similarities, including the bare facial skin and soaring flight. However, more recent molecular studies have blasted this theory—at least for now: Marabou Storks are probably not, after all, long-legged vultures but simply rather vulturesque storks.

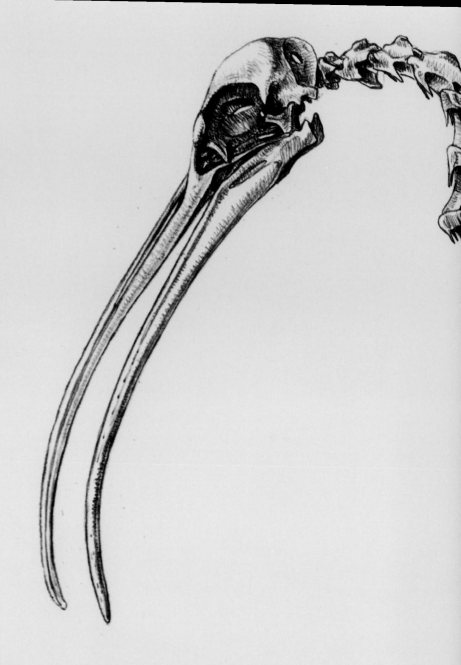

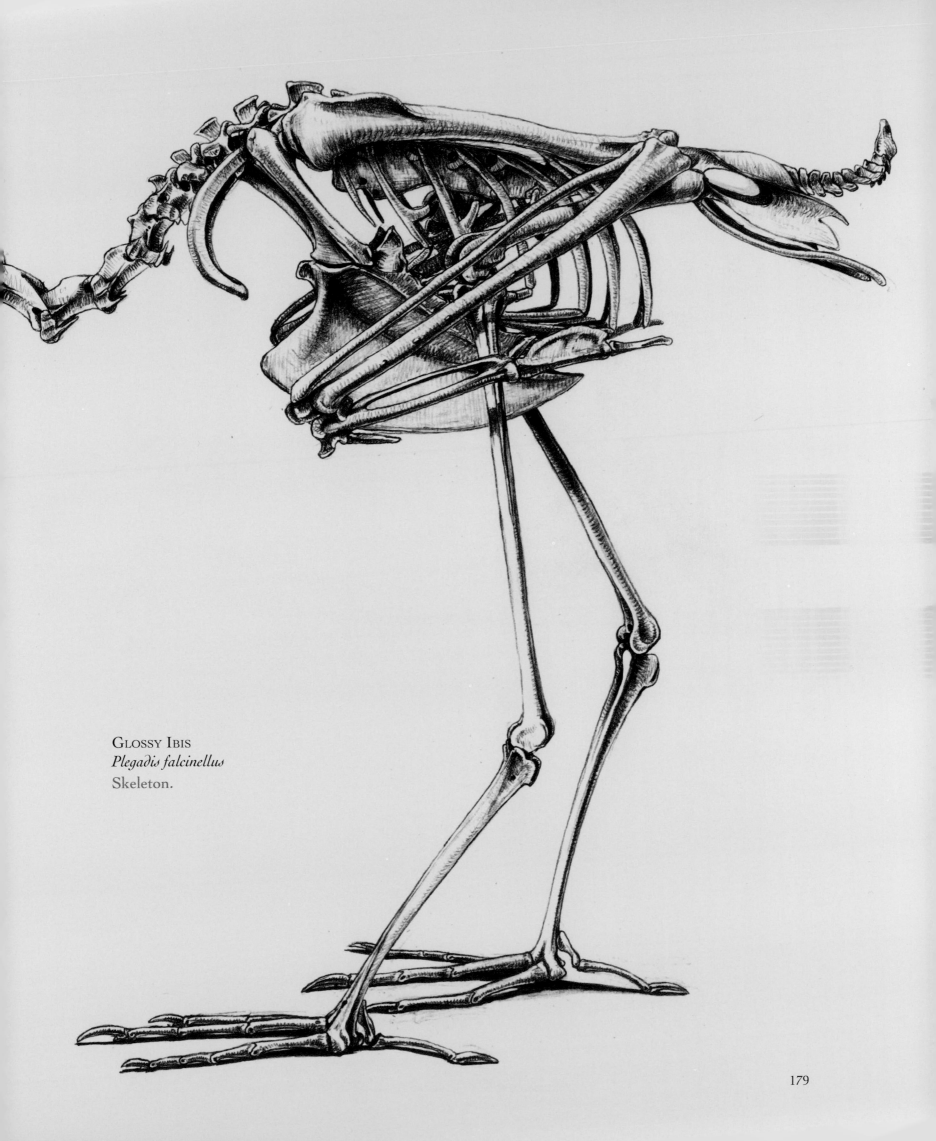

GLOSSY IBIS
Plegadis falcinellus
Skeleton.

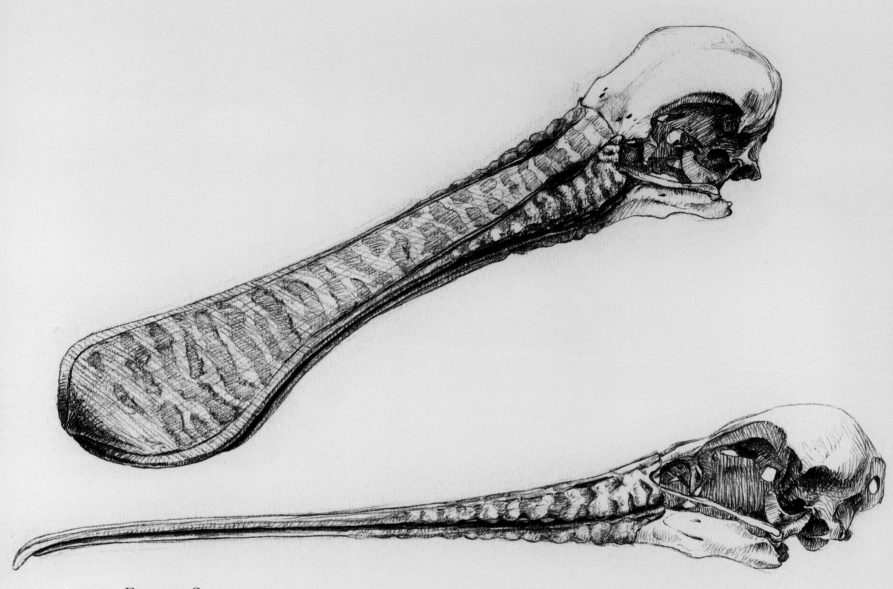

EURASIAN SPOONBILL
Platalea leucorodia
Skull.

Cranes

The similarity between cranes and the other long-legged, long-necked birds, the storks and herons, is no more than superficial. Cranes traditionally belong not to the order Ciconiiformes but to Gruiformes, which they share with the much smaller rails and other ground-feeding bird families. Some of its members are highly aquatic; others are birds of arid grassland and even desert.

The cranes themselves have similarly diverse habitat preferences. Those which habitually wade in water tend to be larger, with a longer neck, bill, legs, and toes, while the Demoiselle Crane, the smallest and most terrestrial species, has short toes for running fast and a shorter bill for foraging for seeds and insects.

In almost all cranes, the hind toe is small and raised above the ground. In the two species of crowned crane, however, it is longer, enabling them to perch in trees to roost. Crowned cranes represent the most primitive branch of the family. They are confined to Africa and, unlike other cranes, are not naturally tolerant of cold climates.

Cranes stand tall; one race of the Sarus Crane is the tallest of all flying birds. They are proportionally longer-legged and shorter-billed than storks, and have a bulkier body and straighter neck than herons, without the distinctive Z-shaped kink. Like storks and flamingos, cranes fly with their neck outstretched. Some crane species undertake lengthy migrations but utilize thermals to a lesser degree than storks do, relying more on powered flight or long glides, at least after gaining altitude. Their wings, although undoubtedly long and broad, are therefore not of the same dimensions as those of storks; their forearm is only a little longer than the upper arm, and the surface area created by the flight feathers is rather smaller.

The inner secondary flight feathers of crane wings are nevertheless elongated—but for display purposes only. On the standing bird they are either curved, resembling the bustle on an old-fashioned ladies' dress, or droop down to give the impression of a long, pointed tail. The true tail, however, is quite small and is usually completely concealed beneath the extravagant plumage of the wings.

The head of cranes is also highly ornamented, either with specialized feathers, wattles, or inflatable pouches or with bare patches of red skin. These patches can be flushed with blood to increase the intensity of color or contracted by underlying muscles. Cranes are highly gregarious outside their breeding season and rely heavily on visual social signals. Of all their complex ritualized maneuvers and posturing, nothing is so enchanting to behold as their habit of "dancing."

Cranes "dance" at the slightest provocation. All species do it, and although the behavior is not exclusive to cranes, no other birds partake in it with such gusto. Even tiny chicks have been observed bowing, leaping, dashing about madly, and tossing small objects into the air.

They also have an extensive repertoire of vocal communication. Each call, or series of calls, has a precise meaning, common to all crane species, although the actual vocalizations are specific to each. The bugling cry of a flock of cranes is among the most evocative sounds in all nature and is audible at a great distance. The comparison with the stirring fanfare of a bugle is no accident. The far-reaching cries of cranes are produced with a wind instrument of their own—an elongated windpipe or trachea—which coils in the same way as man-made musical instruments. However, the question of whether it functions in the same way as a wind instrument or by resonating within the breastbone like the body of a stringed instrument has been the subject of lengthy debate.

About sixty species of birds from a wide variety of orders have an elongated windpipe, presumably associated with the acoustic advantages of exaggerating the apparent size of the bird, though it brings the respiratory disadvantage of the high volume of "dead air" inside. Of course, a long windpipe needs to be

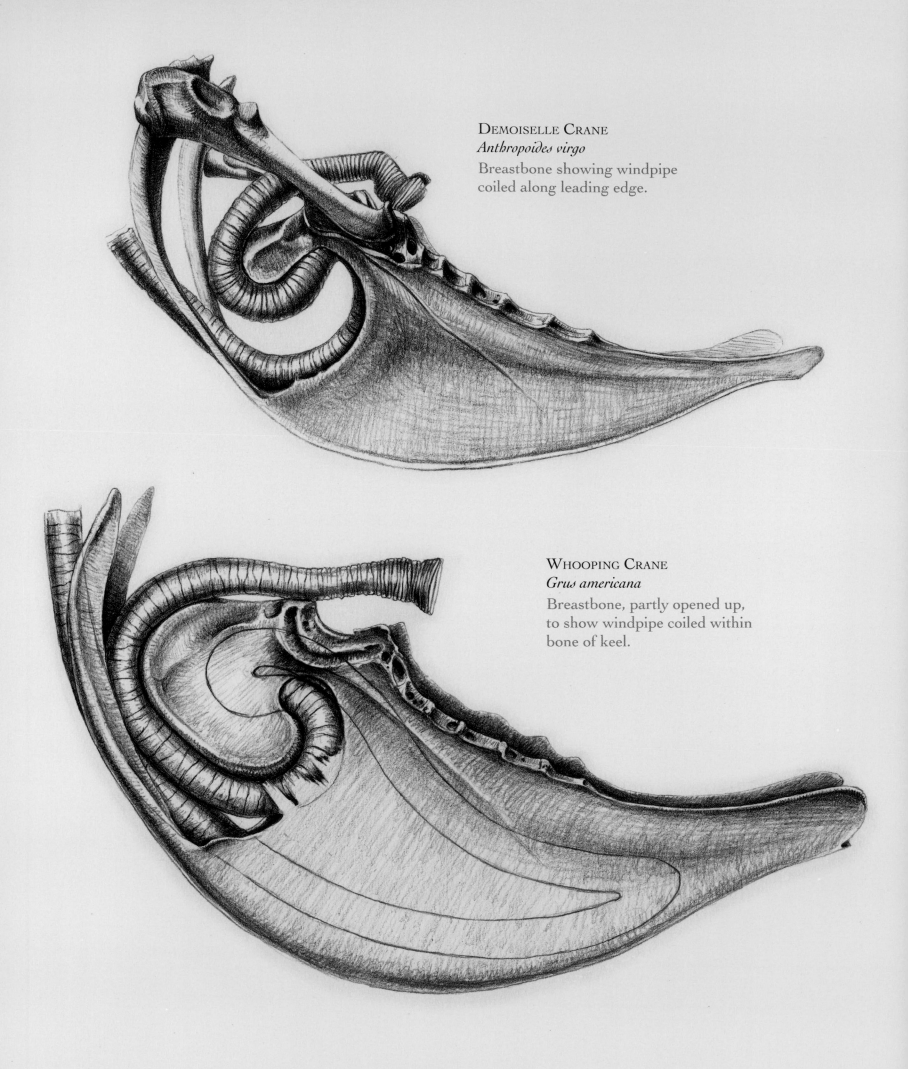

DEMOISELLE CRANE
Anthropoides virgo
Breastbone showing windpipe
coiled along leading edge.

WHOOPING CRANE
Grus americana
Breastbone, partly opened up,
to show windpipe coiled within
bone of keel.

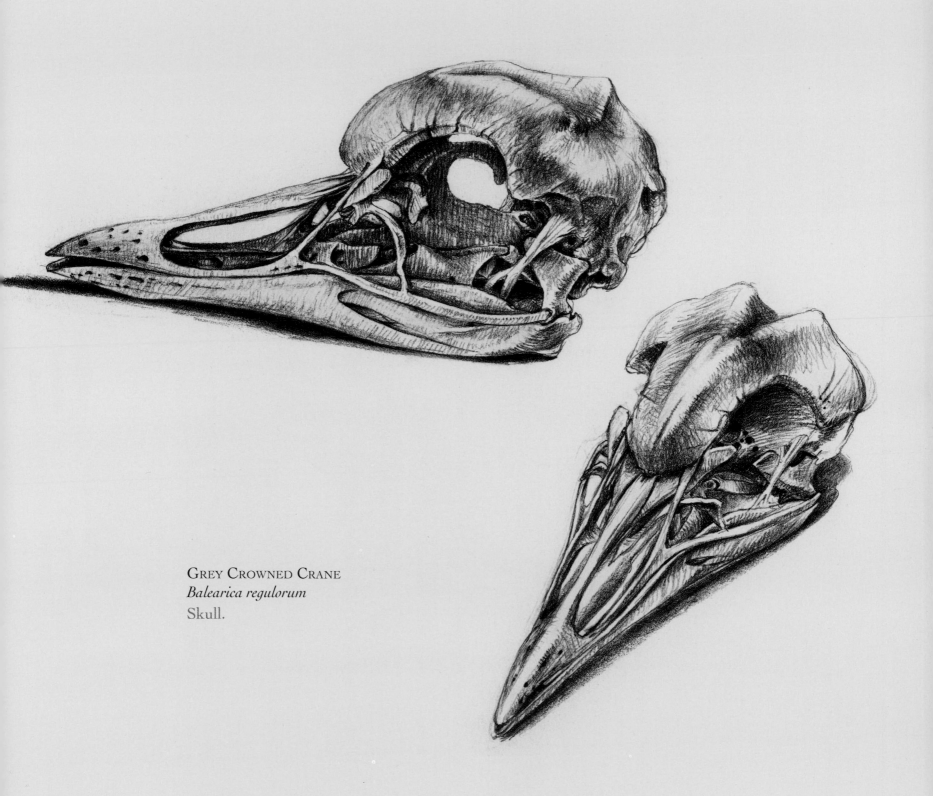

GREY CROWNED CRANE
Balearica regulorum
Skull.

accommodated somewhere within the body, and in many species it forms coils or loops in the neck or thorax or directly beneath the skin of the breast and abdomen. In cranes, however, it is actually coiled within the bony tissue of the keel of the breastbone, which is broad, and fused with the wishbone for greater strength. (Some swan species display a similar invasion of the breastbone, but their wishbone is not fused with the keel.)

There is a direct correlation between the length of the windpipe and the degree and volume of harmonics produced. Those with the shortest trachea, the Demoiselle and Blue Crane, at one end of the scale, produce vocalizations of no great resonance, while the aptly named Whooping Crane, at the other, has the longest windpipe and most penetrating call. Their windpipe forms a double-loop extending the whole length of the breastbone, whereas the Demoiselle's merely sits in a shallow depression at the front edge of the keel.

The more primitive crowned cranes lack all these features. Their windpipe is not especially elongated and passes straight to their lungs, and their wishbone, accordingly, is not in contact with the keel of the breastbone. Crowned cranes are, nevertheless, very noisy and can still be heard from afar, owing to the resonating qualities of inflatable throat sacs.

DEMOISELLE CRANE
Anthropoïdes virgo
Skull.

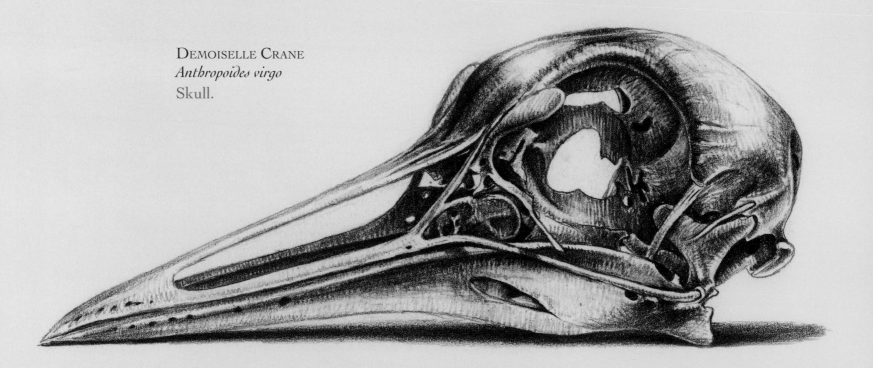

Rails

Reedbeds and grasslands are dense places; the plants are crowded closely together and to live among them, skulking unseen between the stems, you have to be as thin as a rail. Although they have a deep, chicken-like silhouette when seen from the side, rails virtually disappear when viewed from head-on. Their whole body is laterally compressed, as though flattened between the pages of a book.

In addition to the long-billed true rails, which probe in mud and shallow water, the family also includes the crakes, which use their shorter bill to pick insects from vegetation, and the more aquatic coots and gallinules, which are largely herbivorous. The largest of these, of the genus *Porphyrio*, use their deep and powerful bill to snip off plant stems, feeding on the soft, fleshy lower parts, and will even grasp them in their feet, looking like large, purple, and not-so-dexterous parrots.

The bill of rails is rather flattened at the sides, like the birds themselves, and slopes downward at an angle from the skull. The coots and gallinules also bear a conspicuous red or white frontal shield on their forehead, used for display and communication. This is not a bony appendage on the skull but is composed purely of fatty tissue.

Rail legs are long and tremendously strong. The long thigh bones place the knees well forward beneath the body to give the bird a horizontal stance when walking. The toes are long, too. They spread the bird's weight while walking over mud or floating vegetation, and the raised hind toe helps with balance. The coots are the most aquatic of all the rails and are the only members of the family that habitually swim and dive in open water. Like other freshwater diving birds, they are foot-propelled underwater, although they may on occasion use their wings as well. Their feet have scalloped lobes of skin on each side of the toes between each toe joint: one pair on the hind toe, two on the inner toe, three on the middle toe, and four on the outermost. When swimming, these fold back behind the toes as the feet are brought forward, reducing drag, but open out as the feet are pushed against the water on the power stroke.

Some species bear a tiny wing-claw on the tip of their "thumb." Although this is only really useful to chicks, for clambering through vegetation, it may still be present in the adult bird.

With nearly 150 species, rails are by far the largest family in the order Gruiformes and one of the most cosmopolitan of all bird families. They have a particularly wide distribution on remote, oceanic islands; somewhat surprising when one considers that rails are weak fliers, with short wings, barely any tail to speak of, and rather unaerodynamic proportions—not helped by their habit of flying with their legs trailing beneath them. Their breastbone is small, with a shallow keel; the wishbone is slender; and of course the pectoral girdle as a whole is proportionally narrower than in most birds. Nevertheless, several species make substantial migrations each year, and individuals turn up as long-distance vagrants, apparently blown off course, with surprising frequency. The Allen's Gallinule, for example, is the only tropical African bird to be regularly recorded in Europe. But rails can also swim, and they are strong walkers, so therefore have a good chance of survival should they have to touch down en route.

In fact most species will avoid flying whenever possible. Those birds arriving at and colonizing predator-free islands therefore take readily to a flightless existence and very rapidly, in evolutionary terms, lose the power of flight altogether. Their wings and flight muscles degenerate, their legs become still stronger, and there is a tendency for them to increase in size and lose all instinct for self-preservation. A vast proportion of the Rallidae (the rail family), compared with other bird families, is flightless, and all of these species are endemic to oceanic islands. Not surprisingly, when the islands became colonized by Europeans, and mammalian predators appeared on the scene, the days of flightless ground-living birds were numbered. Since that time rails have suffered more extinctions than any other bird family.

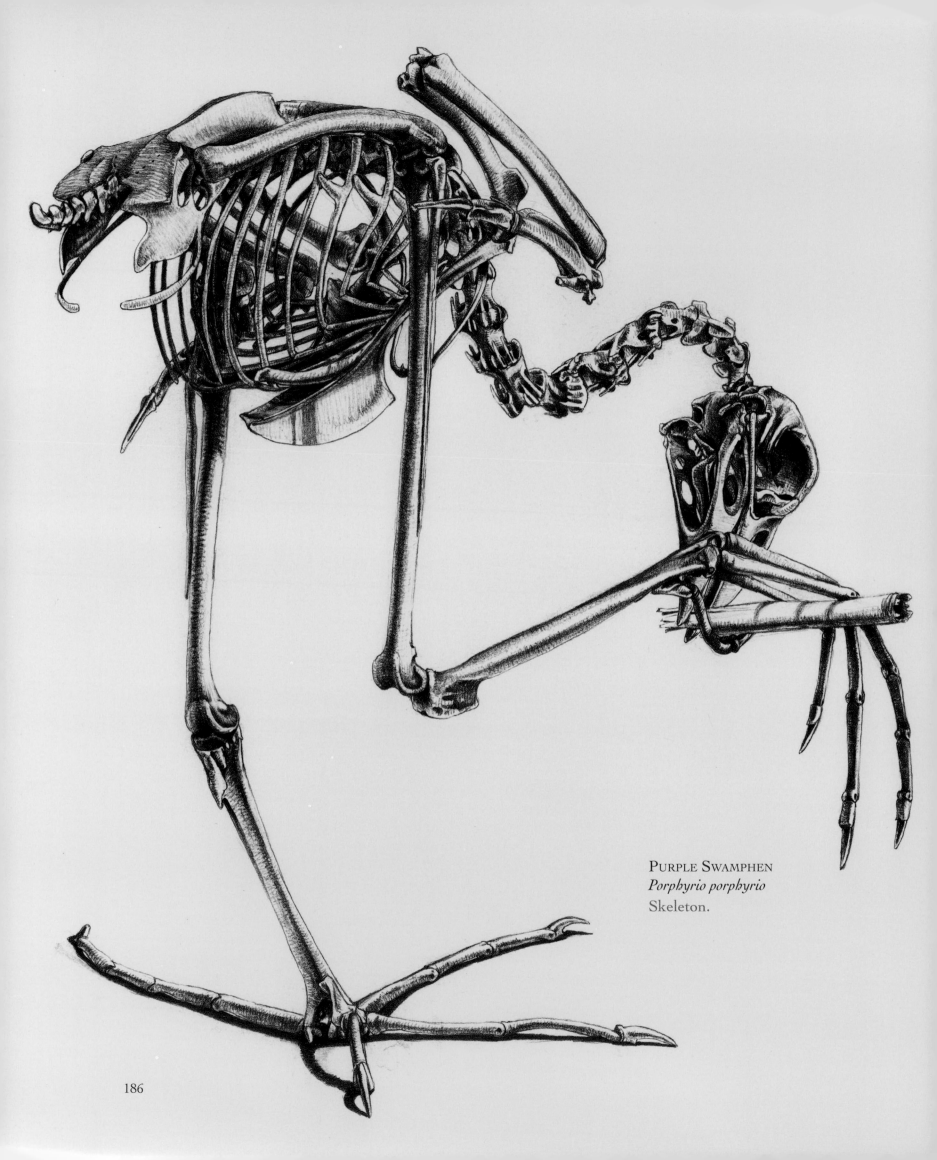

PURPLE SWAMPHEN
Porphyrio porphyrio
Skeleton.

186

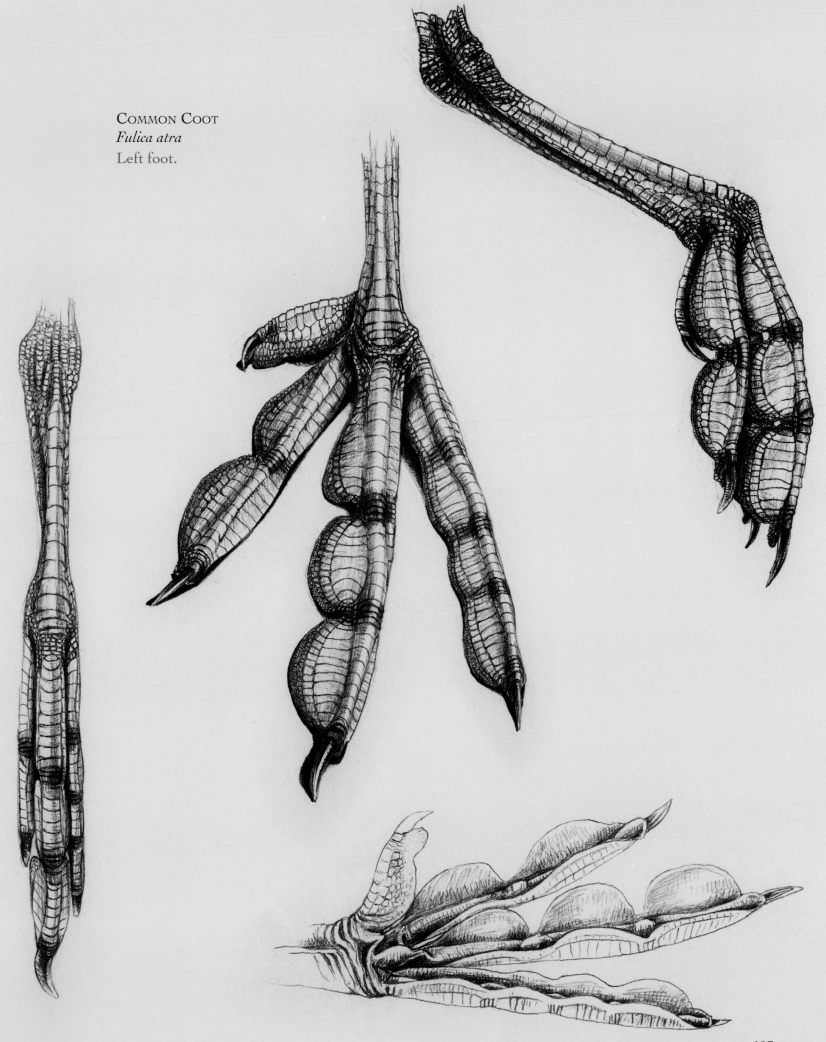

COMMON COOT
Fulica atra
Left foot.

187

The South Island Takahe, a large flight-less gallinule of the genus *Porphyrio* and the largest of all the rails, was, by the early twentieth century, thought to have suffered the same fate. (There was also a North Island counterpart, long extinct and known only from fossil remains.) Then in 1948 an expedition to an isolated area of New Zealand's Murchison Mountains revealed a small population. Now closely protected, numbers are slowly but steadily increasing.

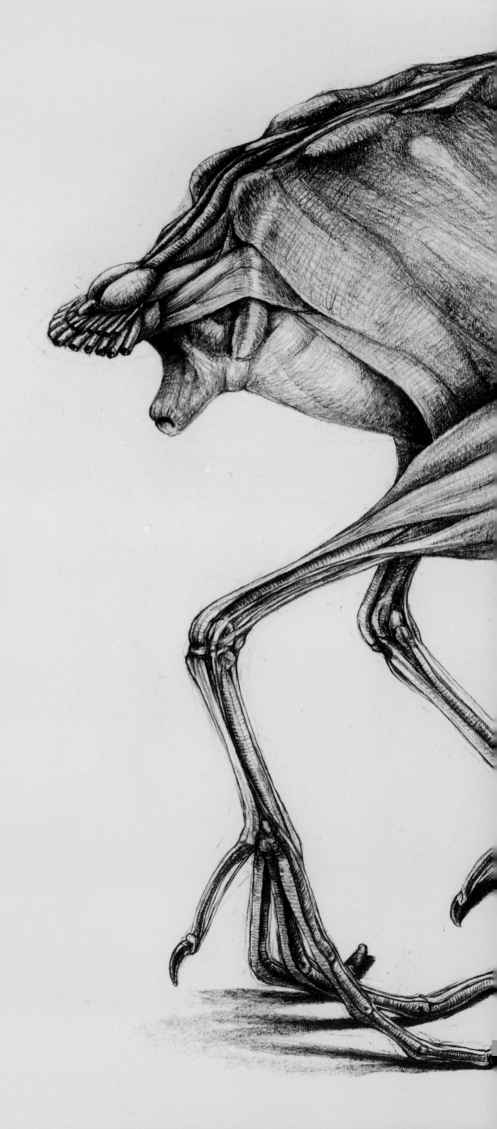

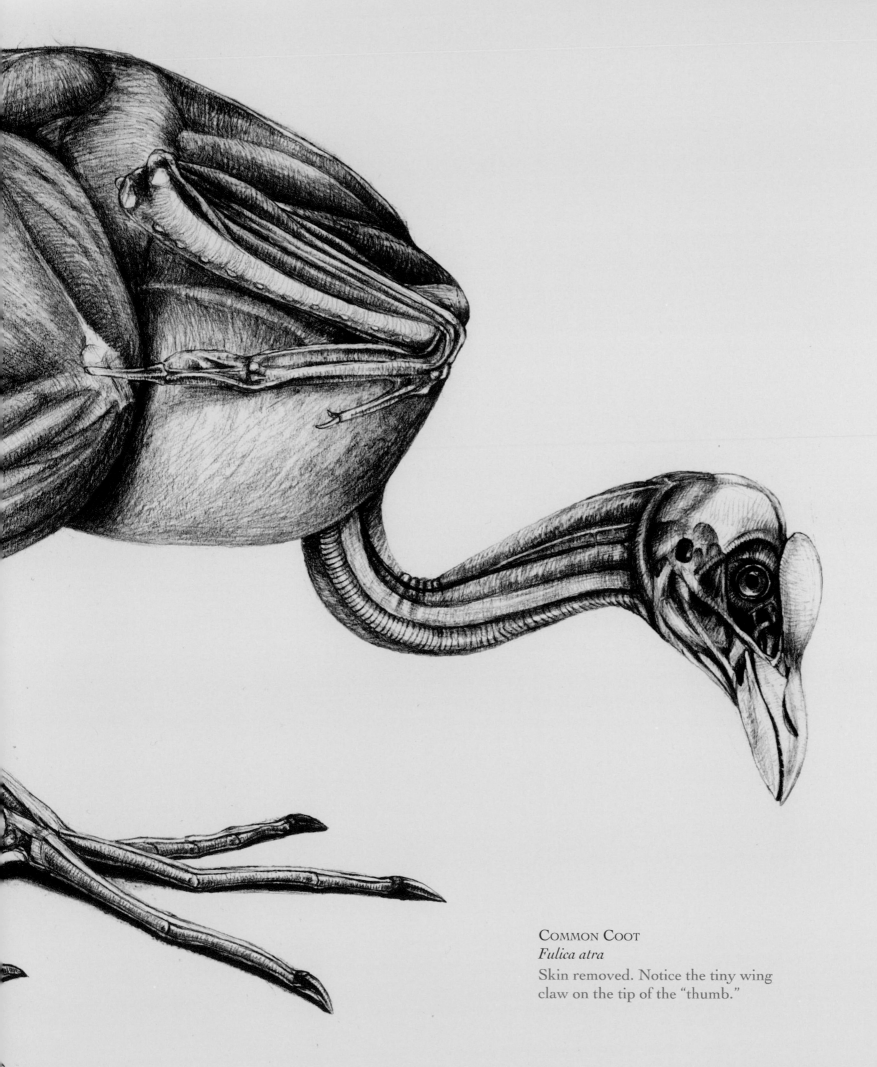

COMMON COOT
Fulica atra
Skin removed. Notice the tiny wing
claw on the tip of the "thumb."

Kagu

Looking like something midway between a rail and a heron, the Kagu is one of those single species families that don't quite fit in anywhere. Endemic to the Melanesian island of New Caledonia where it originally would have had no natural predators, it is flightless, like many of the island rail species, and—unusual for a ground-living bird—has no cryptic coloration. However, unlike the flightless rails, which undergo a reduction in wing size, Kagu wings are well developed and used extensively for balance when walking, running, and climbing over obstacles and even for short downhill glides. The most obvious use of the wings, however, is for display. The primary flight feathers are boldly striped, in contrast to the bird's otherwise uniform dove-gray plumage, and at the slightest sign of threat the bird fans them out before it, quite altering its appearance. This is not for camouflage, however; it's intended to be *seen* and either intimidate or distract a would-be danger or rival.

The legs are long and strong, and the short hind toe is raised slightly off the ground. The posture is characteristically upright, unlike the rather horizontal rails, and the body is not flattened at the sides like a rail or a heron. The upright stance is the result of the curiously angled pelvis, which gives the bird its short-backed appearance while the backbone itself, fused for much of its length, is actually held rather horizontally. Larger vertebrae between the shoulders anchor the strong muscles needed to raise the head. Not surprisingly for a flightless bird, the breastbone has only a shallow keel, and the wishbone is slender.

Kagus have a large skull that looks out of all proportion to the relatively small body. In the feathered bird the size of the head is concealed by the sloping crest, which merges with the feathers of the back to give it a shrouded appearance. The skull also has raised orbits to accommodate particularly large eyes, suggesting that the birds might be active at night, though this is only the case during incubation. They do, however, have excellent binocular vision to hunt for invertebrate prey on the forest floor. The covered nostrils of the bill sheath may serve as protection against the entry of foreign particles as the bird probes in the leaf litter.

Kagus, like herons, preen themselves with powder originating from specialized feathers called powder down. Early taxonomists placed the Kagu with the herons in the order Ciconiiformes, though it is now usually tentatively classified, for want of anywhere better, in the order Gruiformes, alongside the rails, cranes, and the other "misfits"—the Sunbittern and finfoots. DNA evidence has so far proven inconclusive.

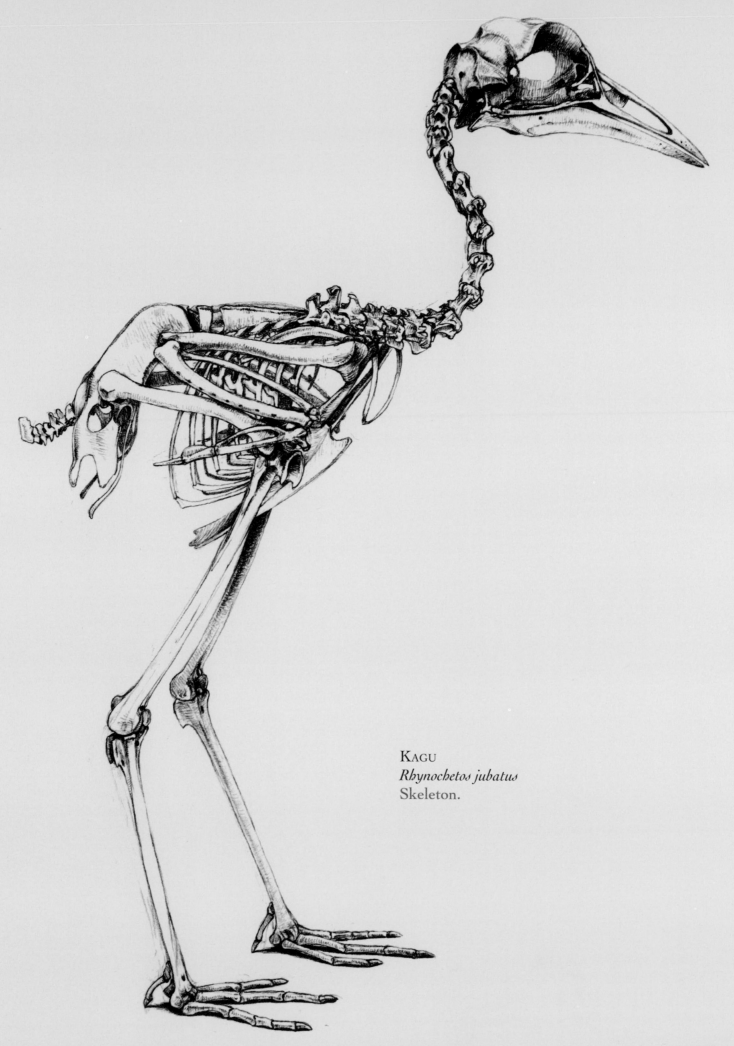

KAGU
Rhynochetos jubatus
Skeleton.

Waders

Any long-legged waterbird is technically a wader, and the term is rather a subjective one. However, no birdwatcher would use the word to refer to herons or storks, for example. It's usually applied synonymously with the family Scolopacidae—the sandpipers, curlews, godwits, snipes, and so on—but equally includes birds of other families that share a similar niche: the oystercatchers, avocets, and plovers. All of these families traditionally belong to the order Charadriiformes, along with pratincoles, gulls, terns, skuas, and auks—birds seemingly a million miles from their long-legged relatives. Not to mention jacanas, which bear every resemblance to rails.

In general, waders are small to medium-sized, ground-living birds, with long legs (especially the tibia) and short toes suitable for walking and running. In most, the hind toe is small or absent, particularly in species that habitually run along the shore, though in most sandpipers it is a little longer, allowing them to perch and even nest in trees. Jacanas are the notable exception, having four exceedingly long, thin toes that spread their weight while walking over floating vegetation.

Waders are broader in the body than rails. Their feats include some of the most impressive long-distance migrations of any bird, so they have the build for fast, direct flight—a broad and deeply keeled breastbone accommodating huge breast muscles, and long, pointed wings. Woodcocks have shorter, more rounded wings than most waders, but they, too, are powerful fliers. Their wing shape gives them good maneuverability through their wooded habitat, and both woodcocks and snipes are capable of flying erratically in a zigzag path as a defense against aerial predators.

In fact the woodcocks are remarkable in many ways, and not least in the structure of their skull.

Now in all other birds, and most other vertebrates, the neck joins the skull at the back end, behind the braincase. In a linear arrangement that's the bill, the eyes, the braincase, and the neck. But a woodcock's skull has been oriented through 90° like a human head, with the neck joining not behind the skull but directly beneath it. The braincase is tucked in at the back, barely extending far behind the eyes, while the eyes themselves project well above the level of the cranium on froglike tubular pedestals. Being inland species, woodcocks and snipes have no salt glands above their eyes. The ear openings, which are usually positioned well behind the eye sockets, are directly beneath them. The bill is angled sharply downward and the eyes upward and to the sides so that they face as far as possible in opposite directions. (Snipes' skulls have a similar structure but the bill is not directed so steeply downward.)

Of course most birds have eyes on the sides of their head. But they are invariably directed slightly forward to give them a reasonable area of overlap, that is, binocular vision in the bill region so that they can locate food accurately. This unfortunately brings the disadvantage of a blind spot behind and above them; but it's good enough for most birds. Woodcocks, on the other hand, take seeing behind them very seriously. Their unique skull structure gives them complete panoramic vision above and to the sides to just above the horizontal plane, so that they can spot a predator approaching from any angle above ground level. It's true that their angle of binocular vision is negligible, but that's of little importance to a woodcock. Their eyesight can be totally devoted to the detection of predators because they have other methods for the detection of food.

Woodcocks, like many of the sandpipers in the family Scolopacidae, have a highly sensitive bill tip and can feed entirely by touch, detecting the minutest vibrations underground. Like other waders they are able to grip prey with just the tip of the bill. It's all due to the nostrils. Waders have elongated nostrils, which effectively divides the bill into three parallel strips of bone—one on each side, and one on top. Somewhere along the length of this section (depending on the species) is an elastic zone of flexible bony tissue that can

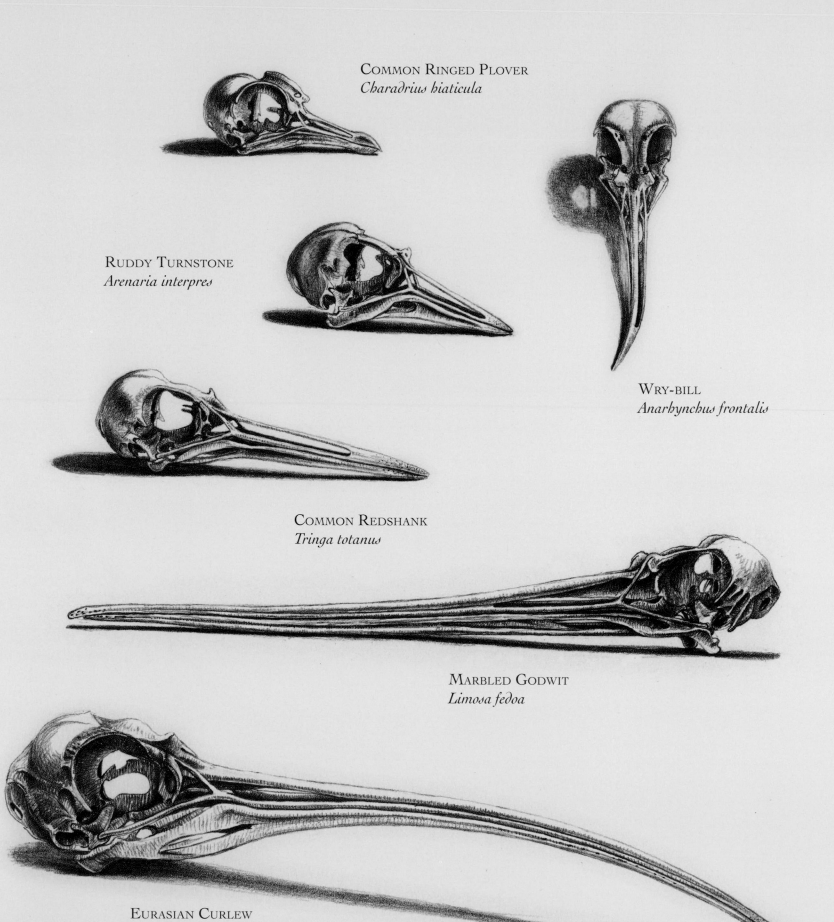

COMMON RINGED PLOVER
Charadrius hiaticula

RUDDY TURNSTONE
Arenaria interpres

WRY-BILL
Anarhynchus frontalis

COMMON REDSHANK
Tringa totanus

MARBLED GODWIT
Limosa fedoa

EURASIAN CURLEW
Numenius arquata

Skulls.

be pushed upward and outward, raising just a portion of the bill's length. Straight-billed waders can even manipulate prey up the bill with their tongue and into their throat without removing their beak from the hole!

Waders such as curlews and some godwits that have a downcurved or upturned bill have more of a problem with this, although a curved bill is certainly more effective than a straight one for probing into worm holes and around corners. A curved bill needs more structural reinforcements, leaving less room for a large tongue inside, so they usually have to remove their prey in the tip of their bill before they can swallow.

Wry-bills—not sandpipers but plovers—also have a curved bill. But with a twist. Their bill is uniquely angled to the side (always to the right side, never to the left), and it is used to sweep the undersides of pebbles for the larvae of invertebrates such as mayflies.

The plovers hunt by sight rather than by touch. In most, the bill is shorter, for aimed pecks rather than opportunistic probing, and their eyes are much larger than those of the sandpipers. In fact plovers are also nocturnal feeders, so having large eyes maximizes the amount of light hitting the retina. They also have a high density of rod cells in the eye, which aids vision under poor light conditions, though at the expense of some color perception. Like those of the woodcocks, plovers' eyes are raised above the level of the cranium, but these are directed much farther forward to give the birds the good field of binocular vision they need. Stone curlews, too—same order, different family—have similarly large eyes to help with night feeding.

Turnstones are sandpipers, but feed by sight, turning over small pebbles to expose the invertebrates hiding beneath. They have an unusually tapered bill, thick at the base and pointed at the end, and lacking the bulbous, sensitive tip of their slender-billed relatives. Oystercatchers, in a family of their own, are adept at opening shellfish, though some individuals have a finer bill structure and feed predominantly by tactile probing.

194

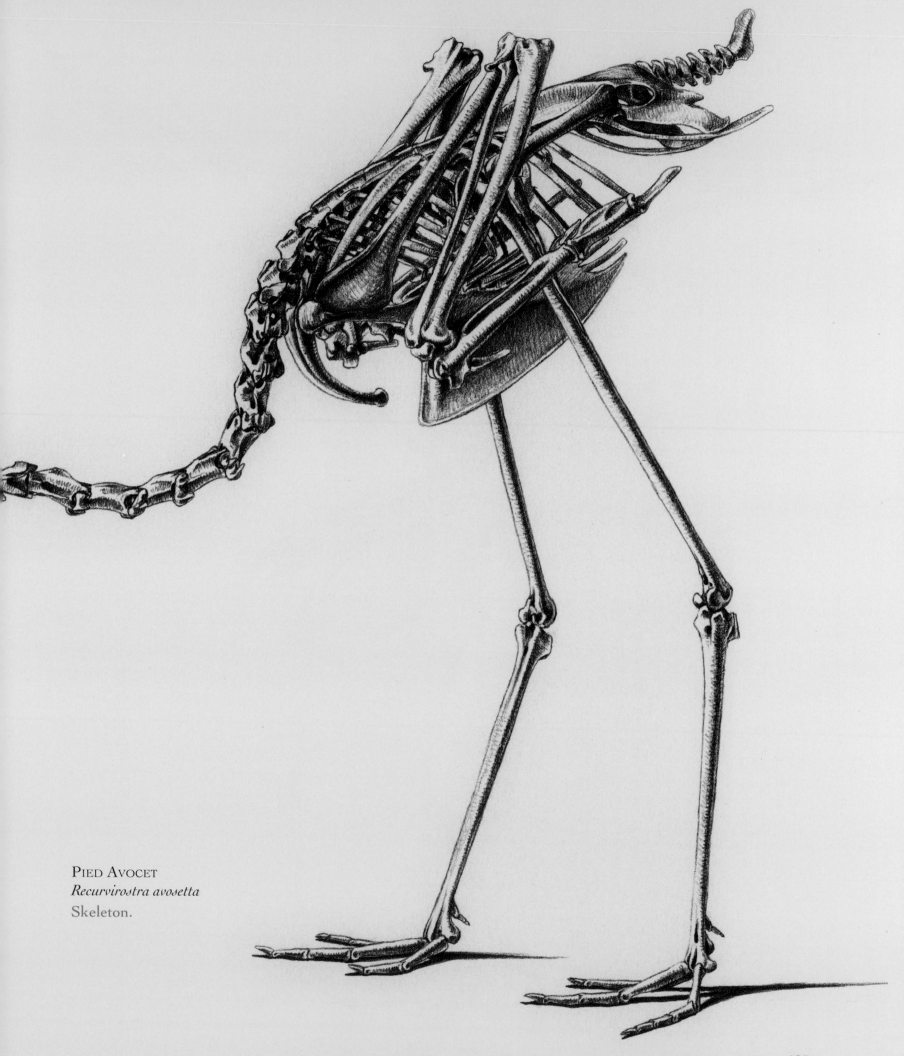

PIED AVOCET
Recurvirostra avosetta
Skeleton.

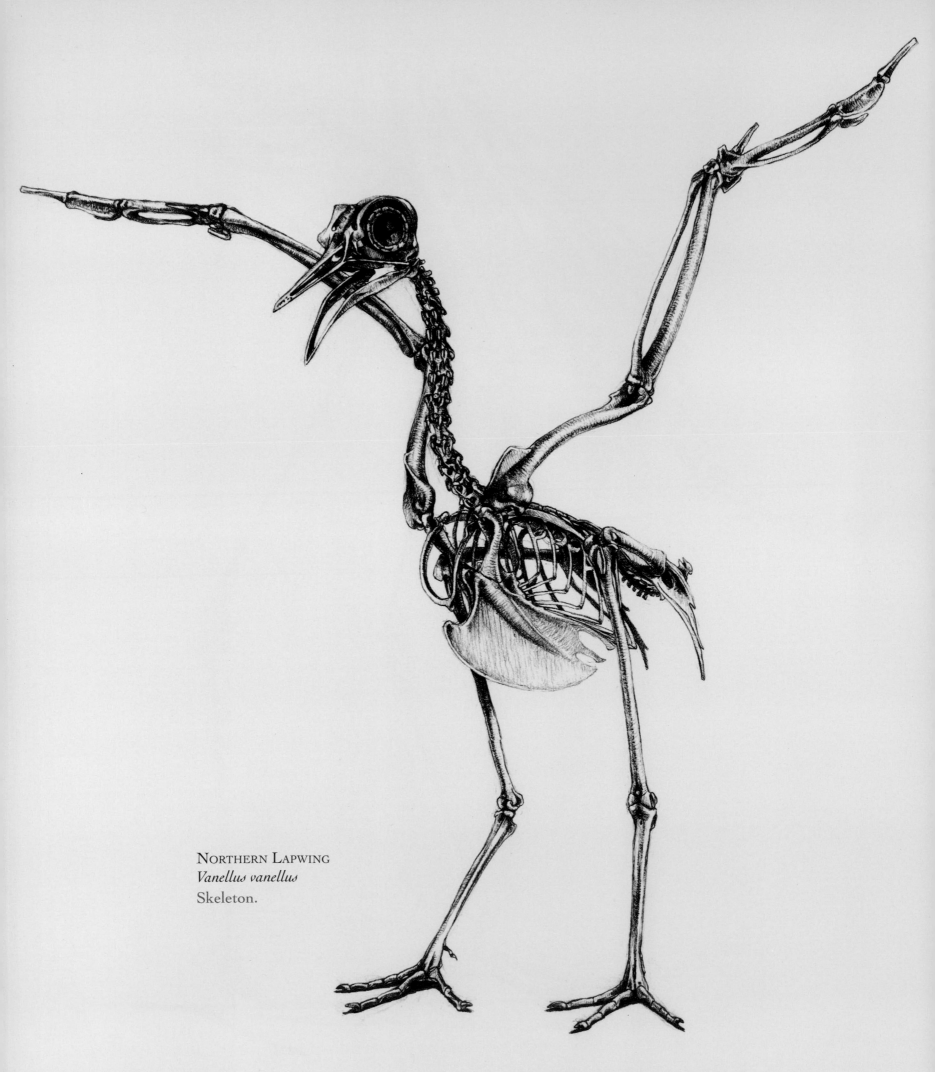

NORTHERN LAPWING
Vanellus vanellus
Skeleton.

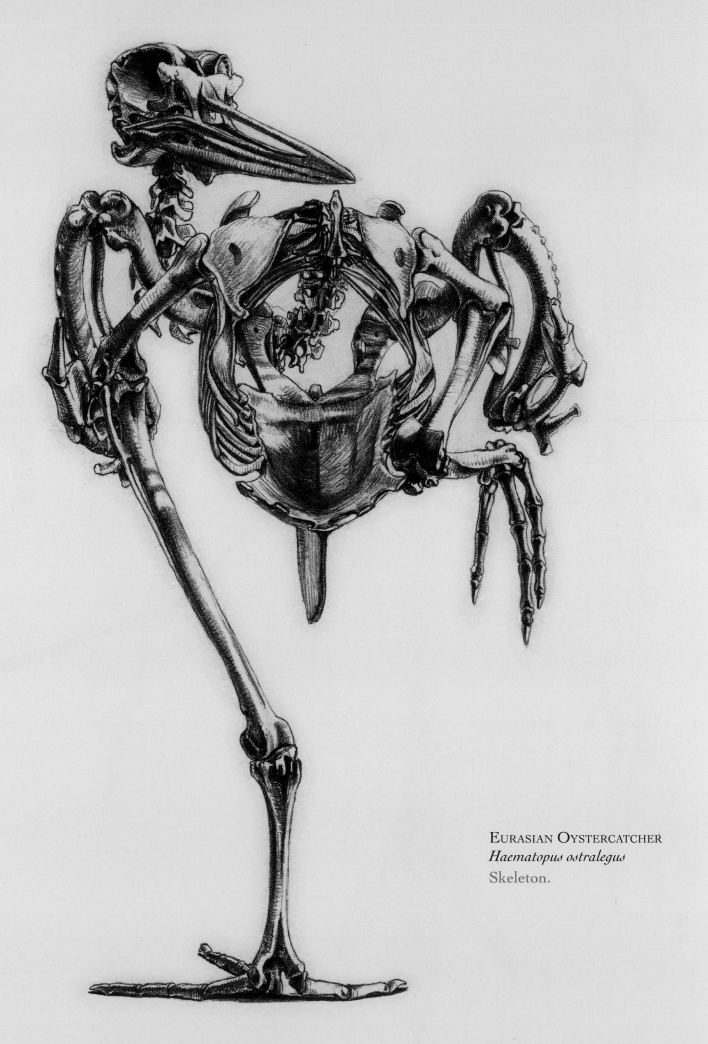

EURASIAN OYSTERCATCHER
Haematopus ostralegus
Skeleton.

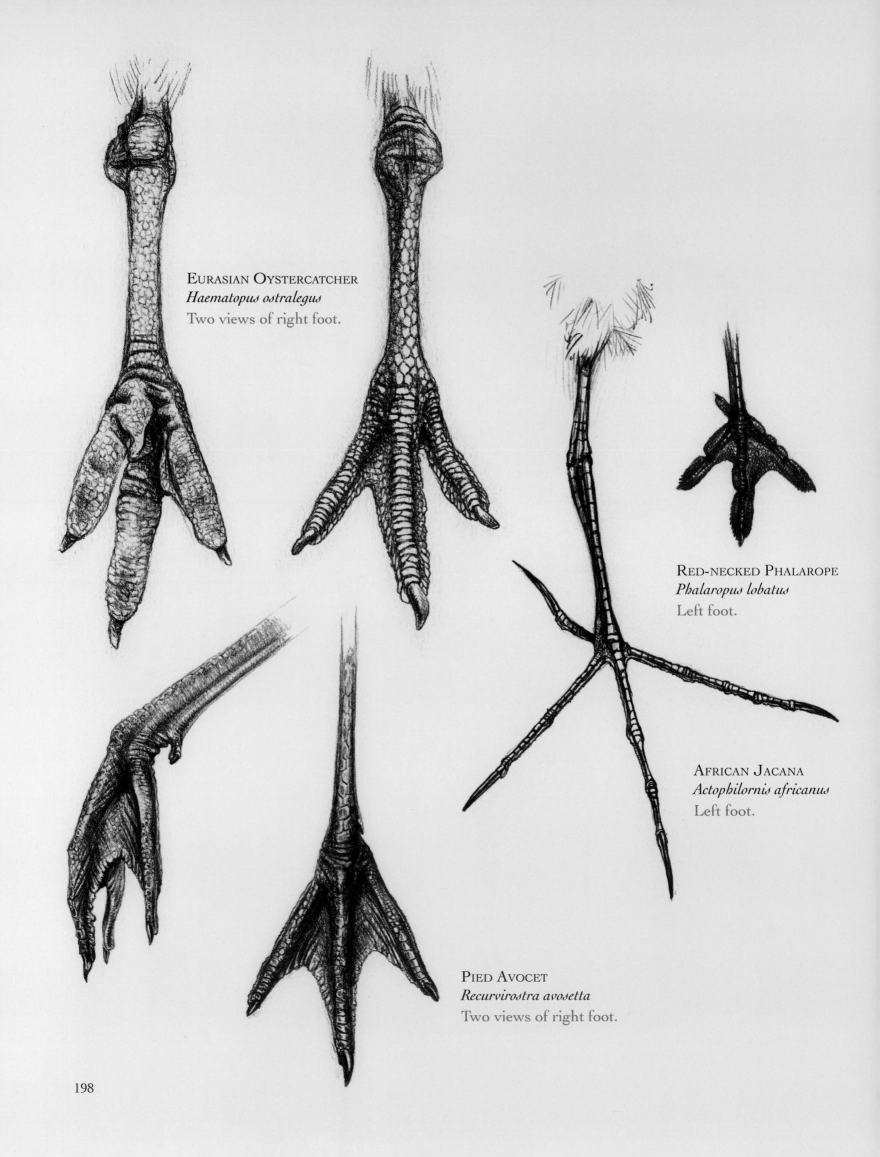

EURASIAN OYSTERCATCHER
Haematopus ostralegus
Two views of right foot.

RED-NECKED PHALAROPE
Phalaropus lobatus
Left foot.

AFRICAN JACANA
Actophilornis africanus
Left foot.

PIED AVOCET
Recurvirostra avosetta
Two views of right foot.

198

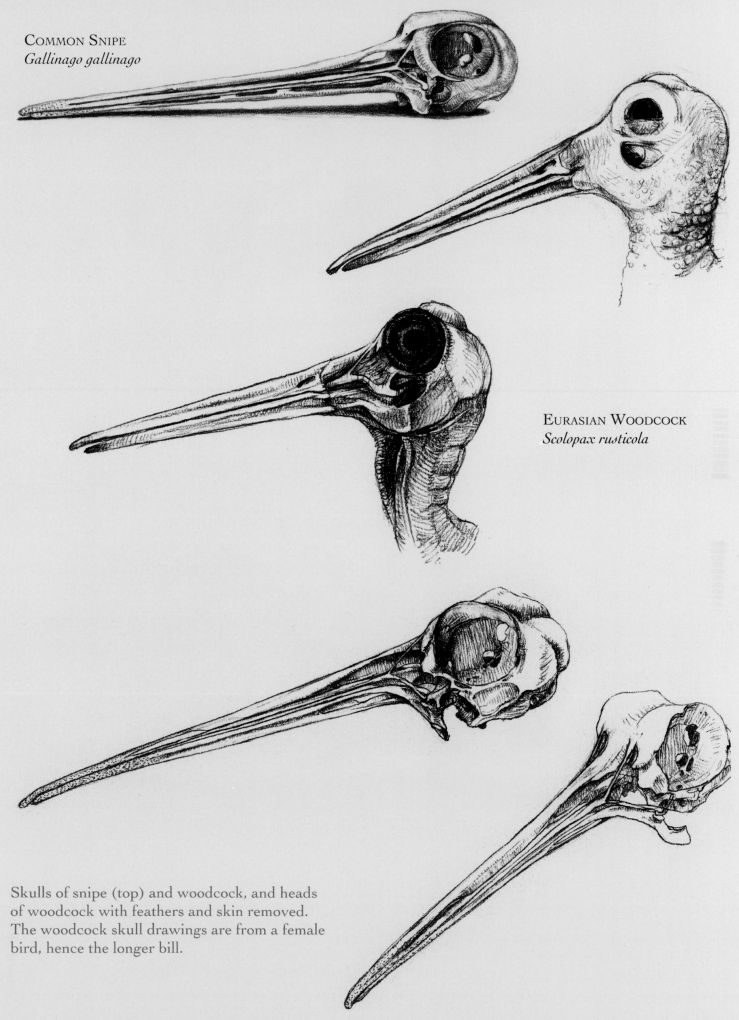

COMMON SNIPE
Gallinago gallinago

EURASIAN WOODCOCK
Scolopax rusticola

Skulls of snipe (top) and woodcock, and heads
of woodcock with feathers and skin removed.
The woodcock skull drawings are from a female
bird, hence the longer bill.

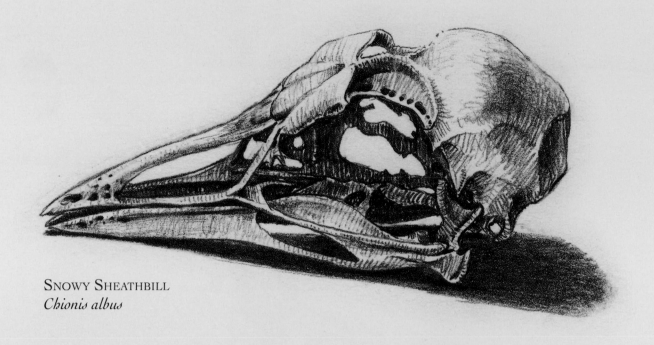

SNOWY SHEATHBILL
Chionis albus

EURASIAN STONE CURLEW
Burhinus oedicnemus

Skulls.

All this beak-work takes a lot of power and waders have surprisingly large neck vertebrae for their size, providing the surface area for the musculature required. Avocets and phalaropes (although from different families) have the finest bills and feed on microorganisms at or near the surface of the water. Avocets sweep their flattened, upturned bill from side to side filtering out particles through tiny lamellae as flamingos do. Their legs are prodigiously long, which enables them to wade in very deep water; and when they get out of their depth, they just swim! Avocets (along with the closely related Banded Stilt) are among the few waders to have partially webbed toes, though oystercatchers have partial webbing between the central and outer toes only. The tiny, short-legged phalaropes swim too, and they have "part-webbed, part-lobed" toes with scalloped edges like a coot on one side of each toe and partial webbing like an avocet on the other!

For every situation near water or on boggy ground—smooth sand, deep mud, rocky coastline, or fresh-water stream—there's a wader to feed on the invertebrates there. And differences in leg length, bill length, and bill structure mean that many species can coexist without competition.

But not all waders lead such a wholesome lifestyle. Looking more like grubby white chickens than the plovers they're related to, sheathbills are the garbage-pickers of Antarctic seabird colonies. In fact they are the only bird family exclusively confined to that region. Predators and scavengers, they will consume anything edible and quite a few things that shouldn't be. But despite their total reliance on the sea, they are wholly terrestrial, scarcely ever even getting their feet wet.

V GALLINAE

Bill convex, the upper mandible arched over the lower; *nostrils* arched over with a cartilagenous membrane; *legs* formed for running; toes rough underneath; *body* fat, muscular, and excellent eating; *food* grain and seeds, which they scratch from the ground and macerate in the crop; *nest* on the ground, made with little care; *eggs* numerous. They are polygamous, fond of rolling in the dust, and teach the young to collect food.

As the name suggests, Linnaeus's Gallinae most closely describes what were to become known as the Gallinaceous birds—the pheasants, grouse, guineafowl, and so forth, though his original order encompassed any of the more rotund, ground-living groups. The very primitive tinamous, masquerading as gamebirds, fit in well here, though the Ostrich is a less comfortable member of the order. At that time most of the ratites were still awaiting discovery by Europeans.

Another portly, terrestrial bird that fits the bill perfectly is the Dodo; by Linnaeus's time, already long extinct. It would be a long, long time before the Dodo's affinities with the pigeons would be realized.

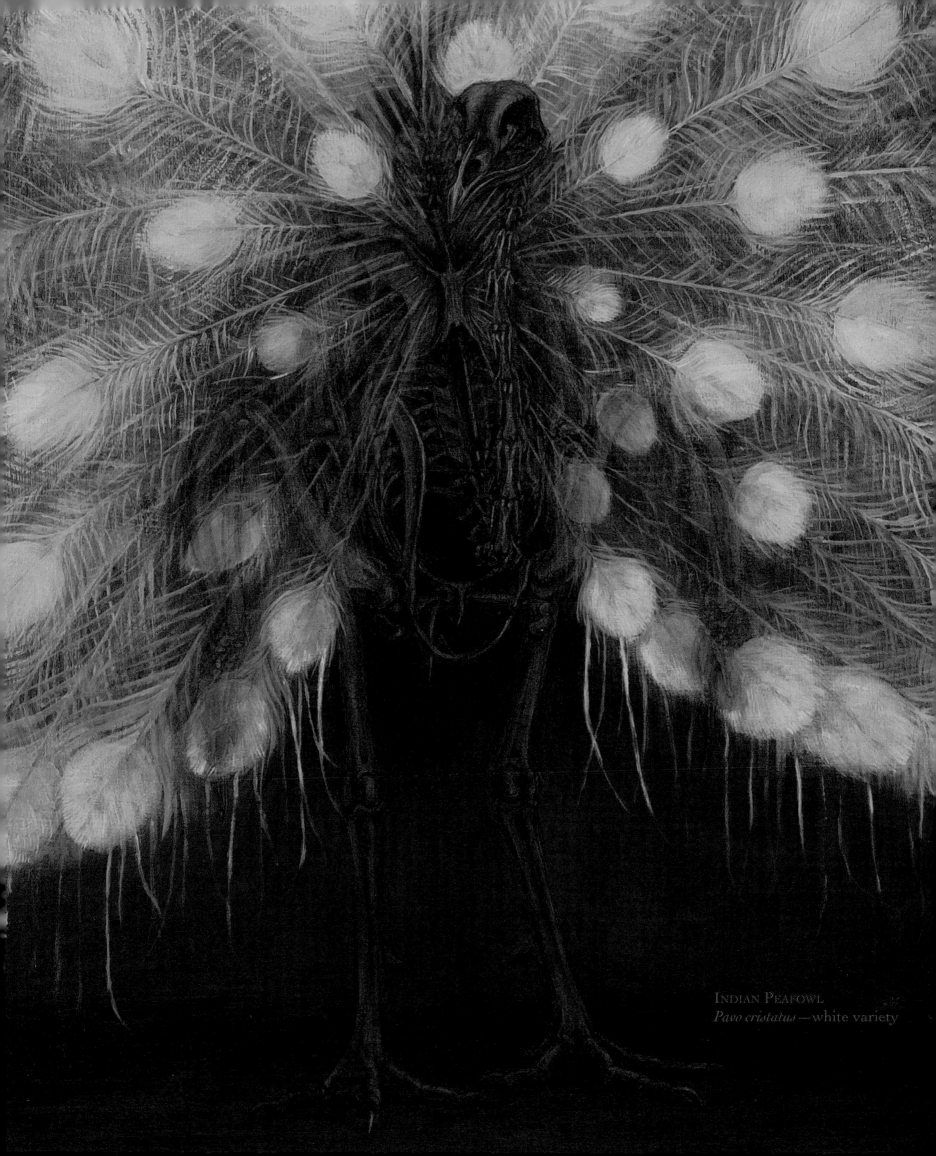

INDIAN PEAFOWL
Pavo cristatus — white variety

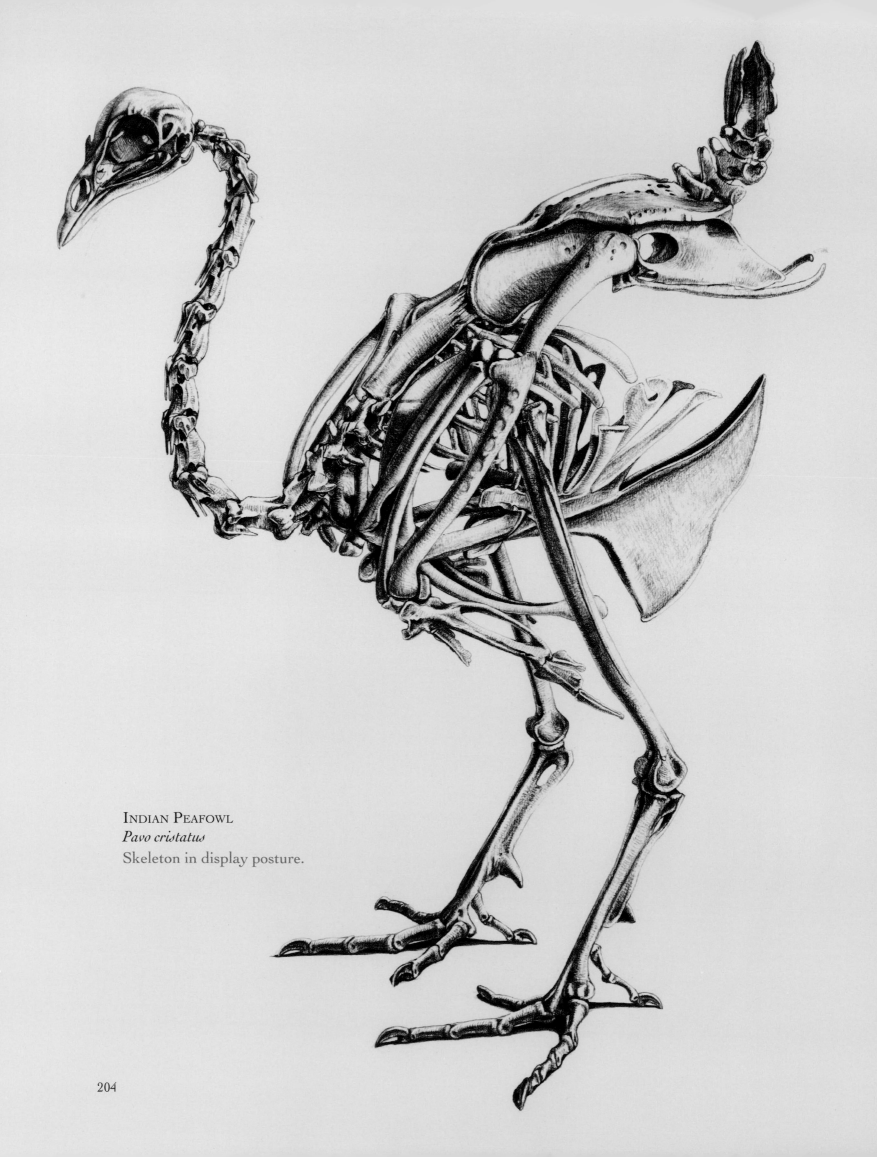

INDIAN PEAFOWL
Pavo cristatus
Skeleton in display posture.

204

Gamebirds

The group of birds loosely referred to as gamebirds is essentially the whole order Galliformes—the pheasants, grouse, guineafowl, and related birds. They're called gamebirds for a reason; they are all essentially plump in the body and make jolly good eating, and with their rapid takeoff from the ground are a challenging quarry for the hunter.

The large breast muscles that are at the root of both of these factors cannot sustain flight for long periods, however; the birds quickly tire and need to rely on protracted glides on downcurved wings to carry them any distance. The keel of the breastbone is, in fact, deep, though the breastbone itself is narrow and is characteristically divided into three long prongs reminiscent of a tinamou, whose flight capabilities are similarly poor.

Although the gamebirds range in size from tiny quails to enormous turkeys, their structure is remarkably uniform: a large body, small head, short, rounded wings, and strong legs. The most primitive members of the order, the megapodes and curassows, differ from all the others in having a longer hind toe at the same level as the three in front—a good foot for perching in trees—but the typical gamebirds are more adapted to a terrestrial lifestyle and have their smaller hind toe raised above the ground. This arrangement is perfect for walking, running, and—a typical Galliform trait—scratching in the soil.

Most groups feed largely on seeds. They're high in protein and carbohydrates and easily provide the energy requirements of a bird. The grouse, however, are highly unusual in having a diet that consists almost exclusively of leaves. Many grouse species will only eat leaves of a particular kind—pine needles, or heather, or willow. Now there's not much energy value in leaves, and they take time to digest. But grouse have a large crop and a long and highly specialized intestine specifically adapted to get the most out of the particular food plant. By gorging themselves morning and evening they can conserve energy by spending the rest of their time simply digesting their last meal, even digging themselves into the snow to sit out the day.

Grouse are well suited to cold weather conditions. The base of their bill is feathered, covering the nostrils, and the tarsi and toes of many species are feathered, too. In others, however, especially the most northern species, the toes undergo a very peculiar winter transformation. They develop extra, elongated scales that protrude from both sides so that their toes look like large millipedes creeping out from among the feathers. In the spring, they are molted off. The precise function of these scales is not fully understood, but it's thought that they may improve grip in the snow or while perching in trees.

Leg spurs are another feature of the gamebirds—at least of the pheasants (including partridges, Old World quails, and francolins), guineafowl, and turkeys. One on the inner hind edge of each tarsus is the norm, though some species or individuals may develop a second spur higher up or even (rarely) from the same base. The peacock-pheasants often have still more; their generic name *Polyplectron* actually means "many spurred." In domestic fowl, spurs may develop in quite spectacular numbers and proportions. Spurs, used in fighting, are usually possessed by male birds, though females may occasionally have them, too, and they increase in size with a bird's age.

Sexual adornments are big in gamebirds, and the group exhibits a bewildering array of head crests, wattles, brightly patterned inflatable throat pouches, combs, and gorgeously ornate plumes that are paraded in an assortment of equally fantastic displays. The best known of all of these, the magnificent quivering fan display of the peacock (the male of the peafowl), needs no description. But for all their familiarity, most people are surprised to learn that a peacock's train is not its tail. Peafowl do have tails, and they are certainly very large ones, but the elongated display feathers actually arise from the back, rump, and upper tail coverts overlying the true, rather drably colored tail. Muscles attached to the feather bases pull them into an upright position for display, while the bird stands with its rear end high in the air to show them to their best advantage. They can be relaxed again afterward, when the peacock returns to a more normal posture.

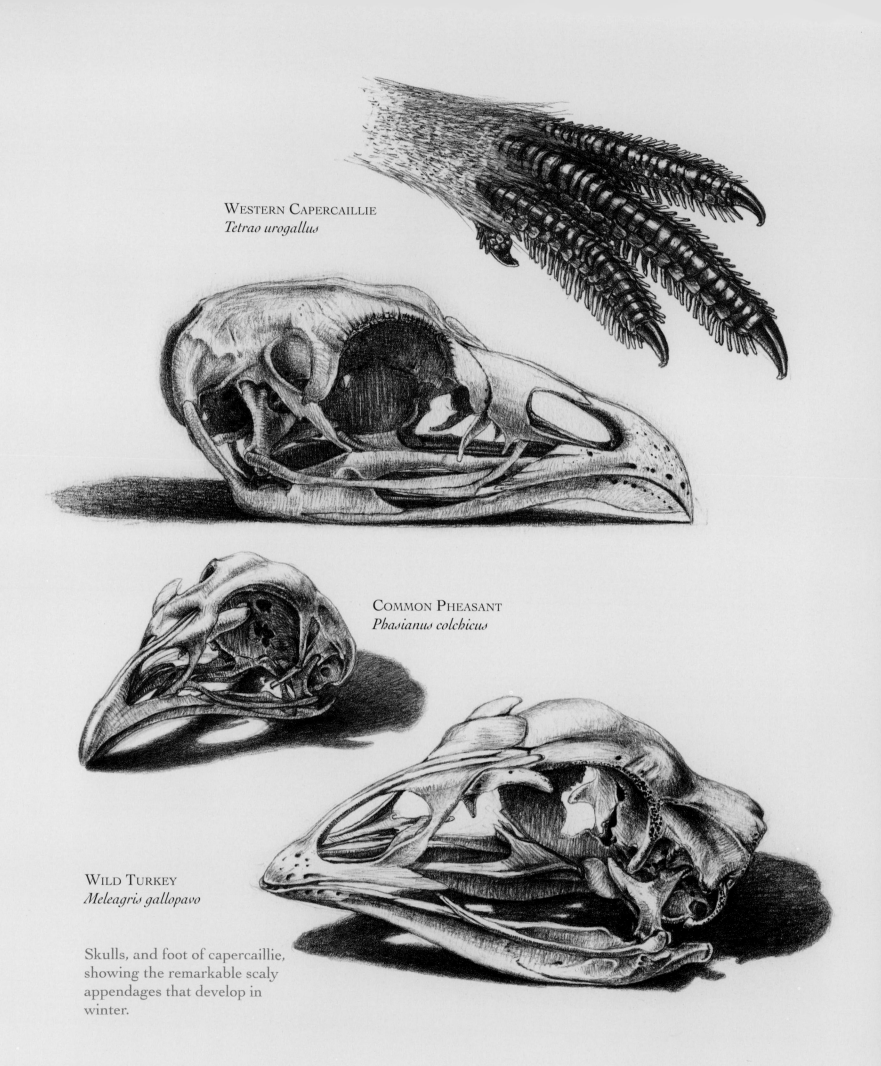

Western Capercaillie
Tetrao urogallus

Common Pheasant
Phasianus colchicus

Wild Turkey
Meleagris gallopavo

Skulls, and foot of capercaillie, showing the remarkable scaly appendages that develop in winter.

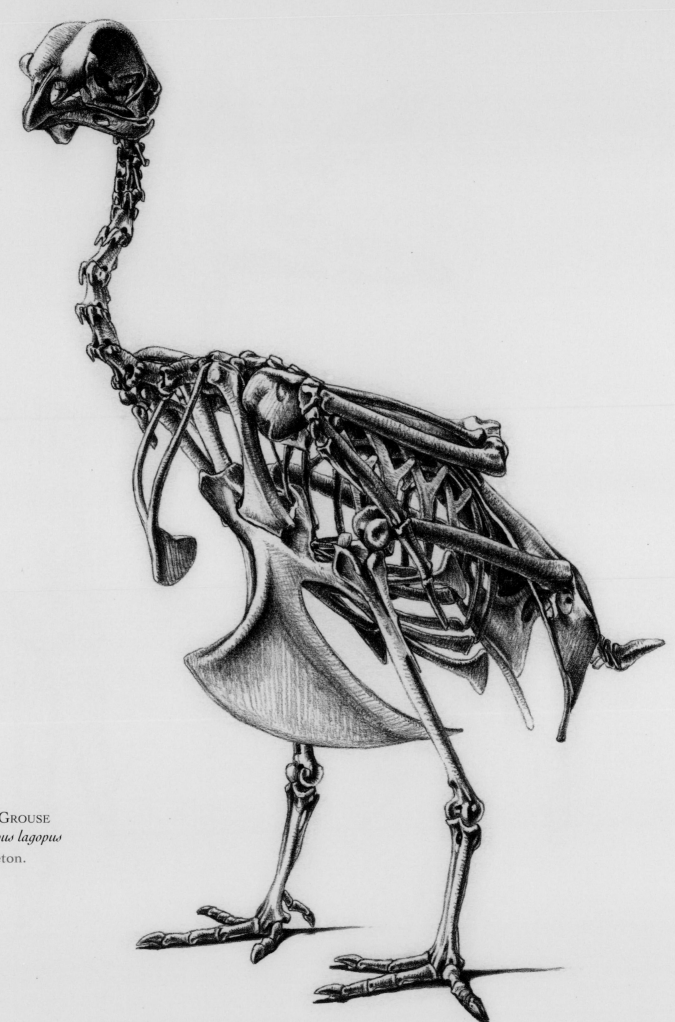

RED GROUSE
Lagopus lagopus
Skeleton.

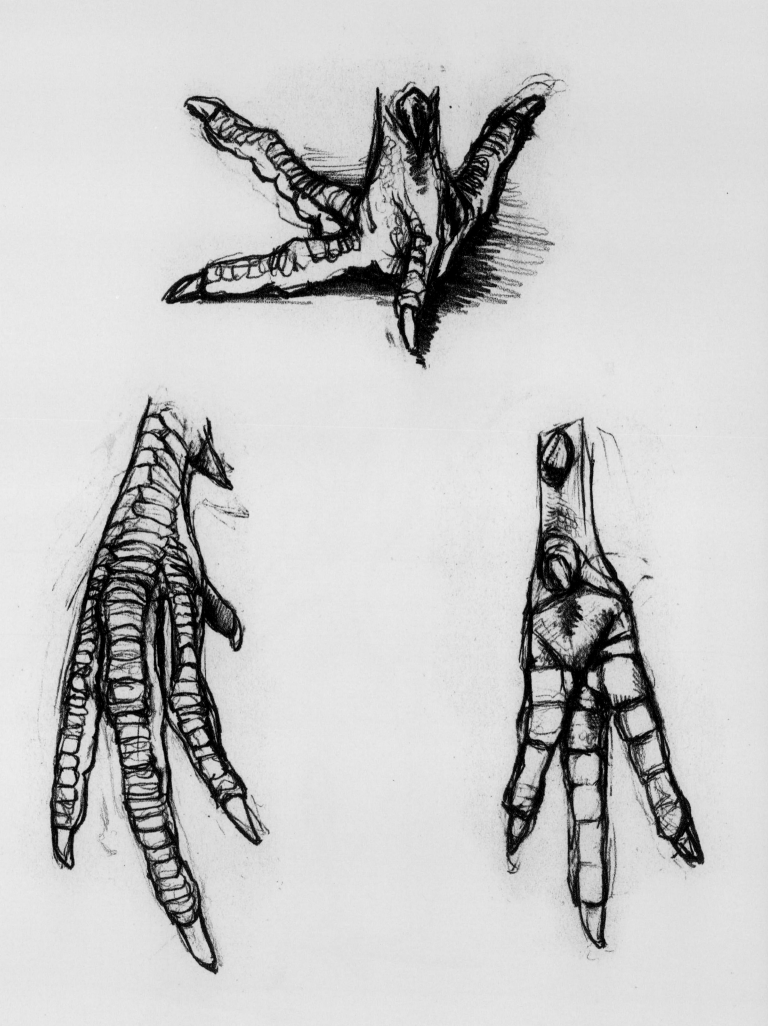

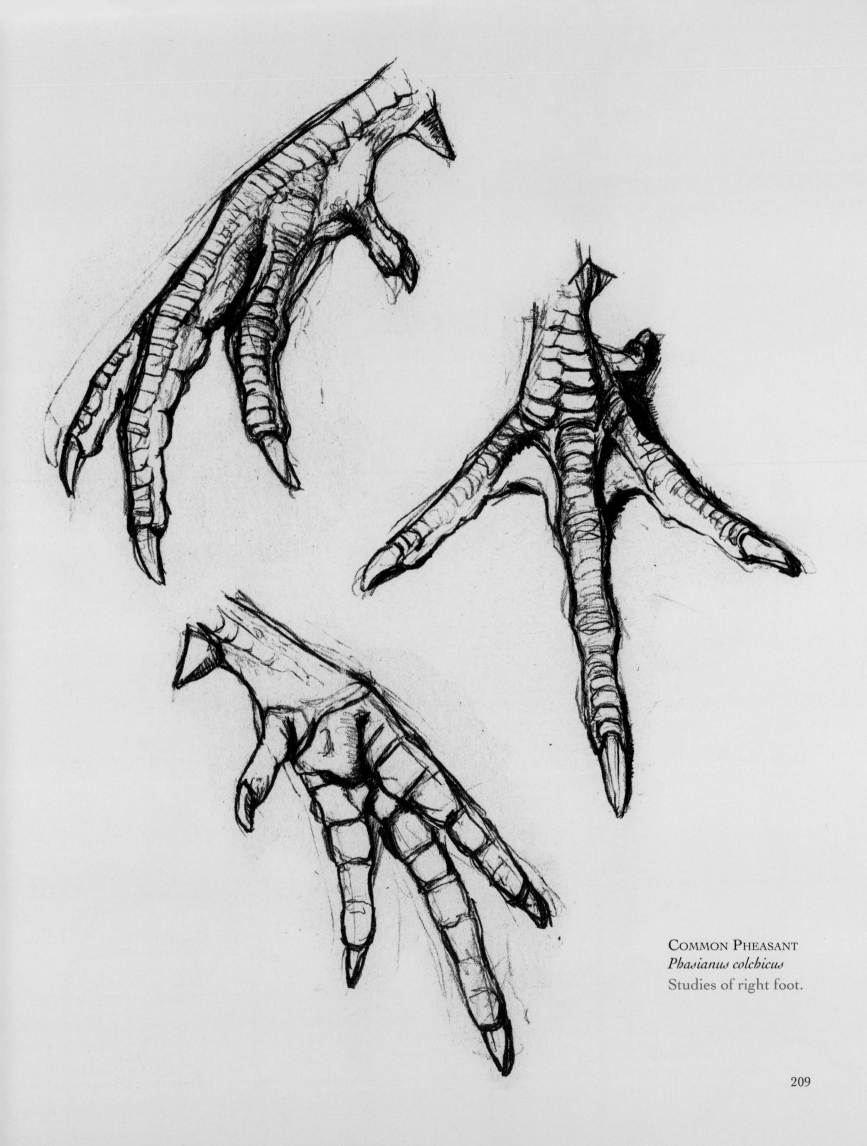

COMMON PHEASANT
Phasianus colchicus
Studies of right foot.

209

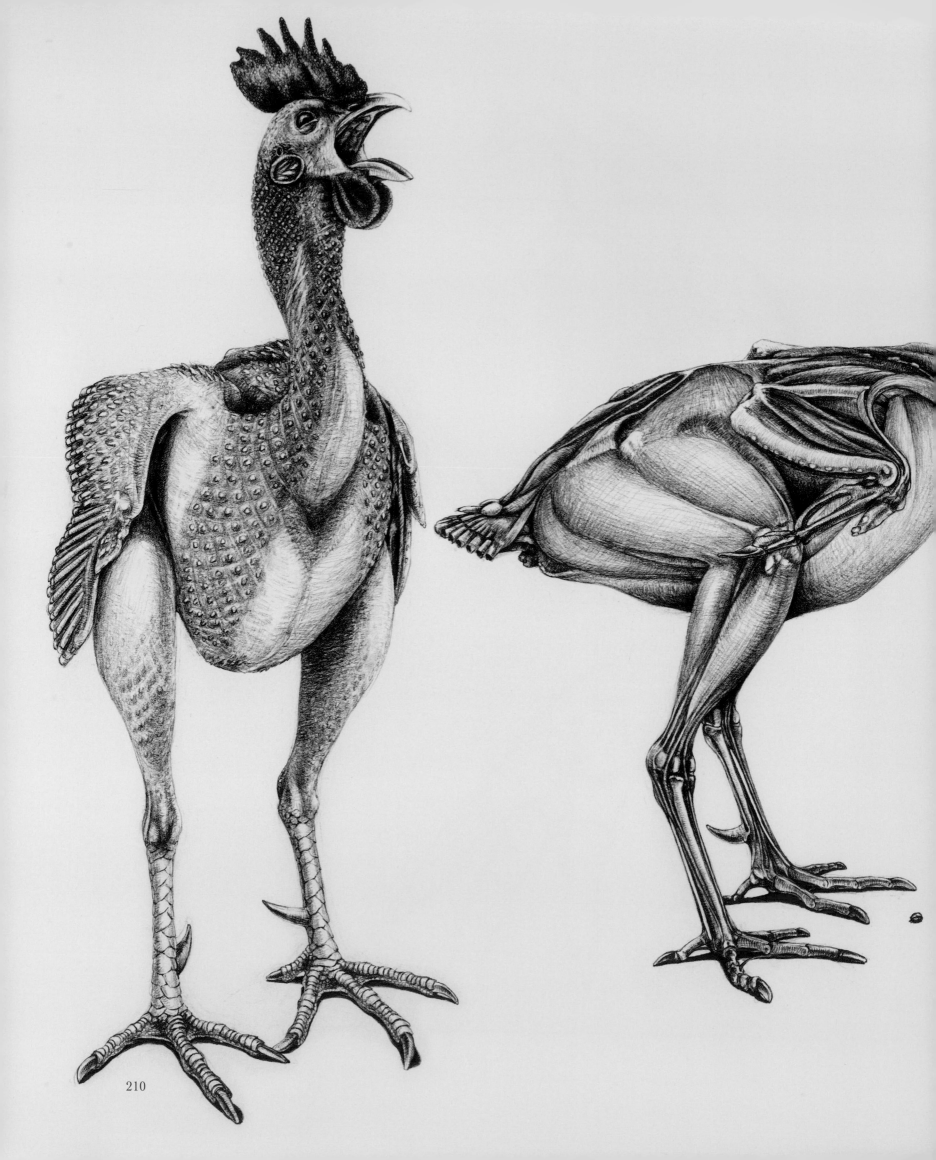

210

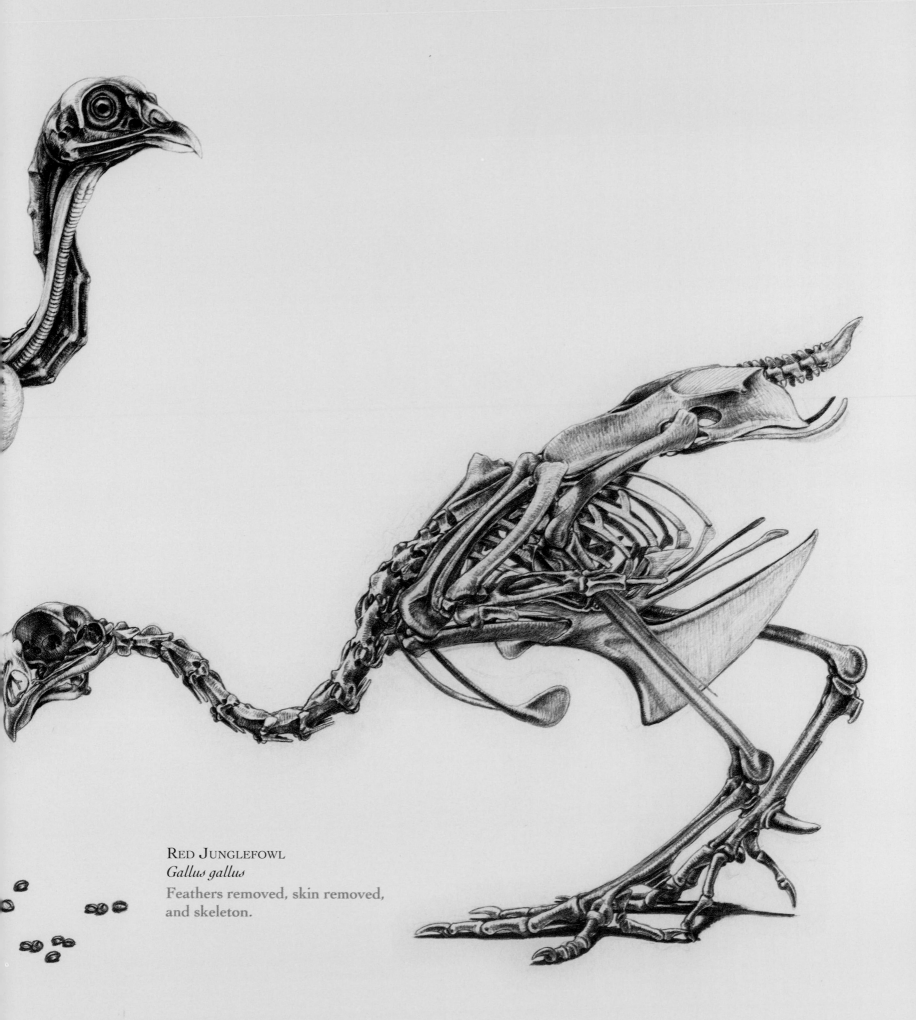

RED JUNGLEFOWL
Gallus gallus
Feathers removed, skin removed,
and skeleton.

211

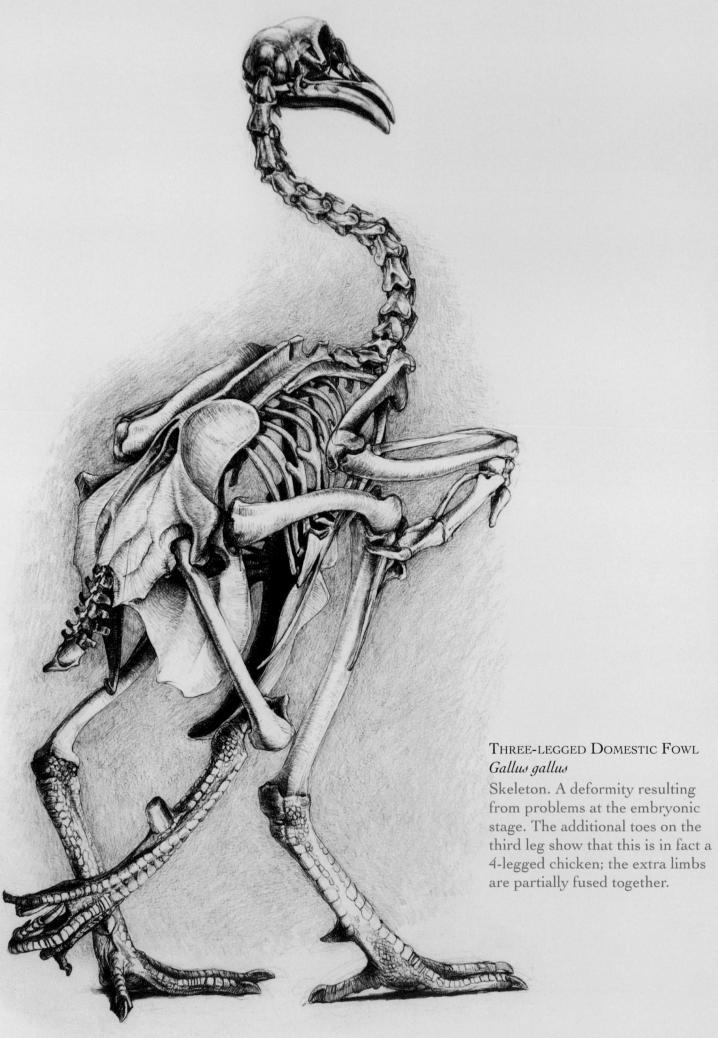

THREE-LEGGED DOMESTIC FOWL
Gallus gallus

Skeleton. A deformity resulting from problems at the embryonic stage. The additional toes on the third leg show that this is in fact a 4-legged chicken; the extra limbs are partially fused together.

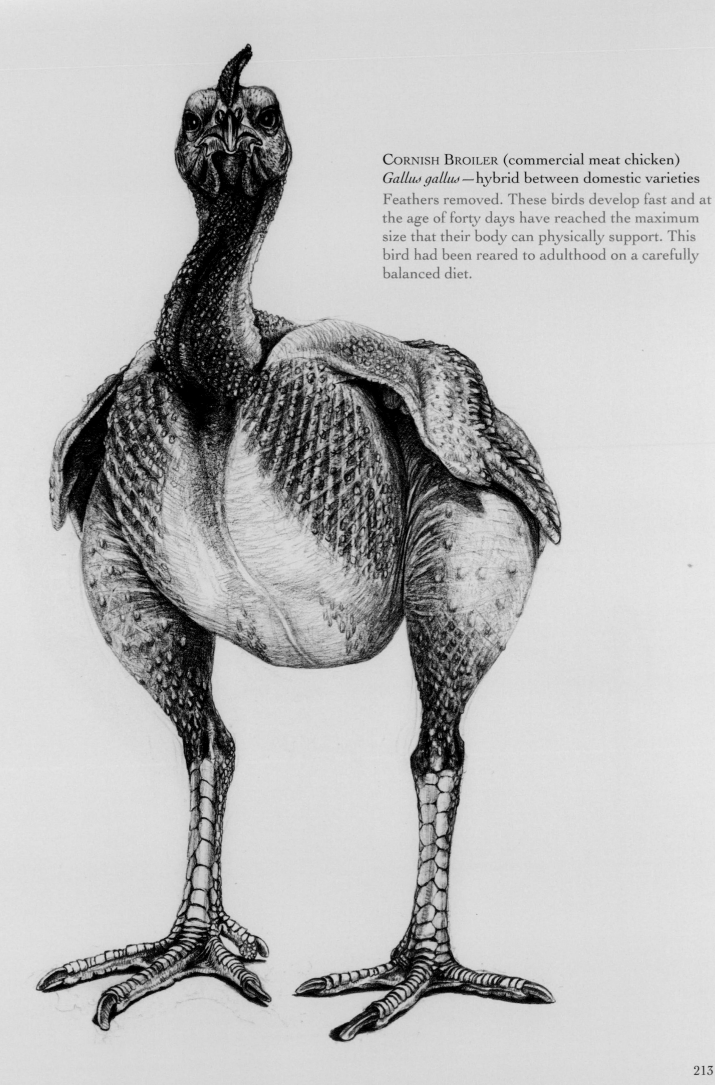

Cornish Broiler (commercial meat chicken)
Gallus gallus—hybrid between domestic varieties

Feathers removed. These birds develop fast and at the age of forty days have reached the maximum size that their body can physically support. This bird had been reared to adulthood on a carefully balanced diet.

JAPANESE BANTAM
Gallus gallus—domestic variety
Feathers removed. The shortened leg—and
wing—bones are the result of the same genetic
mutation that gives us Dachshunds.

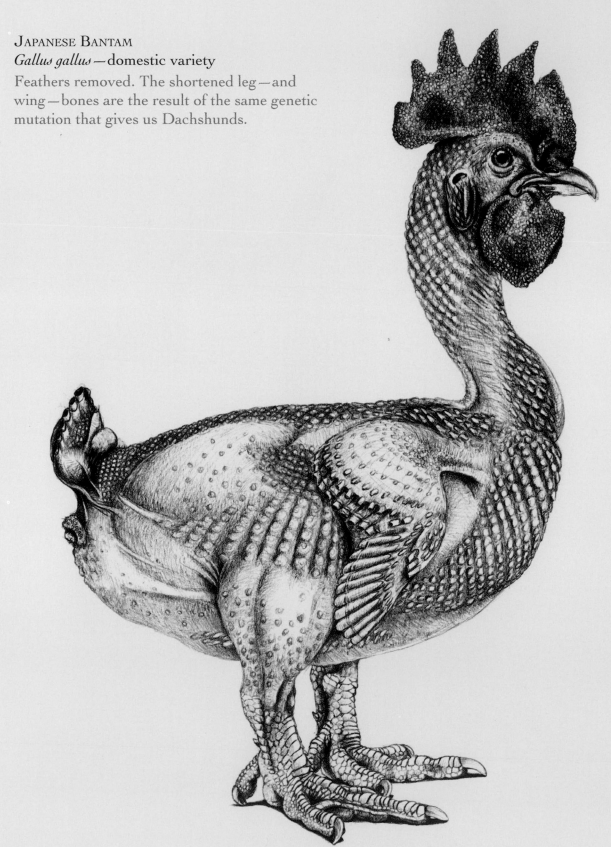

214

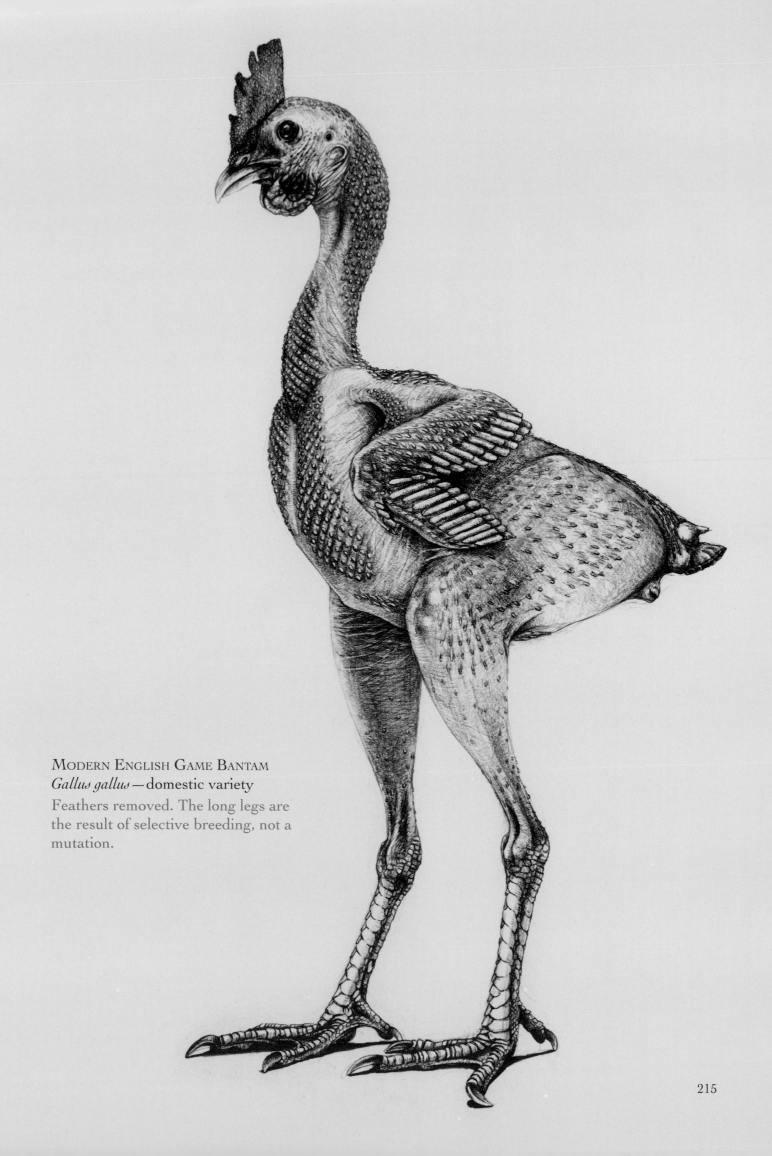

MODERN ENGLISH GAME BANTAM
Gallus gallus — domestic variety
Feathers removed. The long legs are
the result of selective breeding, not a
mutation.

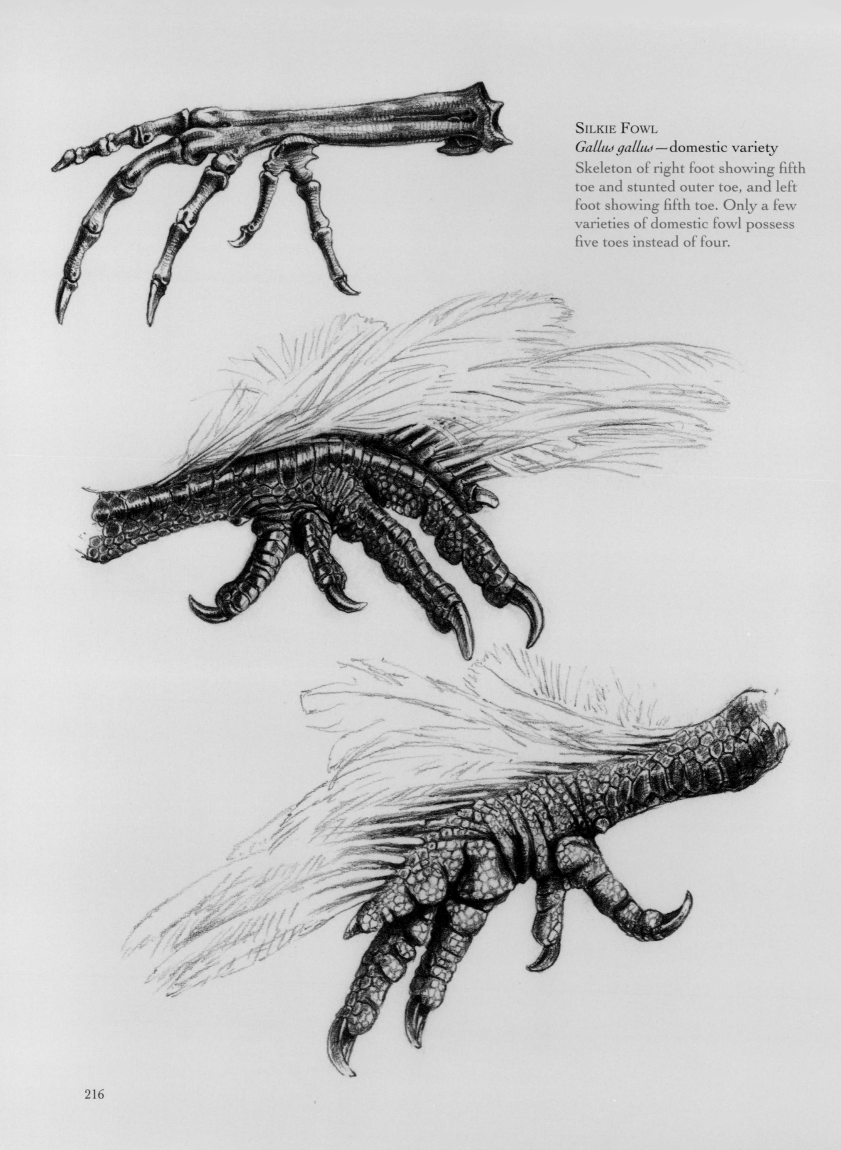

SILKIE FOWL
Gallus gallus—domestic variety
Skeleton of right foot showing fifth toe and stunted outer toe, and left foot showing fifth toe. Only a few varieties of domestic fowl possess five toes instead of four.

POLISH FOWL
Gallus gallus — domestic variety

HELMETED CURASSOW
Pauxi pauxi

MALEO
Macrocephalon maleo

HELMETED GUINEAFOWL
Numida meleagris

Skulls with crests: a product of an artificially selected genetic mutation in the domesticated Polish Fowl and a naturally occurring feature of the others. Notice the open-topped nostrils in the Polish Fowl skull—this is caused by the same mutation.

Domestic Fowl

Domestic chickens are possibly the most widespread bird on the planet and have been around a long, long time. They strutted around human habitations for many centuries before the birth of Christ and had already reached Europe by the beginning of the Classical Era.

All domestic fowl are descended from a single wild species, the Red Junglefowl, although domestication probably occurred independently in several localities throughout the Far East, involving several geographical races.

Over the centuries artificial selection has centered on the chicken's capacity for meat and egg production, so it is not surprising that the junglefowl—until comparatively recently—was smaller and slighter than most domestic varieties. But most breeds now have a bantam version, too—diminutive replicas of their more

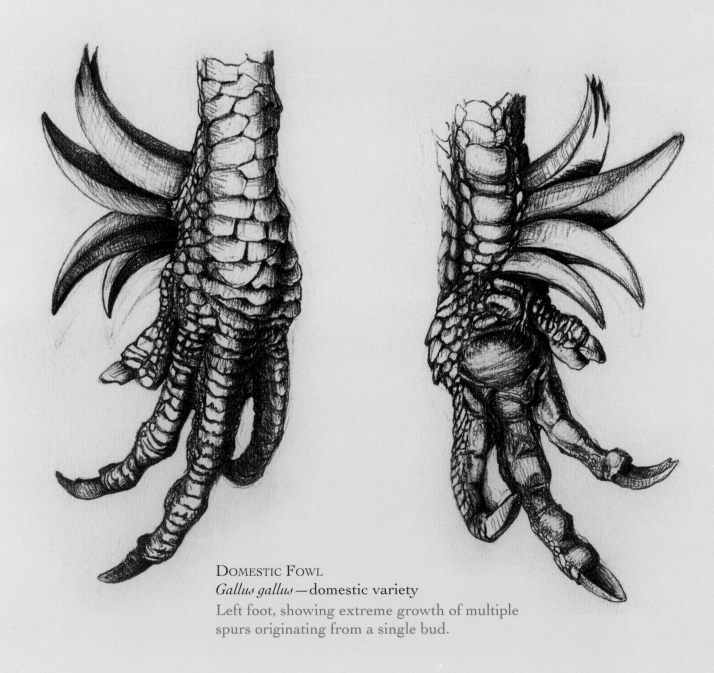

DOMESTIC FOWL
Gallus gallus—domestic variety
Left foot, showing extreme growth of multiple spurs originating from a single bud.

218

commercially viable counterparts created for aesthetic purposes only.

The perfect chicken for the table grows fast. Really fast. At the age of around forty days the breast and thigh muscles are as large as a living body can physically support. Kept alive beyond this period, a bird needs a carefully controlled diet—low in protein and high in mineral supplements—if it is to reach adulthood. For this reason, modern commercial meat birds (called "broilers") can only be created by cross-breeding with other varieties, usually between Cornish and Plymouth Rocks, to produce Cornish Broilers.

Domestic fowl were also kept for fighting, and the stylishly elongated Modern English Game was an exhibition variant on the much broader-bodied fighting breed, the Old English Game. The long legs, accentuated by the upright posture, are not caused by a genetic mutation but are the result of selective breeding. Both varieties exist in both large and bantam forms.

A very few bantams have no large equivalent. They were developed exclusively as small breeds for aesthetic and even spiritual reasons. One of the oldest, and certainly the most remarkable, is the Japanese Bantam. The short legs are the most obvious feature, but a closer inspection will show that they have tiny wings, too. This is a result of the same genetic mutation that causes shortening of the limbs in other animals, including humans and dogs. Think Dachshunds. In chickens, however, the gene is dominant and lethal, which means that embryos with two such genes will die before hatching.

Genetic mutations are necessary for life. They are at the very center of evolutionary biology and without them there would be no biodiversity—though almost all are not even noticeable externally. But when many people think of mutations they have in mind "freaks of nature," "monstrosities" with too many or too few body parts. Such unfortunate creatures rarely live for more than a few days, especially in the wild. But under domestication and with special care, some, like the splendid three-legged cockerel illustrated here, may reach maturity and live many years. Such disfigurements are, in fact, often the result not of genetic mutations but of abnormalities at the cell division stage early in embryonic development, which is why the deformities are often symmetrical. This cockerel appears to have only three legs, but in fact there are four: the extra foot is composed of two fused tarsi and has more than the usual four toes.

Four toes is the normal, ancestral condition in all birds, and although many birds have fewer—three or even two—no naturally occurring wild species has five. Domestic chickens are the exception. The Dorking Fowl is the most well-known five-toed variety, but the feature is present in several others as well, including the fluffy, feathery-footed Silkie. The extra toe arises from the basal bone of the hind toe, which is expanded into two sections. It's actually longer than the hind toe and even possesses an extra bone. Conversely, in Silkies the outer toe is shorter than normal; altogether stunted, it lacks the terminal bone and often even the claw. This has nothing to do with the five toes, however; it's common to all domestic fowl with feathered feet.

Another anomaly is the Polish Fowl—an Old Dutch breed and not from Poland at all. It has a large pompom crest on the top of its head, which is caused by a bubble-like outgrowth of the skull; very different in structure from the highly textured natural skull adornments of other gamebirds and a million miles away from the similar, domestic Crested Duck. The mutation responsible for the lump on the head also causes a reduction of the bone between the nostrils, so the gap in the bill of the specimen illustrated is a normal feature of the breed and not caused by damage.

Screamers

Despite their current classification in the same order as the ducks, geese, and swans, screamers are but primitive ancestors and barely resemble other waterfowl species. Their toes have only minimal webbing and their bill is curved and pointed like a gamebird's rather than flattened as in other waterfowl, although it does bear a rudimentary version of their adaptations to filter feeding. For a long time screamers were considered to be more closely related to the gamebirds or to be a missing link between the two orders. They're peculiar-looking creatures: large and bulky, with long legs, huge feet, and a disproportionately small head. And perched on top of the tiny head: either a pert little crest or an antennae-like ornamental "horn"— an outgrowth from a bony projection of the skull.

Unlike that of other waterfowl, the screamers' hind toe is elongated, like a heron's, and is not raised above the ground. In this way they closely resemble the similarly large-bodied megapodes and curassows— the most primitive of the gamebirds. Screamers favor marshy areas, and the long toes help spread the weight of the bird when walking over rafts of floating vegetation, in the same way a jacana's do.

Perhaps the most remarkable external feature of screamers is their wings, which bear two large, bony, horn-covered spurs resembling large rose thorns. These arise from either end of the hand bone, on the leading edge: one between the wrist joint and the "thumb" bone and the other at the base of the longest finger. These are used for fighting, and their horny coverings have been found embedded in the breast muscles of other screamers, though territorial disputes may be avoided by simply showing off the size of one's spurs to a rival male. Wing spurs at the wrist joint are present in other bird species from a variety of families, including the plovers, jacanas, various waterfowl, and the sheathbills. But screamers are unusual in possessing two pairs, and particularly spectacular ones they are.

It's important not to confuse wing spurs with wing claws. Although both structures constitute a bony core surrounded in a horny sheath, spurs are extra outgrowths of the hand bone (directly comparable with the leg spurs on the tarsi of gamebirds), whereas wing claws are at the ends of the digits (usually the thumb), corresponding with the claws of the feet. Spurs are also rather prominent, increasing in size with a bird's age, and are actively used in combat, whereas wing claws tend to be barely visible and (except in ratites) are usually lost when a bird reaches maturity.

Screamers are remarkable in other ways, too. In most bird families the feathers are grouped into distinct symmetrical tracts with wide spaces in between. Not surprisingly, these gaps are narrower in some diving birds that need dense feathering in order to avoid losing heat. But screamers live in tropical South America; they seldom swim and never dive, but the feathers grow from follicles distributed evenly all over their skin, a feature they share only with penguins and ratites. Feather tracts are nevertheless present during the embryonic stages of development, which suggests that this is not simply a primitive characteristic from the screamers' evolutionary past.

Even the skeleton is bizarre looking, like an assortment of body parts from other species. The formidable spurs are complemented by the fierce-looking overhanging "eyebrows," while the incongruously large feet shatter the illusion of ferocity altogether. Screamers are also the only birds whose ribs lack the backward-pointing bony processes, called uncinate processes, which overlap the rib behind to give strength to the trunk. These are a vital asset to flying birds, making the body rigid enough to withstand the considerable strain imposed by the contractions of the powerful breast muscles. Despite this irregularity, screamers are

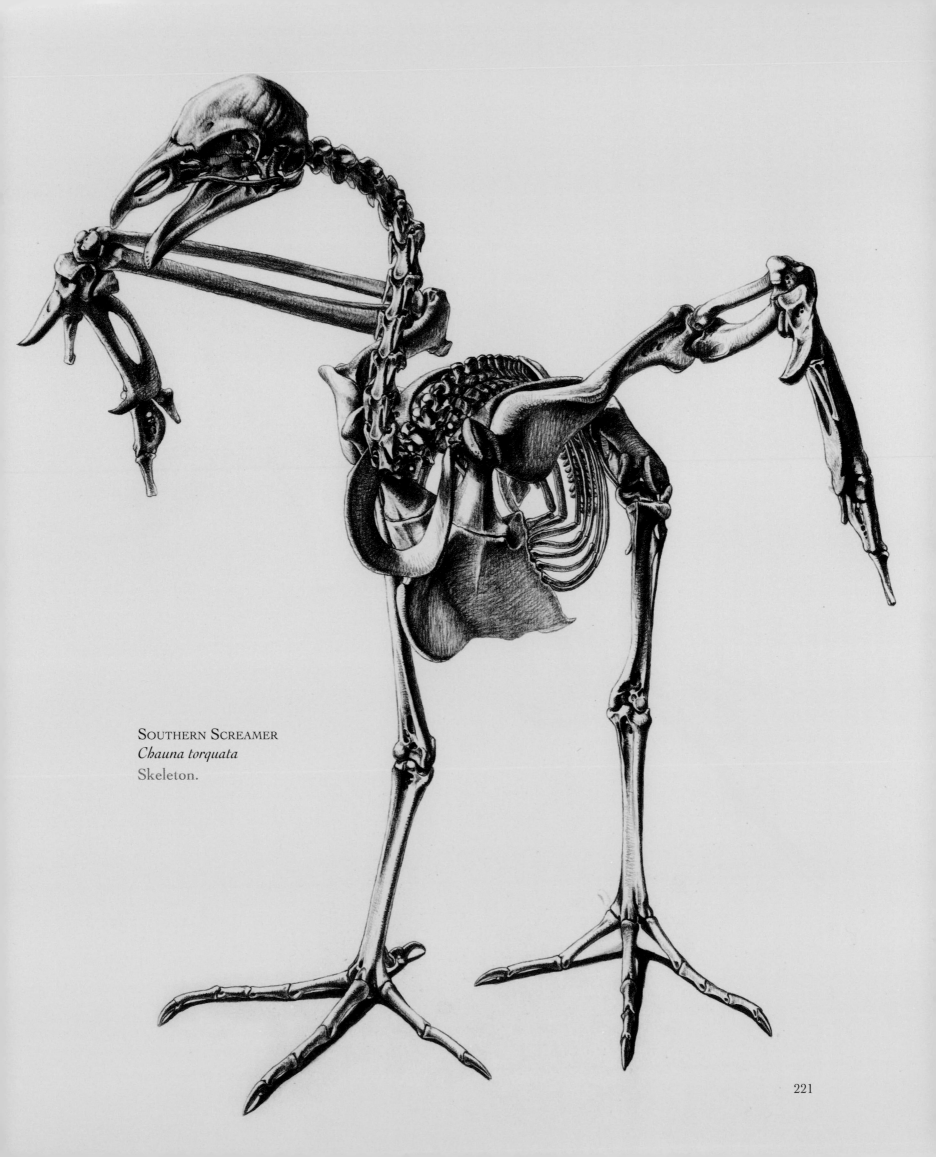

SOUTHERN SCREAMER
Chauna torquata
Skeleton.

strong fliers and have very large wings. Their breastbone is deep and wide with a positively enormous keel, and the wishbone is broad and thick. Their bones, too, are especially light and their body so well supplied with air sacs that it even makes a crackling noise when they move suddenly. They take to the air when alarmed and will invariably then perch in a tree and scream loudly and persistently—the feature that gives screamers their name.

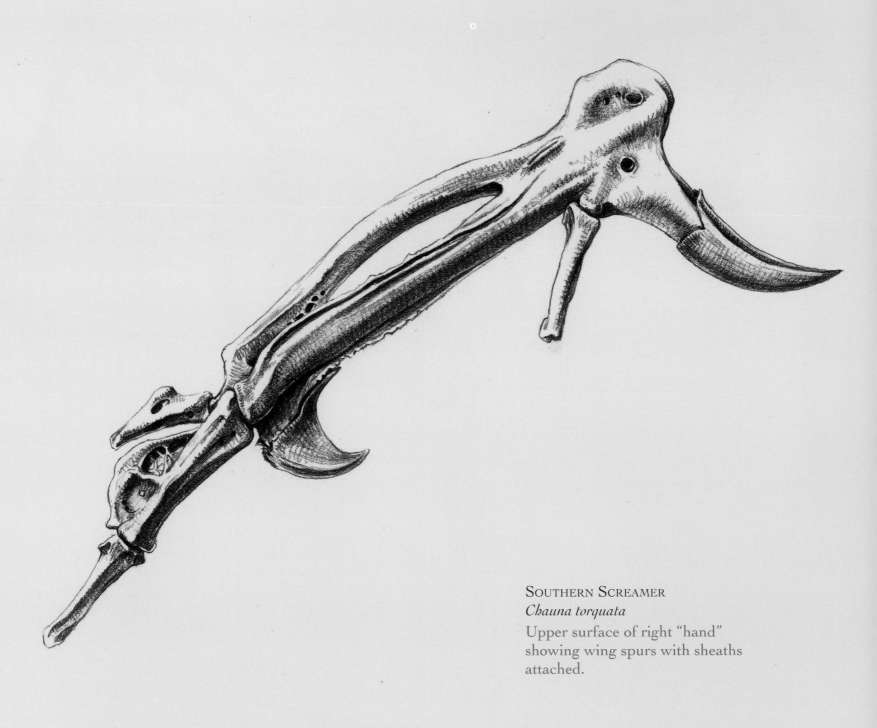

SOUTHERN SCREAMER
Chauna torquata
Upper surface of right "hand" showing wing spurs with sheaths attached.

Hoatzin

With its red eyes, blue face, and outlandish crest of eccentric-looking feathers perched on top of a tiny head, the Hoatzin seems more the product of fiction than reality. Indeed, it looks every inch a bird to baffle science. It is scarcely believable that the Hoatzin is even more remarkable on the inside than on the outside and shows little if any affinity with any other bird group.

Its large body and strong legs at first led to its being classified alongside the pheasants. However, for the past two hundred years or so the unique Hoatzin has been doing a taxonomic tour of the bird world, paying temporary visits to a whole variety of disparate orders before returning to the company of gallinaceous birds or otherwise being placed in an order of its own. There is, however, now strong evidence to suggest that it is perhaps most closely allied to the cuckoos.

One of the problems facing scientists attempting to ascertain the Hoatzin's closest relatives is the presence of seemingly primitive characteristics alongside others more recently evolved. The most famous of these is the clawed wing of the chicks. Archaeopteryx, the fossil link between birds and dinosaurs, had clawed wings, too, among other reptilian features, so it was for a long time assumed that the Hoatzin had retained this as a primitive relic, particularly as they are lost when the birds reach adulthood. However, it is now thought more likely that the wing claws appeared more recently in its evolutionary history as an adaptation to its environment.

Hoatzins inhabit dense Neotropical flooded forests. Their nests overhang the water, and when threatened by a predator, the chicks—even very tiny ones—will launch themselves overboard. Unlike the adults they swim well, both on the surface and during shallow dives underwater when they propel themselves with their legs and wings simultaneously. As soon as they reach the vegetation of their nest area, they haul themselves out of the water, clambering through the branches with the aid of their clawed wings, their feet, bill, and neck—any part of their anatomy—to safety.

The claws are movable by muscles, so they can actively grasp the branches and are not simply used as hooks. There are two on each wing, situated at the ends of the "thumb"—the alula—and longest finger, and turned inward toward the body. Archaeopteryx possessed three wing claws, but the feature is not as exclusive in modern birds as one might imagine. Most ratites—including adults—have one or two on each wing. And finfoots and some rails have them at the tip of the thumb only. Although they are probably used only by the chicks in these groups, for clambering through vegetation, they are frequently retained by the adult bird.

But more remarkable even than the clawed wings is the Hoatzin's digestive system. It is this alone that has truly defined the species and accounts for its singular anatomy and behavior.

Hoatzins live almost exclusively on leaves. Their bill is short and strong, with a hinged upper mandible for biting them off branches, and the jaws are muscular. But unlike other leaf-eaters, such as the grouse, which digest their food primarily in their stomach and intestine, the food of the Hoatzin is broken down in its crop and lower esophagus. In this it resembles cattle and other ruminants; but whereas cows are able to chew the cud, Hoatzins rely exclusively on the action of bacteria and enzymes. This is reported to give the birds an unpleasant odor, similar to fresh cow manure. Only after a lengthy period of fermentation is the food permitted to continue into the gut. The stomach, or gizzard, is consequently much smaller than that of other birds, but the crop is enormous and furnished with thickened muscular walls. So large is it that it has invaded the space usually taken up by the breastbone, which is misshapen to accommodate it, with the keel reduced to a small triangle at the very bottom, leaving little room for flight muscles. Hoatzins are consequently

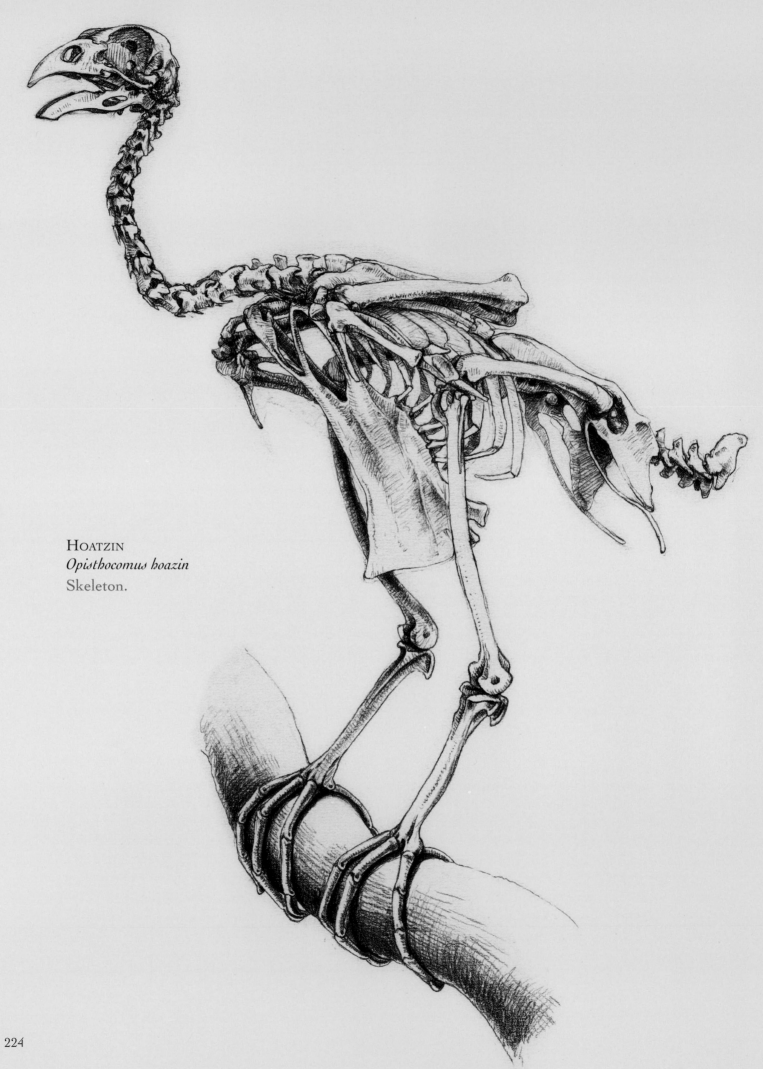

HOATZIN
Opisthocomus hoazin
Skeleton.

very weak flyers, though their large wing area helps to compensate a little by maximizing lift and increasing the efficiency of gliding.

Having a normal perching foot, with three toes in front and one behind, means that they are not particularly efficient climbers. Neither can the adults swim. And there is no dry ground to walk on. Fortunately, Hoatzins don't need to move much. Fermentation is a slow process, and they remain sedentary for prolonged periods, propped up on a branch by a hardened pad beneath their breast to take the weight off their crop, in a constantly repeated cycle of eating and digesting. Sometimes, however, they do make moonlight forays to browse elsewhere.

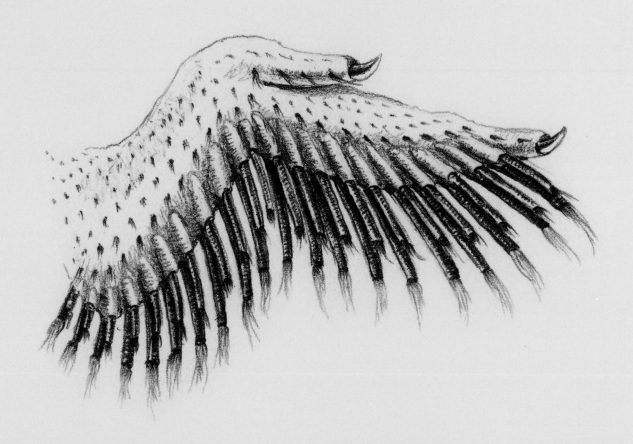

HOATZIN
Opisthocomus hoazin
Right wing of chick. Notice that the claws turn inward, toward the underside, where they can be most useful for climbing.

Ostrich, Kiwis, and Other Ratites

The Ostrich is the largest of a group of primitive, flightless birds known collectively as ratites, and the largest of all the birds. It hasn't always been this way. Some of the thirteen species of moa from New Zealand and the Elephant Bird from Madagascar, all of which became extinct within the last five hundred years, would have towered above an Ostrich. The other members of the group, in size order, are the Emu, cassowaries, rheas, and kiwis. No one would dispute that they are all ratites, though their relationship to one another is still a matter for taxonomic debate.

The name "ratites" comes from the Latin word for "raft" and refers to the "raft-like" breastbone, a comparison that makes little sense until one thinks in nautical terms and remembers that rafts do not possess a keel. Actually "coracle-like" would be a more accurate description, as ratite breastbones are far from flat-bottomed.

The question of whether the ratites arose from flying ancestors, although hotly debated in the past, is now almost universally accepted. Ratites are indeed the only birds that no longer possess a keel. However, Dodos have barely any keel and lost theirs comparatively recently in evolutionary terms, which shows just how quickly even major skeletal structures can degenerate when there is no longer a competitive need for them. So their adaptations for flightlessness are not, in themselves, evidence of the ratites' great antiquity.

But ratites (along with the tinamous, which do possess a keel and can fly) do differ from all other birds in many ways that distinctly suggest that they arose from a very primitive branch or branches of the avian tree. One of these is the structure of the palate, which has led to naming this group (including tinamous) "Palaeognaths"—meaning "ancient jaws"—as opposed to "Neognaths"—"new jaws"—for all other birds.

Ostriches have a broad, flat, triangular bill, with a rounded tip and a somewhat rounded edge, which opens to reveal a very large gape. Their eyesight is excellent, particularly over long distances, and the long neck allows a wide view over their savannah and desert habitat.

More than any other ratite, Ostriches are runners. They are indeed the fastest two-legged animal on the planet. So if a predator should approach—and there are plenty of them on the African plains—they can usually put a safe distance in between in a matter of seconds. When running is not a viable option—for example, if a predator is approaching the nest or chicks—they have a formidable kick, too.

The perfect running foot is raised off the ground, minimizing contact with the surface and increasing the propulsive forward thrust; this principle applies equally well to birds as it does to mammals. In the same way that the ancestral horse raised itself onto its central toe, losing the superfluous side digits along the way, Ostriches have lost not just their hind toe like many ground-living birds but their inner toe as well, leaving them unique in the bird world with only two. The vestigial remnants of the "missing" toe are, however, sometimes present within the skin of the foot, and a small bony spike protruding from the inner edge of the tarsus is all that remains of the point where it would have been attached. Even the bottom end of the tarsus is poised above ground level, and the bird's entire weight is supported by the thickened pads under the tips of the two remaining toes, like a foot in a high-heeled shoe. All other ratites have three toes, except the kiwis and moas, which have (or had) four.

Only the longer, central toe has a claw, and a rounded and stumpy one at that. The cassowaries, however, do claws in a big way. Cassowaries are no less than living velociraptors, with an inner toe armed with a slashing blade several inches long that can eviscerate a would-be predator at one kick. Skirmishes between rivals rarely result in such a degree of violence, however, and with no natural mammalian predators in their

native New Guinea and Australian forests, one wonders how such a formidable weapon came to exist. Defense against crocodiles perhaps?

Another feature of the cassowaries is their casque. Structures like this are not unusual in birds and can be seen in the guans and guineafowl, as well as on the bill of hornbills. Its external covering is of a horny material, similar to the bill sheath, but beneath this the casque is formed of a honeycomb of delicate bony filaments, well supplied with blood vessels, and enclosed by a wafer-thin bony veneer continuous with the surface of the cranium. There has been much speculation about the substance of the casque, while even a cursory examination of skeletal specimens in museums will clearly show it to be part of the skull and very definitely made of bone. The whole structure is very similar to the casque of hornbills (though of course situated on the head instead of on the bill), and it is likely that in both groups it fulfills the function of amplifying sound, rather like the body of a stringed instrument.

All the ratites have immensely powerful legs. It's the leg muscles that have made Ostriches so important to the commercial meat industry, as flightless birds need, and have, virtually no muscles on the breast. In

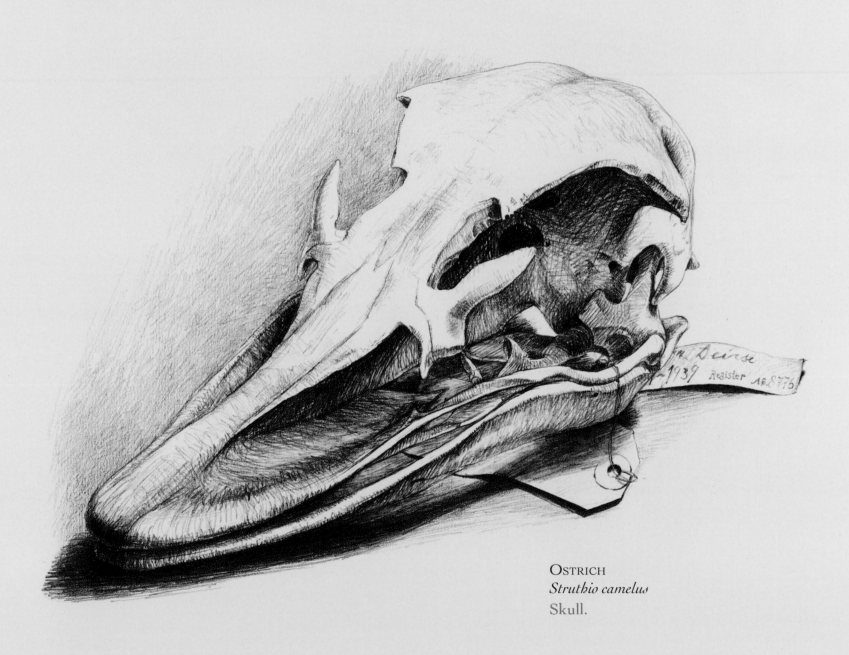

OSTRICH
Struthio camelus
Skull.

227

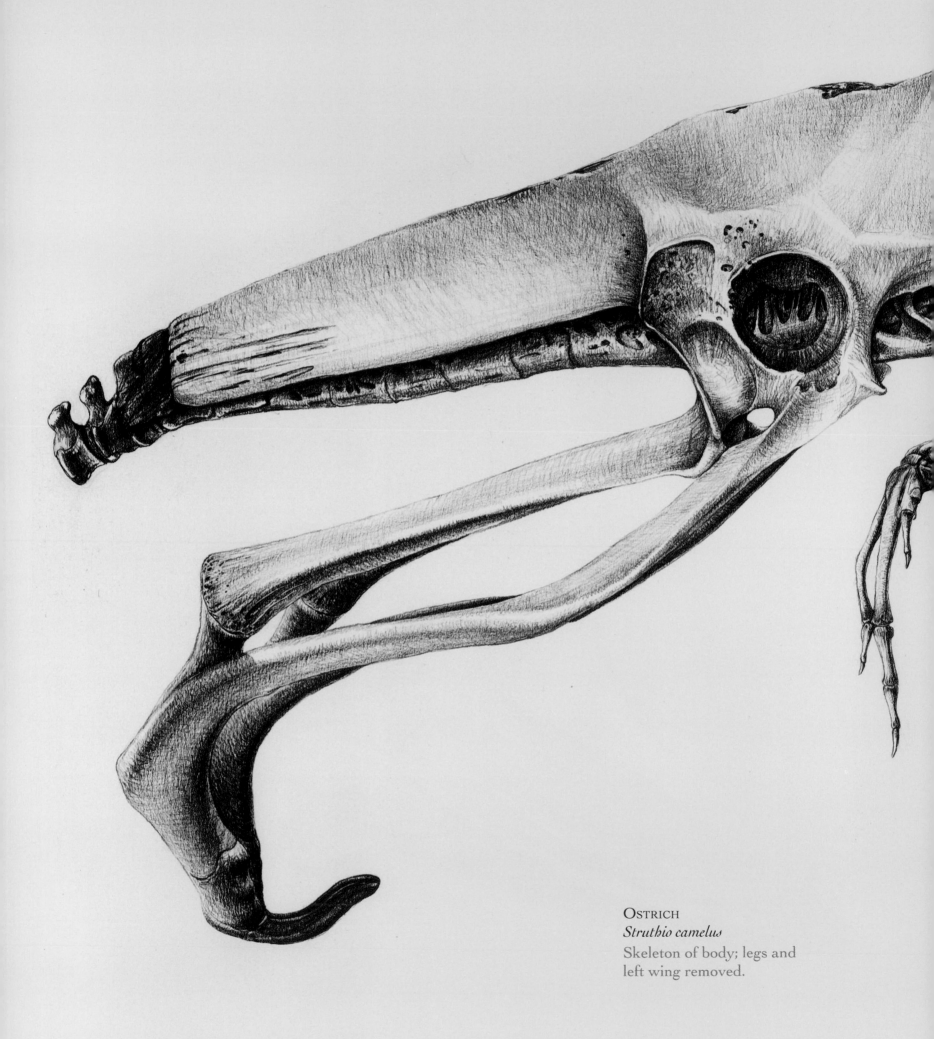

OSTRICH
Struthio camelus
Skeleton of body; legs and
left wing removed.

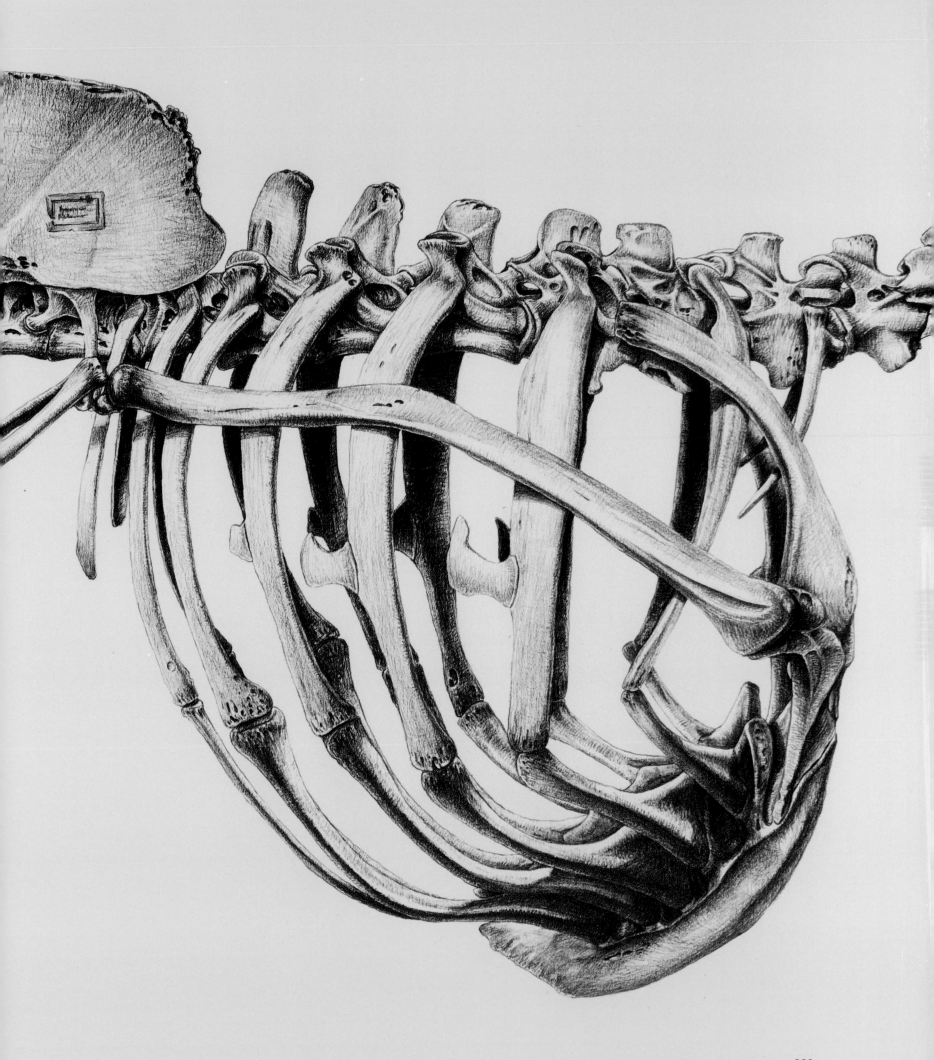

most birds the sides of the pelvis are fused to its central section, giving a wide, smooth expanse of uninterrupted bone for the attachment of the upper leg muscles. But in the primitive Palaeognaths—the ratites and tinamous—the sides of the pelvis are open and make no contact with the central section. In order to support the tremendous musculature required for a flightless existence most ratites have therefore developed a pelvic structure of an altogether different and highly distinctive appearance. Instead of the rather dorsally flattened pelvis of other birds, it forms a laterally flattened, central ridge, enclosing the vertebrae. In the cassowaries and Emu this central ridge is strongly curved, giving the line of their back its characteristic hump, though in Ostriches it is rather straight, accounting for their very different posture.

The Ostrich pelvis is also different from that of other ratites, and indeed of all other birds, in that the thin backward-sweeping projections—called the pubic bones—are joined at their tip. It has been suggested that this is to prevent the abdomen from being crushed while sitting; however, the pubic bones of the extinct moas and Elephant Bird did not meet, and these birds far exceeded the size of a mere Ostrich! The feature is more likely to be an adaptation to the rigors of high-speed running.

Historically, museum reconstructions of moas and Elephant Birds accentuated their great size by presenting them in impossibly elevated postures, towering monumentally upward in a near vertical progression toward the head. But one look at a living ratite is enough to show that their body is actually held quite horizontally, the highest point being above the attachment of the legs, from where the back slopes gently downward to the base of the neck.

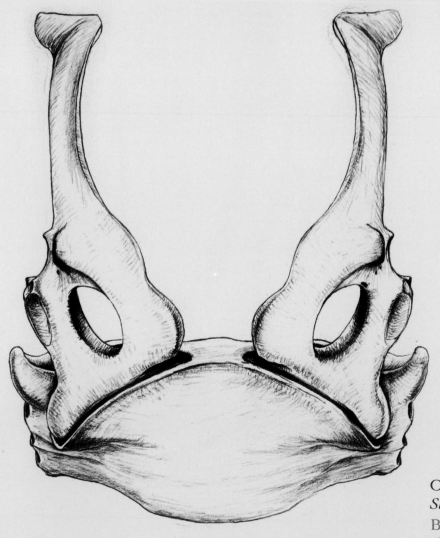

OSTRICH
Struthio camelus
Breastbone and pectoral girdle viewed from the front.

230

In all other birds the breastbone sits more or less underneath, roughly in line with the spine. The two sections of the ribs meet at an angle, and the coracoids—those two struts that support the wings—form an acute angle with the shoulder blades. But ratites appear as though the whole ribcage has been pulled forward: the ribs meet in a straight line, and the breastbone faces virtually toward the front. The pectoral girdle is modified, too. There is usually no wishbone—though in the Emu it is reduced to two short spikes—and the coracoid and shoulder blade are fused together into a single bone. (Ostriches have an extra lobe in theirs that curves around to leave a small "window.")

All ratites have undergone a reduction in their wing bones: in their size and development and—in the Emu, cassowaries, and kiwis—even in the number of actual bones. In these groups the hand section is considerably reduced and the wing is barely discernible externally. Amazingly, all evidence suggests that the moas possessed no wings at all; even vestigial bones are absent from fossilized remains. Ostrich wings are the best developed of all the ratites' as they are used extensively for display, and even have more primary feathers than other birds—sixteen instead of the usual ten. The upper arm is strongly curved and is so considerably longer than the stunted forearm and hand that it gives the false and rather startling impression of articulating the wrong way.

Most species possess wing claws, and Ostriches have two: one on the "thumb" and the other on the longest digit. The cassowaries also have five elongated and stiffened quills arising from the hand and forearm. The function of these claws and quills, present in both sexes, is unknown, though it is unlikely that they are used for defense.

The odd birds out among the ratites are the kiwis. With their small size, proportionally shorter legs and neck, and a very long bill, their whole appearance is a world away from the other members of the group.

Right up until the arrival of man in the twelfth century A.D., New Zealand was, quite literally, a "kingdom of birds." There were no mammals except bats, and the birds had been able to exploit every ecological niche that would elsewhere be occupied by them. Moas diversified to fill all the typical browsing slots while kiwis took over the role usually filled by nocturnal insectivorous mammals. They are the closest thing to a mammal that a bird can be. Or, to be more specific: they are the closest thing to a hedgehog. And more.

Nocturnal hunters of the leaf litter, kiwis are ruthlessly efficient at sniffing out—yes, sniffing—worms, beetle larvae, millipedes, and other invertebrate prey, as well as various fruits and seeds. So mammal-like are they that they even scent-mark their territory with droppings. An acute sense of smell is unusual in birds; but kiwis are highly unusual birds. Their nostrils are situated at the very tip of the bill, but more than simply smelling prey, this sensitive organ is able to detect subtle vibrations in the soil in the same way that snipes and woodcocks do. And like snipes and woodcocks, they are able to open just the very end of their bill to grasp invertebrates and extract them from the ground. They listen for movement, too, and have exceptionally acute hearing. Even the bristles surrounding their bill are tactile; so it's no loss to a kiwi that their eyes are mere pinheads (metaphorically speaking) and that their vision is reduced to just a few feet.

Kiwis nest in burrows that they excavate themselves. So much probing, digging, and bill action takes a great deal of muscle power, and muscle power needs large bony surfaces to anchor to. So kiwis, unsurprisingly, have chunky neck vertebrae, a rod-like back, and a surprisingly heavy-duty ribcage. The latter may also serve to strengthen the body when carrying eggs. Egg-laying makes high physical demands of any bird, and kiwi eggs are, in relation to the kiwi, enormous—a staggering four times larger than those of any bird of equivalent size.

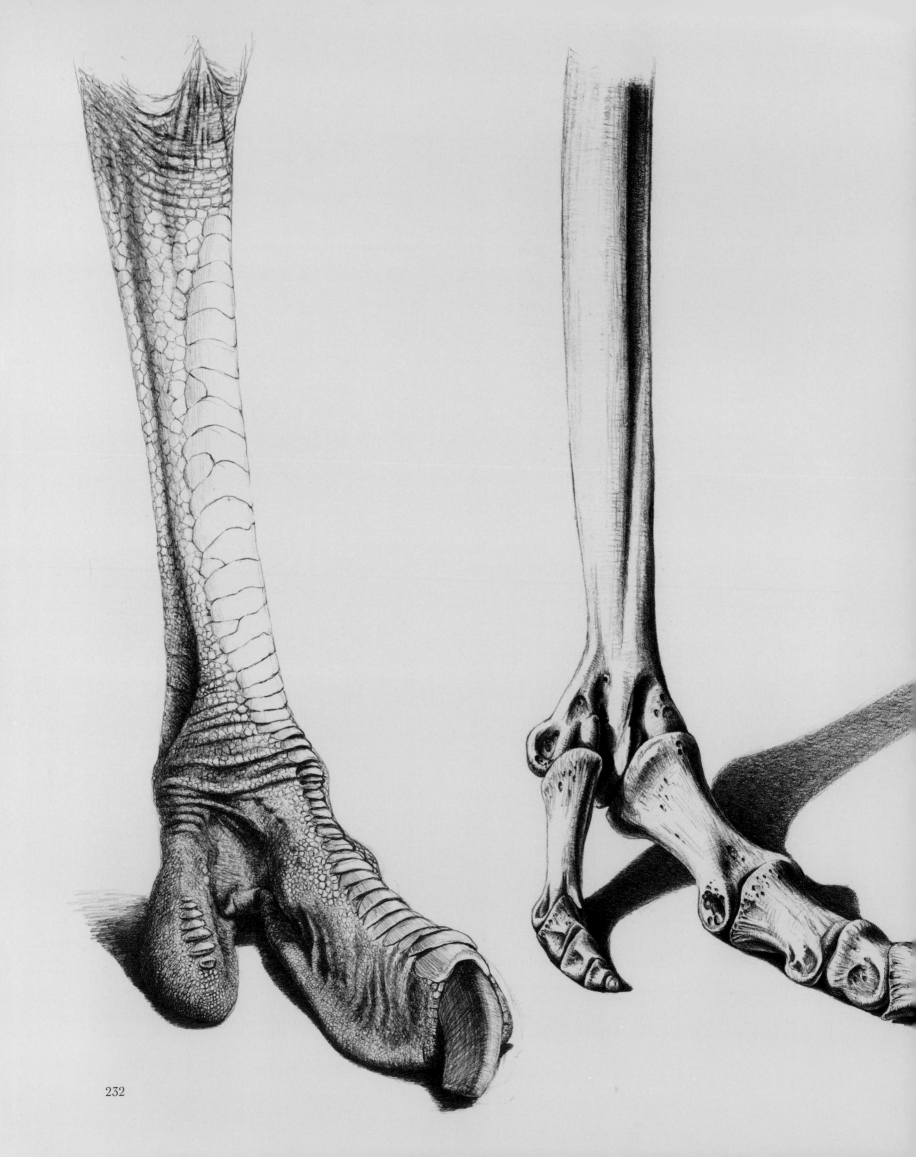

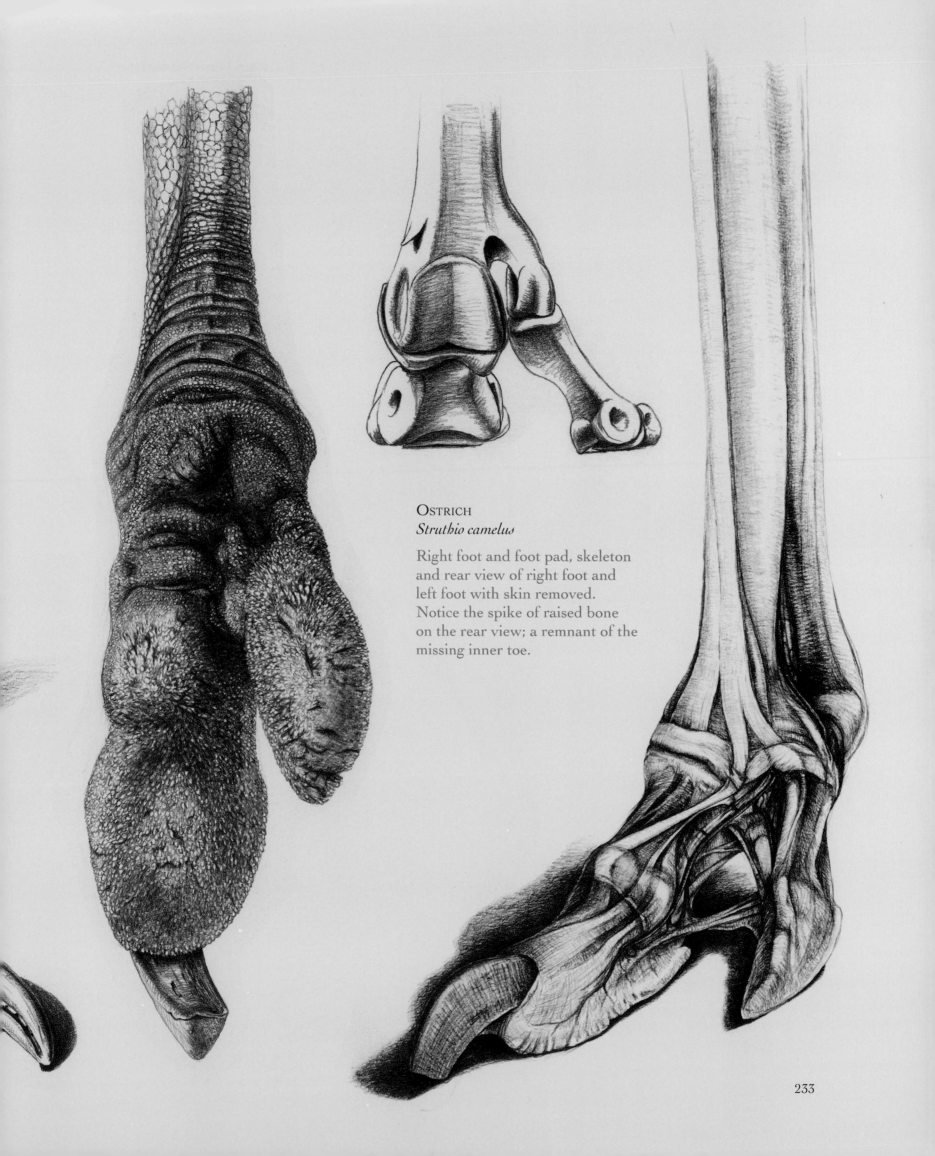

Ostrich
Struthio camelus

Right foot and foot pad, skeleton and rear view of right foot and left foot with skin removed. Notice the spike of raised bone on the rear view; a remnant of the missing inner toe.

233

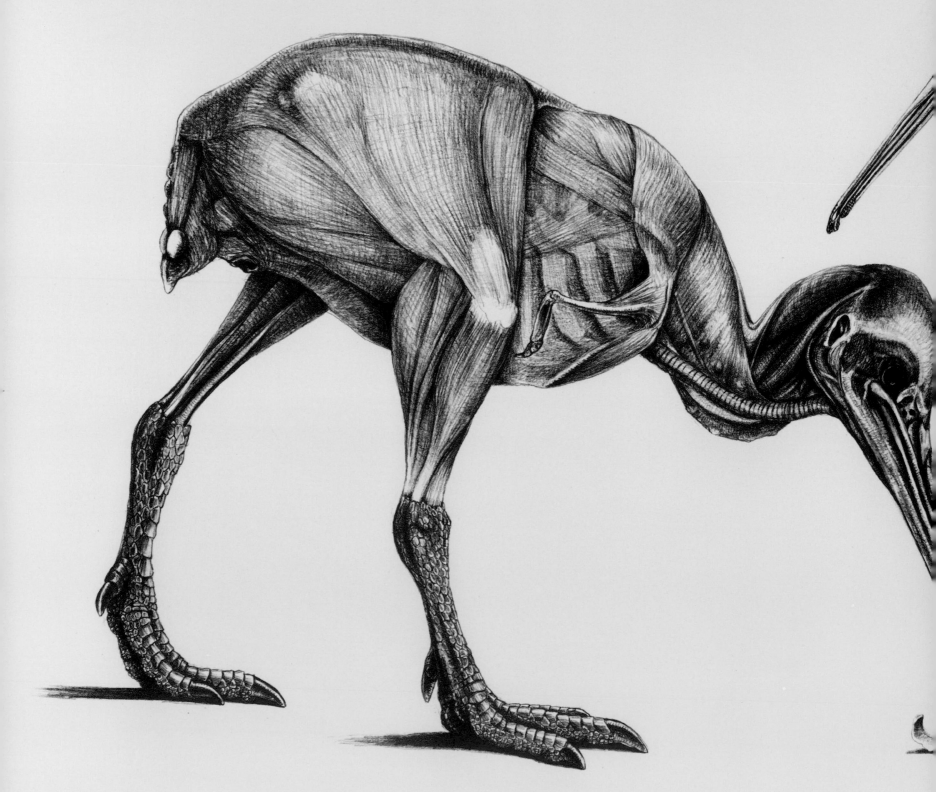

234

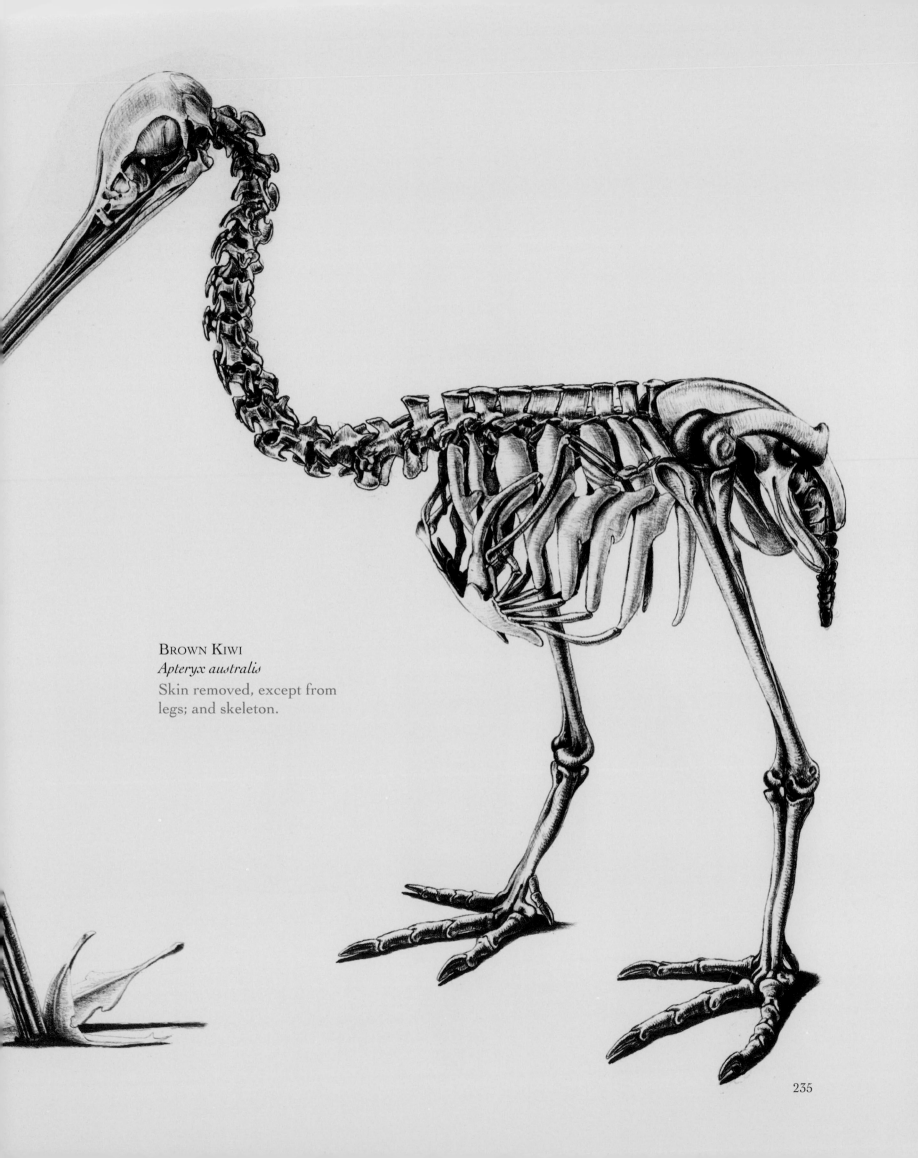

BROWN KIWI
Apteryx australis
Skin removed, except from
legs; and skeleton.

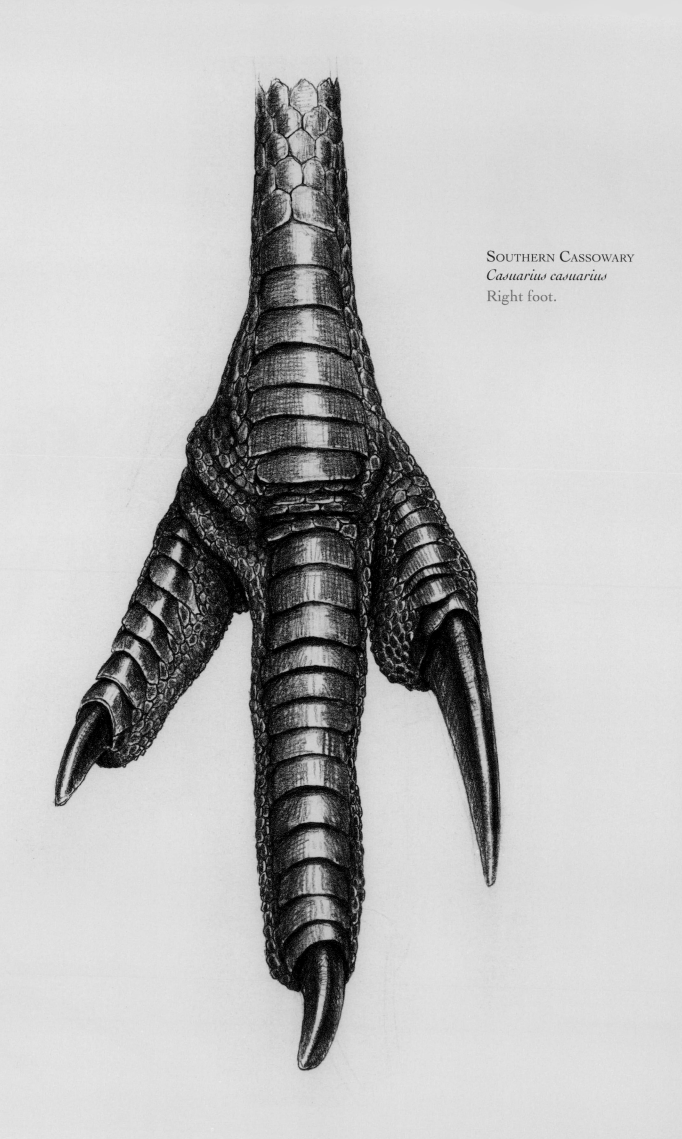

SOUTHERN CASSOWARY
Casuarius casuarius
Right foot.

Tinamous

Everything about the living tinamou says "partridge." The rounded, plump-looking body; the terrestrial habits; the way they crouch and run; and even the way they fly—with rapid wingbeats interspersed with long glides. But tinamous have a secret. They are old. Far, far older than partridges or any other gamebird, perhaps older still, even, than the flightless ratites.

It's easy to make a connection between ancestral birds and flightlessness. But just because the ratites—the Ostrich, cassowaries, and allies—are large, flightless, and primitive looking doesn't mean that they are the link between dinosaurs and flying birds. All birds, even the flightless ones, evolved from *flying* ancestors—ancestors whose closest living representative is, almost certainly, the humble tinamou.

Ratites are, nevertheless, indisputably ancient and there is a long list of characteristics—the structure of the palate, musculature, physiology, and so forth—that they share with tinamous alone that sets the whole group apart from all other birds. But it's the flightlessness of ratites that, instead of proving their antiquity, actually suggests that they are of more recent origin than the flying tinamous. In other words, tinamous may have branched off the ancestral line before the capacity for flight was lost.

Unlike all the ratites, tinamous have a keeled breastbone and well-developed wings. But their powers of flight are nevertheless minimal. The breastbone itself, instead of providing a smooth, flat surface for muscle attachment, is divided into three long and slender prongs, the central blade of which bears the shallow keel. And although they are reputedly muscular, their circulatory and respiratory systems are so poor that insufficient energy is generated for sustained flight. You have to virtually tread on a tinamou in order to prompt it to take wing, and when they do so they frequently crash headlong into obstacles in their path, sustaining serious injury.

Their poor maneuverability in the air is unsurprising for a bird with hardly any tail. In all other birds except the ratites the final few tail vertebrae are fused together into a single unit called the pygostyle, which can support a large tail and provide the surface area for it to be controlled by muscle action. Tinamous, however, have not had the benefit of such fusion and their tail is correspondingly tiny.

Their powers of terrestrial locomotion are only a little better than their powers of flight. Although they are capable of running fast, they soon tire and begin to stumble if pursued over any distance. Their legs and feet are nevertheless strong and, like most ground-living birds, the hind toe is either small and raised above the ground or absent altogether. They share with the ratites an open-sided pelvis, without the fusion of bones found in other birds, but lack the structural strength of the ratites' pelvis with its smoothly curved surfaces for muscle attachment.

In fact, tinamous seem to have drawn the short straw, lacking all of the structural and physiological benefits of both flying and flightless birds. If any bird is a metaphorical dinosaur then this is it. But amazingly they have survived and are even positively successful—with nearly fifty species and numerous races, a widespread distribution all over South and Central America, and no known extinctions in hundreds of years.

The secret of their success is in stealth tactics. They are masters of disappearance; they rely on remaining motionless and trusting to camouflage and actually use the features of the terrain to their advantage. Certainly any army sniper could learn a lot from watching tinamous. If they can find them.

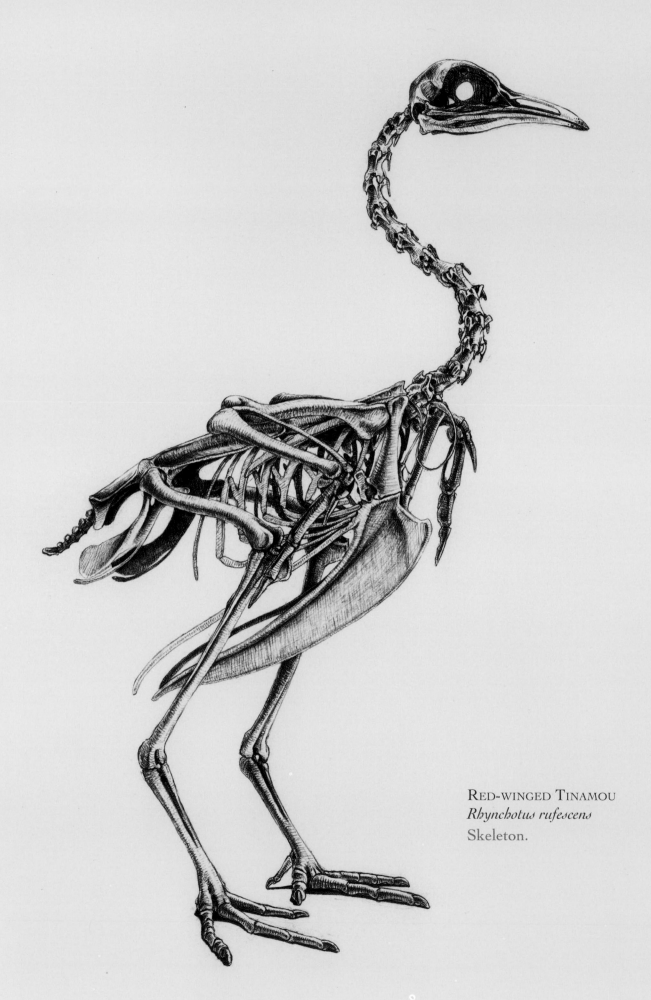

RED-WINGED TINAMOU
Rhynchotus rufescens
Skeleton.

Bustards

"Stately" is the best word to describe bustards. Especially the largest species whose males may stand over a meter tall. Their long, thick neck held proudly erect and head tilted slightly upward complete the aristocratic image as they walk sedately across the plains.

They are birds of wide-open vistas—the plains, steppes, and savannahs of the temperate and tropical regions of the Old World. They like to see what's coming and avoid predators by keeping their distance rather than by flying or running. They can fly, however. In fact they are particularly strong fliers, with an enormous wingspan, and are spectacular to behold once airborne. The Great Bustard and Kori Bustard are, next to the largest swan species, two of the heaviest flying birds in the world. To take off from the ground and have the power for sustained flight, their breast muscles need to be enormous and, of course, be supported by a keeled breastbone that is broad, deep, and robust.

But they prefer to walk. Their legs are long and strong, and their wide pelvis can easily accommodate the muscles required for spending prolonged periods on foot.

Bustards are distantly related to the cranes, in the order Gruiformes, but early taxonomists considered them to have close affinities with the gallinaceous birds and even to the Ostrich and other ratites. Certainly their habits and external appearance loosely resemble those of an Ostrich, but their internal structure is worlds apart; Ostriches have a flat, keel-less sternum, among other adaptations to long-term flightlessness, and an entirely different pelvic bone structure.

Most terrestrial non-passerine birds have undergone some reduction in the toes. Ostriches have only two, and in most waders, cranes, and gamebirds the hind toe is reduced and raised above the ground. Bustards have three forward-pointing toes, and the hind toe is absent altogether. The toes are disproportionately small for the size of the bird—a possible adaptation to avoiding heat loss at night, as well as to long-distance walking—and have a thickened layer of skin beneath. They share this feature with other walking birds of tropical grasslands—the seriamas, Secretary Bird, and ground hornbills. The claws are broad and short, and the scales of the legs are hexagonal in shape.

Bustards have a large skull, rather flattened in profile but with prominent raised eyebrows overhanging large orbits. Good eyesight is important if you need to spot predators from a distance. The bill is straight and powerful and can be turned to a variety of foodstuffs, both animal and vegetable.

Among the most remarkable features of the family is its bizarre courtship displays. These are carried out by the males to an audience of watching females. Displays vary from species to species: some trot around in a frenzy and others leap into the air like a Ping-Pong ball. In most, inflation of the neck and erection of certain groups of feathers plays a major part.

Neck inflation as a display occurs in many bird groups, but it's not always achieved by the same mechanism. In some birds, air sacs—sort of supplementary lungs situated at the base of the neck—are blown up. In others an area of loose skin at the front of the neck, called the gular pouch, is filled with air through an aperture at the base of the tongue. And others inflate the esophagus or specialized branches of the esophagus.

Bustards inflate either their gular pouch or an esophageal pouch. The Great Bustard tilts its head backward to expose the gular pouch as it slowly inflates it like a balloon; but at the same time another transformation is occurring. Hitherto cryptically camouflaged brown and black, and very difficult to see, the bird begins to expose the white feathers beneath its wings and tail, until gradually it loses any resemblance to a bird, appearing as just a shapeless ball of feathers, startlingly white and visible from a great distance. This display *looks* anatomically impossible, as though the bird had somehow turned itself inside out—and in some ways it

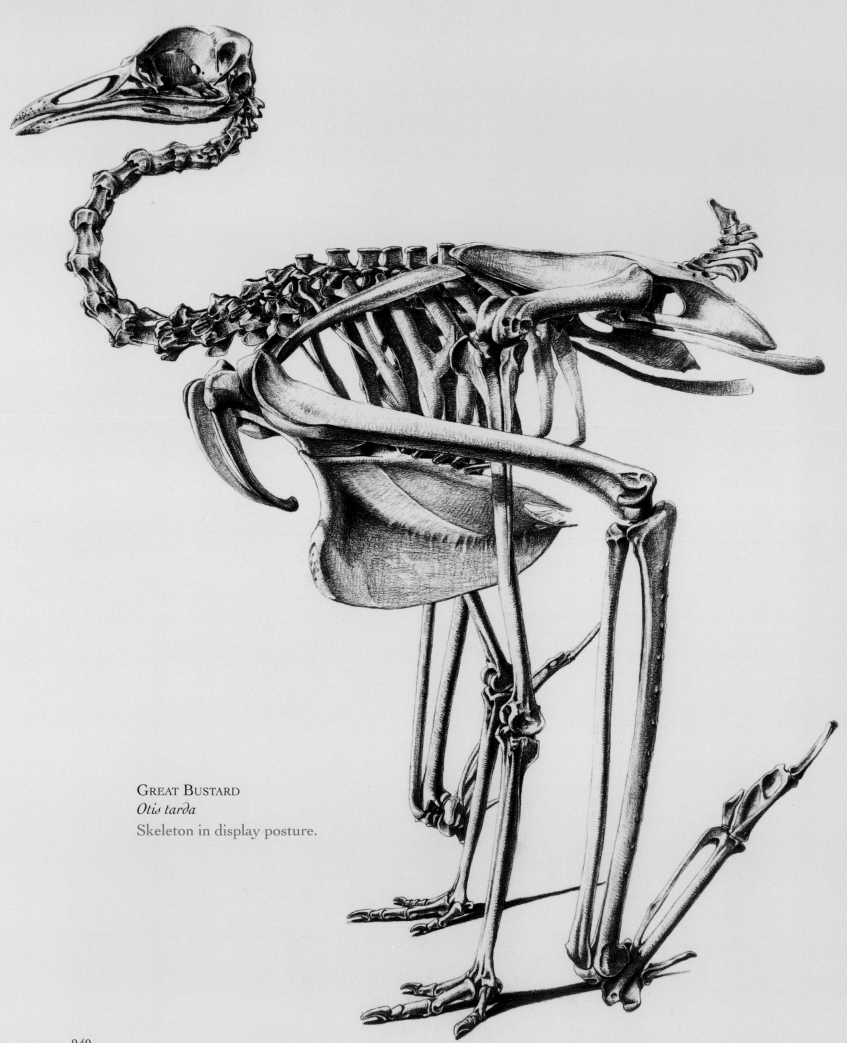

GREAT BUSTARD
Otis tarda
Skeleton in display posture.

has, although the answer is in the feathers, not the internal structure. Anatomically the posture is so simple as to be somewhat disappointing—the wings are dropped so that the wrist joints virtually touch the ground and the tail is brought up over the back. The remarkable feat is that the wing feathers, including the innermost secondary flight feathers and their coverts, which are firmly attached to the bones of the forearm, can be rotated through almost 180° to expose the white underwing coverts beneath. Flipping the broad tail over the back to show the undertail coverts is a rather simpler accomplishment; Great Bustards have particularly wide tail vertebrae, and raising the tail is a straightforward matter of muscle action.

Bustards have no preen gland and maintain their feathers exclusively with the powder generated by specialized feathers called powder down. These feathers are in a constant state of growth and degeneration; thus they are able to provide an inexhaustible supply of powder throughout the bird's life. Bustards are not alone in possessing this feature, though several groups such as herons and tinamous use it in conjunction with oil produced by the preen gland.

There is one more feature that sets bustard feathers apart from those of most other birds. They contain light-sensitive pigments called porphyrins, which actually turn them pink. When exposed to daylight for prolonged periods, however, these pigments eventually break down and the feathers fade to white, so only the down feathers, hidden from the light, retain this vivid color. These pigments in various forms are present in other birds, too—the forest-dwelling turacos, some nightjars, and some owls. Porphyrins appear fluorescent in ultraviolet light, and as birds can see in the ultraviolet spectrum it's possible to conjecture that they may have some visual function, though its significance at present remains unknown.

GREAT BUSTARD
Otis tarda
Left foot.

241

Sandgrouse

Pigeon or grouse? The true affinities of this group have long been hotly debated. Linnaeus considered them grouse. But their resemblance to pigeons cannot be ignored, and their skeleton has been described as being perfectly balanced between the two. Despite the similarities to both groups—the short legs and small head of both pigeons and grouse; the deep keel and pointed wings of pigeons; and the feathered tarsi of grouse—their behavior and ecology indicate that the sandgrouse are most likely, in fact, more closely related to the waders.

Their skeleton is dominated by the large, triangular keel to the breastbone, resembling the sail of a yacht. Although its proportions are accentuated by the birds' small head and diminutive tarsi and toes, this bone, whose function it is to support the substantial bulk of flight muscles, is the key to sandgrouse success.

Strong, fast, and direct flight, sustainable over considerable distances, enables sandgrouse to commute. They can live "out of town," in arid regions, where the seeds that form their diet are plentiful, free from the competition and risk of predation associated with water-rich areas, by simply making daily trips to waterholes to drink.

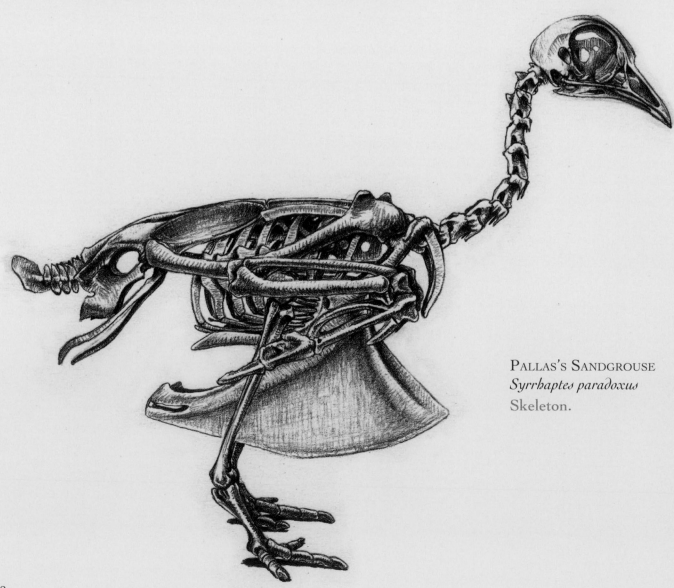

PALLAS'S SANDGROUSE
Syrrhaptes paradoxus
Skeleton.

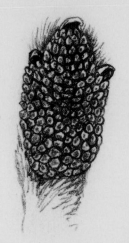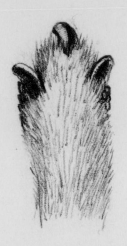

Pallas's Sandgrouse
Syrrhaptes paradoxus
Right foot; more like a little paw than a bird's foot!

Water is, however, no less important for sandgrouse than it is for any desert bird; in fact it is crucial for them. They lose heat by water evaporation through their skin, relying on their low metabolism to conserve energy and prevent dehydration. During the day they avoid overheating by moving little. They feed passively together and keep a very low profile, which makes them difficult to spot on the ground with their cryptic camouflage.

Such arid environments often undergo extremes of temperature—intense heat by day and intense cold by night. Sandgrouse are insulated against both by their well-feathered tarsi, thick-soled feet, and feathered base to their bill.

The feet are tiny and the hind toe, if present, is small and raised well above the level of the others. This minimizes contact with the hot or cold sand, and enables them to walk well and run briskly when necessary. Sandgrouse are exclusively ground-dwellers. In those species, of the genus *Syrrhaptes*, which lack a hind toe, the three forward-facing toes, feathered on their upper surface, are completely fused together within the skin so that the feet resemble little paws; the underside thickened into a single fleshy pad, like the foot of a camel.

Their visits to waterholes are made during the coolest hours: at dusk, before or after dawn, or even during the night. To say they are regular would be an understatement. You could set your watch by them, and each species has its own particular time slot. During these flights, sometimes exceeding a hundred miles in a round-trip, they call noisily to one another, attracting birds to join them to gain safety in numbers. Their wings are long and strong, broad at the base and pointed at the tip, rather like a pigeon's, which enables them to take to the air rapidly and fly swiftly. Sandgrouse have even been known to out-fly hunting falcons. Nevertheless, they approach the waterhole with caution, drink quickly for just a few seconds, then return without unnecessary delay.

They never bathe in the water; they just drink, tilting their head back as they do so. For many years it was assumed that they suck in water as pigeons do, without tilting back their head, a misunderstanding that gave greater credibility to the argument that sandgrouse and pigeons are near relatives.

Chicks need water, too, and sandgrouse have a unique way of attending to their needs without being forced to breed close to waterholes. They carry the water back to them. Not in their crop, but in their feathers. These feathers, which are localized on the belly, form an absorbent, felt-like layer when wet and are capable of holding even more water than a sponge of the same size. Only the males collect water. When they arrive at the nest, they stand, legs apart, for the precocial chicks to take their fill, looking just like a litter of suckling piglets.

Dodo and Solitaire

The best-known icon of extinction since the dinosaurs; everyone has heard of the Dodo. It was a bulky, flightless bird, with a large, hooked beak, and lived on the Indian Ocean island of Mauritius, part of what is called the Mascarene archipelago. It was exterminated, mostly by nest predation by introduced mammals, within a century of its discovery.

There is a tendency for birds to become flightless on islands, where there are no mammalian predators, and to exhibit no fear of the unknown. In the mind of seventeenth-century sailors for whom the Dodo was little more than a useful source of fresh meat, fearlessness and flightlessness were synonymous with being fat and foolish. These contemporary opinions surely influenced the way that Dodos were perceived by Europeans. Dodos certainly were large, with probably a lot of subcutaneous fat particularly around the lower abdomen, and their rotund body must have been accentuated by their tiny wings and lack of any real tail. Nevertheless, artists' impressions from specimens brought to Europe exaggerated their obesity, and these images were copied and stylized by other artists again and again. Computer-generated reconstructions of Dodo skeletons have shown that almost all of these images are anatomically impossible. The notable exception was not the work of a European artist but by the Moghul painter Ustad Mansur, artist at the royal menagerie of the Emperor Jahangir of India, who received two live Dodos as a gift. Mansur's painting shows the Dodo as an altogether more elegant bird; totally plausible and natural looking.

Less celebrated is the Solitaire or Solitary, which suffered a similar fate on Rodrigues, a more remote island in the group. Solitaires were taller and more slender, with a much smaller bill and a rather angular cranium, though unquestionably similar, at least in skeletal appearance, to Dodos. Their rudimentary wings were furnished with large bony knobs on the wrist joint, which they would use in territorial defense. Although a great deal of bone material has now been recovered, no living birds probably ever left Rodrigues; there are no skins or mounted specimens and only a single, rather quaint illustration, executed from memory, remains. There are, however, two excellent and reliable eyewitness accounts that give a precious insight into the Solitaire's appearance and behavior; one is anonymous, the other the published journal of the Huguenot refugee François Leguat, who was marooned on the island with his followers for two years.

Together the two extinct species are the only known members of the family Raphidae. There is, however, a great deal of confusion over a hypothetical white Dodo, also called a Solitaire, from the island of Reunion, though this is now considered to have been an unrelated, ibis-like bird.

With no land connection to the Mascarene Islands, the ancestors of Dodos would probably have flown there. The presence of a slight keel to their breastbone indicates that they lost the power of flight far more recently than the Ostrich and other ratites, though the breastbone of the Dodo is indeed considerably flatter than that of the Solitaire. In both species the wishbone is remarkably small and thin.

Both Dodo and Solitaire had strong legs for walking, and contemporary accounts describe the latter as being particularly agile. But both had three toes facing forward, and one of comparable length and on the same level facing backward. This is the normal arrangement for perching birds and indicates that ground-living was a secondary adaptation; these birds came from arboreal ancestors, used to perching in trees.

All claims about museums having a "stuffed Dodo" are categorically false. There are no stuffed Dodos, or complete Dodo skins, in existence anywhere in the world, though there are some rather attractive models made from the feathers of domestic fowl.

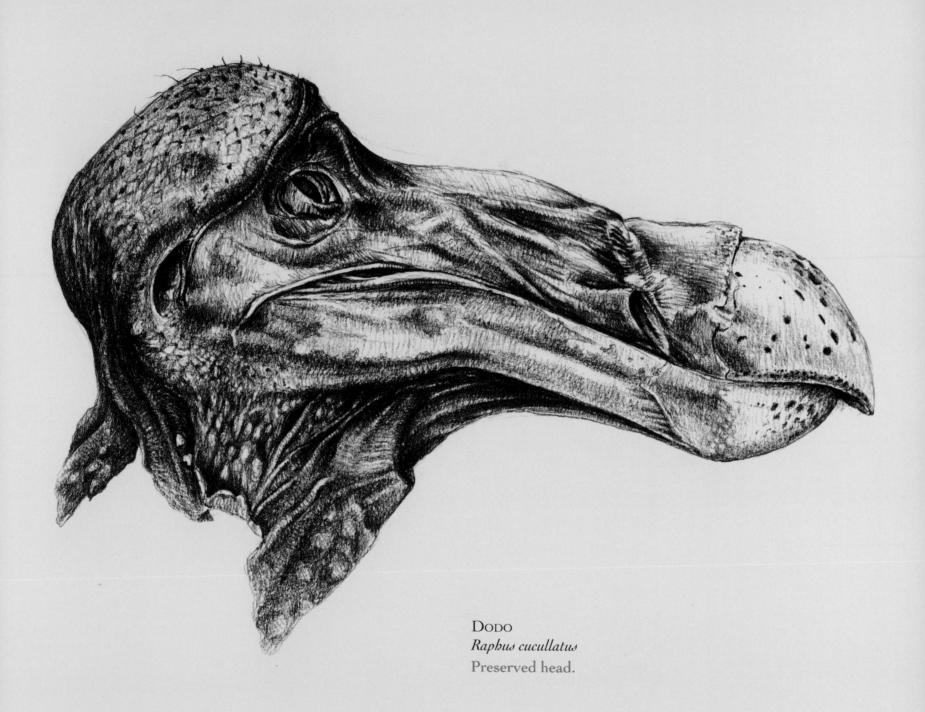

DODO
Raphus cucullatus
Preserved head.

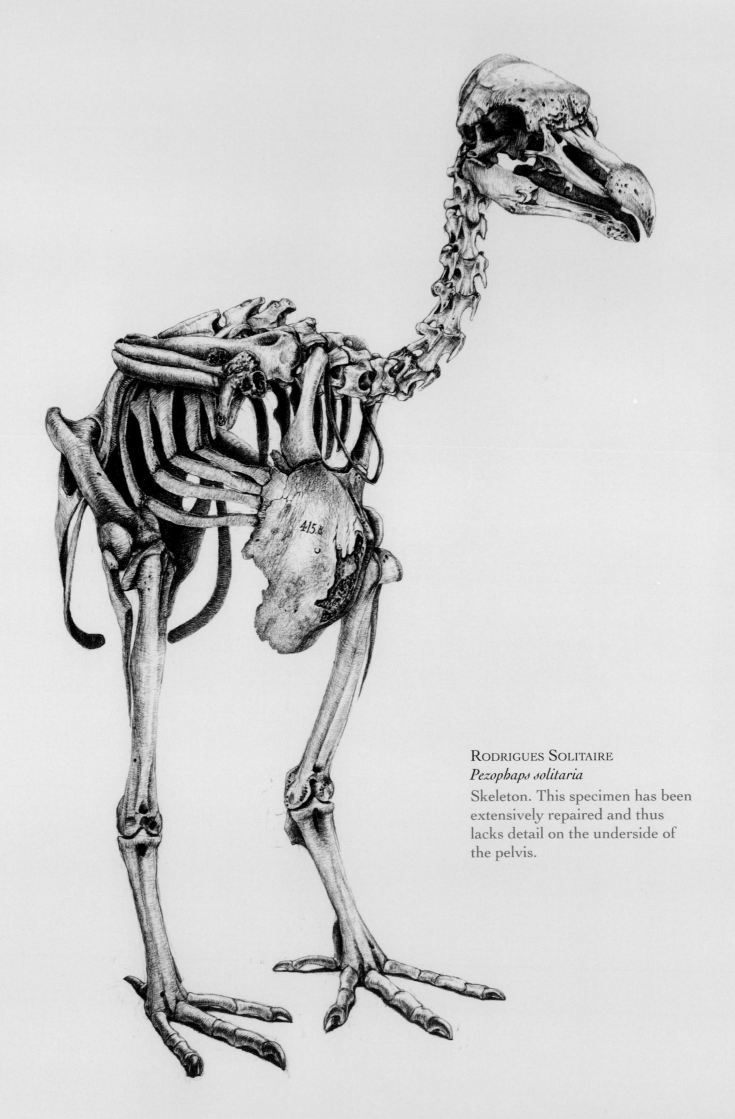

RODRIGUES SOLITAIRE
Pezophaps solitaria
Skeleton. This specimen has been extensively repaired and thus lacks detail on the underside of the pelvis.

The only mounted Dodo recorded belonged to the naturalist John Tradescant, gardener to King Charles II, who kept a private museum in Lambeth, London. Presumably it was the same bird that was recorded as having been exhibited alive in London in 1638. In 1750, 112 years later, when Tradescant's collection had long since passed into the hands of the Ashmolean Museum in Oxford, the Dodo was considered unfit for display and was burned.

Now this is widely considered a deplorable way to treat the only representative of an extinct bird and is universally condemned as one of the greatest acts of vandalism in the history of natural history. However, perhaps the extent of the crime has been exaggerated.

Few taxidermy specimens of the period—before arsenic was used to deter insect pests—could boast a longevity approaching 112 years. Even the living Dodo population didn't manage that after Europeans arrived on Mauritius! Moreover, it's important to consider that Dodos, like pigeons, were probably exceedingly fragile, with skin prone to tearing and feathers that didn't want to stay attached. Dodos were also very fatty and, as every taxidermist knows, unless every last trace of subcutaneous fat is removed— something that would have been very difficult with so thin-skinned a bird and no fancy chemicals available —a bird skin will inevitably end up as a crumbling mass of broken skin fragments.

Although the fragments should indeed have been preserved, Oxford did the next best thing and kept the head and one foot, which are still present at the University Zoological Museum. Unfortunately, in the mid-nineteenth century, the skin of the head was cut into two pieces to expose the skull inside.

Of skeletal material, the world is rather better endowed. Excavations from the Mare aux Songes area in Mauritius in the 1860s and 2005 have revealed a wealth of bones, though most mounted skeletons in museums are composed of bones from several individuals.

From these bones, fragments of skin, unreliable eyewitness accounts, and still more unreliable artists' impressions, taxonomists have attempted to find some resemblance to other known bird groups. Was it a small Ostrich? A pheasant? An albatross? Plover? Vulture? A pigeon . . . ? This unlikely suggestion, now confirmed by DNA analysis, came before the vaguely Dodoesque Tooth-billed Pigeon was discovered to give credibility to the theory. Although Dodo and Solitaire are currently placed in a family of their own, they share the order Columbiformes, exclusively with pigeons.

Interestingly, one very subtle anatomical feature of pigeons is their two-compartmented crop, which balloons off to the left and right of the esophagus just above the breastbone. Bulging with food or with "pigeon milk" to feed chicks, this double swelling was lovingly described by Leguat as resembling "very marvellously, the beautiful bosom of a woman."

VI PASSERES

Bill conic, pointed; *legs* formed for hopping; toes slender, divided; *body* slender; flesh of such as feed on grain pure, of those which feed on insects impure; *nest* formed with wonderful art. They live chiefly in trees and hedges, are monogamous, vocal, and feed the young by thrusting food down their throats.

Linnaeus was among the first to assign an order to the passerines. He called it Passeres, and it was based primarily on the structure of the bill and feet. By no means all the birds we know as passerines were included. And mixed in were nightjars, pigeons, and even domestic pigeon varieties. Swifts were there, too, and there to stay for a considerable time—lumped together with swallows, despite the difference in foot structure.

The order was to remain somewhat ambiguous until the early nineteenth century when the anatomy of the vocal apparatus, or syrinx, was studied in detail, giving clear-cut boundaries on what is, and what is not, a passerine.

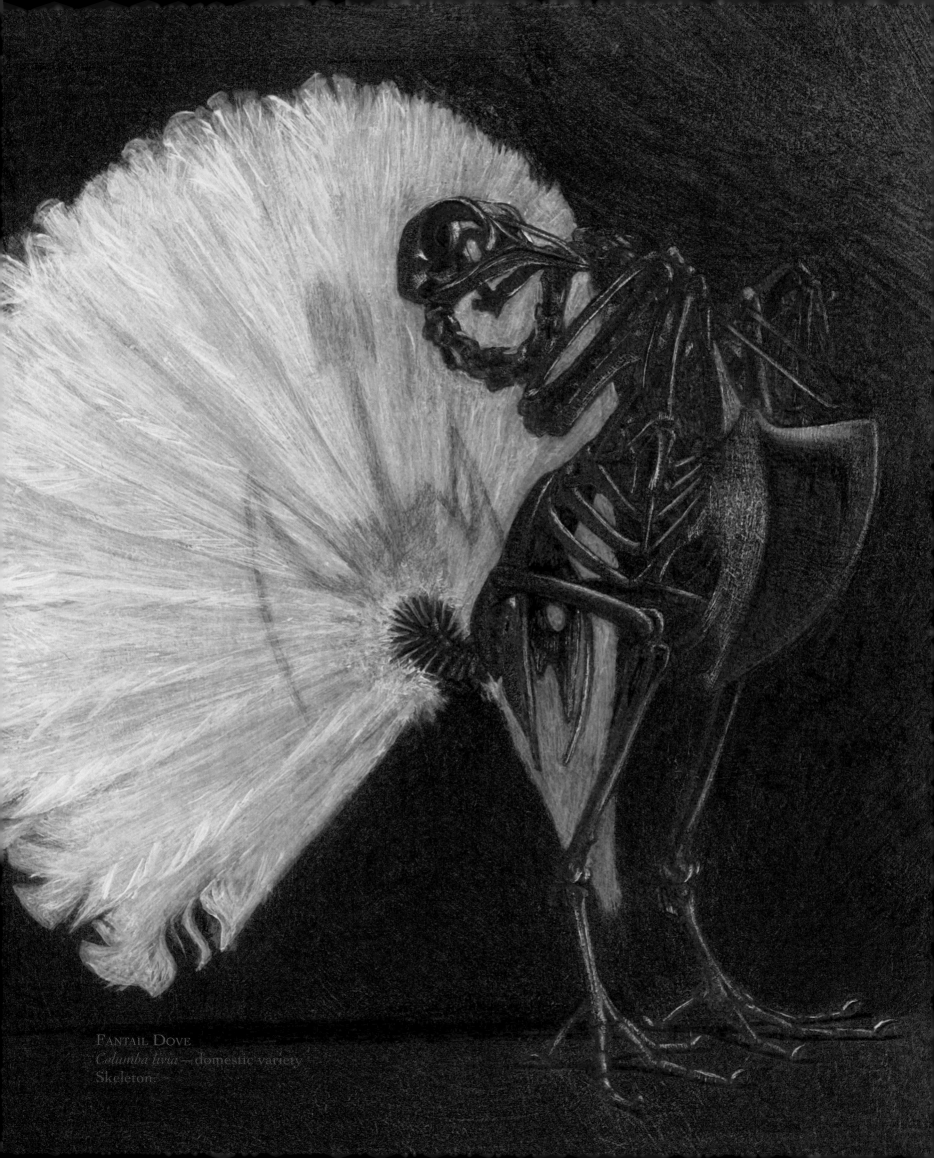

Fantail Dove
Columba livia—domestic variety
Skeleton

Pigeons

Pigeons are not passerines as we recognize the order today. They do, nevertheless, have feet equipped for perching in trees, with three toes facing forward and a fourth of comparable length, opposing them at the same level. The brightly colored fruit pigeons are especially adept at perching. They are arboreal acrobats, often even hanging upside down from branches. But although some pigeon groups have become more terrestrial and may have slightly longer legs, the foot has remained essentially unchanged.

The general structure, too, is rather uniform. Pigeons have a small head, short legs, and a deep, thick-set body. They are excellent fliers, having powerful flight muscles on either side of a large-keeled breastbone. And the pelvis is wide, making them proficient walkers, too. They walk with a head-bobbing motion that allows them to adjust the focus of their eyes during the brief interval when their head is in a stationary position.

The extinct Dodo and Solitaire were both ground-living, flightless birds closely related to pigeons, though placed in a family of their own. With no living relatives, pigeons are now the sole member of the order Columbiformes. There is no distinction between pigeons and doves. The latter term is often used for smaller species, but in many cases the names can be used interchangeably.

Perhaps the most remarkable feature of the family is their unique method of feeding their chicks. A day or so prior to hatching, the crop of both parents begins to develop a thickened lining of cells rich in nutrients, which breaks down to produce "pigeon milk." This is different in composition to mammalian milk and has the consistency of cottage cheese. The newly hatched young feed by inserting their bill inside the bill of the parent, and the "milk" is regurgitated into them. The wide and flexible base of the lower mandible of the adult bird allows the chicks to feed without damage to either parent or offspring. It takes a lot of energy to produce "pigeon milk," which is why most species lay clutches of only two eggs, though they often raise several broods in a year.

The crop has two lobes, one on either side of the esophagus. Interestingly, in pigeons of the genus *Columba* at least, the windpipe crosses from the midline to run down the left side of the neck, not the right side as in many birds.

Domestic Pigeons

Good all-rounders as they are, the order Columbiformes as a whole shows considerably less diversity than exhibited by a single species—the Rock Dove—under domestication. In fact all domestic pigeon varieties are descendants of the Rock Dove.

The range of shapes and sizes is bewildering, and the number of recognized breeds runs into the hundreds. Competitive pressure among fanciers to create and perfect new varieties has pushed them to their anatomical limits. There are varieties, such as the African Owl, whose bill is so small that the bird is unable to feed its own young, and others, like the Vienna Short-faced Tumbler, in which the skull is so reduced that the eyes appear bulbous and globular. The Scandaroon, a favorite of Charles Darwin, has a long skull and a large hooked bill—altogether un-pigeon-like.

Among the most remarkable are those known as "pouters" or "croppers." Now all pigeons pout. That is,

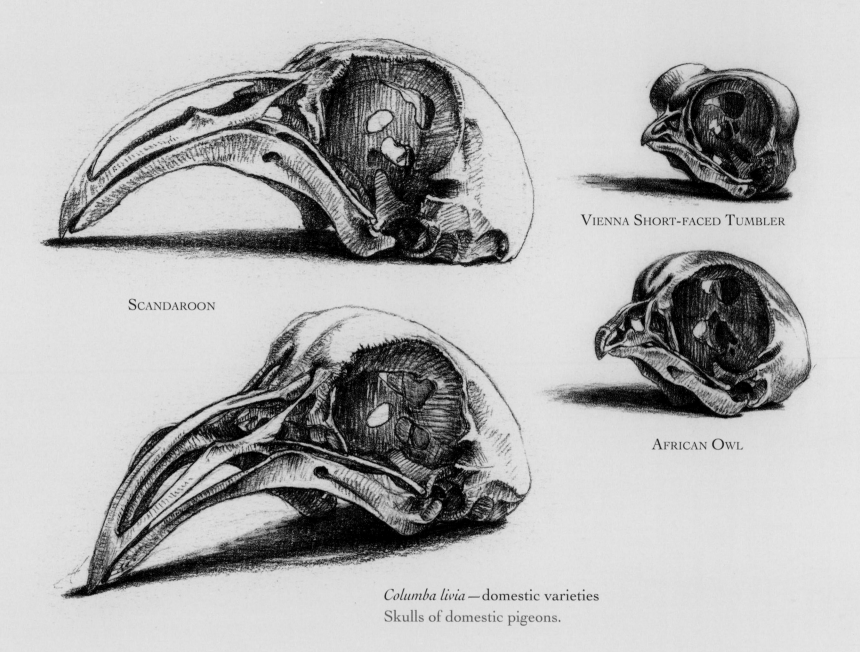

SCANDAROON

VIENNA SHORT-FACED TUMBLER

AFRICAN OWL

Columba livia—domestic varieties
Skulls of domestic pigeons.

they all inflate their esophagus with air, cooing, to impress prospective mates or to proclaim their territory. But the domestic varieties selectively bred for this quality do so at the slightest provocation, and to astonishing extremes. There are many pouter varieties, but none more outlandish in appearance than the English Pouter. Originally rather horizontal in posture, in less than five hundred years selective breeding has created a bird that stands almost vertically upright. Apart from the balloon-like inflated neck, everything is long and thin: long legs; long neck; long, slender body. Even the keel of the breastbone, normally so deep in pigeons, is shallow and slim. The narrowing of the body, to accentuate the upright posture, has had an interesting effect on the development of the ribcage. Instead of becoming shorter, the ribs have curved inward to form a narrow tube, with the sternal sections overlapping to lie close along the sides of the breastbone.

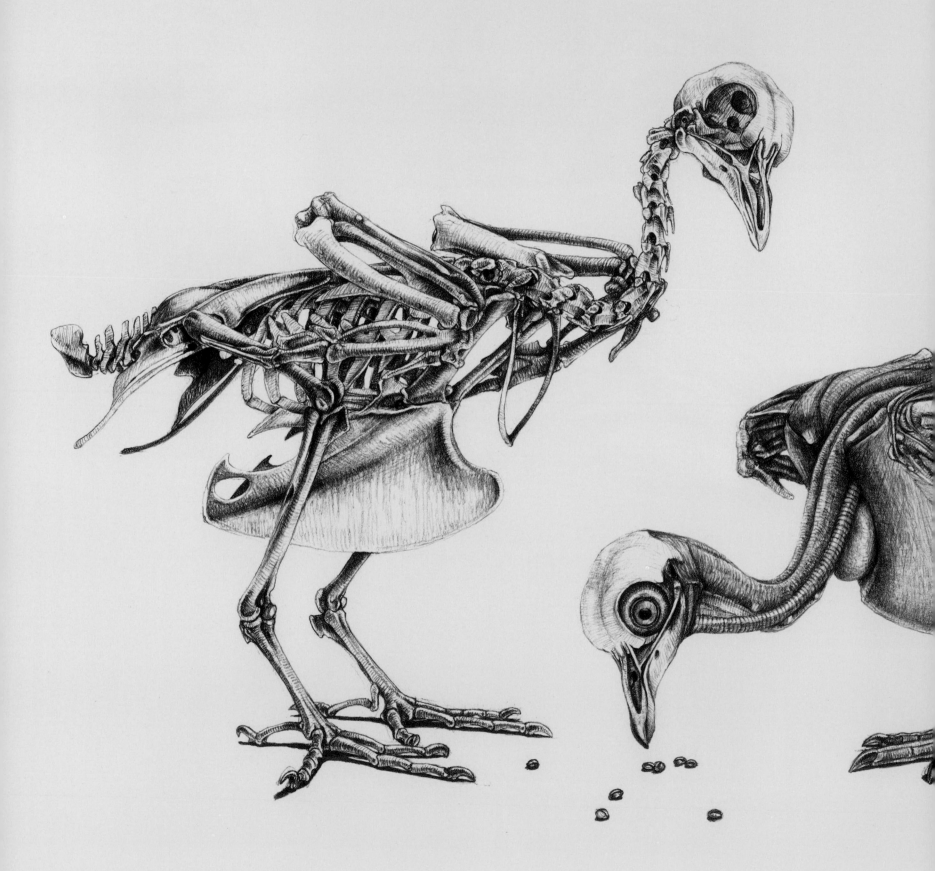

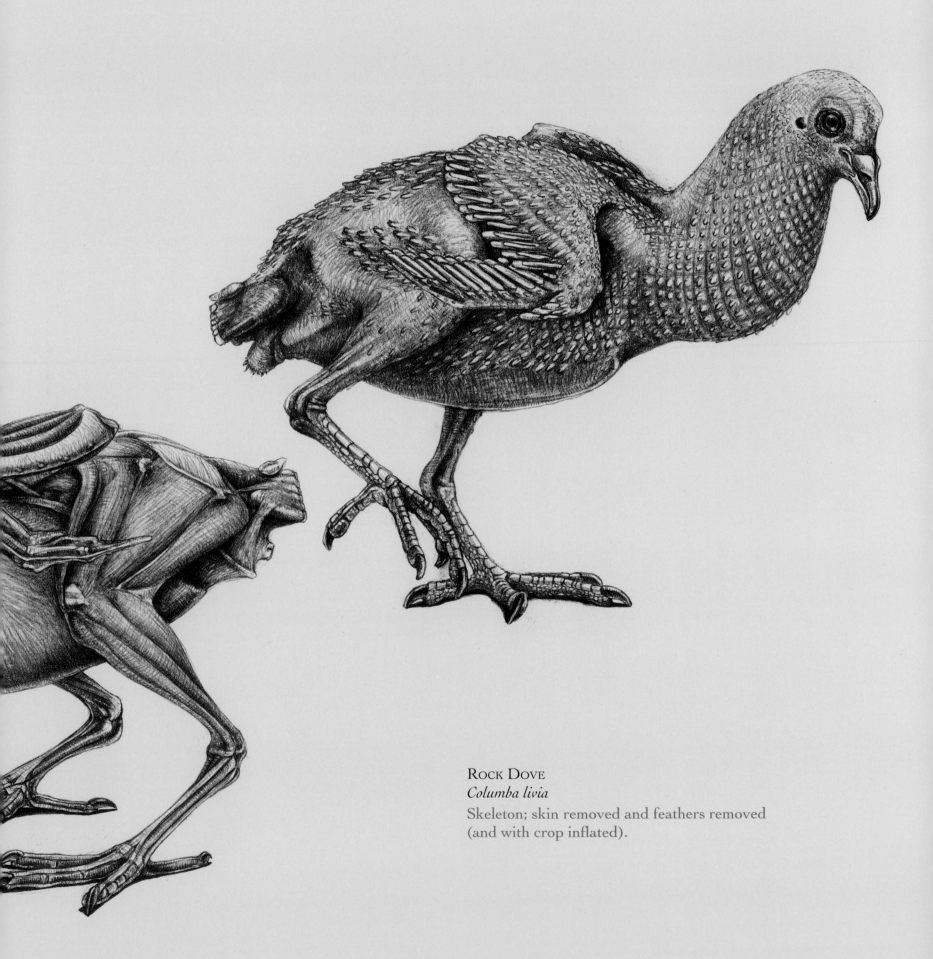

ROCK DOVE
Columba livia
Skeleton; skin removed and feathers removed
(and with crop inflated).

253

The legs, too, are remarkable. In most other birds the thighs lie on either side of the ribcage in a near horizontal position, with the knees hidden well inside the skin of the body. In the English Pouter, however, the body has been rotated so far upward as to expose the knees to view. The preferred attitude is "knees together; feet apart," the knock-kneed appearance being further accentuated by the long feathering of the toes, which splays out around them like the fishtail train on a close-fitting wedding dress.

In domestic pigeons there are two genes responsible for long feathering on the feet. The one present in the English Pouter results in feathered toes, and the other in feathered tarsi. Where both genes are present, birds have long feathers on both the tarsi and the toes. In these birds the feather arrangement on the foot takes on the same pattern as the wing, with the equivalent of secondary flight feathers growing along the tarsus and primary flight feathers growing from the outer and middle toes.

This specimen had only three bones (excluding the claw) in the outer toe instead of the usual four, a common trait in domestic fowl with feathered feet.

Perhaps the best known and loved of all fancy pigeon varieties, Fantails are the popular choice for garden dovecotes and widely admired for their beauty. But in striving to create a thing of aesthetic perfection on the *outside*, fanciers have inadvertently produced one of the most extraordinary skeletons of any domestic bird. The upright posture, with neck swept gracefully back and breast puffed out, belies a seemingly impossible contortion beneath the feathers. The back is not only unusually short but concave—literally bent backward on itself to allow for the unnatural curvature of the neck, and the head is tucked behind, touching the tail. Not surprisingly, birds displaying in this posture are quite unable to see ahead. The fan-shaped tail has more than double the usual number of tail feathers, arranged in two rows, one behind the other. The tail vertebrae are not enlarged as one might expect, to bear the extra weight, though there are more of them than in the ancestral Rock Dove.

Two more unusual-looking varieties, Modenas and Maltese, both belong to a group known informally as "hen pigeons," for obvious reasons. Solid-looking, horizontal in stance, and with their tail pointing vertically upright, their attitude is more reminiscent of domestic fowl than of pigeons. Despite their outward similarities to one another, the two varieties have very different origins. The Maltese was originally bred for meat. Its former name was the Leghorn Runt, a name that alludes to its chicken-like appearance and to its great size (to pigeon-people, the word "runt" implies large breeds rather than small offspring). As well as being a large-boned bird with the heavy build characteristic of meat varieties, it also has long legs and an unusually long neck; at least one extra vertebra longer than the Rock Dove. Its prodigious height is accentuated by its straight-legged posture, with lowered knees and thighs held at an angle instead of in the near horizontal position of most birds.

Seen with their feathers on, Modenas also appear to be powerful, heavyweight birds. They are the bulldogs of the pigeon world—legs set far apart and a solid-looking stance. Unlike the Maltese, however, they originated not as a meat pigeon but as a small flying breed, used, in their native Italy, to lure away other people's pigeons to their own loft! It was only comparatively recently that they were adopted as an exhibition variety and selectively bred for size. So despite the Modena's robust appearance and increased musculature, its underlying bone structure is little more substantial than that of a Rock Dove. The misshapen breastbone on this specimen is a common show fault and the consequence of a skeleton insufficiently strong to support its great weight.

Charles Darwin was a passionate devotee of fancy pigeons, and his work with them did much to formulate his theory of evolution by natural selection. Artificial selective breeding showed how far a single species—the Rock Dove—could be changed under domestication, and thus served as a model for how species could potentially change in the wild. In the opening chapter of *The Origin of Species*, Darwin wrote,

Altogether at least a score of domestic pigeons might be chosen, which, if shown to an ornithologist, and he were told that they were wild birds, would certainly be ranked by him as well-defined species.

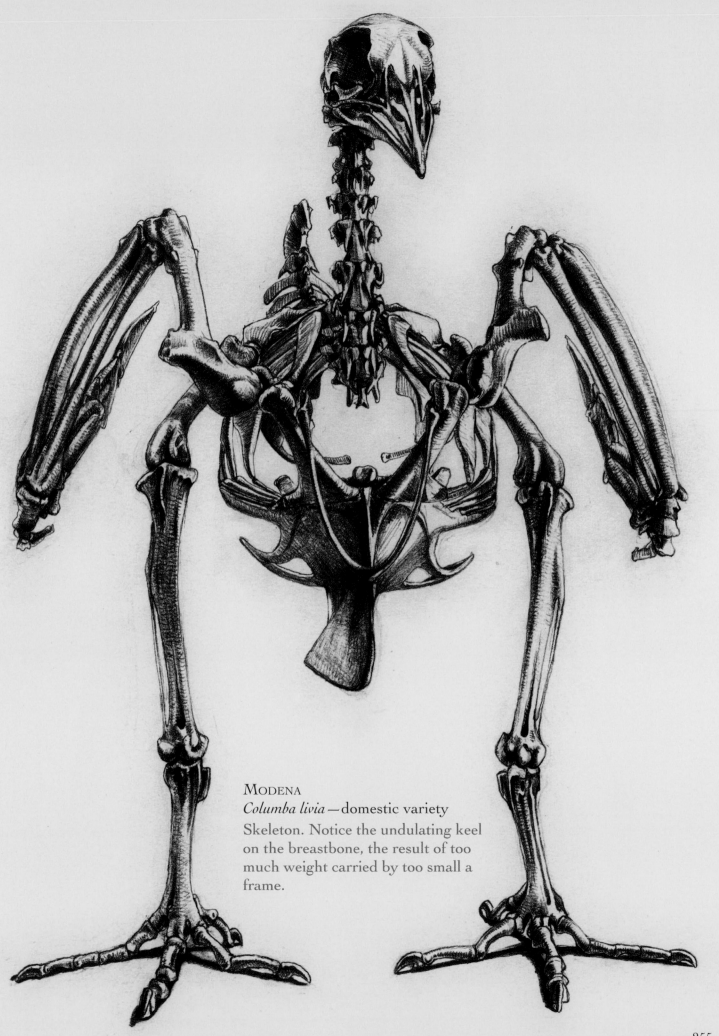

MODENA
Columba livia—domestic variety
Skeleton. Notice the undulating keel
on the breastbone, the result of too
much weight carried by too small a
frame.

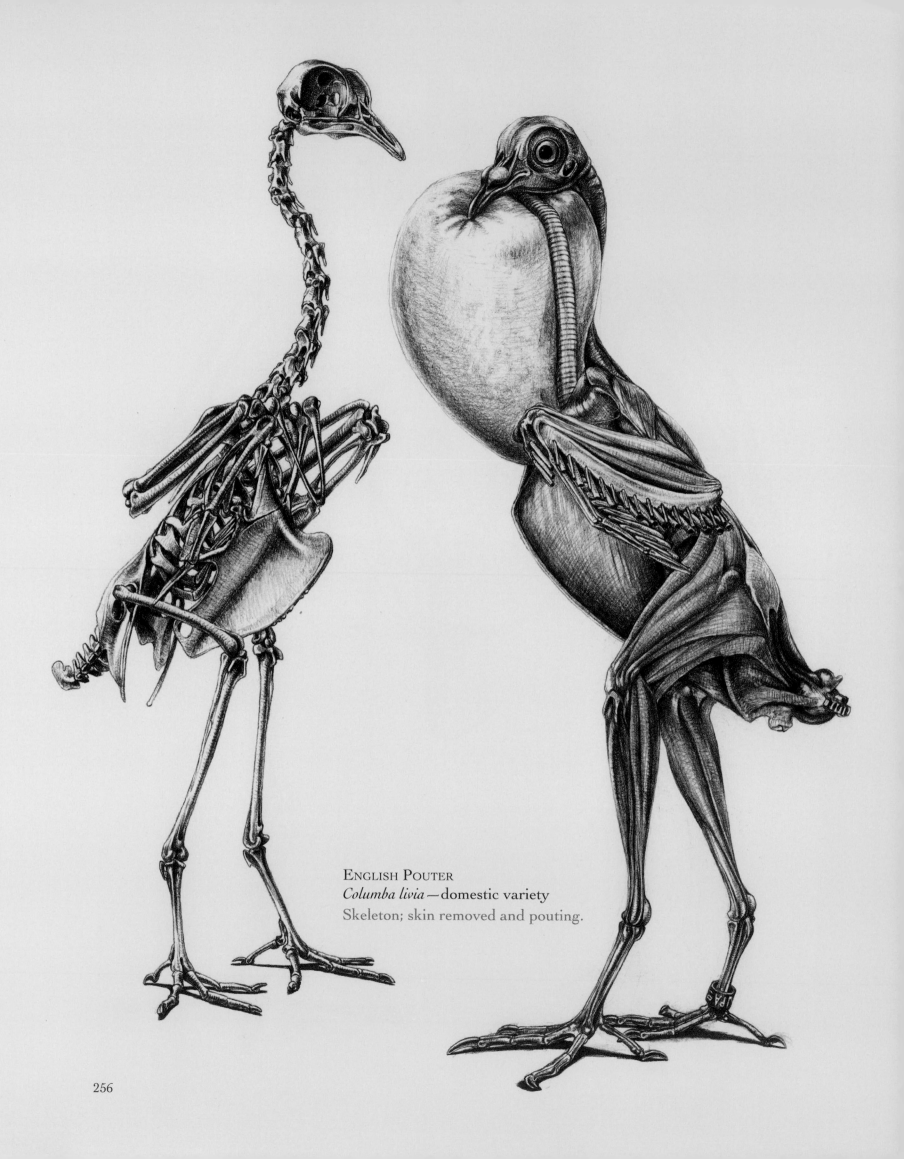

ENGLISH POUTER
Columba livia — domestic variety
Skeleton; skin removed and pouting.

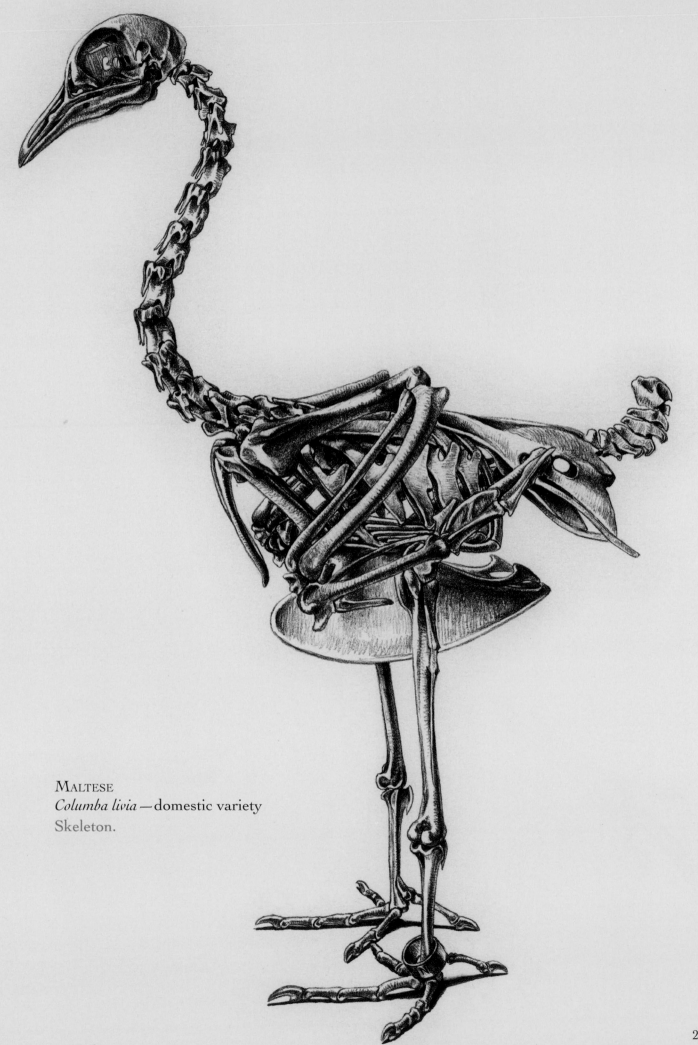

MALTESE
Columba livia — domestic variety
Skeleton.

Nightjars

Abroad only by dusk or bright moonlight; secretive and shrouded in mystery; bizarre to behold, unearthly to hear—few birds can stake such a claim on the supernatural imagination as nightjars. Five families make up the order Caprimulgiformes: the potoos, the Oilbird, the owlet-nightjars, frogmouths, and true nightjars, which includes the very similar nighthawks. The name "Caprimulgus," meaning "milker of goats" and the colloquial common name for the European Nightjar—"goatsucker"—reflects the popular belief that they will actually suck milk from goats and other livestock during nighttime raids—though of course they are there only to feed on the insects attracted by the animals. But this is only a fraction of the folklore surrounding these enigmatic birds right across their range.

One remarkable characteristic of the family is their eyes. Nightjars' eyes are large, and the true nightjars of the family Caprimulgidae have a reflective layer to increase the amount of light hitting the retina, which gives them an eerie glow in artificial light. They share this feature—called a tapetum—with many nocturnal mammals, but with no other birds, and their night vision is therefore significantly superior even to that of owls.

The eyes are situated on the sides of the head to give all-around vision when resting. The family of owlet-nightjars, however, shares the forward-facing eyes of owls; like many owls, they nest in holes and thus have slightly less need for vigilance than do the open-nesting groups. The potoos of South America have two or three vertical notches in the edge of their upper eyelid, which allows partial vision even when the eyes are closed. They are also able to move their upper and lower eyelids independently.

Frogmouths are characterized by their powerful, thick bill, resembling a pair of exaggerated cartoon lips. The bill of the true nightjars, however, is tiny and weak looking. It nevertheless opens into a gape that is simply enormous. But it is much more than just a large mouth; the bones of the lower jaw spread and become taut on opening, rather like the struts in an umbrella, pushing out the sides into a wide arc. Long, stiff bristles (actually modified feathers) surround the bill to form a fan encircling the gape and probably function

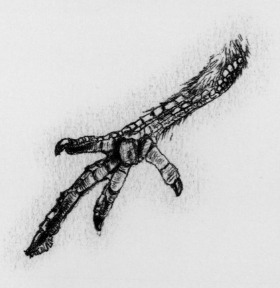
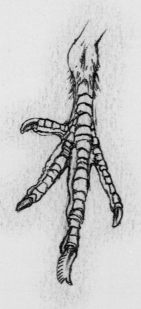
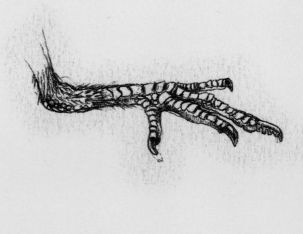

EUROPEAN NIGHTJAR
Caprimulgus europaeus
Left foot showing pectinated middle claw.

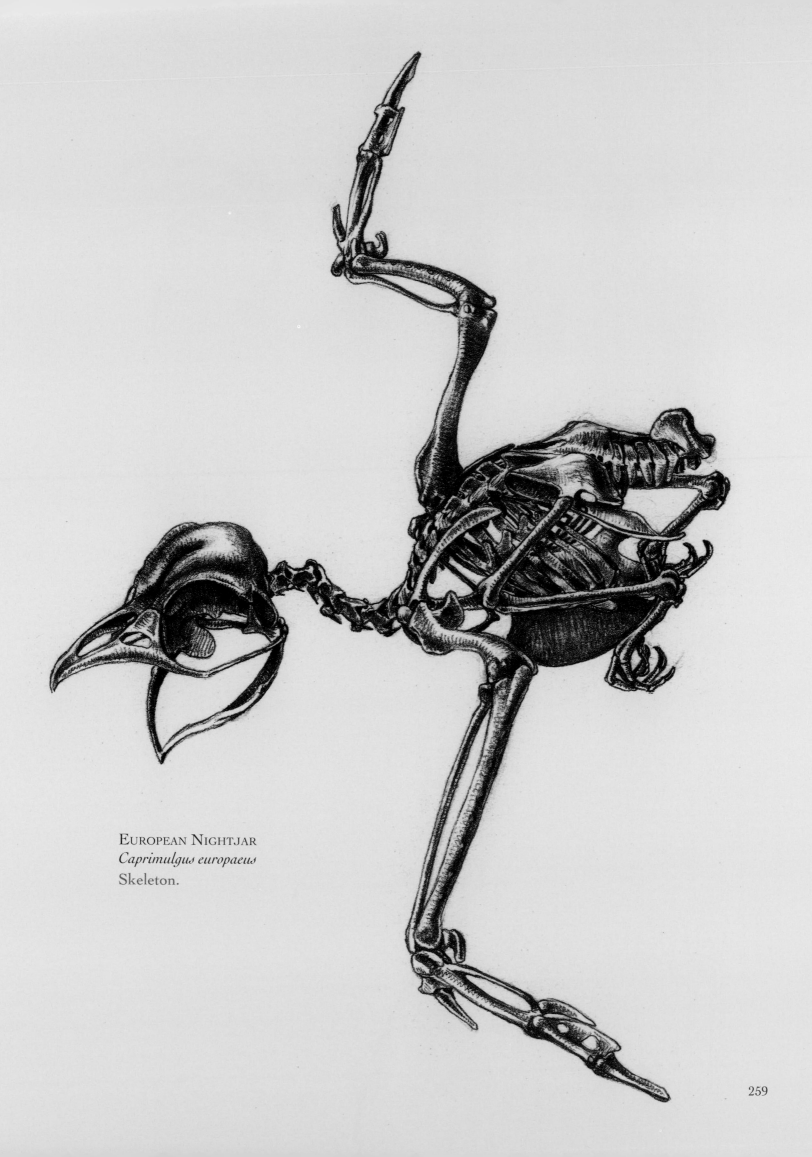

EUROPEAN NIGHTJAR
Caprimulgus europaeus
Skeleton.

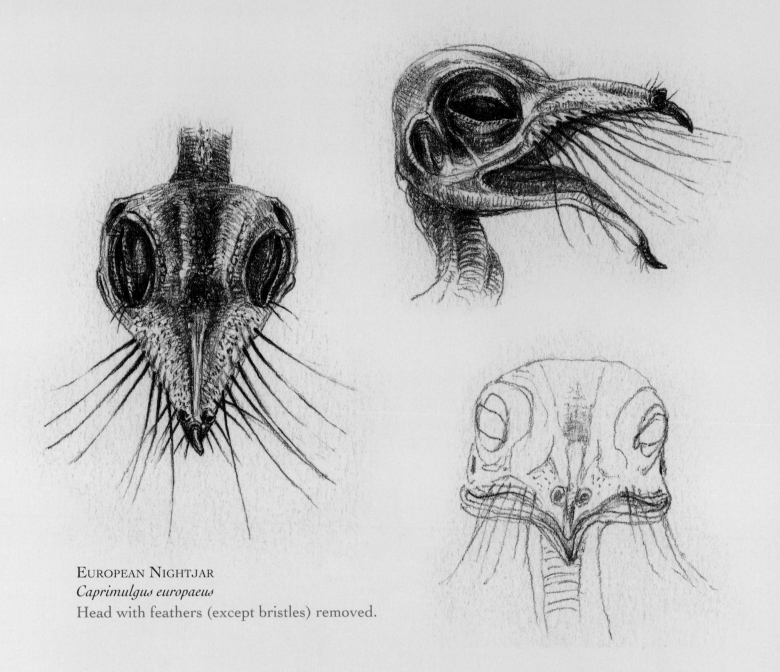

EUROPEAN NIGHTJAR
Caprimulgus europaeus
Head with feathers (except bristles) removed.

as a funnel to assist in the capture of insect prey. Aside from hunting, nightjars use their wide gape to great effect as a threat display to warn predators away from the nest. Opened slowly while emitting a sinister hiss, and raising their wings meanwhile, it is a most un-bird-like spectacle.

Nightjars don't feed by randomly trawling with open bill, as is often supposed. They are supreme aerial predators. Surprisingly lightweight birds for their size, their large wing area in proportion to their body mass and long, mobile tail give them the agility needed to pursue and capture individual insects of their choice.

They have much in common with swifts, and their skeletons bear a superficial resemblance to one another: a substantial skull to accommodate the wide, fly-trapping jaws and large eyes; a short but deeply keeled breastbone to support the well-developed flight muscles; a minimal hind limb; and long, sweeping wings. However, nightjar wings have adapted for greater aerial maneuverability and low-speed control, with a forearm and hand section of about equal length and each only slightly longer than the upper arm. Swifts, by comparison, have a short forearm, a tiny upper arm, and a hand section that exceeds the length of both. Swifts have sacrificed agility for speed and therefore hunt at higher altitudes where there are fewer obstacles in their path. The all-important tail of nightjars is also supported by a correspondingly larger tail bone than that of swifts.

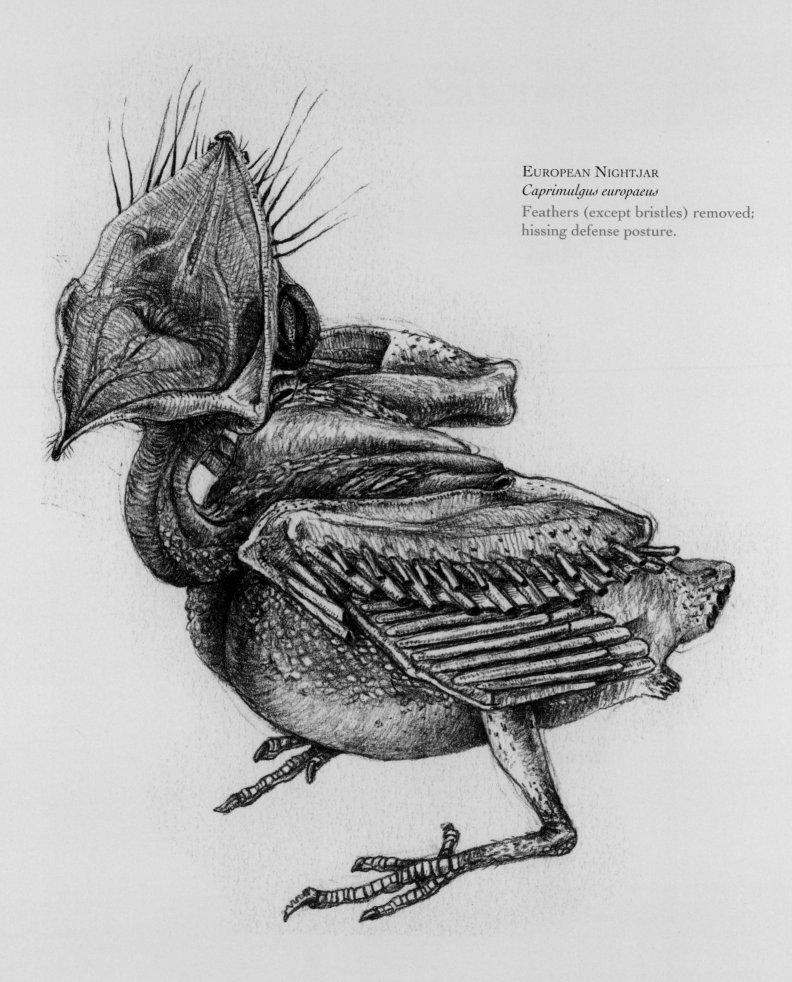

EUROPEAN NIGHTJAR
Caprimulgus europaeus
Feathers (except bristles) removed;
hissing defense posture.

The bone of the foot—the tarsus—is short and weak, and particularly so in the frogmouths. Nightjars feed in the air and rely on camouflage to evade predators while roosting, so an unimpressive hind limb is only to be expected. However, in more terrestrially mobile species the legs and feet are rather better developed. In all groups, the central forward-facing toe extends well beyond the others and, with the exception of the frogmouths, the outermost toe has only three bones instead of the usual four. In the true nightjars of the family Caprimulgidae, the claw of the central toe has a serrated inner edge. The function of this is not yet wholly understood, though it appears to have a connection with preening. It has been suggested that nightjars use it to clean their feathers of the sticky secretions of insects. It's equally possible that they may use it to remove parasites or preen the bristles surrounding the gape, though it remains a mystery why this feature may be absent in closely related groups sharing similar habits.

Not all nightjar families are insectivorous, or even carnivorous. The Oilbird is the only nocturnal fruit-eating bird in the world. It is the sole member of its family and a cave-dweller, navigating in the pitch darkness with the aid of echolocation.

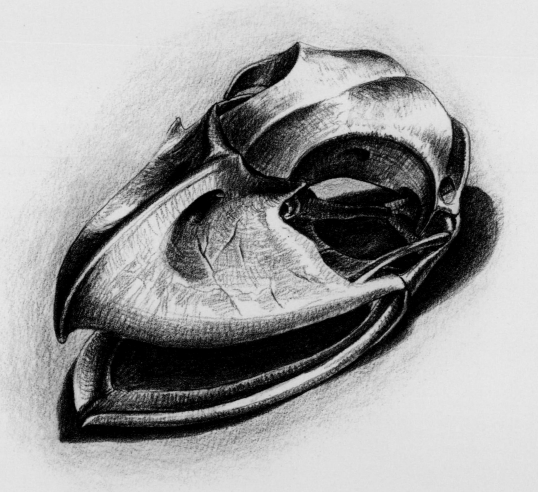

TAWNY FROGMOUTH
Podargus strigoides
Skull.

Swifts

Treated as "honorary swallows" by early taxonomists, swifts had a place in passerine classification right up until the nineteenth century, long after their closest true relatives, the hummingbirds, had been removed. In fact, few groups could be more ill described as "perching birds" than swifts.

The most aerial of all birds, swifts spend the majority of their life on the wing. They certainly feed, drink, and bathe in flight, though the claim that they also copulate in the air has yet to be proven. Sleeping in flight, at high altitudes, is also largely unsubstantiated and has only been observed with certainty in the Common Swift. Nevertheless, they indeed appear more at home in the air than anywhere else.

Perhaps not surprisingly, their feet are tiny. The scientific name for the swift family, "Apodidae," implies that they do not have feet at all! But anyone who has handled these birds knows that they certainly do and that they are armed with formidable, needle-sharp claws. Their feet are adapted for gripping, not perching. Most species are not even able to perch and can become airborne from a *horizontal* surface only with extreme difficulty. However, slippery rock walls, tree trunks, or the vertical walls of buildings pose no problem. In fact the swiftlets, spinetails, and the more primitive American swifts do have feet similar in structure to those of perching birds, with the hind toe opposing the three forward-facing toes. However, the typical swifts, by comparison, have a unique arrangement in which the hind toe is brought forward in line with its neighbor,

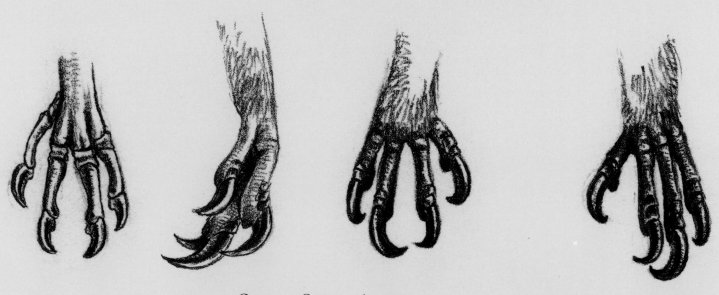

COMMON SWIFT—*Apus apus*
Left foot: skeleton of foot, whole foot in side view, with toes in normal "chameleon-like" position, and with hind toe opposing the others.

and together these oppose the outer two, rather like a chameleon. This is seldom evident from an examination of museum skins and has given rise to the slight misconception that all four toes always face directly forward, a strategy adopted only for particularly smooth and challenging surfaces.

The toes are also short and have undergone a reduction in the number of bones in each, giving them fewer toe bones than any other bird. Disregarding the bone within the claw, each toe has only two: the

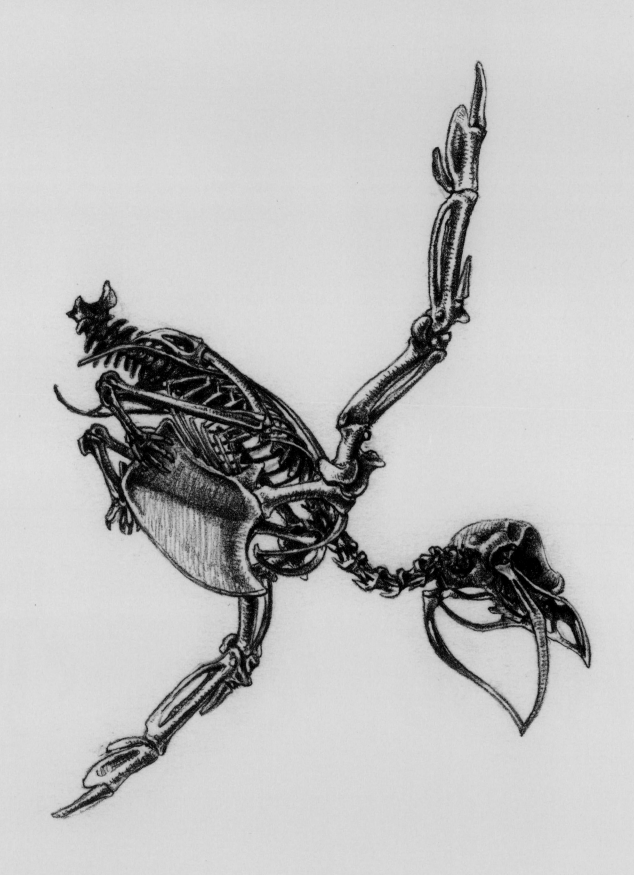

COMMON SWIFT
Apus apus
Skeleton.

farthest is normal-sized, while the one adjoining the tarsus is tiny. Such feet make preening difficult, and swifts carry far more than their fair share of feather parasites.

The gravitational problem of gripping onto vertical surfaces is counteracted in some species by stiffened tail feathers ending in a spiny tip, acting as a prop against the upright plane in just the same way as the tail of woodpeckers.

The confusion with swallows and martins is understandable. They, too, are day-flying aerial insect-predators, pursuing and consuming their prey on the wing and, consequently, share several features in common. Such similarities are not the result of a direct relationship, however, but have evolved independently to suit their lifestyle—a process called convergent evolution. Swifts and swallows are not closely related. Swifts belong to the order Apodiformes, which they share with hummingbirds, whereas swallows are passerines.

Nor, in fact, do they occupy precisely the same niche. Swallows fly at a leisurely pace at *low* altitudes. They can change direction quickly and navigate around objects in their path. Swifts, by comparison, are high-speed hunters of the upper air, although bad weather will sometimes force them lower. Their highly specialized anatomy enables them to fly fast, but at the expense of maneuverability.

Swifts have a flight silhouette like a bow and arrow—wings swept back in a crescent; long, narrow primary flight feathers, tapering down to short secondaries. But it's not the feathers alone that give them this distinctive shape. The bone of the upper arm, the humerus, is extraordinarily short and stout. This gives maximum leverage for the contraction of the well-developed pectoral muscles to produce the downward thrust of the wing. The forearm, too, is much shorter than in other birds. But the shortness of the arm is more than compensated by a hand section of considerable length and disproportionate size. The bone structure of the wing is shared only by hummingbirds, their closest relatives. (Hummingbirds are supremely maneuverable, but *their* mode of flight is quite unique—more like a helicopter than a jet aircraft.) A now obsolete name for the Apodiformes—Macrochires—appropriately means "large hands."

It is not surprising that swifts share several features in common with another group of aerial predators—the nightjars. Indeed, their skeletons can be easily mistaken at first glance, though nightjars lack the peculiar wing structure of swifts. Like the nightjars, the tiny, pointed bill of swifts belies a prodigious gape, though without the surrounding fan of bristles. Swifts do, however, have bristles in front of their large, deep-set eyes, which protect them from the sun's glare—a problem rarely encountered by nightjars!

Swifts feed on what has been aptly described as "aerial plankton": small insects and spiders high above the ground. Again, like nightjars, they don't trawl randomly with open bill but actively pursue choice prey items, rejecting unfavorable quarry such as stinging insects.

The chicks are fed on clusters of insects glued together in a ball with sticky saliva. Saliva is also used to bind together the nesting material, and in several species of cave swiftlet the nest is comprised of saliva alone. These nests are edible, and in fact are a gastronomic delicacy! The dense colonies, in the pitch darkness of vast cave systems, are harvested annually for the food industry.

Passerines

There are nearly one hundred passerine families comprising well over half of all known bird species, so it would be impossible to do justice to the order in a book such as this. However, despite its size, the Passeriformes is a single order nevertheless and does not exhibit the same degree of anatomical diversity as the twenty-six or so other orders that together make up the non-passerines. Indeed, apart from differing considerably in posture and dimensions, the passerines are rather uniform in structure. The principal differences are in the shape of the bill, which has adapted to suit a variety of foraging methods and thus reduce competition.

Some of the best examples of this can be seen within a single family. The finches, with their sturdy, conical bill generically adapted for seed eating, illustrate very clearly that there is as much diversity within "seeds" as there is between the birds that eat them. The largest species, such as the Hawfinch, feed on the largest seeds and are able to exert a tremendous force to crush even hard cherry stones. Their bill is massive, and the deep jaws to accommodate the tremendous musculature required give the bird its heavy-headed appearance. At the opposite end of the spectrum, goldfinches feed on thistle and teasel seeds, and use their fine-pointed bill to prise them out. The two species' bills are as different as heavy-duty pliers are from fine forceps. Of the many intermediates, crossbills are remarkable in having overlapping mandibles. They use these as levers, forcing open the scales of pinecones and removing the seed with their tongue.

In ecosystems where there are niches left unfilled, such as remote islands without a resident bird population, avian colonists arriving by chance are able to virtually take over, that is, exploit not only those niches occupied by birds similar to themselves but even those that would normally be the province of entirely unrelated families. Under these circumstances, the mushrooming of a single ancestral species into multiple species and even genera—usually a slow process over geological time scales—occurs rapidly in an evolutionary scramble to take possession of the vacant lots. This process is called adaptive radiation; and the most famous example is, of course, that of Galapagos finches, or "Darwin's finches" as they are better known. They exhibit a seamless gradation of every bill shape: from the most robust nut-cracking tool to the finest, warbler-like instrument for feeding on insects.

Although the mechanism by which speciation occurred in this case is a perfect example of the principles of natural selection, Galapagos finches themselves received little attention from Darwin when he visited the archipelago during the voyage of the *Beagle*. It was the ornithologist and publisher John Gould who first alerted Darwin to their importance after he returned with his specimens to England.

But there are other, and still better, examples of adaptive radiation among passerines. The Hawaiian honeycreepers, descendants of finch-like ancestors, have evolved a variety of bill shapes to exploit the roles not just of seed and insect eaters but of nectar-feeders, too. Sadly, so great a number has become extinct due to the predations of introduced mammals that their true diversity will never be fully appreciated.

But it's the vangas of Madagascar that offer living proof of the full potential of island colonists. Originally thought to be a small family of shrike-like birds, albeit with widely differing bill shapes, more and yet more species previously thought to belong to *other* families—flycatchers, warblers, and babblers—are steadily being added to their ranks.

Passerines evolved as perching birds from a common ancestor. This means that even groups that do not habitually perch—larks, pipits, and wagtails, which walk on the ground; nuthatches and treecreepers, which cling to vertical rock faces or tree trunks; and even dippers, which forage underwater—all have the same basic foot structure. This was among the main criteria used to classify them (when they were finally appointed an order of their own) right up until the early nineteenth century when their internal anatomy was studied in greater detail.

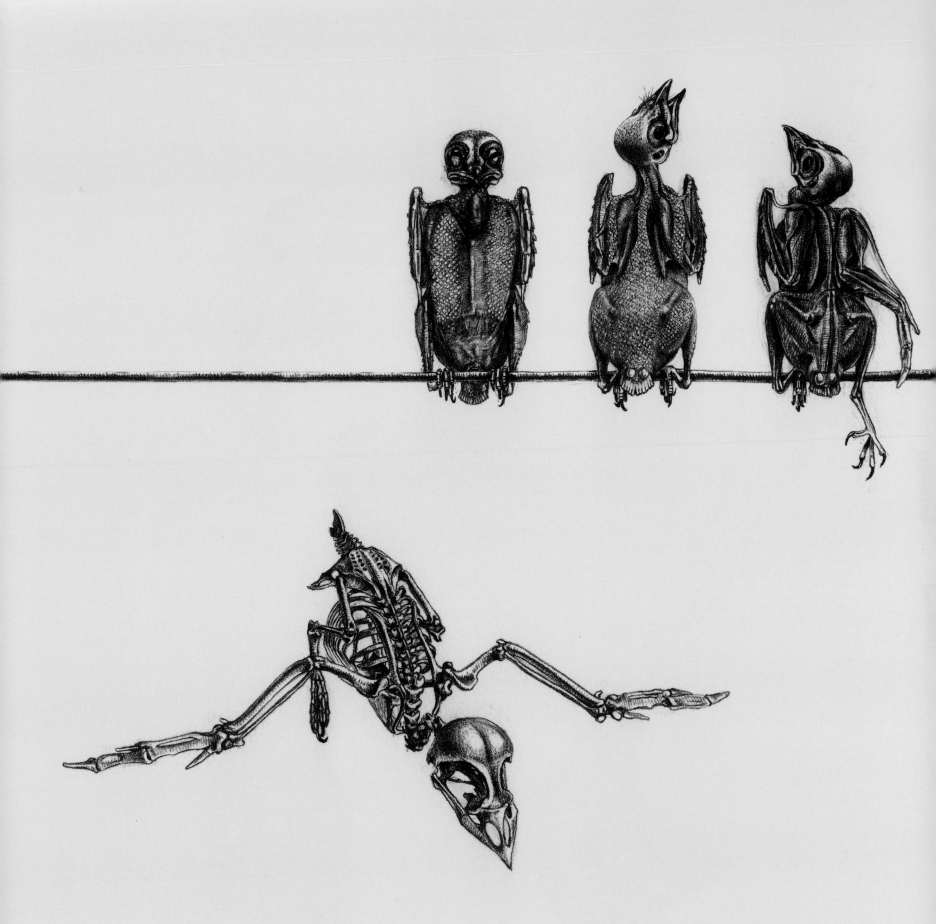

BARN SWALLOW
Hirundo rustica
Skeleton; feathers removed—front
and rear views—and skin removed.

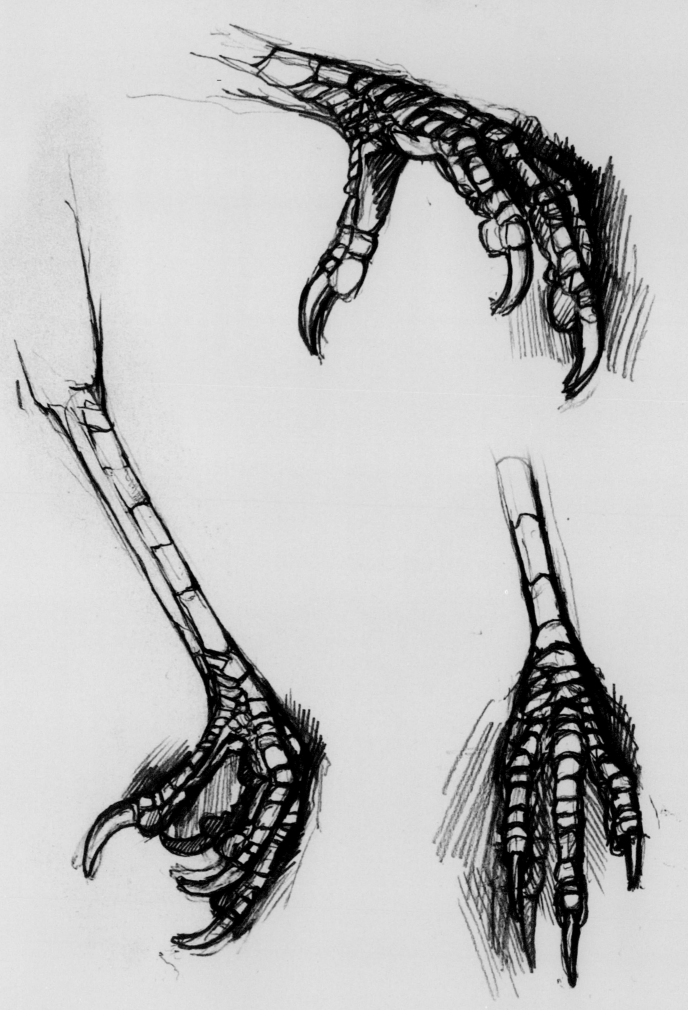

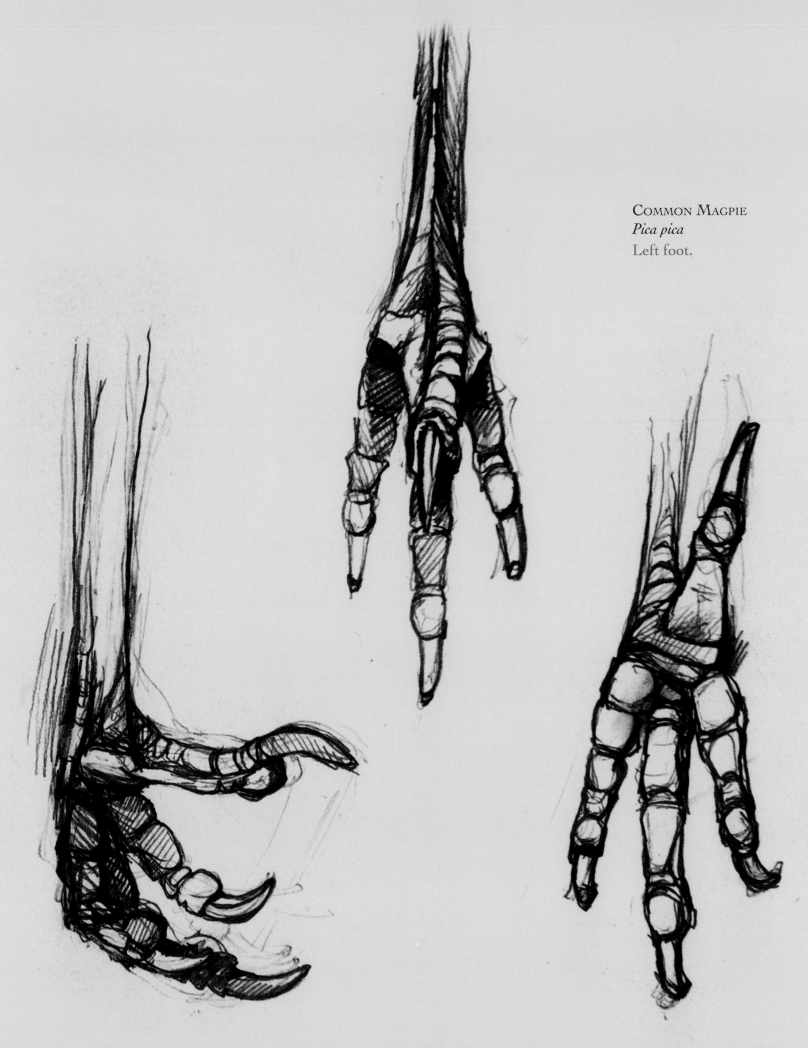

COMMON MAGPIE
Pica pica
Left foot.

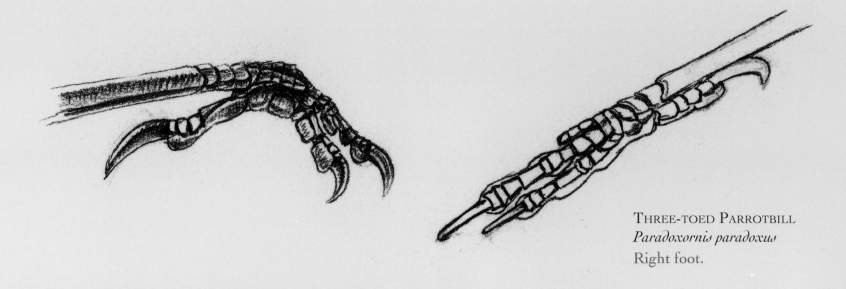

The typical perching foot has three toes facing forward, with the hind toe facing backward to oppose them. The hind toe is of a comparable length to the others and is on the same level, not higher up on the tarsus. For every rule there is an exception, and the aptly named *Paradoxornis paradoxus*, the Three-toed Parrotbill, has only three toes, the outer one having been reduced to a clawless stump. This is the only bird species to lose the outer toe and not the hind or inner one. It is nevertheless still a passerine, and the missing toe was lost very recently in its evolutionary history.

But it's not the possession of a perching-type foot that qualifies a bird as a passerine. It's the vocal capabilities resulting from the structure of the syrinx—the avian equivalent of the human voice box—that truly unite the order. This observation has now been firmly backed by molecular studies to confirm that all passerines share a common ancestral origin.

Birds produce vocal sounds not in their larynx in the throat, as mammals do, but at the other end of their windpipe, in a structure called the syrinx. All birds except New World vultures have a syrinx, including those capable of imitating human speech, such as parrots and mynahs. The word "syrinx" comes from an alternative name for pan pipes and appropriately refers to the sound of the wind through a hollow reed. (In Greek mythology Syrinx was an Arcadian river nymph, transformed into a reed to escape the amorous advances of the satyr Pan. Thwarted, Pan cut the reeds to make the pipes that bear his name.) The syrinx is situated where the windpipe, or trachea, divides into two to enter the lungs, and consists of membranes and flexible pads that can be extended into the airstream and vibrate when air is passed across them. These react in a variety of different ways, and the two sides may be "played" independently of one another and even simultaneously to produce a harmonious internal duet. The tension of the membranes and pads is controlled by paired muscles, and it is the number and position of these muscles that is of principal taxonomic significance.

The overwhelming majority of passerine families are the true songbirds, comprising the group known as oscine passerines. They are considered the most advanced of all birds and have multiple pairs of syringeal muscles operating within the syrinx itself, producing the most complex vocalizations.

The remainder, with a less highly advanced vocal repertoire, are the suboscine passerines. Their much simpler syrinx, with only a single pair of external muscles, sets them apart from the oscines but still qualifies them as passerines.

The term "songbird" doesn't simply refer to how aesthetically pleasing a bird is to listen to. Although one wouldn't associate crows, for example, with singing, they share the same anatomical structure of the syrinx with the most accomplished songsters. Conversely, many non-passerine birds have vocalizations highly pleasing to the human ear, though made with only the most basic syringeal apparatus.

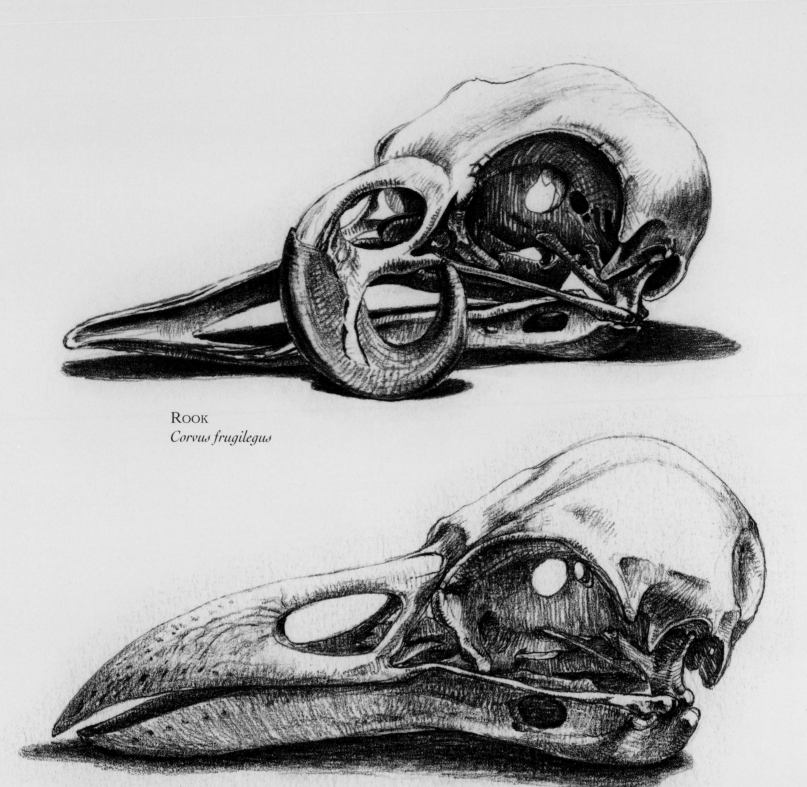

ROOK
Corvus frugilegus

COMMON RAVEN
Corvus corax

Skulls; the Rook has a severe bill deformity.

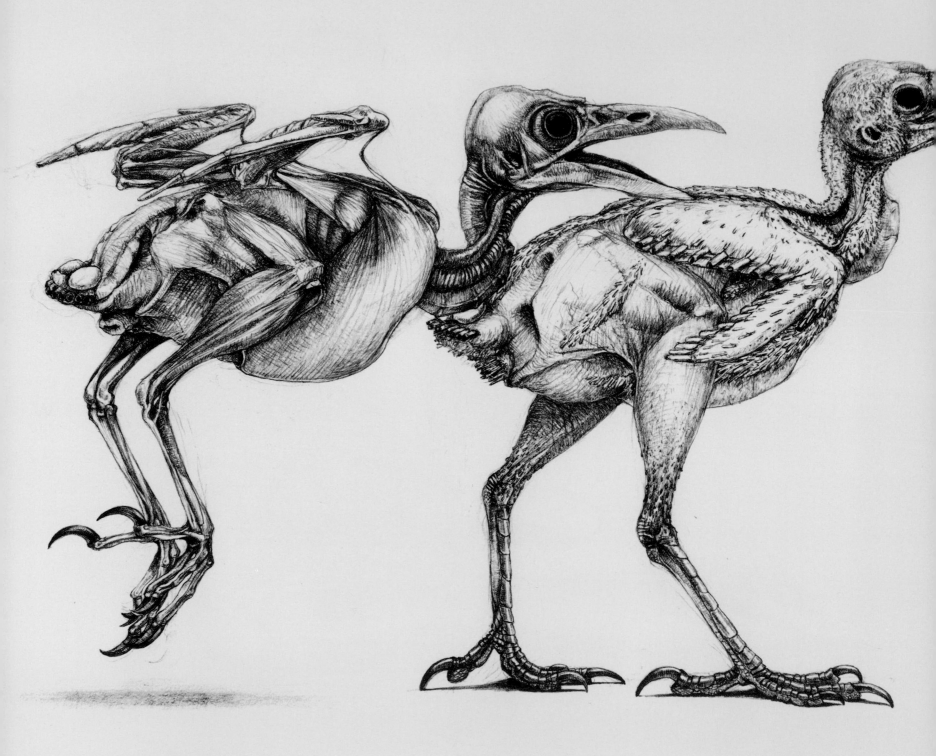

272

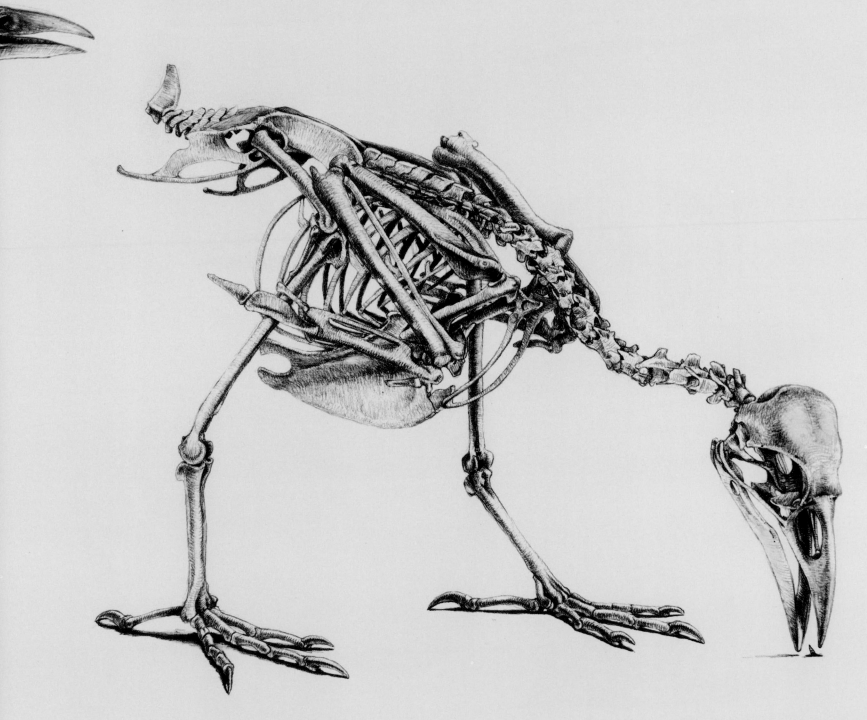

ROOK
Corvus frugilegus
Skin removed, feathers removed, and skeleton.

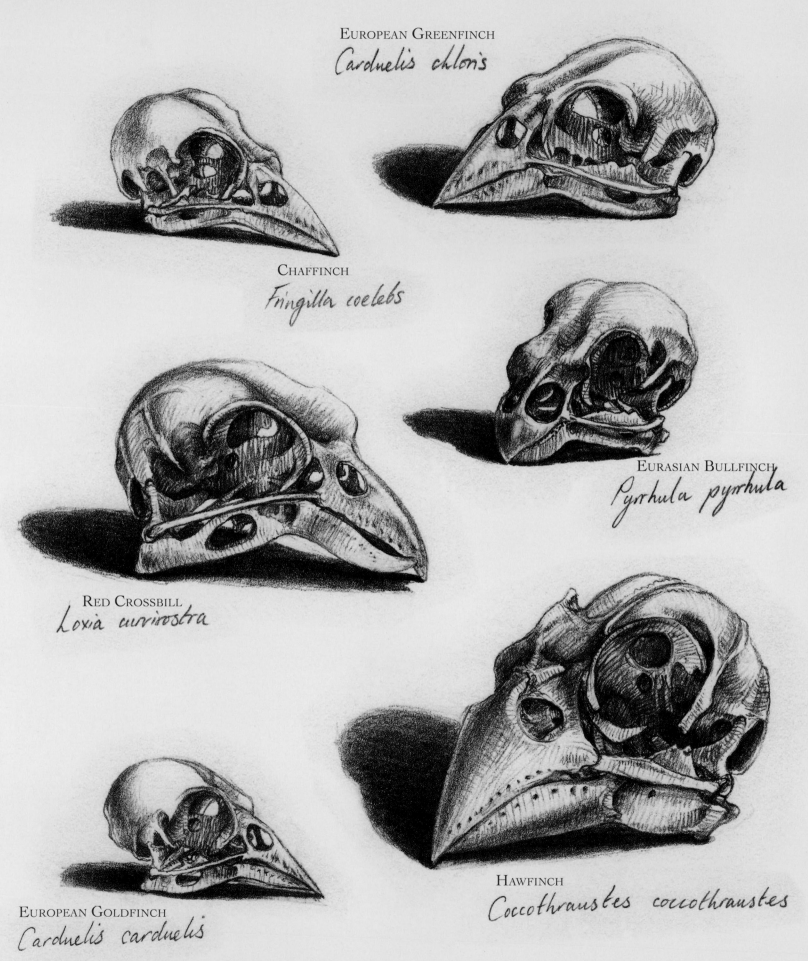

EUROPEAN GREENFINCH
Carduelis chloris

CHAFFINCH
Fringilla coelebs

RED CROSSBILL
Loxia curvirostra

EURASIAN BULLFINCH
Pyrrhula pyrrhula

EUROPEAN GOLDFINCH
Carduelis carduelis

HAWFINCH
Coccothraustes coccothraustes

Skulls of European finches showing range of bill shapes.

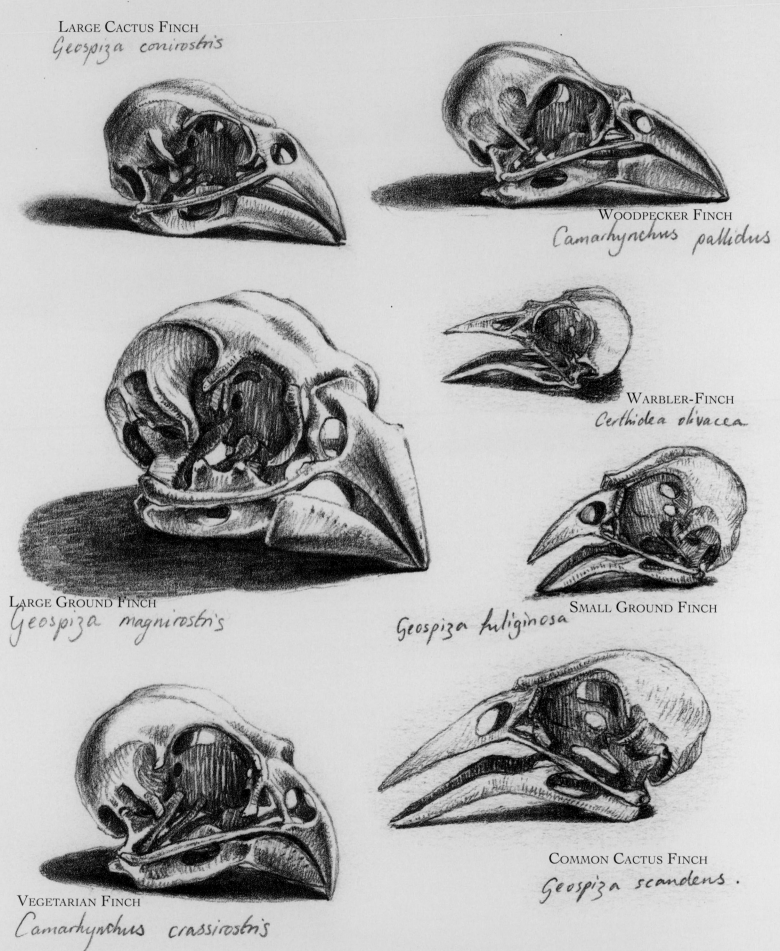

LARGE CACTUS FINCH
Geospiza conirostris

WOODPECKER FINCH
Camarhynchus pallidus

WARBLER-FINCH
Certhidea olivacea

LARGE GROUND FINCH
Geospiza magnirostris

SMALL GROUND FINCH
Geospiza fuliginosa

VEGETARIAN FINCH
Camarhynchus crassirostris

COMMON CACTUS FINCH
Geospiza scandens.

Skulls of Darwin's finches, showing adaptive radiation in bill shape.

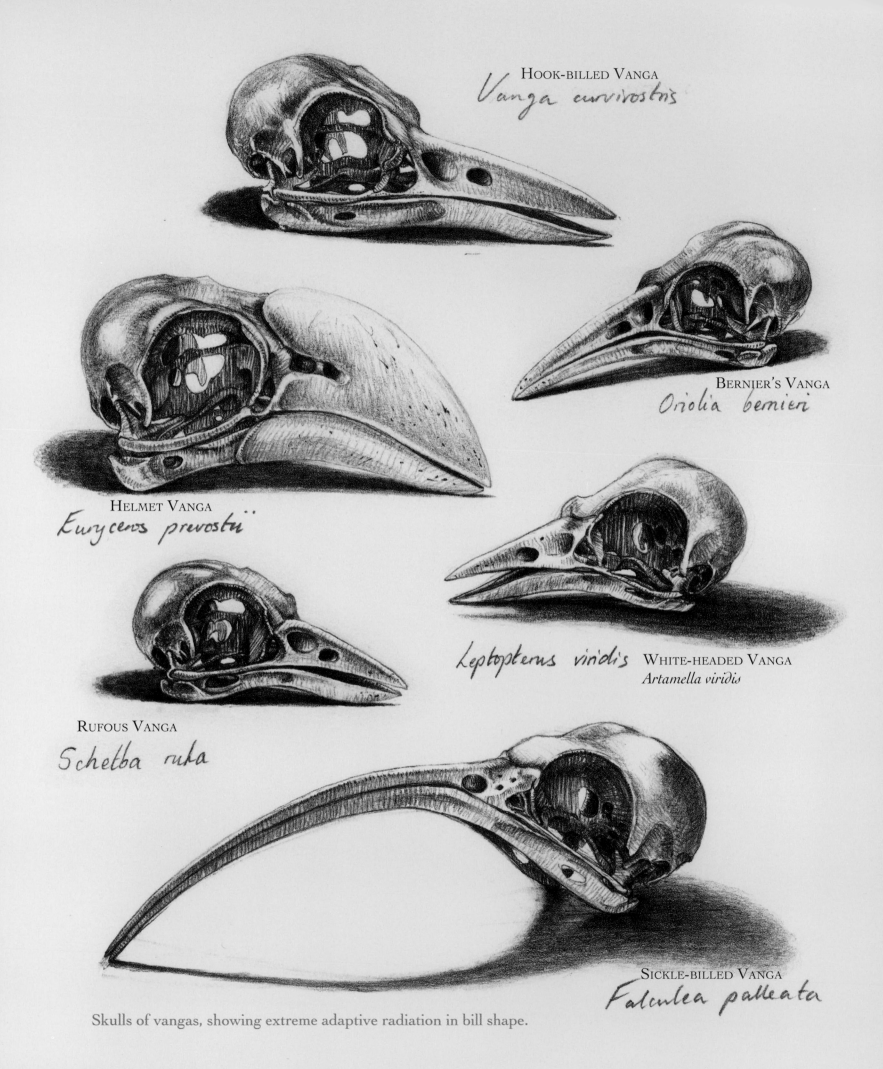

HOOK-BILLED VANGA
Vanga curvirostris

BERNIER'S VANGA
Oriolia bernieri

HELMET VANGA
Euryceros prevostii

RUFOUS VANGA
Schetba rufa

Leptopterus viridis WHITE-HEADED VANGA
Artamella viridis

SICKLE-BILLED VANGA
Falculea palleata

Skulls of vangas, showing extreme adaptive radiation in bill shape.

The trachea itself also has a part to play in bird vocalizations. It lies alongside the esophagus on the side of the neck and usually takes a direct route into the thoracic cavity to the syrinx, where it divides to enter the lungs. However, in a seemingly random assortment of about sixty bird species, scattered among half a dozen or so orders, the windpipe is *longer* than the neck and "fits" into the bird's body by coiling. The coils may be enclosed within the thoracic cavity or may sit in a hollow pit in the cradle of the wishbone; they may be embedded within the bone of the sternum or lie just beneath the feathers, sandwiched between the muscles and the skin. Many reasons have been proposed for tracheal coiling, few of which provide a satisfactory explanation appertaining to all four types. A likely interpretation, however, is that the sound transmitted via a longer windpipe exaggerates the apparent size of the bird. Within the passerines, only the manucodes, the largest and most unspectacular of the birds of paradise, exhibit this phenomenon—but arguably the most spectacular coiling of any bird's windpipe. Presumably the auditory advantages amply compensate for the lack of visual impact in the plumage department.

Modern taxonomy is constantly striving to reflect genuine evolutionary pathways, grouping the most closely related taxa together in the order in which they evolved. It's a tantalizingly elusive goal—the more we come to understand birds the further we seem to be from accomplishing this end. Simple morphological characters sometimes do reflect true relationships, but with a shoal of red herrings thrown in to confuse the taxonomist. The Passeriformes is rife with examples of convergent evolution, and there are doubtlessly many more waiting to be exposed. Unsurprisingly, the precise arrangement of families and genera within the order is a subject of ongoing debate.

Differences in the morphology of the inner ear, the tendons of the foot, the formation of the palate, and the all-important syrinx are just a few of the anatomical criteria traditionally and currently used to establish true relationships. These characteristics, now used in combination with behavioral, molecular, and biochemical analyses, nevertheless often yield conflicting and unsatisfactory conclusions. The jury is still out on many, many matters of passerine, and non-passerine, classification and promises to be so for some considerable time.

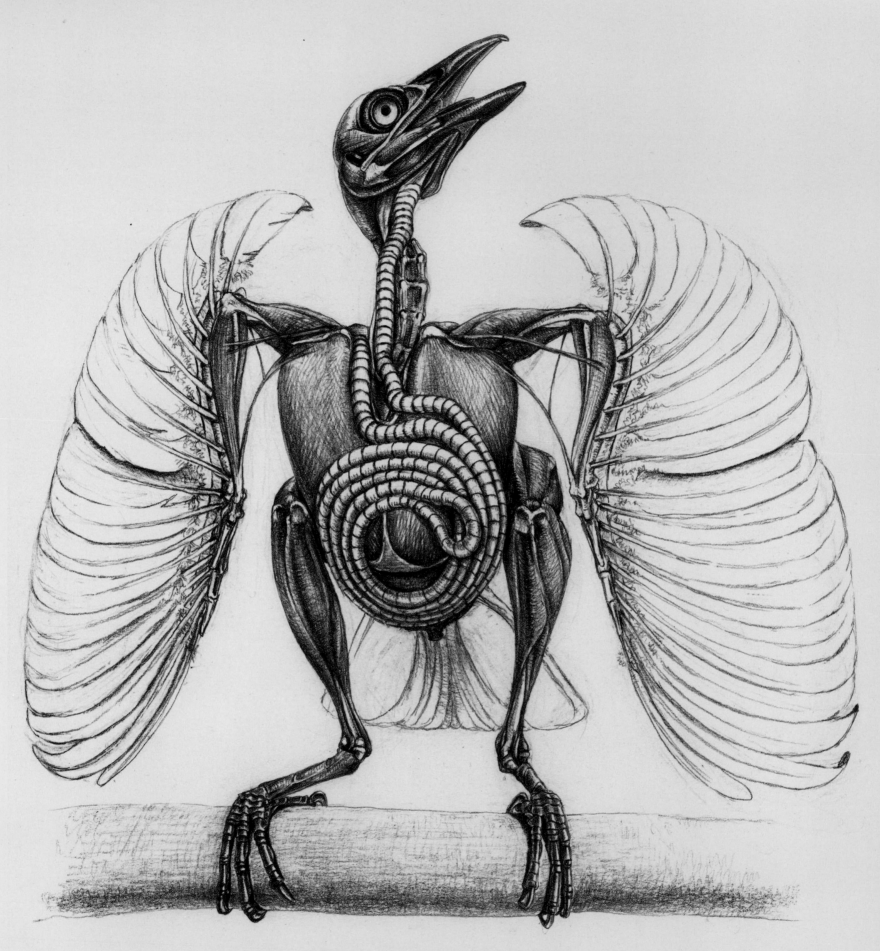

TRUMPET MANUCODE
Phonygammus keraudrenii
Bird in display posture with skin removed revealing
the extraordinary coiled windpipe.

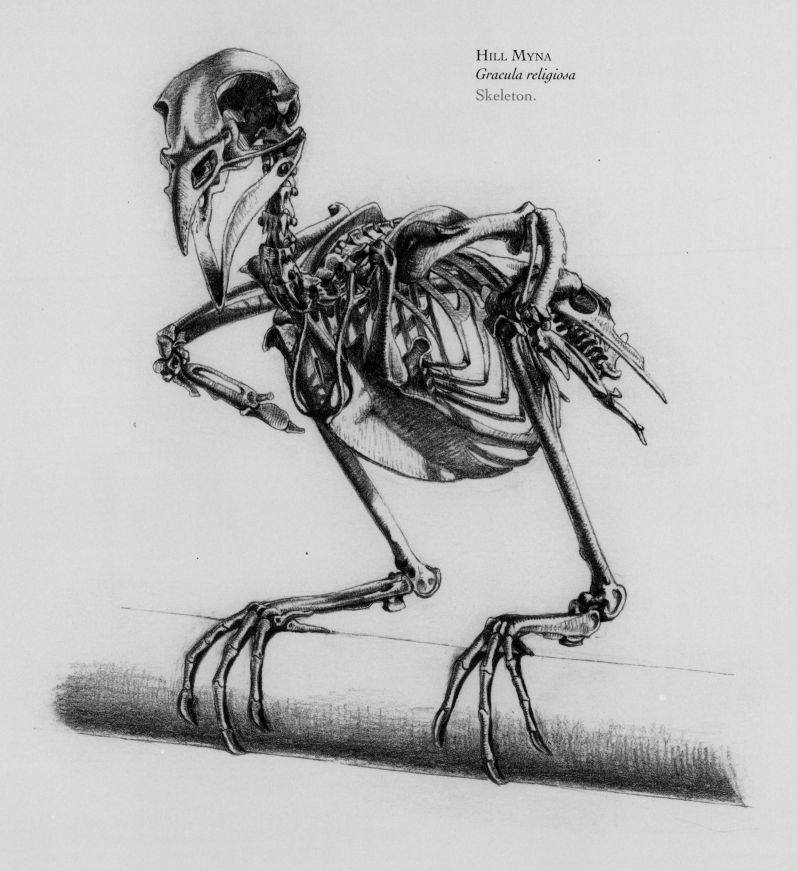

HILL MYNA
Gracula religiosa
Skeleton.

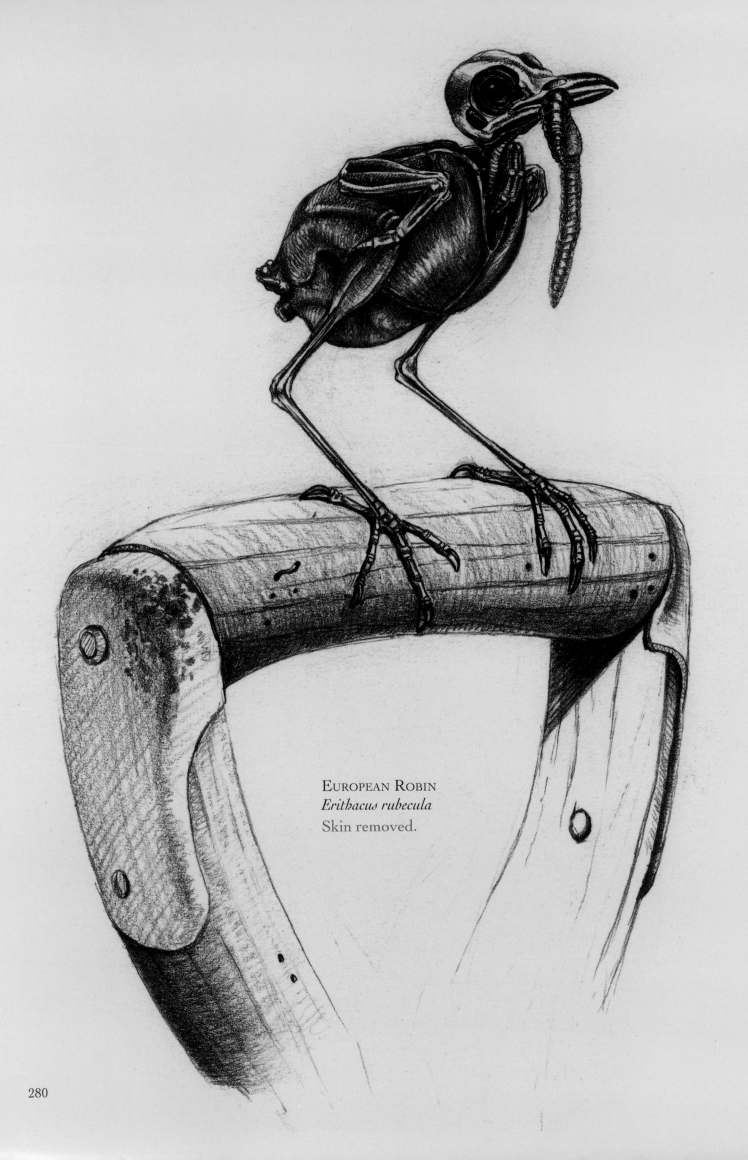

EUROPEAN ROBIN
Erithacus rubecula
Skin removed.

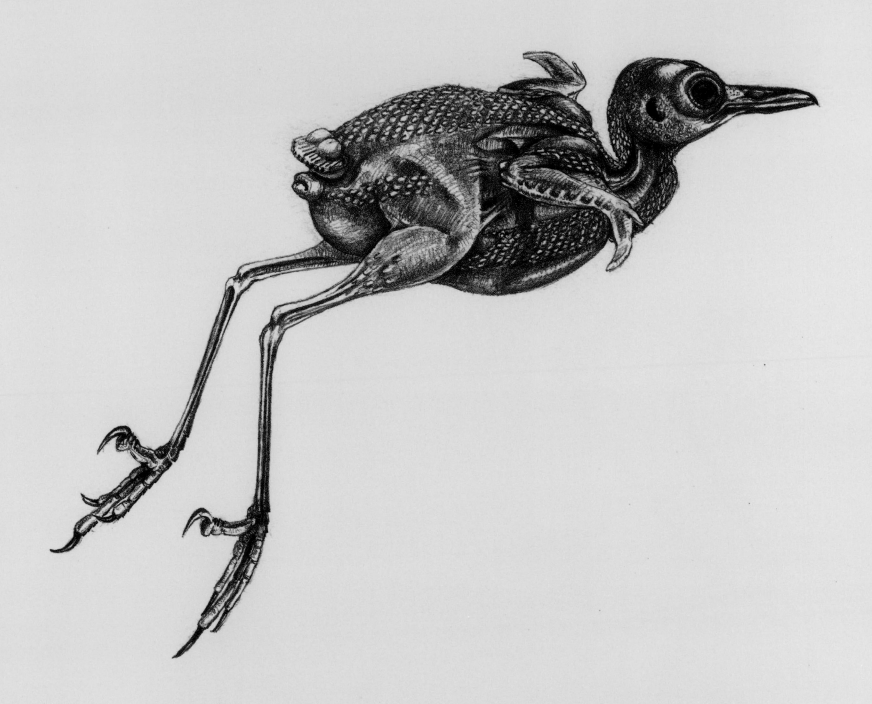

EUROPEAN ROBIN
Erithacus rubecula
Feathers removed.

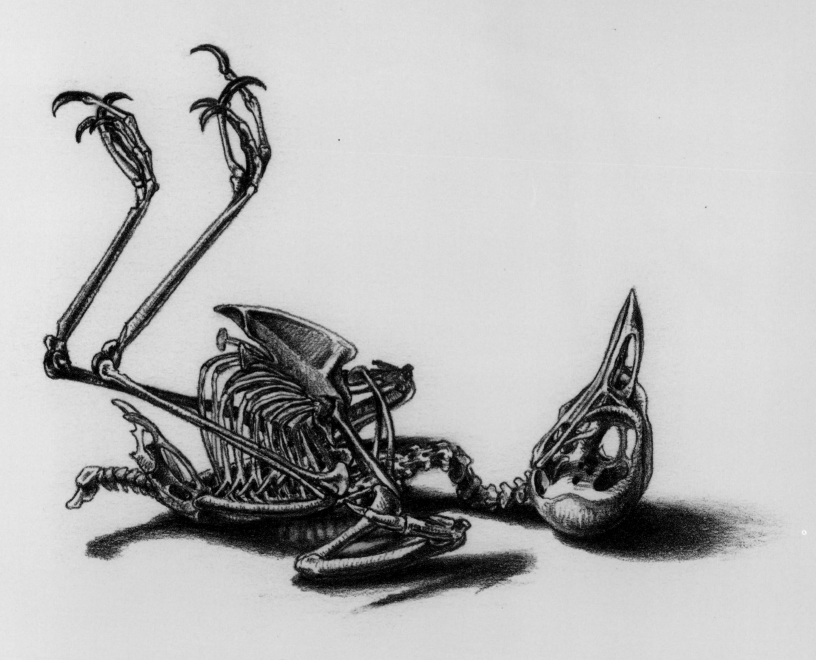

EUROPEAN ROBIN
Erithacus rubecula
Skeleton.

Index

MALLARD
Anas platyrhynchos
Skeleton.

Accipiter nisus 40, 41

Actophilornis africanus 198

Aegolius acadicus 49

Aethia psittacula 157

African Harrier-Hawk 37

African Jacana 198

African Owl 251

Alca torda 158, 160

Alcedo atthis 62, 63

Amazona amazonica 55

Anarhynchus frontalis 193

Anas clypeata 92

Anas platyrhynchos 4–5, 6–7, 16–17,
 20–21, 94, 95, 97, 284, 287

Anas platyrhynchos (domestic variety) 87, 96, 99

Andean Condor 31

Anhinga melanogaster 149

Anser anser 100

Anser anser (domestic variety) 101

Anser anser x Anser cygnoides 103

Anser cygnoides 100

Anser cygnoides (domestic variety) 87, 101, 102

Anthropoides virgo 182, 184

Aptenodytes forsteri 110–111

Apteryx australis 234–235

Apus apus 263, 264

Ara chloropterus 56

Ardea cinerea 168–169, 171

Arenaria interpres 193

Artamella viridis 276

Atlantic Puffin 156, 157

Balaeniceps rex 172

Bald Eagle 38

Balearica regulorum 183

Barn Owl 50, 51

Barn Swallow 267

Bernier's Vanga 276

Black Kite 38

Black Scoter 90

Black Skimmer 153

Black Vulture 33

Black-browed Albatross 126, 127

Blue Tit 41

Blue-throated Barbet 73

Botaurus stellaris 170

Branta bernicla 89

Branta Canadensis 89

284

Brent Goose 89
Brown Fish Owl 45, 46
Brown Kiwi 234–235
Bucephala clangula 91
Buceros bicornis 66, 67, 68
Budgerigar 57
Burhinus oedicnemus 200
Buteo buteo 39

Cacatua moluccensis 53
Call Duck 99
Calyptomena viridis iv
Camarhynchus crassirostris 275
Camarhynchus pallidus 275
Campephilus principalis 75
Canada Goose 89
Cape Barren Goose 88
Caprimulgus europaeus 19, 258,
 259, 260, 261
Carduelis carduelis 274
Carduelis chloris 274
Caspian Tern 152
Casuarius casuarius xi, 236
Cereopsis novaehollandiae 88
Certhidea olivacea 275
Ceyx fallax 64
Ceyx melanurus 64
Chaffinch 274
Charadrius hiaticula 193
Chauna torquata 221, 222
Chinese Goose 87, 101, 102
Chionis albus 200
Ciconia ciconia 176–177
Coccothraustes coccothraustes 274
Coeligena torquata 83
Colius striatus 61
Collared Inca 83
Columba livia 252–253
Columba livia (domestic variety) 249,
 251, 255, 256, 257
Columba palumbus 9, 22–23, 24–25, 27
Common Black-headed Gull 151
Common Cactus Finch 275
Common Coot 187, 188–189
Common Eider 90
Common Goldeneye 91
Common Hoopoe 69
Common Kingfisher 62, 63
Common Magpie 26, 268–269
Common Moorhen 3

Common Pheasant 206, 208–209
Common Raven 271
Common Redshank 193
Common Ringed Plover 193
Common Shelduck 91
Common Snipe 199
Common Swift 263, 264
Coracias benghalensis 69
Coragyps atratus 33
Cornish Broiler 213
Corvus corax 271
Corvus frugilegus 271, 272–273
Corythaeola cristata 60
Crested Duck 99
Cygnus columbianus 87
Cygnus olor 85

Dacelo novaeguineae 64
Darter 149
Demoiselle Crane 182, 184
Dendrocopos major 76, 77
Diomedea exulans ii–iii
Dodo 245
Domestic Fowl *(unspecified variety)* 218
Domesticated goose hybrids 103
Double-toothed Barbet 73

Egyptian Vulture 34
Emperor Penguin 110–111
English Pouter 256
Ensifera ensifera 82
Eos rubra 54
Erithacus rubecula 280, 281, 282
Eudyptula minor 105
Eurasian Bittern 170
Eurasian Bullfinch 274
Eurasian Buzzard 39
Eurasian Collared Dove 40
Eurasian Curlew 193
Eurasian Oystercatcher 197, 198
Eurasian Sparrowhawk 40, 41
Eurasian Spoonbill 180
Eurasian Stone Curlew 200
Eurasian Woodcock 199
European Goldfinch 274
European Greenfinch 274
European Nightjar 19, 258, 259,
 260, 261
European Robin 280, 281, 282
European White Stork 176–177

Euryceros prevostii 276
Eutoxeres Aquila 82

Falco peregrinus 38
Falculea palleata 276
Fantail Dove 249
Fratercula arctica 156, 157
Fregata magnificens 132, 134–135
Fringilla coelebs 274
Fulica atra 187, 188–189

Gallinago gallinago 199
Gallinula chloropus 3
Gallus gallus 210–211
Gallus gallus (domestic variety) 212,
 213, 214, 215, 216, 217, 218
Gavia stellate 114, 115, 116–117, 118
Gentoo Penguin 106–107, 108, 109
Geospiza conirostris 275
Geospiza fuliginosa 275
Geospiza magnirostris 275
Geospiza scandens 275
Glossy Ibis 178–179
Gracula religiosa 279
Great Auk 159
Great Barbet 73
Great Blue Turaco 60
Great Bustard 240, 241
Great Cormorant 145, 146–147
Great Crested Grebe 120–121,
 122–123
Great Hornbill 66, 67, 68
Great Skua 152
Great Spotted Woodpecker 76, 77
Great White Pelican 12–13, 137, 138
Greater Flamingo 163, 165, 166
Green Broadbill iv
Green Woodpecker 75, 78
Grey Crowned Crane 183
Grey Heron 168–169, 171
Greylag Goose 100
Grus Americana 182
Guillemot 155, 160

Haematopus ostralegus 197, 198
Haliaeetus leucocephalus 38
Hammerkop 172
Hawfinch 274
Heavy-footed Moa xiii
Helmet Vanga 276
Helmeted Curassow 217

Helmeted Guineafowl 15, 217
Hill Myna 279
Hirundo rustica 267
Hoatzin 224, 225
Hook-billed Duck 99
Hook-billed Vanga 276

Indian Peafowl *front and back cover,*
 202–203, 204
Indian Roller 69
Indian Runner Duck 87, 96
Ivory-billed Woodpecker 75

Jackass Penguin 112–113
Japanese Bantam 214

Kagu 191
Ketupa zeylonensis 45, 46
King Vulture 33

Lagopus lagopus 207
Lappet-faced Vulture 34
Large Cactus Finch 275
Large Ground Finch 275
Larus ridibundus 151
Laughing Kookaburra 64
Leptoptilos crumeniferus 176–177
Leucochloris albicollis 81
Limosa fedoa 193
Little Penguin 105
Loxia curvirostra 274
Lybius bidentatus 73

Macrocephalon maleo 217
Macronectes giganteus 125
Magnificent Frigatebird 132, 134–135
Maleo 217
Mallard 4–5, 6–7, 16–17, 20–21, 94,
 95, 97, 284, 287
Maltese 257
Manx Shearwater 128–129
Marabou 176–177
Marbled Godwit 193
Megalaima asiatica 73
Megalaima virens 73
Melanitta nigra 90
Meleagris gallopavo 206
Melopsittacus undulates 57
Mergus serrator 90, 91
Milvus migrans 38
Modena 255
Modern English Game Bantam 215

Morus bassanus 139, 140–141, 142
Musophaga violacea 59
Mute Swan 85
Mycteria leucocephala 175

Neophron percnopterus 34
Northern Gannet 139, 140–141, 142
Northern Lapwing 196
Northern Saw-whet Owl 49
Northern Shoveler 92
Numenius arquata 193
Numida meleagris 15, 217

Oceanites oceanicus 131
Opisthocomus hoazin 224, 225
Orange-winged Parrot 55
Oriolia bernieri 276
Osprey 36
Ostrich 227, 228–229, 230, 232–233
Otis tarda 240, 241

Pachyornis elephantopus xiii
Painted Stork 175
Pallas's Sandgrouse 242, 243
Palm Cockatoo 10
Pandion haliaetus 36
Paradoxornis paradoxus 270
Parakeet Auklet 157
Parus caeruleus 41
Pauxi pauxi 217
Pavo cristatus front and back cover,
 202–203, 204
Pelecanus onocrotalus 12–13, 137, 138
Peregrine Falcon 38
Pezophaps solitaria 246
Phaethon aethereus 133
Phaethon lepturus 134–135
Phalacrocorax carbo 145, 146–147
Phalaropus lobatus 198
Pharomachrus mocinno 61
Phasianus colchicus 206, 208–209
Philippine Dwarf Kingfisher 64
Philippine Eagle 38
Phoenicopterus ruber 163, 165, 166
Phonygammus keraudrenii 278
Pica pica 26, 268–269
Picoides tridactylus 75
Picus viridis 75, 78
Pied Avocet 194–195, 198
Pinguinus impennis 159
Pithecophaga jefferyi 38

Platalea leucorodia 180
Plegadis falcinellus 178–179
Podargus strigoides 262
Podiceps cristatus 120–121, 122–123
Polish Fowl 217
Polyboroides typus 37
Porphyrio porphyria 186
Probosciger aterrimus 10
Puffinus puffinus 128–129
Purple Swamphen 186
Pygoscelis papua 106–107, 108, 109
Pyrrhula pyrrhula 274

Ramphastos toco 70–71, 72
Raphus cucullatus 245
Razorbill 158, 160
Recurvirostra avosetta 194–195, 198
Red Crossbill 274
Red Grouse 207
Red Junglefowl 210–211
Red Lory 54
Red-and-green Macaw 56
Red-billed Hornbill 69
Red-billed Tropicbird 133
Red-breasted Merganser 90, 91
Red-necked Phalarope 198
Red-throated Loon 114, 115,
 116–117, 118
Red-winged Tinamou 238
Resplendent Quetzal 61
Rhynchotus rufescens 238
Rhynochetos jubatus 191
Rock Dove 252–253
Rodrigues Solitaire 246
Rook 271, 272–273
Ruddy Turnstone 193
Rufous Vanga 276
Rynchops niger 153

Sagittarius serpentarius 42
Salmon-crested Cockatoo 53
Sarcoramphus papa 33
Scandaroon 251
Schetba rufa 276
Scolopax rusticola 199
Scopus umbretta 172
Secretary Bird 42
Shoebill 172
Sickle-billed Vanga 276
Silkie Fowl 216
Small Ground Finch 275

Snowy Sheathbill 200
Somateria mollissima 90
Southern Cassowary xi, 236
Southern Giant Petrel 125
Southern Screamer 221, 222
Speckled Mousebird 61
Spheniscus demersus 112–113
Stercorarius skua 152
Sterna caspia 152
Streptopelia decaocto 40
Strix aluco 47, 48, 49
Struthio camelus 227, 228–229, 230, 232–233
Sulawesi Dwarf Kingfisher 64
Swan Goose 100
Sword-billed Hummingbird 82
Syrrhaptes paradoxus 242, 243

Tadorna tadorna 91
Tawny Frogmouth 262
Tawny Owl 47, 48, 49
Tetrao urogallus 206
Thalassarche melanophrys 126, 127
Three-legged Domestic Fowl 212
Three-toed Parrotbill 270
Three-toed Woodpecker 75
Tockus erythrorhynchus 69
Toco Toucan 70–71, 72
Torgos tracheliotus 34
Tringa tetanus 193
Trumpet Manucode 278
Tula Goose 101
Tundra Swan 87
Tyto alba 50, 51

Upupa epops 69
Uria aalge 155, 160

Vanellus vanellus 196
Vanga curvirostris 276
Vegetarian Finch 275
Vienna Short-faced Tumbler 251
Violet Turaco 59
Vultur gryphus 31

Wandering Albatross ii–iii
Warbler-Finch 275
Western Capercaillie 206
White-headed Vanga 276
White-tailed Tropicbird 134–135
White-throated Hummingbird 81
White-tipped Sicklebill 82

Whooping Crane 182
Wild Turkey 206
Wilson's Storm Petrel 131
Woodpecker Finch 275
Woodpigeon 9, 22–23, 24–25, 27
Wry-bill 193

MALLARD
Anas platyrhynchos
Skeleton.